P9-ECX-947

DAN DAILEY

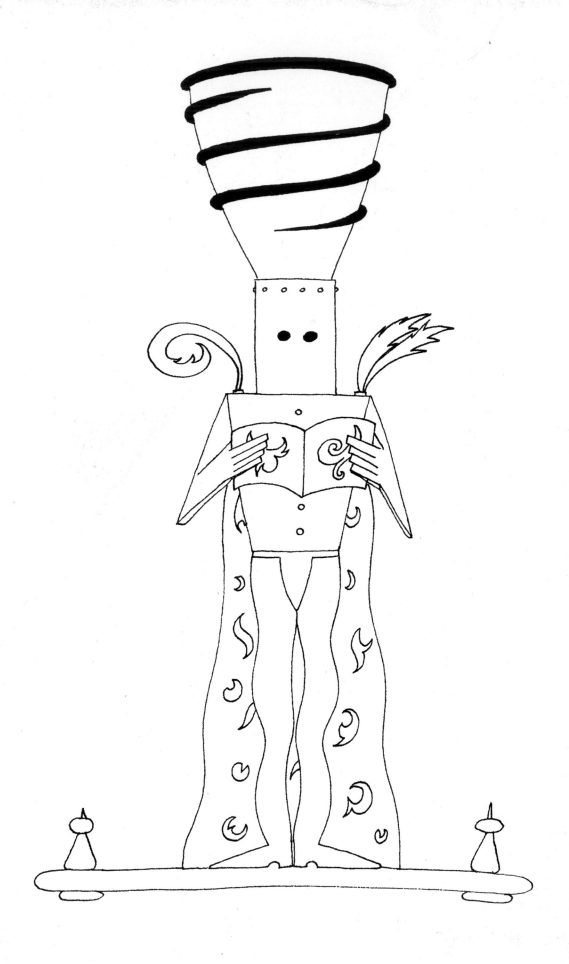

The Savant

DAN DAILEY

DEDICATED TO
LINDA MACNEIL
ALLISON DAILEY
OWEN DAILEY

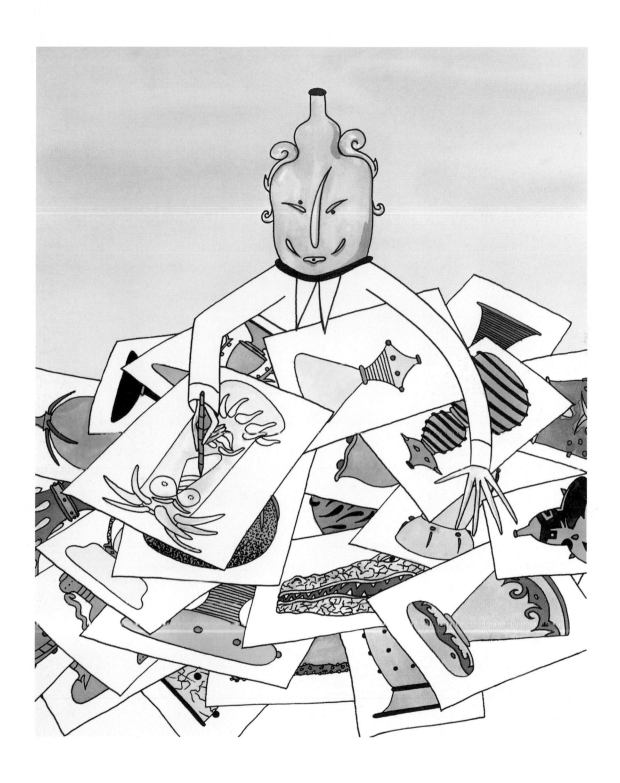

PREVIOUS
The Savant
14H x 9W"
1992

ABOVE
*The Artist Trapped
by the Vase*
12H x 9W"
1992

FOLLOWING
Man's Best Friend
8H x 5W"
1974

DAN DAILEY

EDITING | DESIGN | JOE RAPONE

FOREWORD

"There is no art; there are only artists." So begins Gombrich's magisterial "The Story of Art," his overview of art and human culture. He thus relieves us of the mind-bending exercise of defining what is an artist and how can we identify and evaluate one. Why do we care? Perhaps it is because art is so strongly linked to human survival. It is the most benign way of creating commonalities and a sense of community that our species has discovered.

A visit to Dan Dailey's home and studio helps us understand his view of life and the essential spirit of his work. The atmosphere is charged with the energy of people working in concert to create objects that are well made. "Ben fatto," the Italians say from the vantage point of a culture that has admired artisan production for thousands of years.

What do we mean when we use the phrase "well made"? Obviously, it suggests that the object can perform its intended task. A chair must support the sitter. But utility is a rudimentary way of looking at the issue. We want more from our chairs, vases and lighting fixtures. We want aesthetic satisfaction. We want beauty.

The very idea of "beauty" may be deeply embedded in our genetic code and linked to the idea of "good" and a moral universe. All of Dailey's work is inevitably linked to notions of history, style and beauty. I would not be surprised to discover that Dailey's model for a workshop or studio was informed by the years he spent in Italy. The studio (the derivation of the word comes from the root, "to study") by definition is a separate universe where artists experiment to discover new ways of observing reality. These observations find a way of entering the larger culture and have the potential to define and transform its values.

Art-making is a family business at the Dailey compound. His wife, Linda MacNeil, is a brilliant jewelry designer whose work is celebrated for its impeccable craftsmanship and imagination. Their daughter, Allie, (who I must admit interned for me in 2001) is a delightful young woman now working as an architect. Their son, Owen, is a sculptor who assists his father in making models and solving dimensional problems. Dan Dailey has created many impressive works, but this sweet family collective working to create art is perhaps his most touching accomplishment.

MILTON GLASER

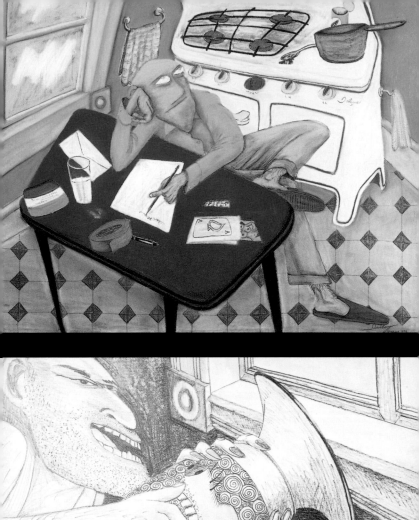
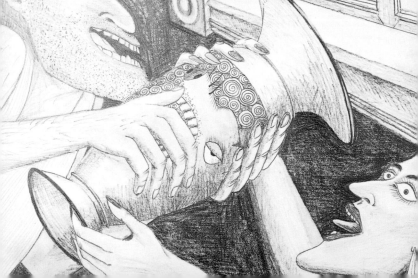

MAKE IT REAL

There was once a cherished theory among historians that a predominant spirit could characterize each era, and that it was possible to tell the story of a time by focusing on the unfolding of that Zeitgeist. Edward Gibbon, author of the *Decline and Fall of the Roman Empire,* even sought to extend the idea of the "ruling passion" as a guide for interpreting the historical behavior of individuals. Art historians adopted a similar idea when they sought to define a predominant style.

Sometime in the twentieth century this all fell apart, as historians and philosophers and advanced critics challenged the belief that history tells a coherent story, or that art can have a prevailing style. Today, the world appears to us as far more random, even anarchic, and our interpretation of events has become more cynical and ironic. The art world has adopted this position with abandon, rolling out new styles and superstar artists with ever increasing frequency, only to tear them down with relish. Today, no single style reigns supreme in art: many artists in fact proclaim themselves proficient in multiple styles.

This academic state of affairs has not, however, stopped anyone from longing for a good story, well told. There remains something supremely satisfying in the old-fashioned narrative. I believe that it has been Dan Dailey's particular genius to stick to a certain measured narrative simplicity, an elegance of presentation, even as he has adopted many of the outposts of advanced modern art, specifically its irony and distracted sense of the real. One of the charges of the modern era was to "make it new." Dailey has always held to another one: "make it real."

By way of illustrating my point, I'll examine two drawings by Dan Dailey: the first is titled "Distant Thoughts." It shows a person seated at a kitchen table writing a letter. Surrounded by a glass of milk, a roll of tape, a deck of playing cards, a stove, and other ordinary objects, the writer stares at the ceiling above the table in a state of calm reverie. The second artwork is titled "Tug of Art" and shows a similar character wrestling with a female over a vase. The main characters in both drawings display two personality extremes; one sedate and pensive, and the other aggressive and conflicting, while the vase in "Tug of Art" is wryly indifferent to the battle.

These two works by Dailey are meant to show him not only as an ironic observer and narrator of life, but also as an artist willing to display empathy for the human condition. In a letter from the 1970s, Dan wrote: "It is an obvious conclusion that man can never be more than a sophisticated savage. However, it is an obvious alter conclusion that man's gentleness and love will always be a balance to the warring side of his nature."

Dan Dailey is a master narrator and illustrator of human nature, but he has a literal spin on what that means. In another letter from the 1970s he wrote: "Man is an animal and has all of an animal's characteristics and more. . . not less." And elsewhere he talks about "the beginnings of an acceptance of man's animalness." Much of Dailey's work probes this link between human and animal natures, for example, in the sculpture titled *Sick as a Dog* (p.80).

Dailey's work emerges from a very specific art movement, studio glass, which centers not on a specific style of art making, but on a specific technology. Studio glass traces its roots back to the immediate post-World War II era. At that time, the artist Harvey Littleton sought to free glassmaking from the confines of the industrial factory and to make it available to the artist in the intimacy of the studio. Littleton also wanted to establish studio glass as an educational program taught in leading universities. Studio glass owes a debt to the tenets of the Bauhaus (a school of

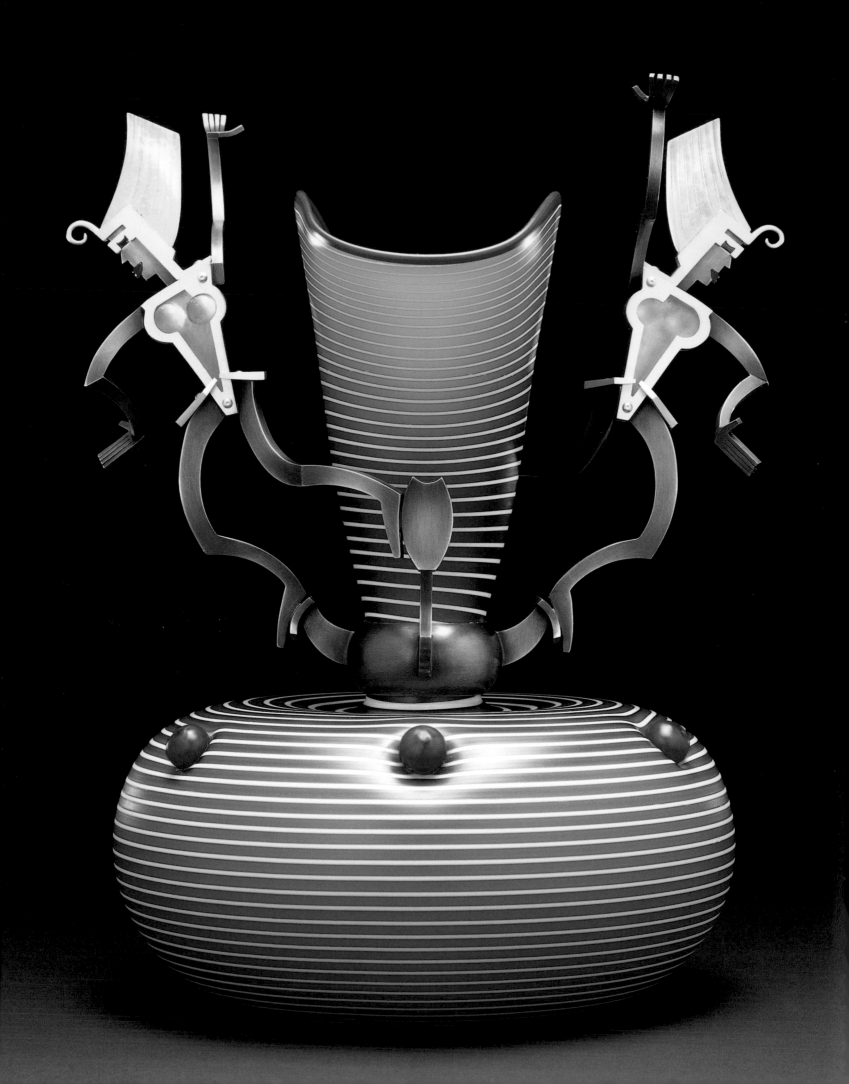

design and art founded by Walter Gropius in 1919 in Weimar), and Dailey feels that the Bauhaus, with its attitude of caring deeply about the actual process of making objects, has influenced his approach to art. Gropius sought to elevate crafts to a level with the arts, and to bring all the various art media together so that artists could work as a team on increasingly complex projects. Dailey has adapted these ideals in his work.

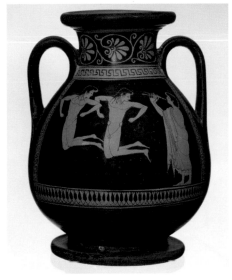

Dailey's work remains somewhat outside of what has become "traditional" about studio glass, which in its earliest phases was heavily influenced by Abstract Expressionism as evidenced in the color field sculptures of Littleton and Chihuly. Curiously, studio glass was never very much influenced by popular realism or folk art: When glass makers have turned toward realism, they more often than not have been captivated by the remote in time and place and have shown a marked sympathy for Magical Realism. The work of William Morris, for example, spotlights prehistoric cultures, while Janusz Walentyno-wicz shows the influence of Magical Realism in his mysterious, slightly out-of-focus figures. Dailey is among the few artists using glass who make work about people you or I might encounter in our everyday lives: taxi drivers, bartenders, or toll collectors. These individuals are most often rendered in a direct, highly concrete form of realism. Dailey's focus upon figural realism is significant. For much of the immediate pre- and post-World War II era, figural sculpture was practically banned from the realm of so-called high or advanced art, and Abstract Expressionism dominated the museum and gallery scene. But in the late 1950s

and early 1960s, the New Realists, a group that includes Jasper Johns and Robert Rauschenberg, sought to re-establish the connections between art and life by introducing real (found) objects into their work: for example, a goat and a tire, or an old bedspread, might be attached onto, or melded into, the surface of a canvas. Dailey fits eccentrically within this group: he chose to make hyper-real objects himself, rather than draw upon found objects.

His vases and lamps are not truly vases and lamps: they are works of art using vases and lamps as their format. Every Dailey is the result of a complex series of decisions. Most begin as a drawing—a carefully made composition that builds on many hours of experience with pen and paper. Dan's studio has a shelf lined with sketchbooks, one for each year stretching back to the early 1970s, that chronicle his take on human nature. Using a drawing as a sort of "armature," Dailey decides how to bring an idea to life as a three-dimensional artwork. In some cases, that involves folding the drawing around a blown glass vase—not literally wrapping it, but rather through another cascade of decisions, adapting the inked sheet of paper to the cutting and painting and other processes best suited to glass. If the drawing is to give life to a lamp shaped like a nude female, then sheets of metal, usually brass, must be cut out by hand and assembled into human forms: hands, breasts, a torso. Here the density and subtlety of the decisions become crucial, striking a balance between the rigidity of the metal and glass, and the fluidity of his drawing. Dailey's drawing style suits itself well to the materials in its precision and angularity, while his paintings capture the more subtle aspects

OPPOSITE
Geométrance
15H x 10D"
2001

ABOVE
Euphronios
12.25H x 9.5D"
520–515BCE
MUSEUM OF FINE ARTS, BOSTON
ROBERT J. EDWARDS FUND
PHOTOGRAPH © 2006 MUSEUM OF FINE ARTS, BOSTON

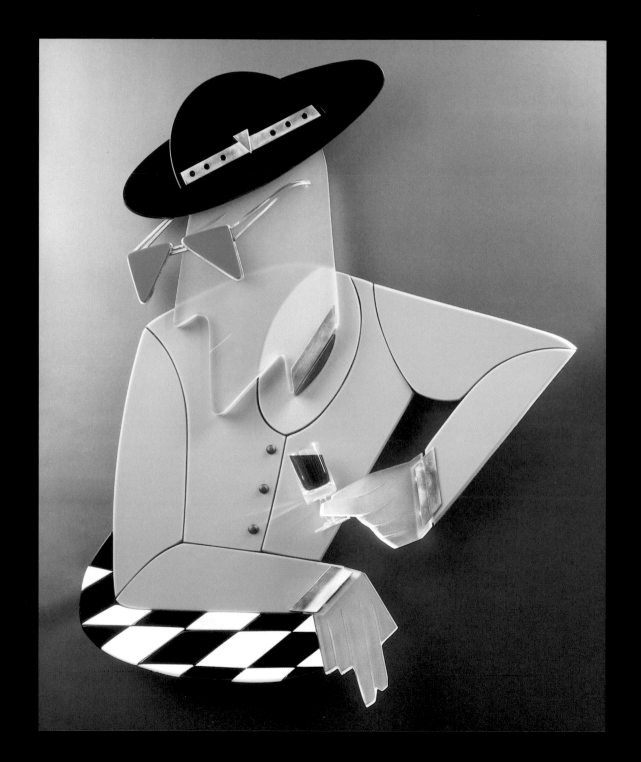

of softly etched glass. Another example of the decision making process involves scale. Dailey says he is attracted to detail, and chooses to work at a scale that is compliant with the delight he takes in excessive detail. But within each piece, he enjoys "playing the scale game" to excess: for example, in his Circus Vase series, Dailey contrasts small, highly detailed parts on the handles with larger expanses of minimally detailed surfaces on the vase form itself. From across a room, it's the silhouette and striking color of the vase that capture your eye and draw you toward it. Once you're in front of the vase, it may be the pea-sized, glinting inlaid glass eye of a figure on the metal handle that urges you to lean in close and appreciate the finely wrought detail (see *Sparklers* p.261).

Dailey's work has enjoyed widespread appeal among collectors in part because of its pleasing human scale. But even in a two-ton mural work like *Orbit* (p.367), created for the Rainbow Room at Rockefeller Center, interplays of scale are more important than sheer size for size's sake. The glass mural has an image that is meant to be seen across the cavernous space (about 200 feet) but is also accented with much smaller details that only come into focus close up. Most of Dailey's large murals are intended to work this way in similar fashion to his more intricate vases, such as the *Circus* series.

Dailey's objects have "multiple layers of meaning" that I describe as the "mechanics" of his art, which depends upon the density of decisions. Dailey has created through mechanics and intricacy a kind of assembled Cubism that provides views of personality from many directions simultaneously. For example,

a figure might have an anguished face, but the sheen of the face (from the glass) can be quite lovely, transporting the anguished look to a more spiritual plane.

Several examples of Dailey's art draw upon ancient Egyptian art: for example, his Vitrolite (a type of flat glass) wall panels function as hieroglyphic images. *Nude on the Phone* (p.111), could—except for the deluxe and modern nature of its subject matter—adorn a pharaoh's palace or tomb: they are replete with the vibrant colors and the exquisite small details of life so beloved by the Egyptians. Additionally, their pharaohs were fascinated with scenes depicting the hunter and the hunted, a subject Dailey has explored in his work from time to time. The funerary mask of the Pharaoh Tutankhamun, which I consider to be the first great multimedia artwork, is an outstanding instance of the collaboration of the metalsmith (using mainly gold) and the glass-maker (many, but not all of the inlays are glass—the others are semi-precious stones). Some "aesthetic purists" have trouble with Dailey's work because it mixes glass and metal. However, for me, one of the chief attractions of Dailey's multimedia art is that it draws upon deep, rich, and ancient traditions.

One aspect of Mark Twain's genius was to recognize the richness of slang and incorporate it into novels like *Huckleberry Finn*; Louis C. Tiffany's genius was to recognize that impurities give glass a richer character. Dailey's genius has been to adapt the nineteenth century literary interest in hieroglyphics to visual art. Dailey's artistic corpus is a rich text of hieroglyphics that tell

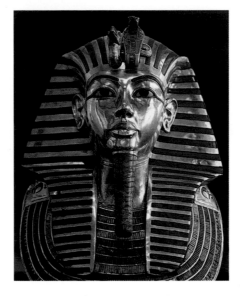

Mask of Tutankhamun
21.25H X 15.3W X 19.5D"
1324–25BCE

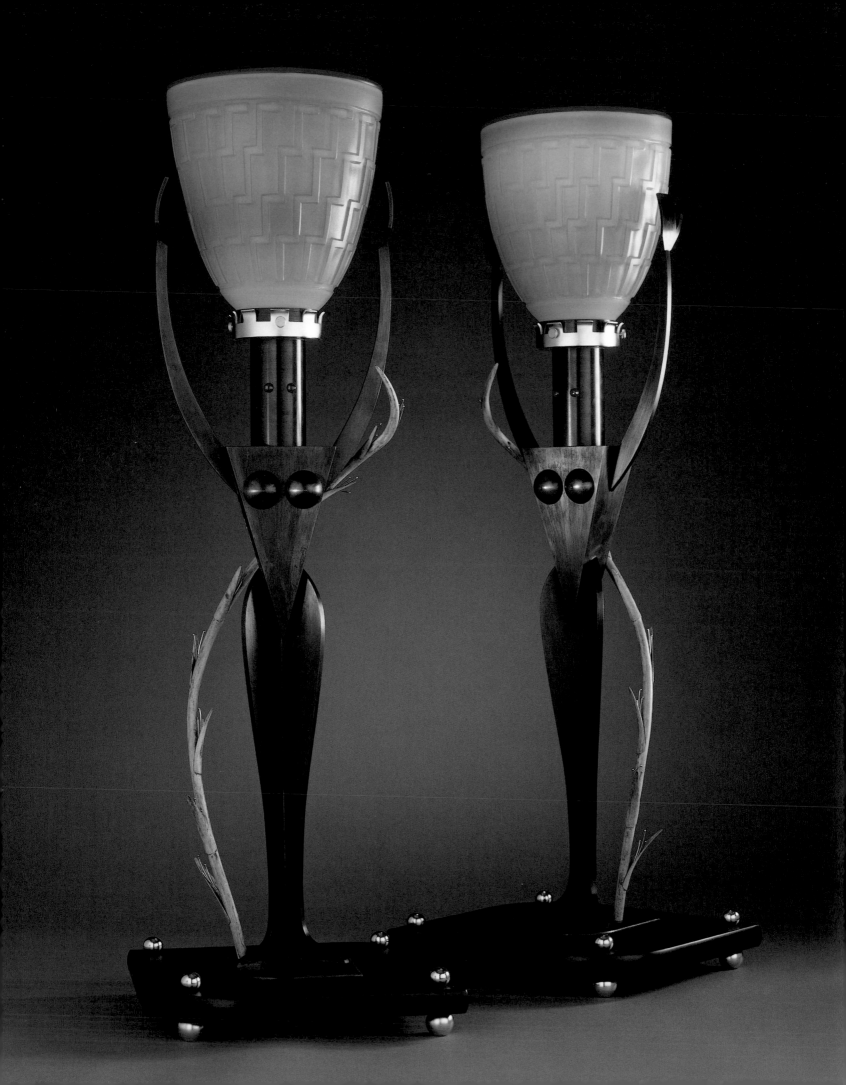

a story of human nature. In the nineteenth century, Emerson, Melville, Thoreau and Whitman (among many others) were all interested in the significance of Egyptian hieroglyphics, which had recently been deciphered by Champollion in France. Melville saw the white whale, Moby Dick, as simultaneously marked by hieroglyphics and itself a singular hieroglyphic. Emerson wrote in his essay *Nature* that: "Every man's condition is a solution in hieroglyphic to those inquiries he would put." He argued that as we go back into history, "language becomes more picturesque." Dailey's innovation in realism was to resurrect something of the power of pure, simple, unadorned hieroglyphics from the encrustations of the Victorian and Art Deco eras and make them modern. In this way, he orchestrated a harmonious outcome to the tug between the (very) old and the (relatively) new.

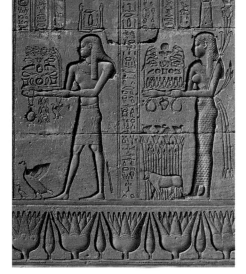

It's true that the foundations of Dailey's sculptural realism are rooted in Egypt, Greece, the pre-Columbian world, and ancient China, but they are deeply transformed by his need to tell a story and explore human nature. Dailey has discovered that the ancient world's ability to distill the essence of an image, dissecting it down into its simplest elements, is a powerful tool that can be used in telling a good visual story: so, for example, he looks at a man's "powerful undercut jaw" and distills that into a key element in a sculpture, almost as if it were a single hieroglyphic that together with other such symbols can create a powerful spell.

There has been a tendency to regard Dailey as a postmodernist. Surely his work fits within the classic meaning given by Charles

Jencks in "What is Post Modernism?" in 1986 as "the eclectic mixture of any tradition with that of its immediate past: it is both the continuation of Modernism and its transcendence." However, Chris Baldick, writing in 1990 in *The Concise Oxford Dictionary of Literary Terms*, proposed (in my opinion) a more accurate definition when he linked postmodernism to a "superabundance of disconnected images and styles" and described it as a culture of "promiscuous superficiality. . . in which . . . qualities of depth, coherence, meaning, originality and authenticity are evacuated or dissolved."

Where the postmodernist (or for that matter the deconstructionist) depends upon the use of irony and cynicism to deflate and conflate the significance of works as "Low" and "High" art, Dailey preserves such terms in his exploration of human nature. It is essential that Dailey retain the distinctions between various levels in the social hierarchy so that he can tell realistic stories about how people interact.

I see Dailey as a late modernist. My view of what it means to be "modern" is a little different from the prevailing ones—some aspects come from my reading of the art critic Clement Greenberg. I think most people see modernism as an attempt to throw off the excesses of previous eras and strip styles down to their "basics." For example, an elaborately wrought, marble Corinthian column becomes a simple unadorned support made of steel. But nothing says that Modernism must be simple. "To be modern" also implies an adherence to a system of values that include a deep respect for materials and the importance of the density of decisions that are required to make a good artwork. Thus, our steel beam can

OPPOSITE
Treasure Bearers
29H x 11W x 8.5D"
1995

ABOVE
Reliefs (detail)
EGYPT, DENDRA, TEMPLE OF HATHOR
PRESENTATIONS OF OFFERINGS
125BCE—65CE
COURTESY OF GETTY IMAGES

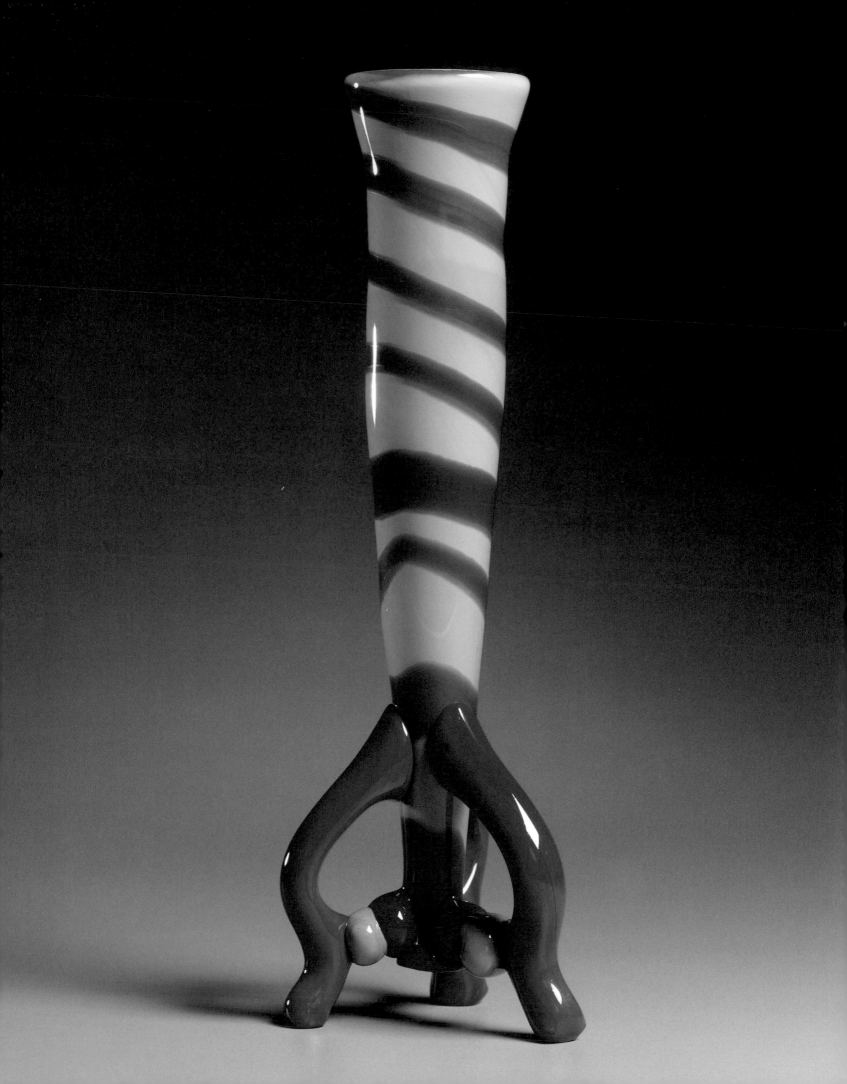

be a work of modern art, but only if the material from which it is made is handled with deference and the proportions and placement of that beam have been carefully thought out. In this regard, Dailey surely follows in the footsteps of the other great modern artists.

Modernism confronts all the traditions that have come before it and struggles with them in order to move forward in a bold and confident manner. The modern artist takes all these traditions seriously and does not seek, as the postmodernist or deconstructionist might, to detonate them and recast their meaning. Dailey immersed himself in the details of making glass and drawing and sculpture long and hard enough to know them well. That "schooling" gave him the tools and techniques to create densely textured artworks that resonate with meaning.

Dailey Is also influenced by post-war industrial design, where he admires its regard for the obvious and its use of straightforward assembly techniques (as in folk art, but in a far more technologically advanced and refined fashion). Within the studio glass movement, Dailey admired the teamwork and social organization evident, for example, on the floor of the Venini glass factory or in the Glass Art Society. During his time at Venini he worked on the lamps, blew glass himself in the venerable factory, and received instruction from the master glass blowers. He was impressed with the Italian principles of glassmaking and says, "There was a great factory atmosphere: the workers took real pride in the levels of their skills. And they used a unique color palette that emerged from a distinctly Italian color sensibility—the earthy tones were so natural. I found all that really intriguing. Working in Italy also got me used to working in a team and being in control of a team as a designer."

Dailey's prior experience with glassmaking, while similar to many of the characteristics of an industrial process even when transplanted into the art studio, had been one of working alone. In Italy, he learned the advantages of teamwork: it allowed him to step back and evaluate the making of glass as an art process. Directing this process served him very well later when working at the Daum glass factory in France.

Since the Venini days, Dailey has periodically returned to Europe, always to work. "All my relationships in Europe are based upon friendships I've made working there throughout the decades. I still have a bedroom I can call my own at Christian Poincignon's house in Lay St. Christophe (near Nancy, where the Daum factory is located). Christian recently retired as the head designer for Daum, and I consider him a mentor."

Dailey began work at Daum in Paris during the summer of 1977, and stayed for two months that summer. "I was not allowed to walk into certain rooms at the factory because of secret processes related to *pâte de verre* production. Daum, as you may know, has the best and most extensive *pâte de verre* color development in the world. Compared to the Czechs, or the recent work being done in Taiwan, Daum's palette of 586 natural colors, along with their mold-making and casting expertise developed over 100 years, is far beyond anything others have ever attempted."

OPPOSITE
Pistachio and Corallo
Stripe Vase
VENINI ITALIA
11.25H X 3.5D"
1972

ABOVE
Abstract Lizard Lamp
VENINI ITALIA
12H"
1973

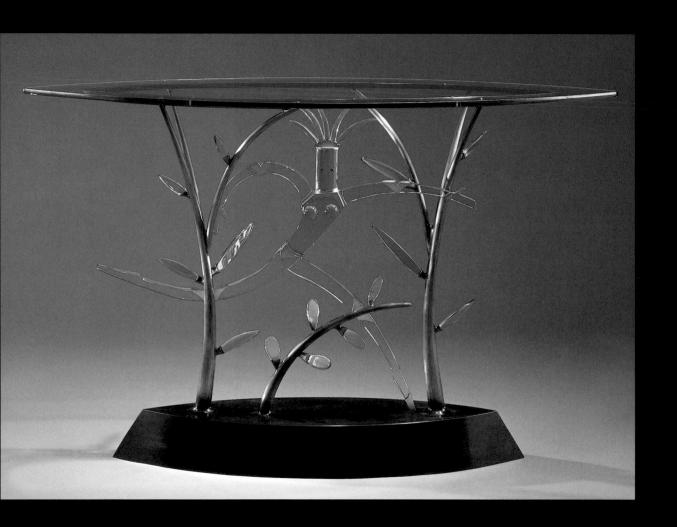

Dailey's first "assignment" was determined in a manner similar to the way many of his commissioned works of art have come about. Pierre de Cherisey looked through Dailey's sketchbook and selected a couple of drawings, which the artist developed as full-scale three-dimensional clay models. "I made a definitive plaster model of *Les Danseurs* that was eventually edited as my first piece for Daum. It is incredible how little the Daum directors or technicians changed the original in the editing process. This is true for all of the artists they work with. They take care to respect the artist's vision, and this is the strength of their history as art editors. They have produced the works of many artists including Dali, Leger, Cesar, Folon, Walter, Berge, Decorchemont, Argy-Rousseau, Cros, Adzak, L'Hoste, and numerous others over the years."

Once Dailey's original plaster model was completed and he was satisfied that it would look good when cast in glass, the mold makers assisted him in the process of making the molds. Dailey left that first summer with a good understanding of the process that he was not supposed to know, but with a promise to Pierre that he would not divulge any secrets. "I never have, but since the 1970s many artists around the world have made *pâte de verre*, including me in my studio, and few secrets remain regarding the process. The unique thing that Daum had and still has is the incredible range of colors that they create from raw materials; it's a very natural palette, unlike any other glassmaking facility."

The nudes Dailey created for Daum were in response to Pierre's selection from his sketchbooks. *Le Vent* (p.338) was loosely based on a 1931 Lalique automobile mascot titled "Electra," where the hair streaming back suggests motion. In Dailey's version, the hair is more like the carved basalt of an Egyptian queen's hair, very geometric and linear, and the figure is a cross between the Egyptian statues and a classic pin-up nude. The nudes are perhaps the most realistic figurative pieces Dailey has made, and they are deliberately made to exhibit sensuality. Where sex as a topic in his work is concerned, the Daum nudes are the most accessible because they are more realistic. Dailey says "My abstract nudes may have more overt sexual gestures in some cases, but the Daum nudes have a quality that invites viewing to many appreciators of the female form, yet they depart from reality enough in the 3-D to 2-D, human form to geometric form translation, that you can never forget you are looking at a sculpture." The softness of the *pâte de verre* color, and the satin polished surfaces also add to the character of the sculptures.

Dailey reminisces: "Going to work in France for the past 27 years has been very rewarding. I escape the juggernaut of my own momentum in the studio for a period of time and isolate myself in a creative world at the factory in Nancy. I can have all the help I want or be left completely on my own. The time I have worked at Daum has been supplemented by many visits to museums and other places of cultural importance in Europe. I also have made many friends over the years, and we have seen each other's children be born, grow up, and have their own children; going through all of the things in life you might imagine. It has certainly enriched my life. When I arrive in Venice or Paris or Nancy

ABOVE
Les Danseurs
15H X 13W X 4D"
1979

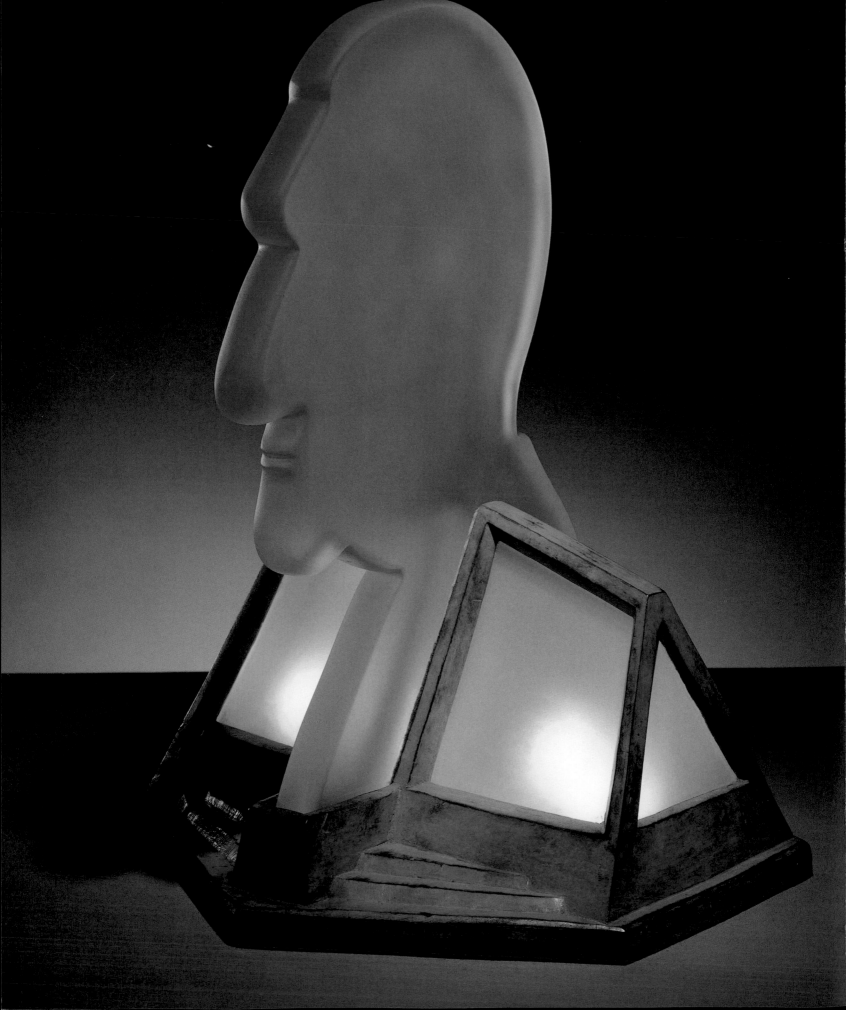

I feel right at home, with many favorite places to go and people to visit."

After Dailey's marriage to Linda MacNeil in 1978, they moved to Amesbury, Massachusetts. Dailey says, "It was nice to live in a house in a small town. I commuted to teach in Boston. Teaching at Mass Art (Massachusetts College of Art) has also affected my work. In 1974 I built the studio at the school with the help of four students, and took all of the machines and equipment I owned to set up a shop at the college. I used it as my personal studio for about two years, sharing the equipment with my students. I blew glass from 4 to 8 a.m. most mornings and got a lot done, then taught my classes at 9 a.m. I had also built the studios at PCA (Philadelphia College of Art, now The University of the Arts), RISD (Rhode Island School of Design), Haystack Hinckley (Haystack Mountain School of Crafts), and assisted a bit at Pilchuck (Pilchuck Glass School)." In 1979 Dailey received tenure after seven years as a full time instructor. He took a sabbatical and spread it out over two years by teaching the fall semester both years, and worked in France and completed a commission. He then resigned to half time, continuing to work the fall semesters only. Dailey reduced this to quarter time in 1983, and now teaches two studio courses one day a week for one semester. Dailey states, "The interaction with students and the need to explain concepts and evaluate their work is an important part of my thinking as an artist. I am regularly forced to consider my opinion about some aesthetic issue, or the success of one particular approach over another to the realization of an idea. I have never been a teacher's teacher,

devoting my life to the college and students; my belief is that I am a better teacher for being a practicing artist and devoting my time to making art."

In 1980 he became president of the Glass Art Society, an international nonprofit organization founded in 1971. By the early 1980s Dailey had established himself as a significant emerging talent. Henry Geldzahler, who when curator of Twentieth Century Art at the Metropolitan Museum of Art had done much to solidify and verify Andy Warhol's career, wrote of Dailey: "What struck me first about Dan Dailey's work was its directness and confidence. . . Dailey's brilliance of invention and technique can be confidently traced back to its origins in his hard-nosed loyalty to the fantasy world of his early years." By 1982 Dailey had established a network of art galleries and a stream of commissions. And his family grew as well, with the births of Allison in 1980 and Owen in 1983. Dailey says of them, "Being a father changed me. It didn't make me more ambitious, but made me search for a more profound meaning in what I do. That's because children are always asking questions."

It is unusual, but more than a little predictable, that an artist who has so brilliantly melded high fantasy and nuts and bolts reality should have done so by building a framework that still includes a settled family life and a highly productive studio with dedicated employees. Dailey has become a professional artist. He never believed that the romantic scenario of the starving artist was the only route to success in the art world; his experiences

OPPOSITE
Marcel DuChamp
18H X 14W X 14D"
1977

ABOVE
Wire Series Vase
12H X 4D"
1978

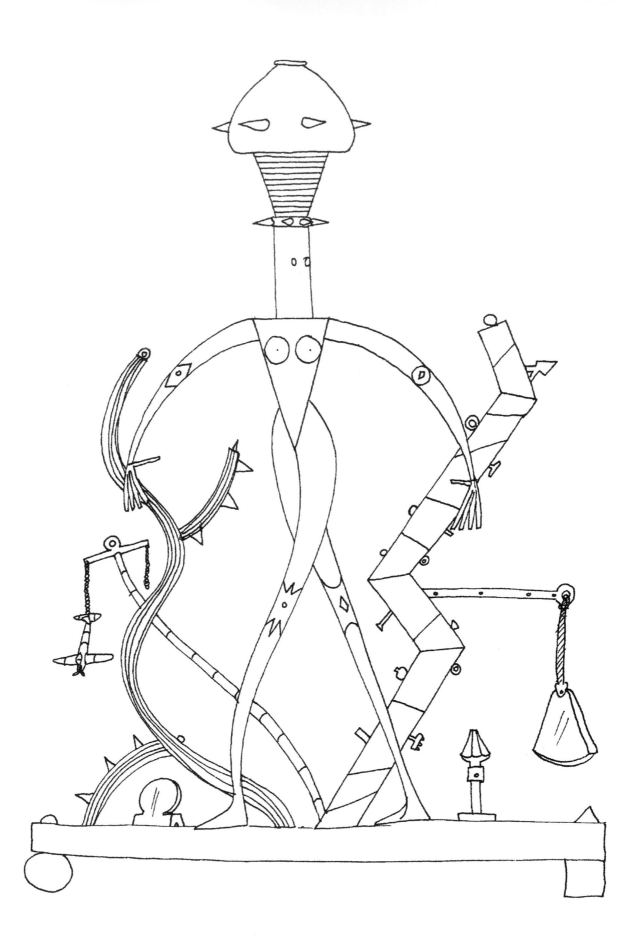

Nude in Junk

had convinced him that the most effective way to make art was through a blending of discipline and creativity.

Over the years, Dailey has come to depend upon his constant drawing as an engine for his creativity and says "the sketchbook provides total freedom. But drawing also clarifies and codifies my thinking." Dailey struggles with those two poles, which became evident to him in his training as an artist. On the one hand, he admires the philosophy that holds that beauty is in the making. On the other hand, he admires the looseness that, for example, Chihuly personified in the 1970s. Dailey believes "the two are not mutually exclusive, but it's difficult to make them compatible. They are hard to blend. You can't force them, they need to flow together, looseness and the beauty of the well made." Dailey's artworks and drawings are most poignant when they capture a single gesture—for example, a face contorted into a guffaw, or a hand depositing a coin into another hand at a tollbooth. Dailey says that "a lot of my art is affected by my observations of humanity—even in my most cynical work, the value of humanity is preserved." When asked where that edge of cynicism in his work comes from, Dailey replies that he is simply "making a realistic assessment of how things are. . . nothing and no one is infallible." Dailey's work celebrates our common plight. Ultimately, everyday life has had the greatest influence on Dailey: café scenes, clothing, and possessions. He composes drawings from the telling and eccentric details, the quirky gestures, the outrageous behavior of the human animal.

The pages that follow survey the results of Dailey's project, which has been nothing less than an exploration of human nature into whatever screwball corners it may lead him. They contain frowns, and laughs, and diving acrobats as well as divas, wrapped up with, and around, or adorning a menagerie of lamps, vases, tables, banisters and doors. It is a parade of humanity portrayed simultaneously with irony and cynicism, love and wit. Perhaps the best way to view all this is to let the pages and images wash over you, stopping to catch a glimpse of ourselves, and our humanity, taking a moment to ponder how truly extraordinary it is that among us, someone like Dailey has been endowed with the skill and will to put it all down on paper. If it stopped there, he would be noted for his drawings, but Dailey's project has taken him beyond that: he chose to take those drawings up, using them as cartoons in the Renaissance sense—designs for creating a larger and more concrete reality. Dailey has transformed his signature drawings into an endless tapestry that captures the dance that is human nature in all its lust and animal wantonness, sophistication and precision, laughter and anguish.

— *WILLIAM WARMUS*

OPPOSITE
Nude in Junk
11H X 9W"
1978

ABOVE
Tollbooth and Hitchhiker (detail)
11H X 7W X 3D"
1982

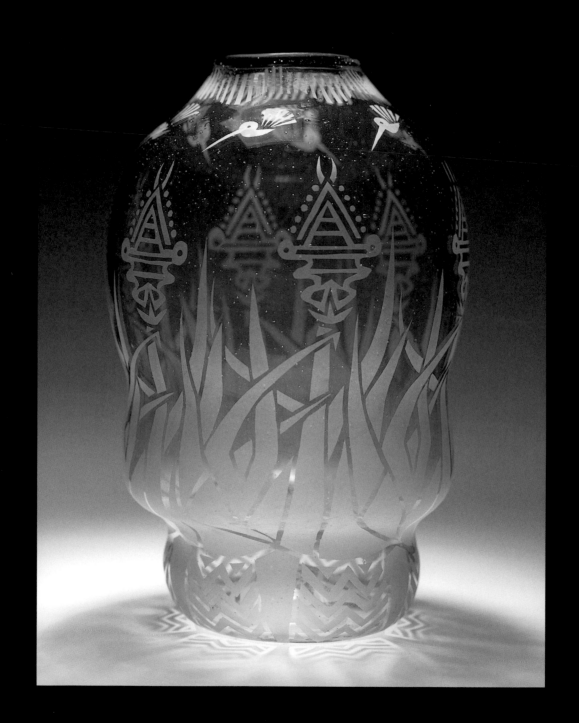

PREVIOUS
Odd Duck
11H X 24W X 7D"
1984

ABOVE
Hummingbirds
10H X 5D"
1972

28

STYLE AND THE DELUXE

TINA OLDKNOW: *Dan, you seem to be someone who could easily design in a variety of media: you could do furniture, windows, objects, and fabrics. Like Frank Lloyd Wright, or the Greene brothers, or even William Morris in England. Does their work interest you?*

DAN DAILEY: Yes, each one interests me because of the very identifiable characteristics that make their work recognizable. Some of that comes from a particular way of dealing with form—and solving otherwise ordinary problems—in a unique manner. That's a necessary thing: to have an identifiable quality to your work. I think it's helpful to focus, because if you stay on a subject long enough, then you have the ability to take it to higher levels. However, having said that, I don't always do that. When I get an idea, I don't think, 'That's not my style, I'm not going to do it.' I do it anyway, and it sometimes results in art that looks very different from anything else that I have made.

TO: *Some of your works—and I am thinking of your lamps in particular—have a strong, Art Deco/Art Moderne feeling. What intrigues you about Art Deco?*

DD: The combinations of materials and the idea of making luxurious, sophisticated things, things that are 'deluxe.' The concept of the deluxe has always appealed to me. It is not so much a mood as it is, perhaps, a creed. Art Moderne and Art Deco are responses to the curvilinear, organic nature of Art Nouveau. Art Deco is so deliberately geometric, so evocative of the 'streamline,' which suggests motion, speed, the future. It is suave. Art Deco has consistently intrigued me, and I take pleasure in looking at

Art Deco furniture and buildings, especially the Chrysler Building. So much of that attitude of luxurious quality is lost now in the face of staying on budget.

TO: *Are you interested in ancient art? Some of your work seems stylized, in the way that Egyptian art is stylized, for example.*

DD: I've always enjoyed Egyptian art, and I've tried to understand it in some detail. I also like pre-Columbian and Native American art, but the rendition of the figures is so blunt, there is very little articulation. It doesn't suggest movement the way that Egyptian art does.

TO: *Some people might see more movement in curvilinear Mayan art than in Egyptian art, which can be flat and hierarchical.*

DD: Egyptian art has geometric movement. It seems contained, yet there's an attenuated grace to Egyptian figurative renditions, whether it's paintings or statues.

TO: *In all the art that you're talking about, the movement is very geometric. I had always thought of curves as being most indicative of movement, but now I am beginning to see how edgy geometric shapes can be more dynamic.*

DD: I like carved stone and the stylized basket decorations of the Native Americans. A mountain range becomes a bunch of zigzags, and a river is made from the same zigzags, but on a different angle. It's a method of producing a feeling and conveying a message with very simple elements. On baskets, or in Egyptian hieroglyphics, the forms are interpreted and simplified. There's a deliberate attempt to boil things down to their purest form. Some of my work—especially the sandblasted pieces in the beginning—was

ABOVE
Mimbres Culture Bowl
3.575H X 9.125D"
CA 1000–1130/1150CE

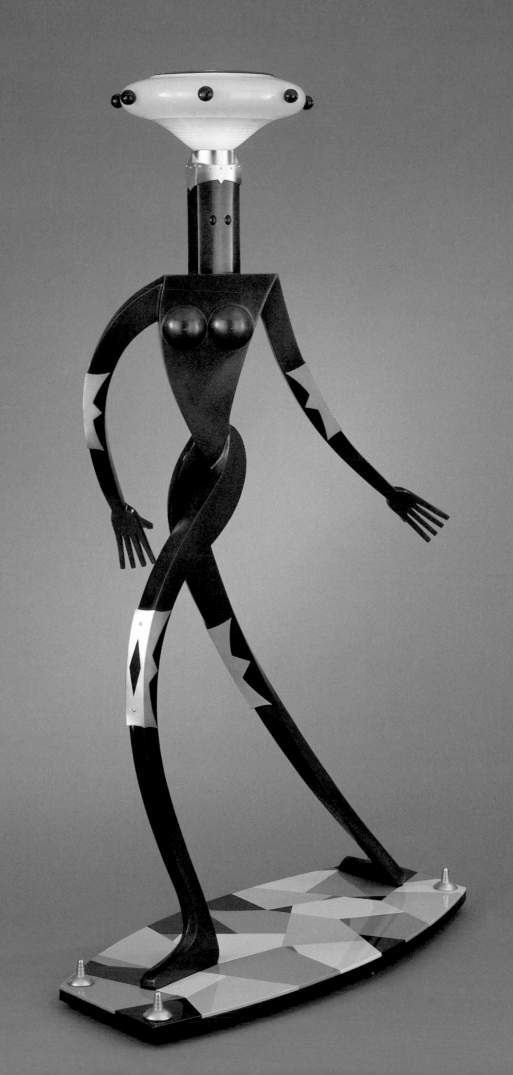

deliberately influenced by the zigzags of Babylonian cuneiform writing, that pressing of the stylus into the clay tablet.

TO: *I think your work is very joyful. It's the color, partly, and the movement, I think, that make it that way. Do you think that individual colors have different emotional values?*

DD: Yes. Brass, bronze, chrome, silver, and gold also have emotional value. If you make something all brown, it has the potential to be dull and serious. Yet, if you are making brown figural lamps and putting gold details on them, the gold comes up in contrast as something that's bright and cheerful. It gives the feeling of deluxe quality, but it also adds a note of cheerfulness to something that's otherwise somber.

TO: *But, your subject matter isn't always upbeat. There's sometimes a tension between the presentation and the content that is intriguing.*

DD: That's true. The thoughts that generate my work are based on observations of human nature. While I tend to illustrate characteristics or behavior that I find amusing, there is also a satirical side to my work. The most important thing that I try to give my work is a kind of magnetic quality. It's something that attracts or entertains or engages a person in a way that causes an interaction. The interaction may be intellectual or it may be sensual. Spiritual is too big a word, but this quality is something that a person relates to, and it has staying power over time. That's a goal I shoot for in everything I make.

TO: *You grew up in a designing household; both your parents were designers. You worked in ceramics and then glass while you were at the Philadelphia College of Art (PCA) from 1965 to 1969.*

What kind of glass program did PCA have?

DD: In 1967, the school received a $5,000 grant to build a glass studio from the Fostoria Glass Company in Moundsville, West Virginia. Roland Jahn, who was a ceramics teacher at PCA, had been a student of Harvey Littleton. Roland asked me if I would take a summer job building the studio. I didn't know anything about glass or glassblowing studios, but he showed me how to build the equipment. I worked with him and we built the furnace and the annealing oven. We didn't have much else: just a bench and some glassblowing tools. When the furnace finally got running, I had the honor of being the first to use it.

TO: *What kinds of things did you make as a student?*

DD: We didn't have anyone to demonstrate, there was no Lino Tagliapietra or Dante Marioni to visit and demonstrate. All we could do was get a book out of the library and say, 'Let's try to make this.' Roland had a style that was a lot like Harvey's, dipping and blowing these bubbles that respond to gravity. You'd roll the bubble in silver nitrate or some other stuff, wiggle it around, stick it on a punty, and push on it a bit. They approached the material almost as a ceramist would. If you look at Fritz Dreisbach's first pieces, or Harvey's, or Marvin Lipofsky's, or those of anybody else who was at the University of Wisconsin at Madison then, there's a similarity to the work. It relates to the pottery of the 1960s. I got interested in Scandinavian glass from looking at books in the library, and I tried to make it. It was fun, although I could not make anything with any degree of proficiency or skill. But, glassblowing put its hook in me then.

OPPOSITE
Female Figure Floor Lamp
72H X 44WX 28D"
2001

ABOVE
Erotic Dancers
11H X 7D"
1974

31

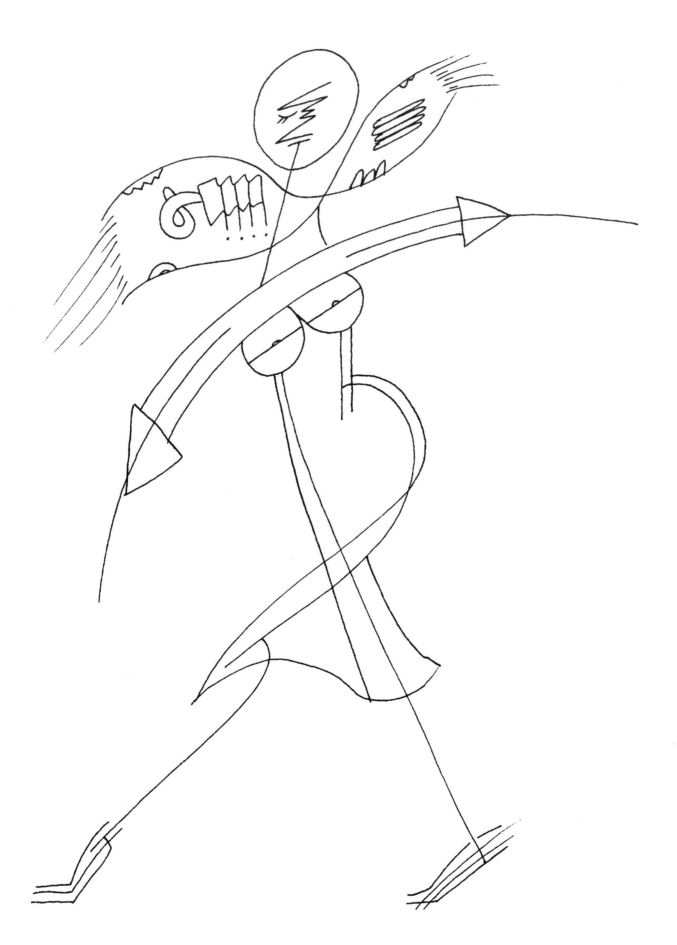

HAUTE COUTURE

TO: *After PCA, you went to the Rhode Island School of Design?*

DD: No, I moved to California after graduating from PCA in 1969. One of the reasons I went West was to choose a graduate school. Marvin Lipofsky had accepted me to both the University of California at Berkeley and the California College of Arts and Crafts (CCAC) in Oakland. But, when I got to California, I found that I wasn't really interested in going back to school. I drew cartoons for a while. I started a carpentry business, and that was immediately successful. I could have easily stayed in San Francisco, fixing people's houses, but that wasn't what I wanted to do. I moved back to Philadelphia in 1970 to work for Bill Daley. Bill had been my teacher for four years, and he often hired me to assist him with large-scale commissioned ceramic architectural works. No teacher ever influenced me more, or gave me such insightful criticism. I went to Providence later that year to meet Dale Chihuly at RISD. Chihuly accepted me as a student, and I ended up going to graduate school there.

TO: *It interests me that you once drew cartoons, because you always seem to be developing human and animal characters. They turn up in your drawings and in your objects.*

DD: When I moved to California in 1969, I met a cartoonist, who introduced me to the Zap Comix artists, but I did not draw comics for long. Drawing has always been the basis of my work, and some people feel that my drawings have a cartoon look. Everything I do starts out as a drawing. If you page through my sketchbooks, you can see where my ideas originated. Not every drawing is intended to be made as a thing. Sometimes it's just a thought.

TO: *Do you make a distinction between the things that can be made and the "thoughts"?*

DD: Yes, I'm very comfortable seeing something in three dimensions, and I can usually picture what I am drawing as I'm drawing it. I copy down things that are in my mind: I take down a visual note and then make it start to look like something on paper. I draw quickly, whatever comes to mind. Then I think about it, get rid of the stuff that's worthless, and continue with what I feel is useful.

TO: *Do you make a distinction in your mind between the ideas that can be made and those that can't?*

DD: I wouldn't say 'can't be made.' An idea might change a great deal in the transformation from drawing to object. To realize a certain idea as an object might take away from it. You can do things on paper, with a pen or a drawing instrument, that you can't possibly do in three dimensions. Free drawing allows me to come up with things that I would never come up with if I was just sticking to the rules all the time. I like drawing because you can do things that can't be done three-dimensionally; it can be total fantasy. But, when I know that I'm going to make the thing that I've drawn—or when I'm translating one of those things that I think of as a fantasy at the start and then decide to make an object out of it—then I have to modify it. I start doing things to it that will allow me to make it three-dimensional.

TO: *What do you do if an idea is not working out? Do you reject it and start over?*

DD: That's an advantage of drawing. I might draw an idea ten times and say, 'All right, I'm going to do number three, or number seven.'

OPPOSITE
Haute Couture
11H X 9W"
1978

ABOVE
Accoutrements
24H X 12W"
1979

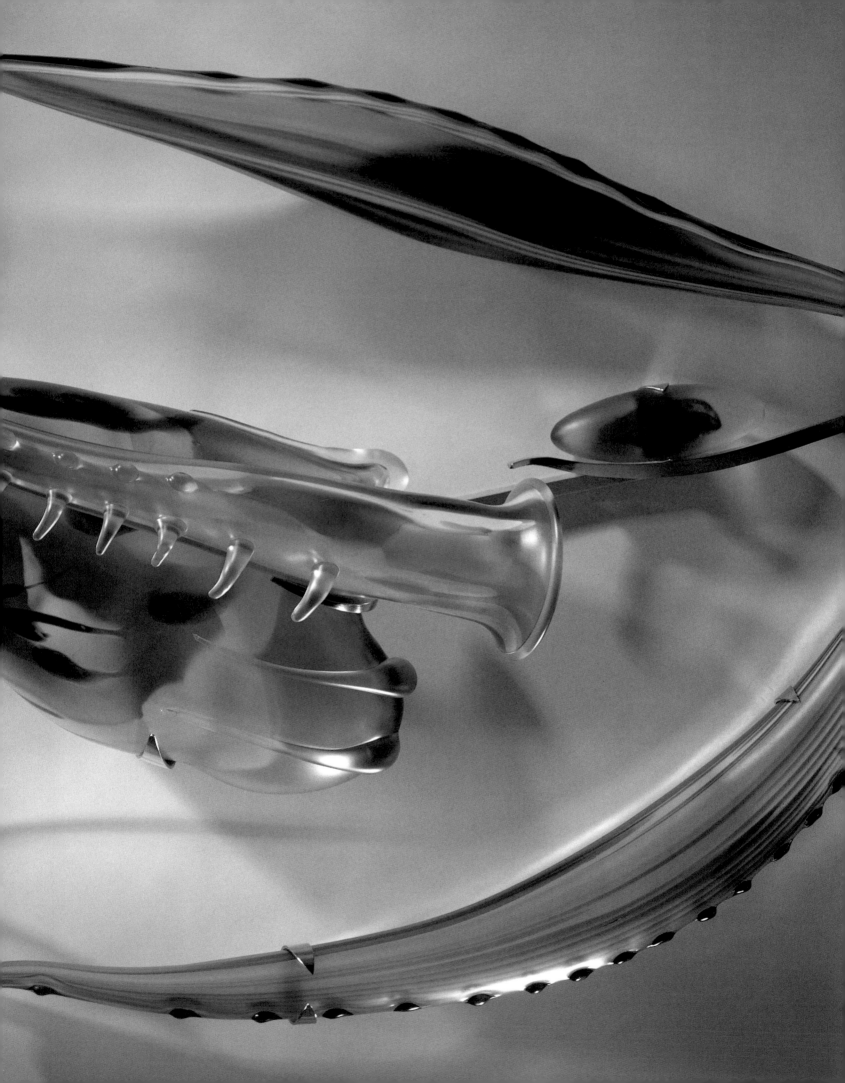

I draw it again, I refine it, and I draw it a few more times. By the time I make it, it's an idea that's been honed by repetition.

TO: *Why do you do anything but draw? Why make objects?*

DD: I've always been attracted to objects. I like drawings, paintings, pastels, and other media for two-dimensional work, but I have a good time making objects, I'm an object maker. When I go to museums, I look at paintings and drawings, but I mostly respond to the objects. The drawing is just the first step in realizing a concept. First, the idea is an ethereal thing that's floating in your brain, and to bring it to some level of reality, you draw it. The next step is to make it. The more realistically you draw it, the more believable it is. If you can physically make the thing come to life, then the drawing has been taken to the final step.

TO: *Is most of your work narrative? Have you done anything that's purely abstract or formal?*

DD: My music series is probably the closest I have come to making something purely abstract. While there is an identifiable element or two in the composition, the basis of the image is sound and rhythm, which are represented by form and color. No matter how abstract my work might become, I still need to link it to some kind of illustration, so it is not form for form's sake. If you are talking about shapes with no basis in illustrative concept, I can respond to that kind of abstraction in other artists' work, but when I do it for myself, I feel it isn't me. It seems like every time I play with pattern and non-representational composition, I end up feeling like I'm playing the decorator game. It could be the techniques that I use; it could be the medium that I work in. I'm not sure what

it is, but I've never been satisfied with my work in that direction. Compositionally, it works and there might be something to that, but I don't know if it's enough. I feel the need to tell more of a story—human stories or animal stories. I am not satisfied by just making shapes.

TO: *Your two-dimensional and three-dimensional works relate closely to your drawings, but not always in the same way. I know you like to use Vitrolite for the wall pieces. Does Vitrolite still exist, can you get it?*

DD: I have a collected library of Vitrolite. People still call me up and say, 'I've got 19 pieces of black, will you buy it?' I have enough to last me forever. I am planning to make some new panels that have cityscapes and landscapes, but these probably will not be Vitrolite.

TO: *Do you ever look at some of your murals from the 1980s and think that you would like to revisit some of those ideas?*

DD: No, not really, because I am more interested in new ideas: I have so many that I never get to. However, I do go back to things sometimes. For instance, I have an unfinished mural. It's 14 years old, but I could place myself back 14 years and finish it.

TO: *Why would you mentally go back 14 years?*

DD: I'm not going to update it, I'm going to finish it as I would have at that time. I know that I wouldn't make it the same way if I were to make it today.

TO: *Do you consider your murals to be three-dimensional objects, like your vessels?*

DD: For me, the mural is almost a cartoon; it is a way of getting a drawing out of my sketchbook. It is more poetic—it exists because

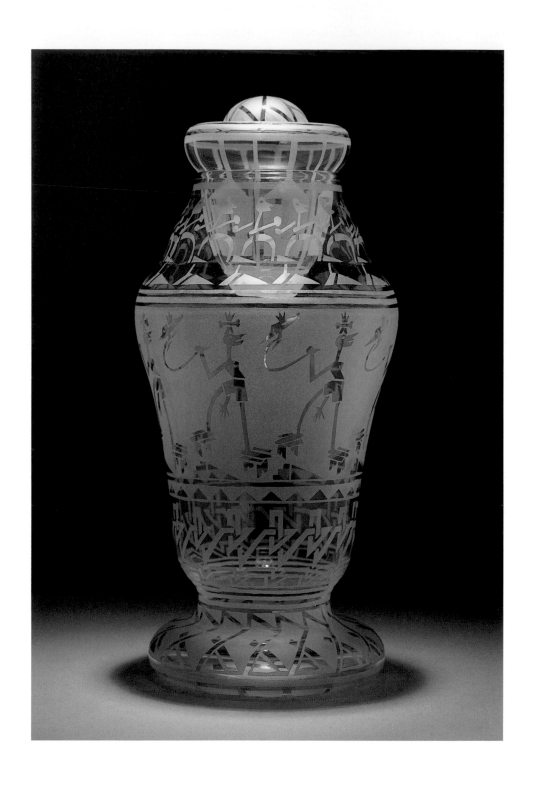

Men Flying Kites
14H X 6.5D"
1975

it's a thought. It doesn't exist as an object, it is more like a painting. But, it also emphasizes the qualities of materials, the concept of the deluxe. I think the drawings that became murals have more impact. There's a certain kind of visual impact to them that my vases don't have. Glassblowing is almost a spectator sport, and there is so much activity going on around the process. Many of the ideas that people generate are in service to the process, rather than beginning with a raw idea that is then interpreted. You either have the idea and then figure out a way to bring it to reality, or else you know the method and you figure out something to do with that method.

TO: *That's partly the distinction between craft and art, going from technique to object rather than from idea to object. Do you feel that it makes a difference if someone else, like a fabricator, makes the object rather than you making it yourself? The reason I ask this is because in the 1970s, it was important for artists, especially in the crafts, to make their own objects. Much later, the 'blowpipe for hire' phenomenon started happening. People realized that others could blow what they wanted better than they could do it themselves.*

DD: When I first went to RISD, there were all kinds of hooks around the shop so you could hang up your blowpipe and do every little bit yourself. People were racing around like acrobats trying to do it all. I don't have any qualms about people helping me; I have to have other people help me. It would be physically impossible otherwise. Over the past 10 years, I have increasingly removed myself from the glassblowing process. This is so I can be free to objectively observe the piece in progress, and jump in whenever

the team needs me. I am fortunate that several artists, who are far better at glassblowing than I ever was, get together to help me make my work several times a year. By having help I can make a lot more of my ideas, and even so, I only make something like 10 percent of what I draw. There are always compromises when you work with others, but you learn to work with a person's strengths.

TO: *How do you do that?*

DD: If you know that someone's good at something, you make that part of what you're doing. I got that from industry. For instance, you think you have a perfect idea. You make a prototype, hand it to the factory, and they say, 'Great, we'll try it.' Six weeks later they show you what they came up with, and it's nothing like what you made because their worker can't make it. And he's their best guy. I learned that the prototype should be made by the people who are actually going to produce it. With my own assistants, I try to learn what they are capable of. I give them examples of things that I'd like to have done in a certain way, and I also look at what they've done with their own work. I think about their strengths, and I try to match their talents to my ideas so I can get the work done.

TO: *Technically, your work seems so perfect, so finished.*

DD: I think of this as a hang-up, sometimes, and sometimes I think of it as a strength. Once in a while, I look at a quick drawing that I've made, and I see a spark there that doesn't exist in my work because it's been labored over so much. But, that's the nature of the methods of production I use. When I make my hot glass pieces with the team, though, there's a spontaneity that happens

Venus of Willendorf (detail)
ORBIT MURAL
11H X 11W"
1987

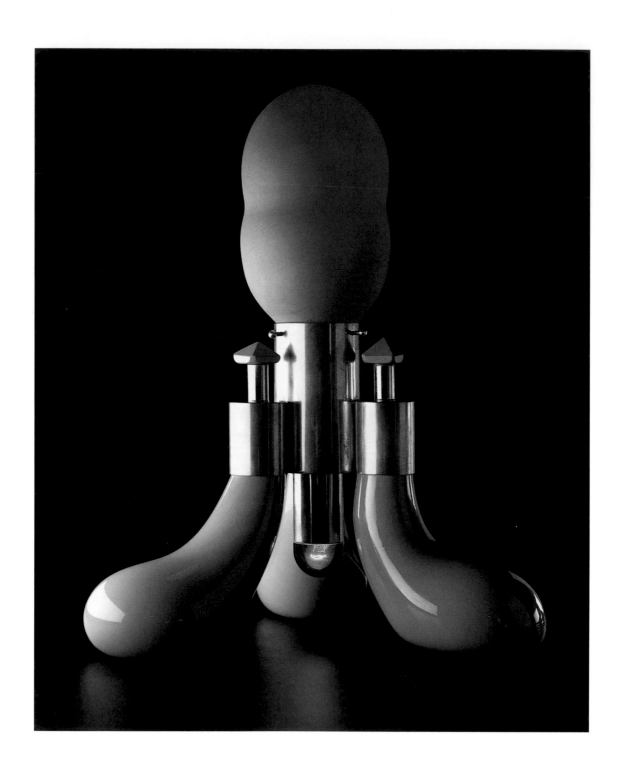

Pistachio Lamp
14H X 10W 10D"
1972

that can't happen in any of my constructed works. This quality is similar to the spark that I see in my drawings.

TO: *You completed the graduate program in glass at RISD in the summer of 1971. But, you didn't go with Chihuly to Washington State, to help build Pilchuck Glass School. This surprises me, since you spent so many summers teaching at Pilchuck.*

DD: In 1971 I had a summer teaching job and a commission, so I had to work. In the summer of 1972, I received a Fulbright grant to go to Italy. Dale, who had been to Italy, helped me: he told me to apply to Venini and other glassworks on Murano. I can remember distinctly that I had a huge pile of letters and photographs, well over 50 of them, which I sent to carefully chosen addresses in Murano, Venice, and the Veneto. Only 13 replies came back, and three of them were positive. One was from a toilet company that said that even though they didn't have anything to do with glass, they would be happy to have me come and spend some time as a designer. The other two were from Venini and Barovier and Toso. I chose Venini, because Dale had been there, and other Americans like Dick Marquis. Dale said I would like the director, Ludovico Diaz de Santillana, and he was right, we became friends.

TO: *What was your experience like at Venini?*

DD: I did all kinds of things. Just before I got there, the factory had a terrible fire and everything was closed. I could have gone to Barovier and Toso instead. But, I hung around and cleaned photographs and swept floors and shoveled debris. After a couple of weeks, I was working in the factory on a regular basis. They gave me a bench and let me use any glass I wanted. Venini had an incredible number of compatible colors to work with. It was a revelation at the time, since we had so few compatible colors at home, and I could do anything I wanted. I presented my designs to Ludovico and we discussed them. Then, we chose a design, it was made, and we reviewed it to see whether it was successful. I made a number of lamps, and I hoped Venini would take them on as production items. Nothing worked out with Venini, but I had a great show with the lamps at the U.S. Embassy in Rome and at the Theo Portnoy Gallery in New York a year later.

TO: *Did you see your designs for Venini as distinct from your own work?*

DD: No, and maybe that is why they were not successful. My designs were so wacky, they were mainly about satisfying myself. When Ludovico saw them, he thought they were crazy. He kept walking around, smacking his head, saying, 'These are mad.' They looked like Venini products in the sense that they were made out of their materials, but the forms were totally different. I think only two of the lamps were kept as prototypes, but neither of them ever saw production.

TO: *Did you find the factory experience disappointing?*

DD: No, not at all, I liked the factory environment. I still work at Daum and I still work at Fenton. I've worked at Steuben, Waterford, and other places. When I finished at Venini in 1973, I returned to the States and immediately began teaching at the Massachusetts College of Art in Boston, where I started the glass program.

TO: *You are one of a small group of American artists to work at Daum—the famous French glassworks in Nancy—but you must be the only American to have worked there for so many years.*

Rocket Ship Lamps
12H X 15W"
1972

disdain

DD: Yes, that's true. My first visit to Daum was in 1977. Jacques Daum had invited me, but when I got there, he had retired and was replaced by his nephew, Pierre de Cherisey. It was terrific, they just opened up the doors for me. My wife, Linda MacNeil, and I stayed there for seven weeks the first time, and I designed several pieces in *pâte de verre*. I would also blow my own things for three or four hours in the morning, and then work the rest of the day in the plaster studio. The first time I used my blown Daum crystal blanks was about 1980. A couple of times I went to Daum with Mark Weiner, and we blew off-hand pieces from their tanks of crystal.

TO: *Was your design work for Daum different from the design work you did for Venini?*

DD: Yes, I worked on assignment: they told me what they wanted. For example, they asked me to design a set consisting of a big bowl, a plate, a vase, and an ashtray, all in the same style. I also designed some drinking glasses and made some experimental pieces in *pâte de verre*. Since its reintroduction of *pâte de verre* in 1962, Daum has invited a number of artists to design special editions for them. I made my first *pâte de verre* models in 1978, and then started on the nudes. These were an assignment from de Cherisey to make something in the Art Deco style, and they turned out to be much more realistic than any other work that I had done in glass. When I work for Daum, I'm usually making something that's going to be produced as a limited edition. I make the original, and they make molds to produce the edition.

TO: *Have you ever handed over a design to be fabricated?*

DD: Yes. I'm not usually very pleased with the results, because there's a transitional phase between a two-dimensional drawing and a three-dimensional object. One important change is scale. Something that looks small on paper, in full volume, will become larger. A drinking glass is a good example: your design might look good on paper, but when the glass is sitting in front of you, you realize that it holds quite a bit more than you expected.

TO: *Would you allow yourself to be imperfect?*

DD: In some media, maybe. When you're combining glass and metal, you have to get it just right. I know that I'm obsessive. Things have to look good from every point of view—the 60s craft ethic, you know. But, you can find beauty in imperfect efforts, such as African masks or scrimshaw sailor carvings, or Persian rugs: when you get down to the details, they're not perfect.

TO: *You told me that if you wanted to, you could focus—for commercial reasons—on the successful things that you know how to do, rather than explore something else. Many people have chosen to do this.*

DD: Sometimes you want to follow your own successes because of the feeling that you got. There is also the commercial pressure. Sometimes I look back and think, 'That was interesting, maybe I should try something like that again.' I don't have opinions about my work, hot off the press. For me, it takes a year or so to know how I feel about a piece I've made.

TO: *Do you wish sometimes that you could keep your work around for a while to look at after you have finished it?*

DD: That would be an ideal situation. But, I have photographs, which I study while I'm working on the next piece. And, of course, I have drawings of everything; full-sized drawings that I work from.

Often I don't feel satisfied with what I've done. Sometimes, I don't feel like I've done very much, especially in comparison to artists such as Salvador Dali or Edgar Brandt. But, certain projects that have come along have given me the opportunity to do something significant.

TO: *Like the dining room you designed for a private residence in California?*

DD: Yes, the dining room, or the work I made for the Rainbow Room, or for Windows on the World (p.316–321). They were all great projects, and I feel that they are significant works. They are opportunities to stretch yourself and get beyond where you've been.

TO: *How do you define 'significant'?*

DD: Something enduring and pleasurable. I think Tchaikovsky's *Nutcracker* is very significant. The amount of times that piece of music has been reproduced and taken in by a receptive audience, hackneyed as it has become, is proof that it is significant. And Picasso's *Guernica*, because it seems to have been done in a fit of passion, and it is the kind of work that stretches the capacity of the individual. Music affects you in a different way than visual art, you succumb more readily to it. Lately I've been questioning the necessity for an intellectual basis for works of art. I've been wondering just how important it is that a work of art say something, rather than give a feeling. Or capture a moment. Or just be what it is in a simple and honest way.

TO: *You said that you would like to make a series on jazz. You have recently started on this series, and you have made quite a few pieces. What do you think about this body of work?*

DD: I like it. One of the things I like about this series is that I get a lot of response to it. Often, people react to my work from a technical point of view. They'll walk up to a piece and they'll say, 'Oh this is beautifully made,' and they'll get caught up in the details. When it comes to thinking about what the piece is doing, or what it's there for, people are often at a loss for words. With the jazz pieces, I have had all kinds of people coming up to me—who are connected to music or not—who tell me that they really like the work. Music has patterns that are immediately recognizable, and this is a kind of imagery. The musical experience intrigues me because it is sometimes more sensual, more memorable than visual experience.

TO: *Do all of the jazz pieces incorporate a musical instrument?*

DD: So far, they have. I make a literal rendition of the instrument that's prominent in the musical composition, or the piece makes a direct allusion to the title of the music. Each piece I've made so far is loosely based on a particular musical composition. I'll take a Miles Davis tune, or a Thelonius Monk tune, or some other artist, and I think about what they've done. I'm not listening to the music and making a spontaneous drawing and coming up with a visual rendition of the sound. I listen to the music and think about it and play around with it. You could say that the abstraction of the shape is the rhythm, or undulating pulsing, of the sound.

TO: *I am interested in the way you combine the representational and the abstract forms in the compositions.*

DD: For me, the form of the instrument is the most compelling thing visually about these pieces. It's what got me hooked in the

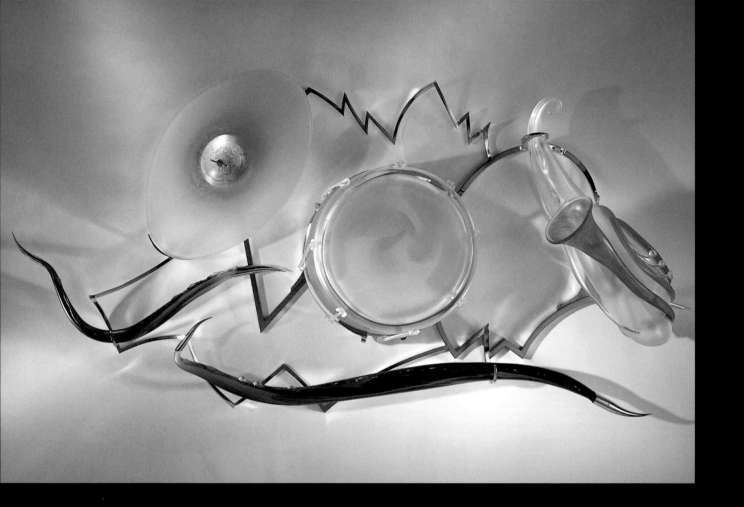

Paradiddle
31H X 62W X 5D"

first place. I bought a book on jazz, and it had a section on instruments. As I started to think about the shapes of all these things, I realized that there is a pretty limited range of instrumentation in the common jazz orchestra or group. There are only a dozen or so instruments, but everybody tones and shapes it their own way. Because of the way that the instruments are played, they take on individual characteristics depending on the artist. I began to think about that as a form.

TO: *They are really different from the rest of your work. When I look at your instruments, they remind me of the futuristic, electric guitars. I have always had trouble understanding musical instruments made of a material that they are not meant to be made of. I guess I just think of musical instruments as functional things to play. It's interesting that you abstract their shapes into something else.*

DD: I try to morph the instrument into something that alludes to the feeling I get from the sound. For example, there is a saxophone shape that has a cloud sticking off of it, or a trumpet that looks like it is growing out of a pillow. I am thinking of the sound that these instruments made which, in both cases, was velvety, soft.

TO: *What if you took the instrument out of the work?*

DD: I like the instrument itself. I like to make the elements of the instruments stand out three-dimensionally in contrast to the other forms. I think of these pieces like paintings or murals. It is an image on the wall, a low relief that plays down the three-dimensional quality. The shadowing and the lighting are important. I like it to be a soft image, not to have the hard quality that a sculptural, and especially glass, object has. The whole composition stems from and depends on the instrument, from the forms to the colors to the way light and shadow enhance the mood. The music series has some similarity to the abstract heads I made in the 1990s. Soft colors and liquid forms were my basic palette, and each piece was a depiction of a mood or an emotion. When I look back at them, I think that the ones with the more obvious facial features were the most successful in conveying the feeling that I intended.

TO: *How do you 'change gears' in the things that you make? For example, moving from Animal Heads to the Circus Vases?*

DD: I started out thinking of the Circus Vases as whimsical things; combinations of the stupendous and the strange. Yet, they look precious to the point of elegance, and deliberately so. Each time I make one, I think of a few more. That's something I've learned in my own working process: one concept fuels another—it's like a branching tree—it goes off in all different directions.

— *TINA OLDKNOW*

Antic
18H X 15D"
1996

SCENIC AMERICA VASES
OCEANIC VASES
HEAD VASES
FISH/BIRD VASES
PEOPLE/ANIMAL VASES

1979 – 1982

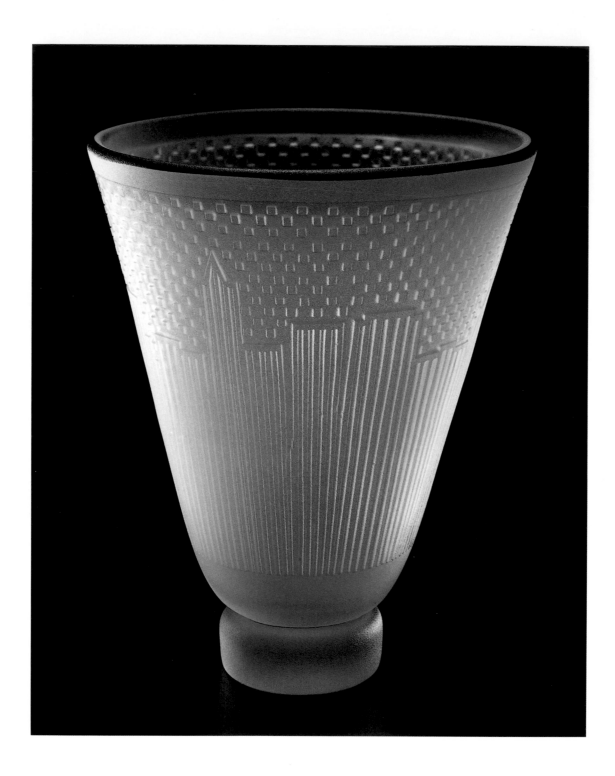

PREVIOUS
Talls and Vents (detail)

ABOVE
Stars and Skyline
13H"
1979

OPPOSITE
High Rise Units
10H"
1980

48

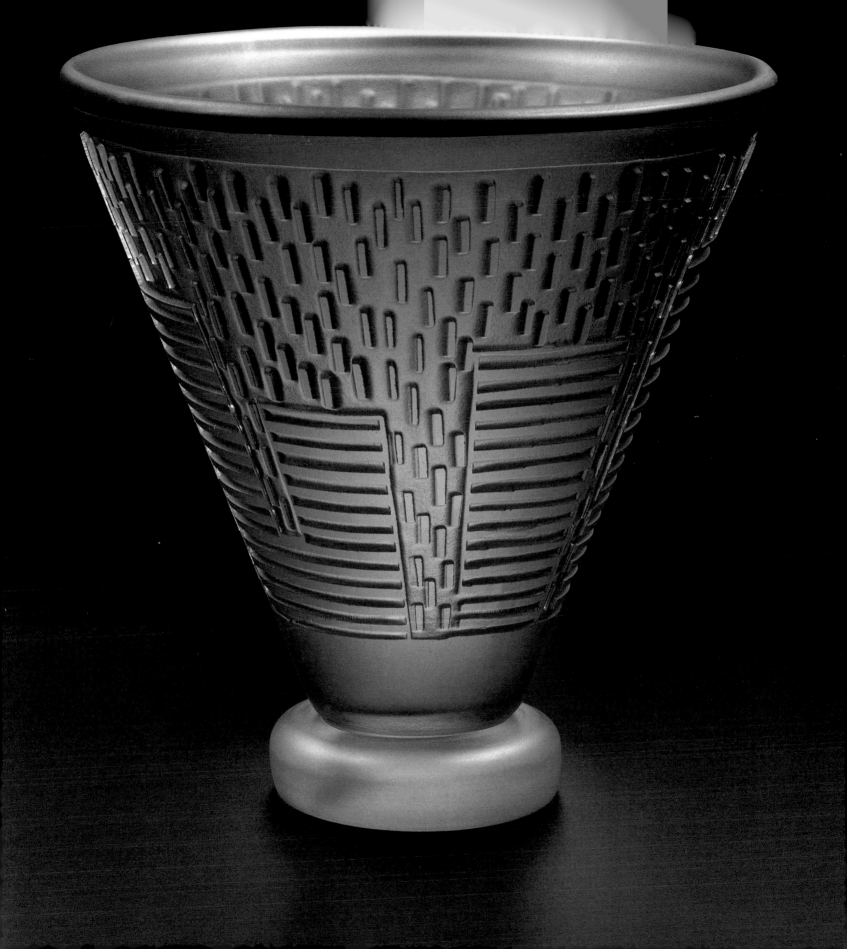

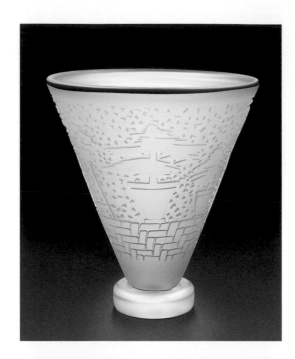

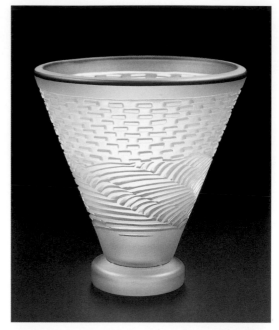

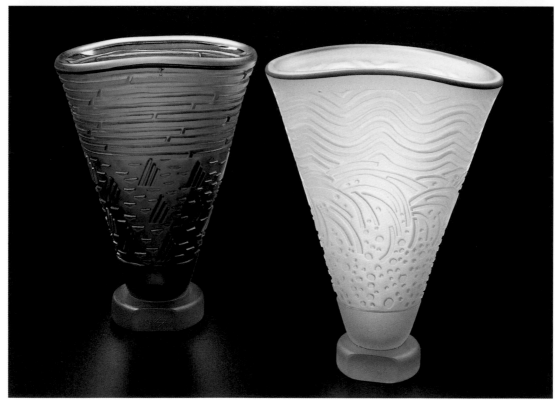

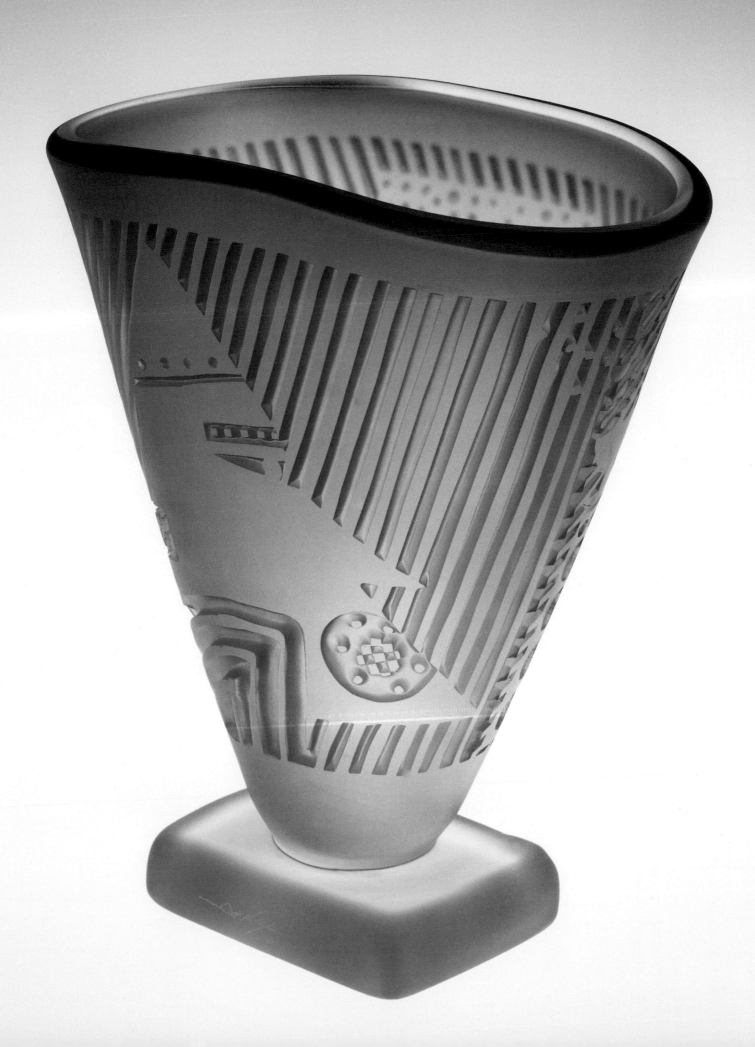

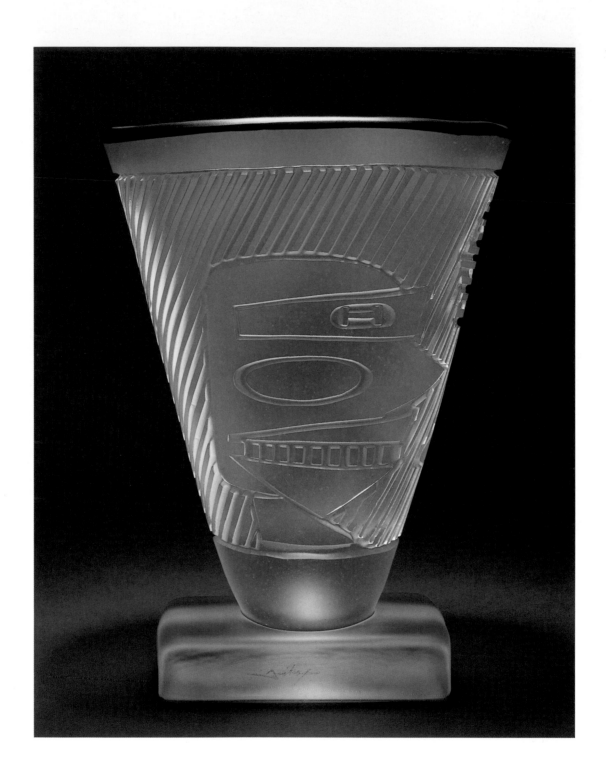

ABOVE
Strangers
10н"
1981

OPPOSITE
Abstracts
11.5н"
1981

52

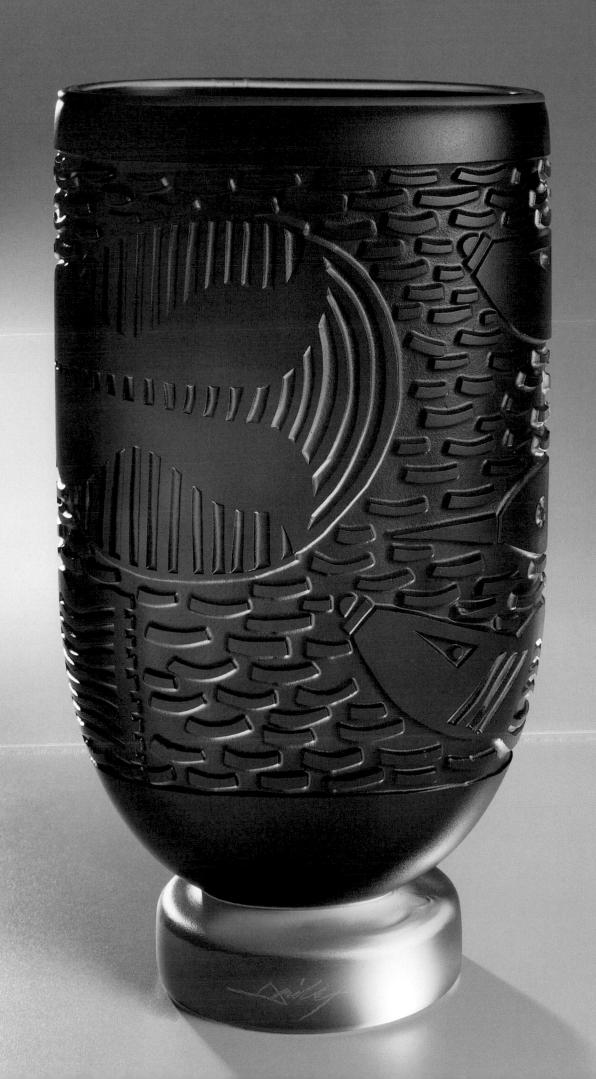

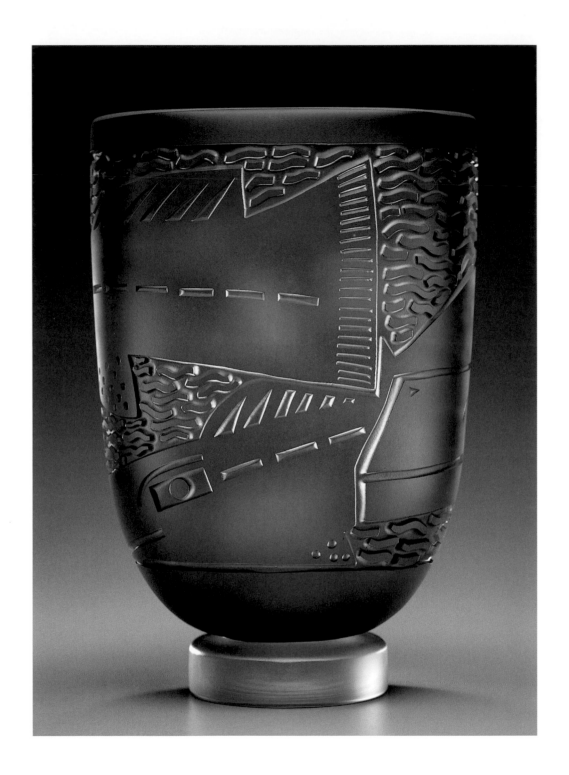

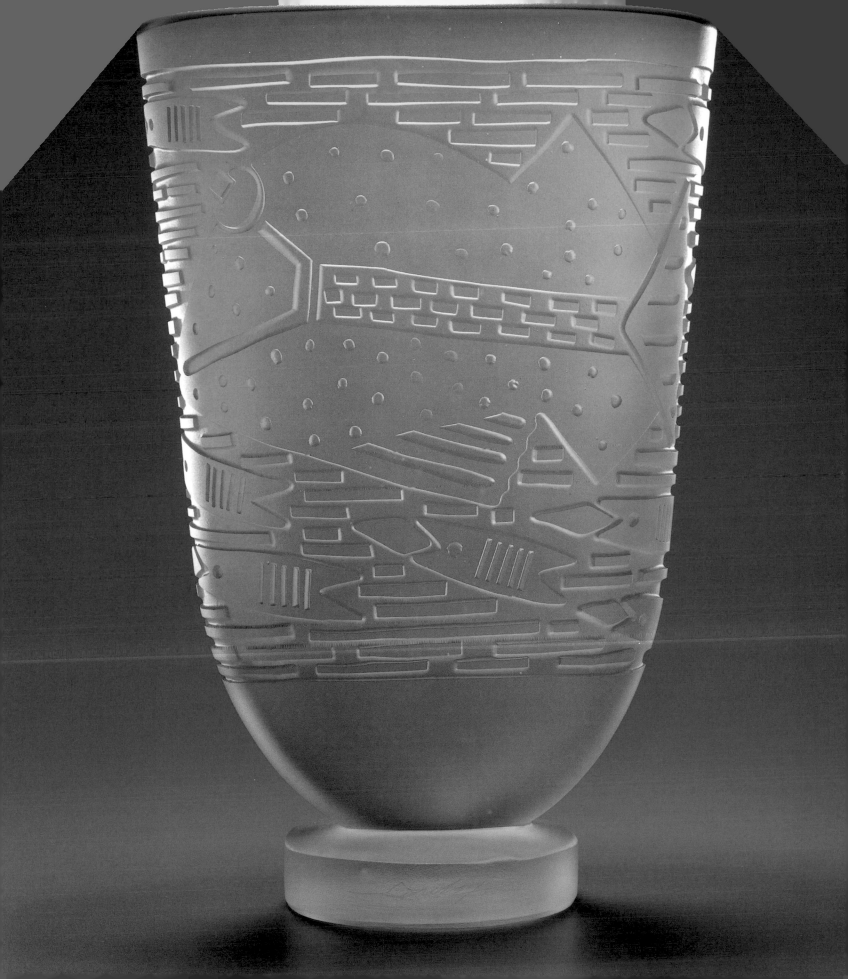

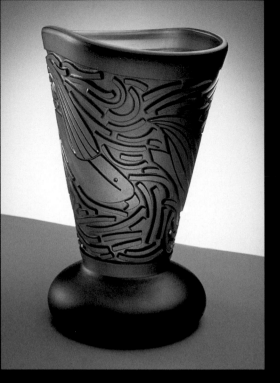

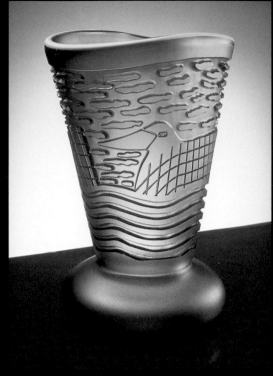

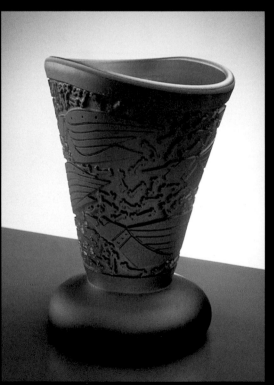

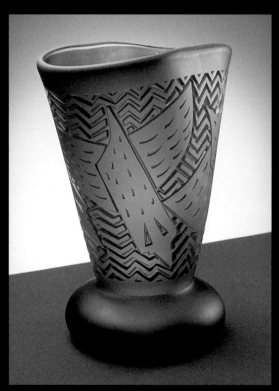

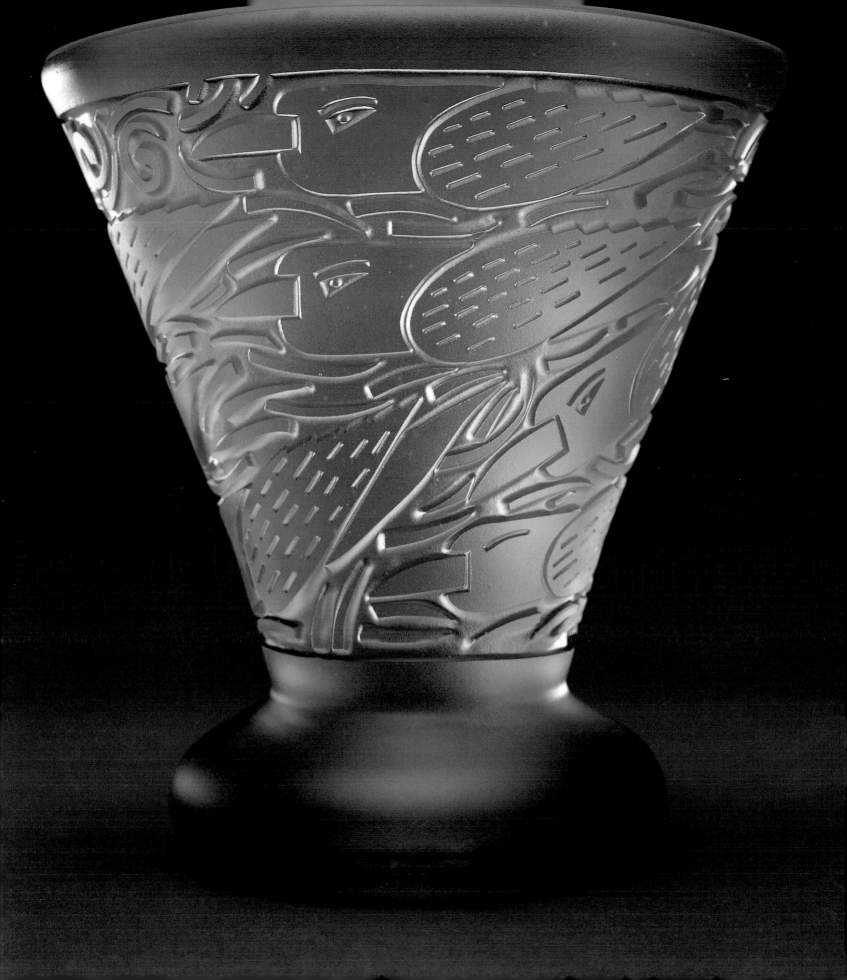

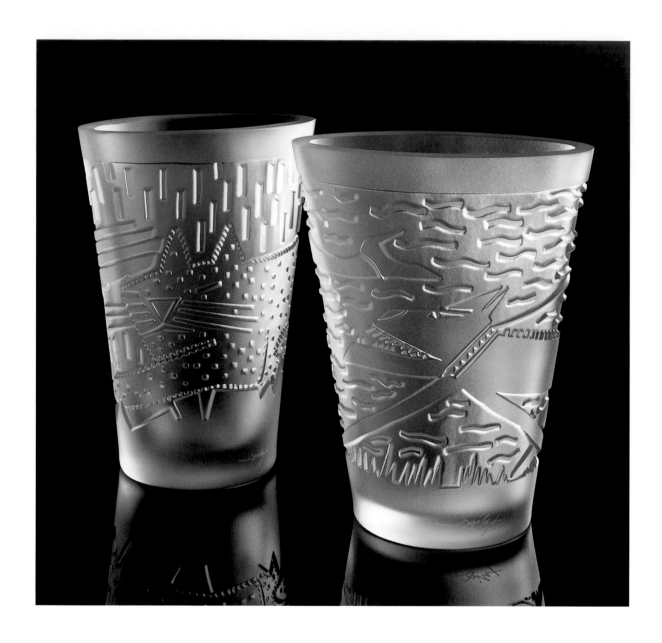

ABOVE LEFT
Man with Cat
10H"
1981

ABOVE RIGHT
Woman Running with Dog
10H"
1981

OPPOSITE
Dinochat with Tender
10H"
1982

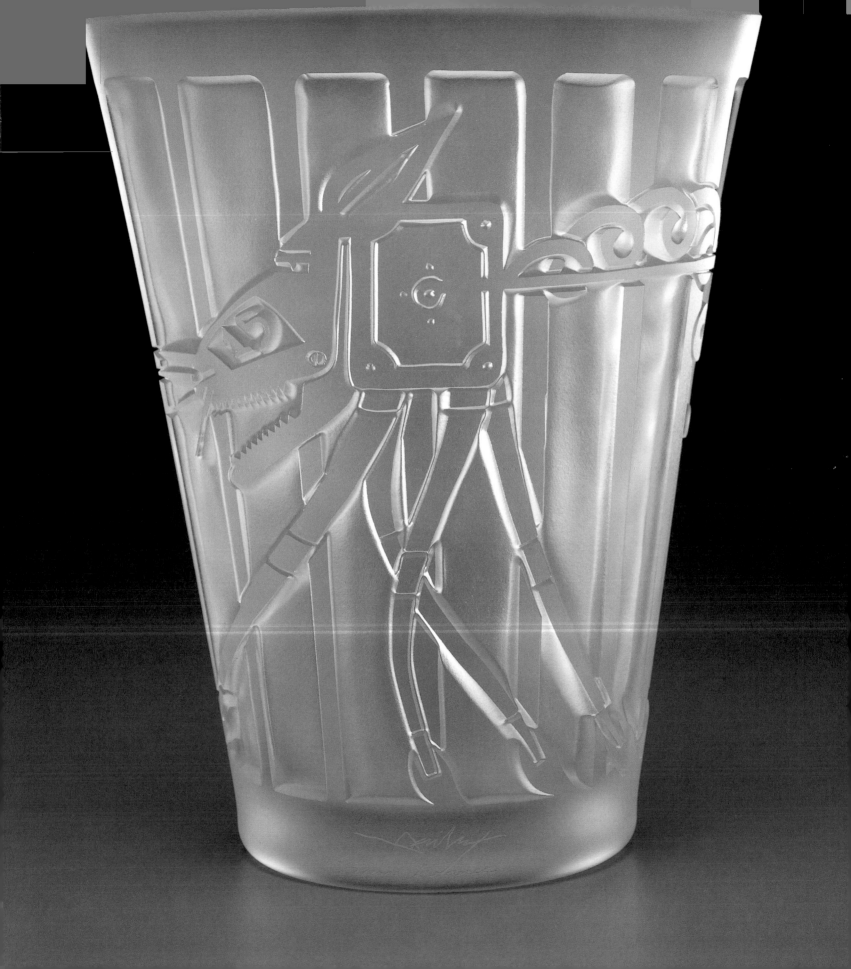

TRIPOD VESSELS
DISTORTED VESSELS

1980 – 1982

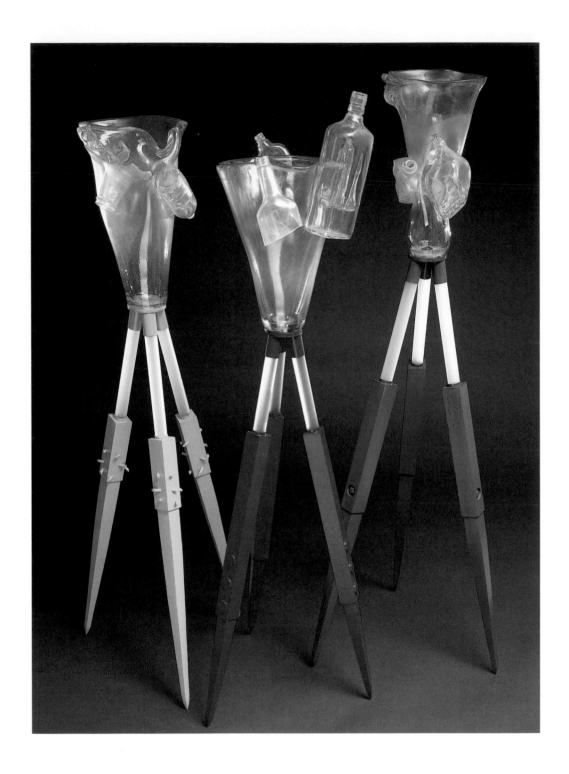

PREVIOUS
Statue (detail)

ABOVE
Stick-ons
48H"
1980

OPPOSITE
Pencils and Canes
46H X 21W X 21D"
1980

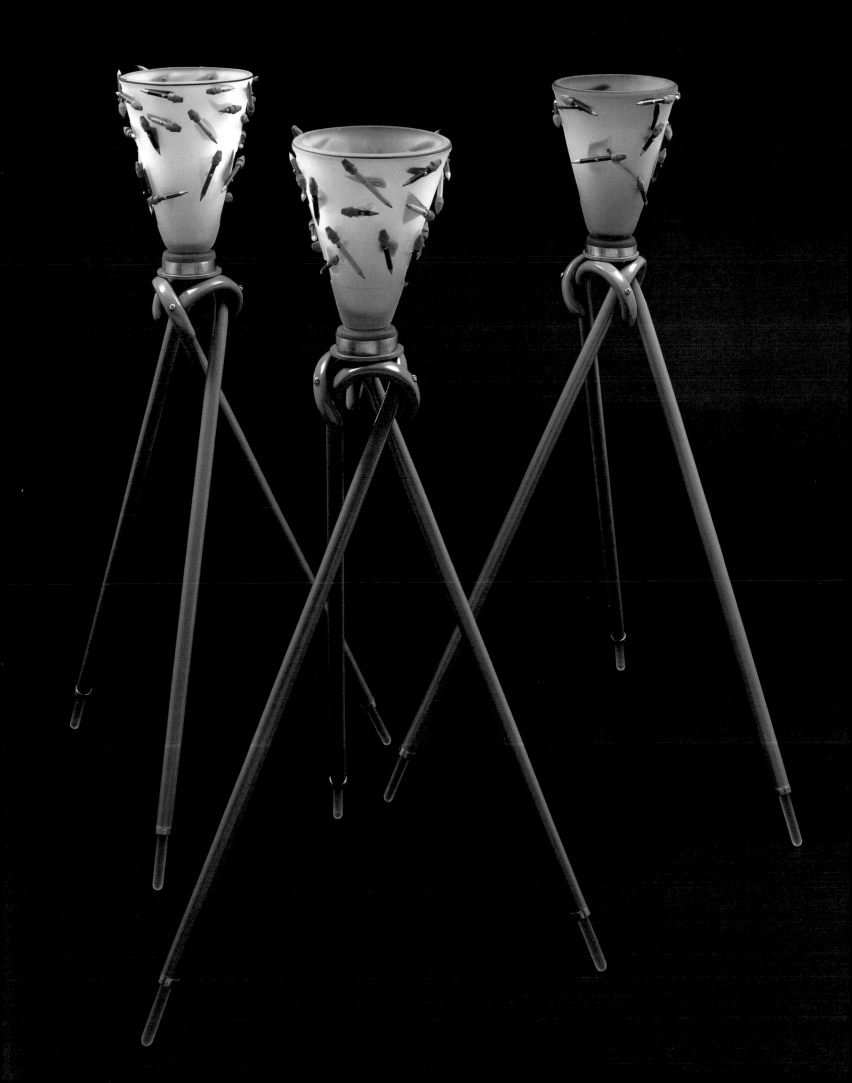

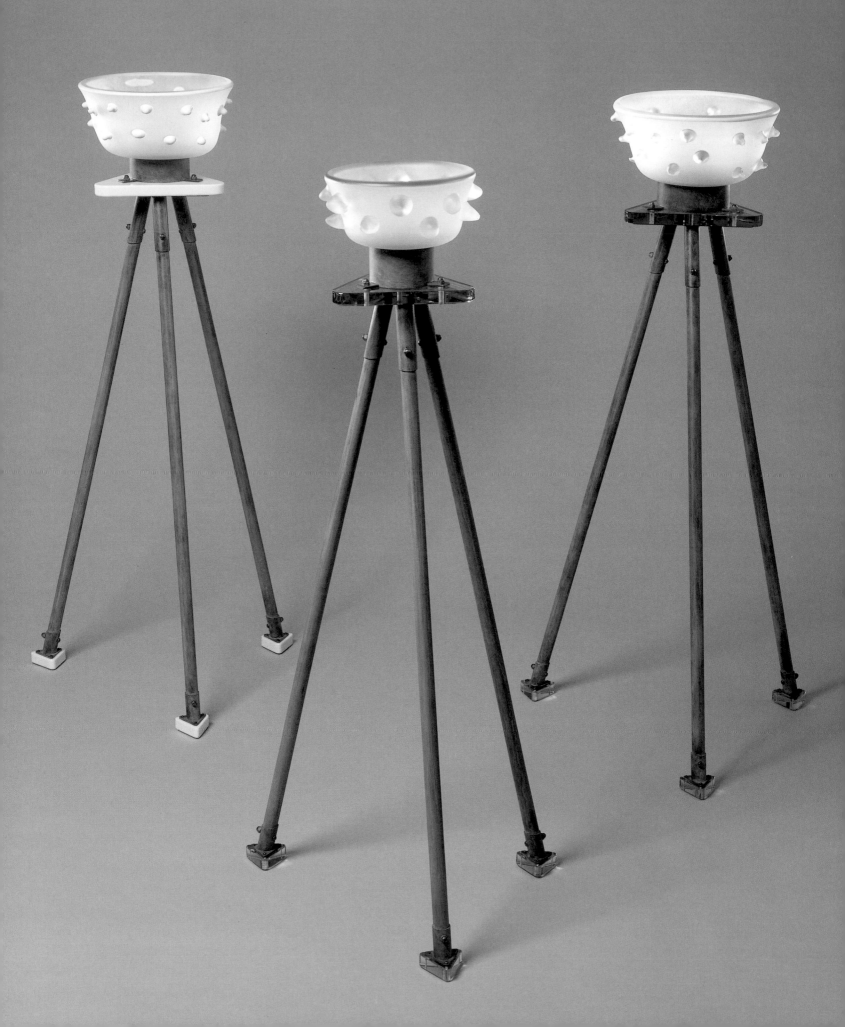

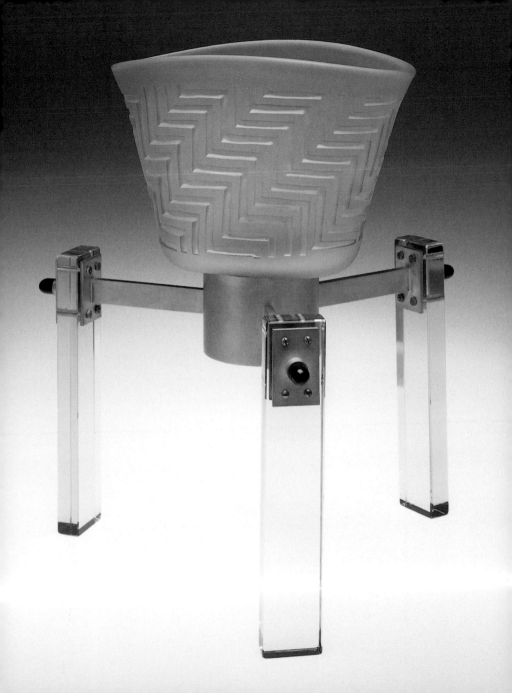

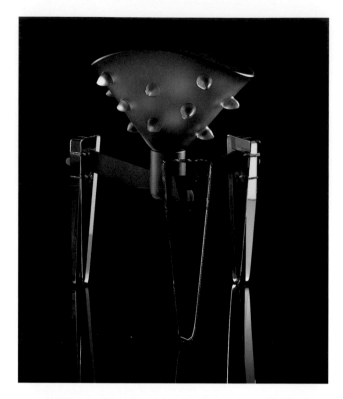

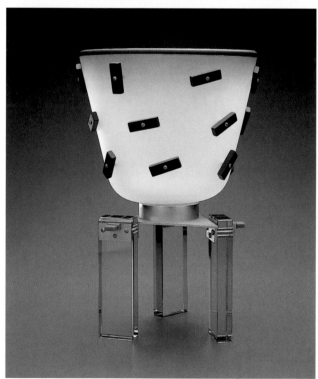

ABOVE
Fall
18H"
1981

BELOW
Rectangulaire
10H"
1981

OPPOSITE
Statue
26H"
1980

66

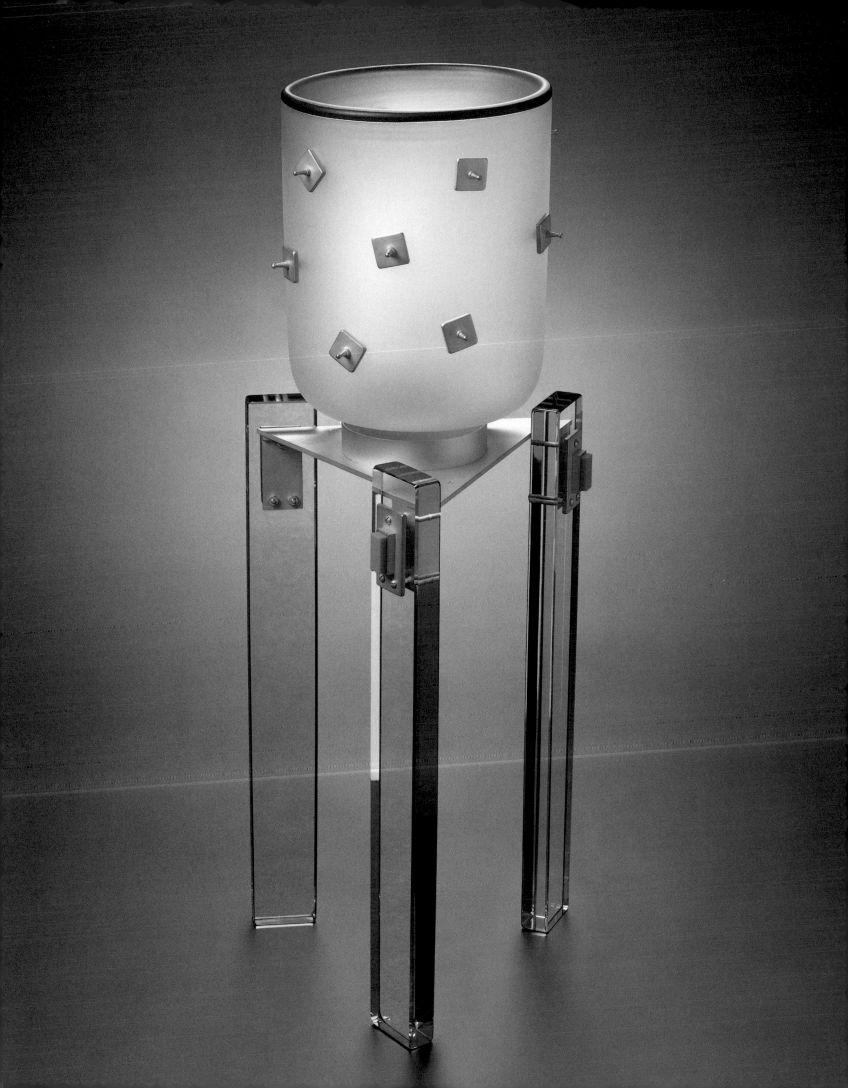

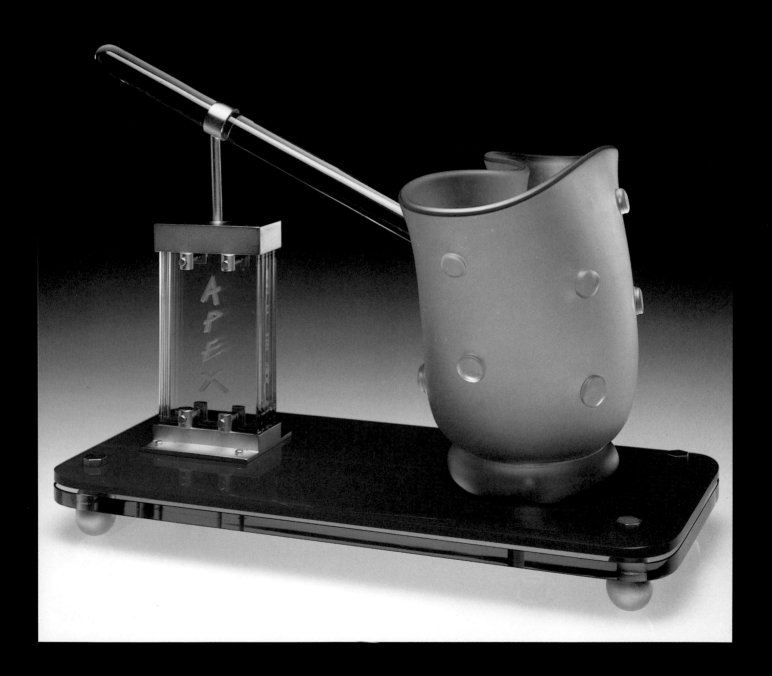

Apex
14H x 18W x 8D"
1982

ABOVE LEFT
The Poke
12H X 15W X 10D "
1980

ABOVE RIGHT
Leaner
18H X 16W X 8D "
1980

BELOW LEFT
Hard Flag
16H X 20W X 8D "
1980

BELOW RIGHT
Slope
12H X 15W X 8D "
1980

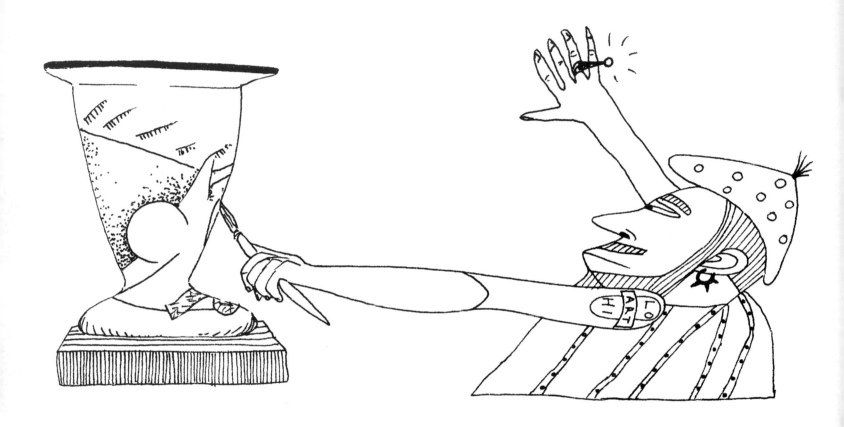

The Vase as Art

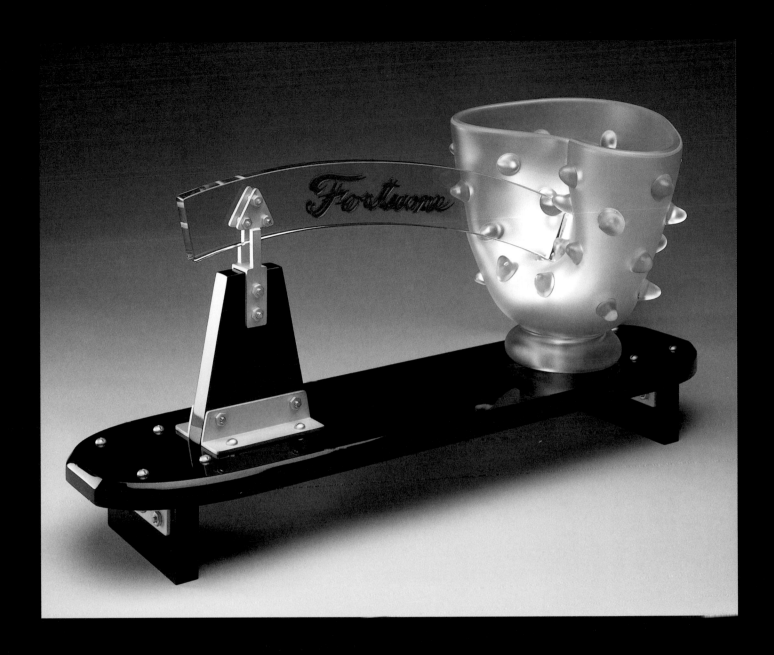

OPPOSITE
The Vase as Art
14H X 9W"
1986

ABOVE
Fortune
16H X 24W X 8D"
1980

71

CONVERSATIONS
HEADS
BUSTS
ANIMALS

1982 – 1995

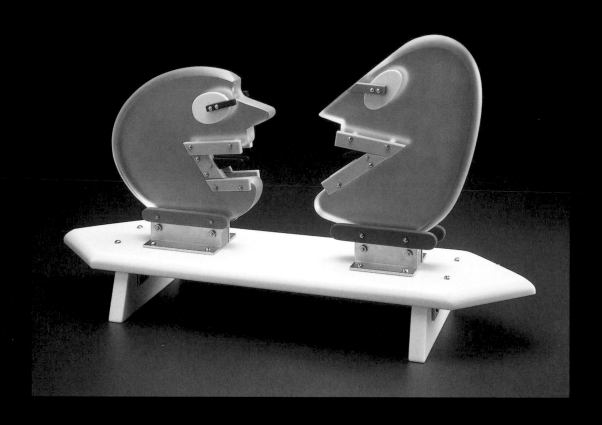

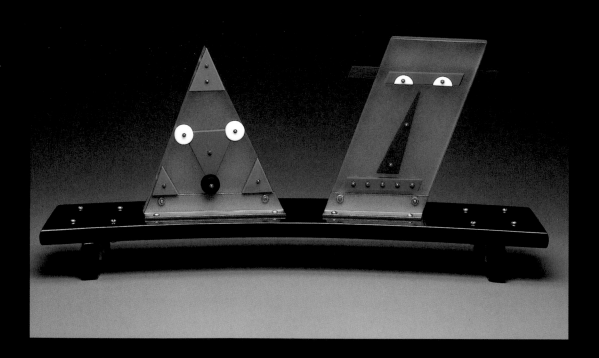

PREVIOUS AND ABOVE
Gift of Gab
13H x 24W x 7D"
1982

BELOW
The Clowns
11H x 24W x 8D"
1982

74

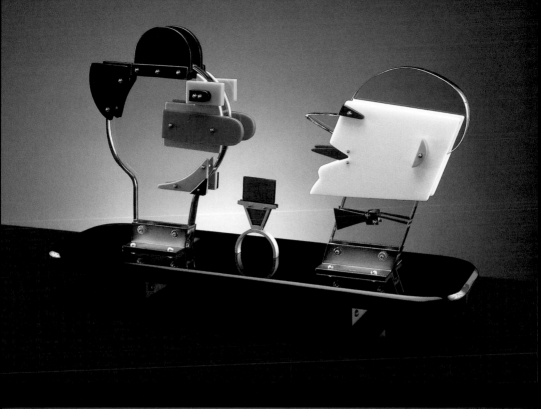

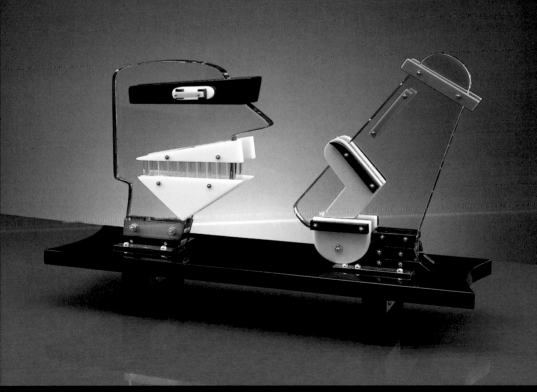

ABOVE
The Bar
14H x 26W x 6D"
1982

BELOW
The Stylists
4H x 20W x 6D"
1982

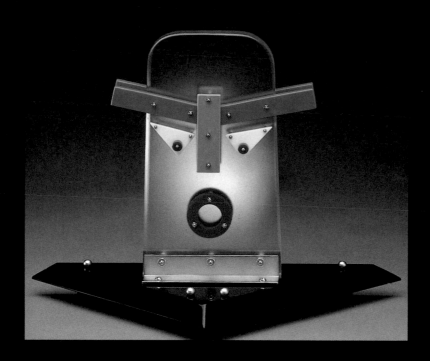

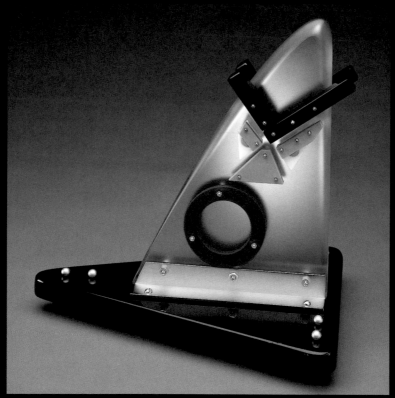

ABOVE
Consternation
14H X 16W X 8"
1983

BELOW
Rage
12H X 12W X 8D"
1983

76

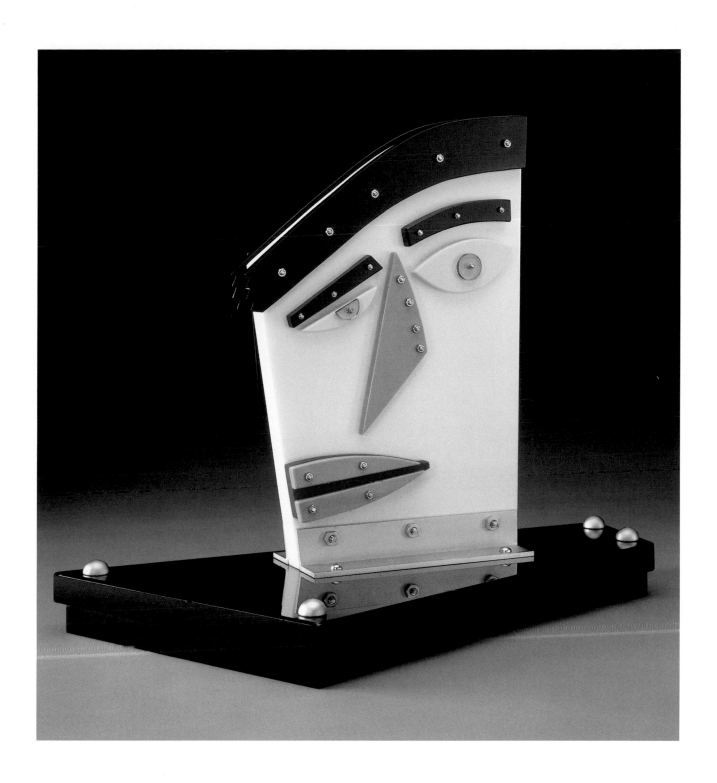

Fatigue
14H X 16W X 8D"
1983

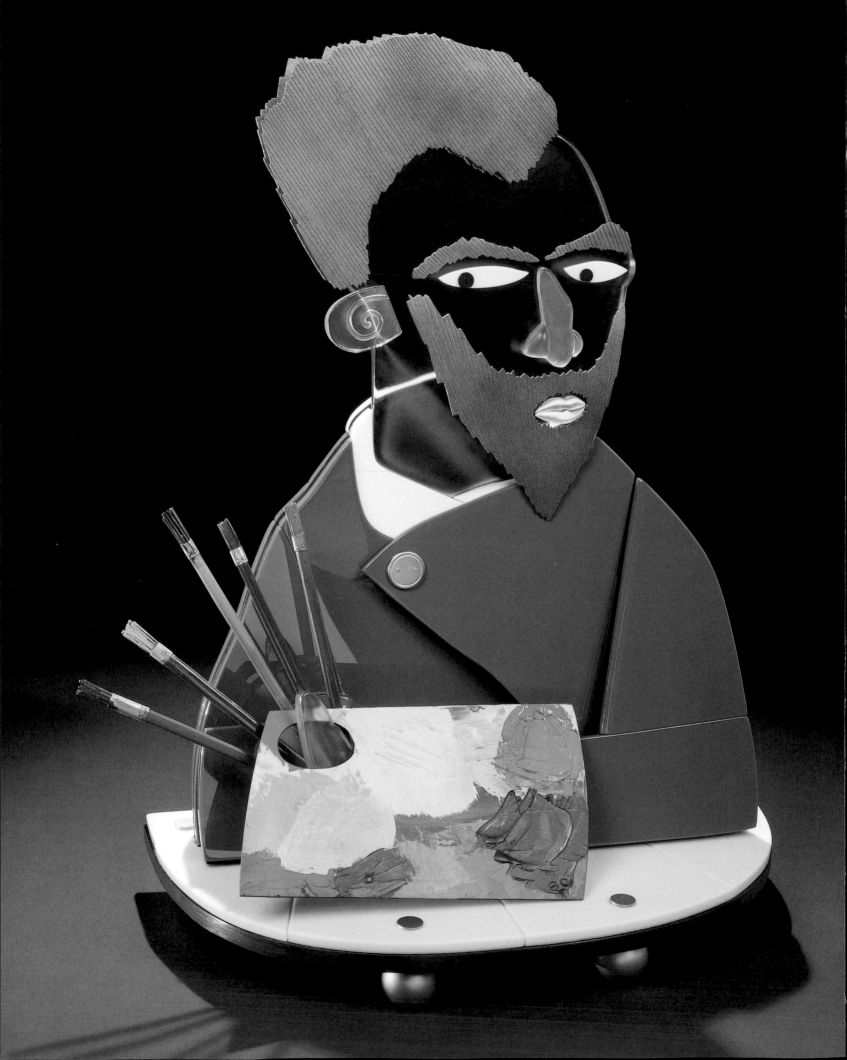

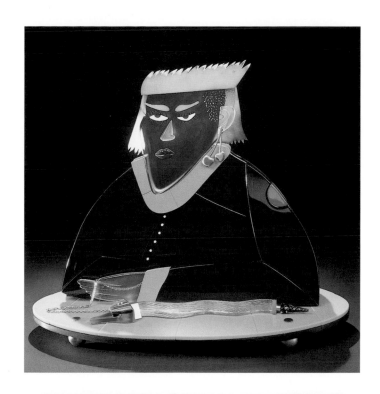

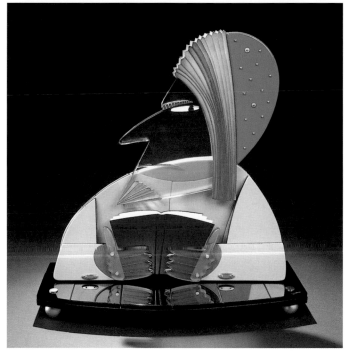

OPPOSITE
Vincent van Gogh
26H x 16W x 12D"
1987

ABOVE
Serpentina
24H x 20W x 12D"
1987

BELOW
Momus
23H x 20W x 12D"
1987

FOLLOWING
Sick as a Dog
10H x 16W x 12D"
1984

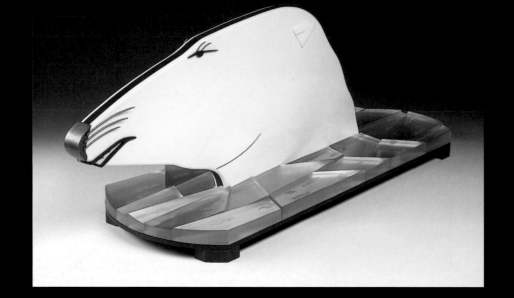

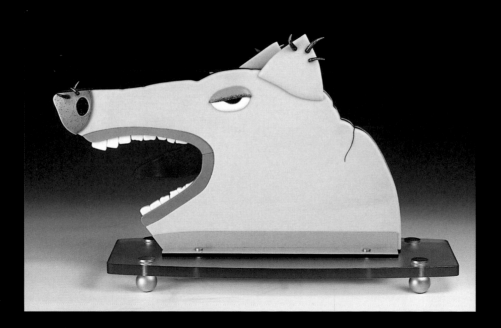

ABOVE
Polar Bear
18H X 22W X 10D "
1994

BELOW
Hog
17H X 24W X 10D "
1984

84

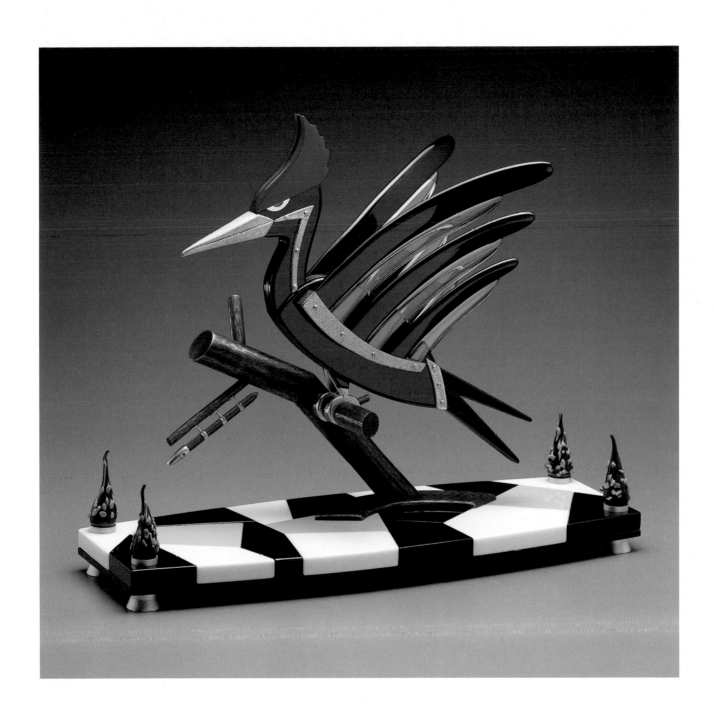

Woodpecker
18H X 22W X 10D"
1995

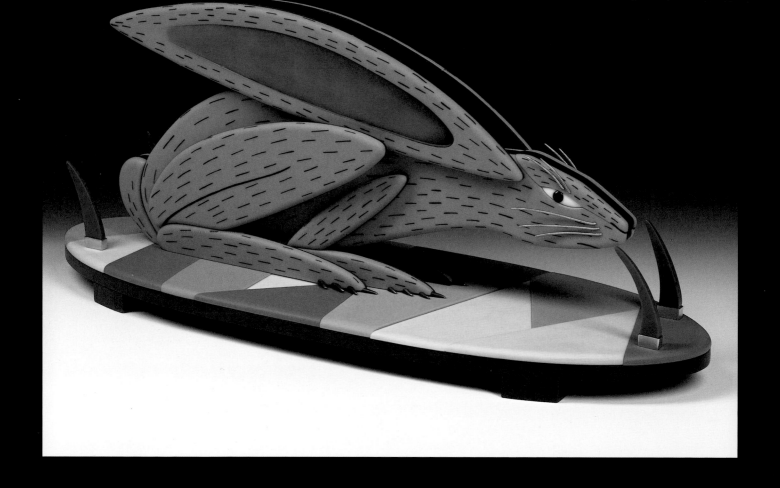

Jackrabbit
12H X 26W X 12D"
1994

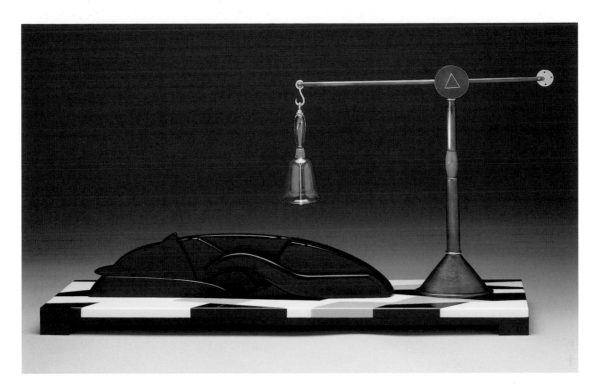

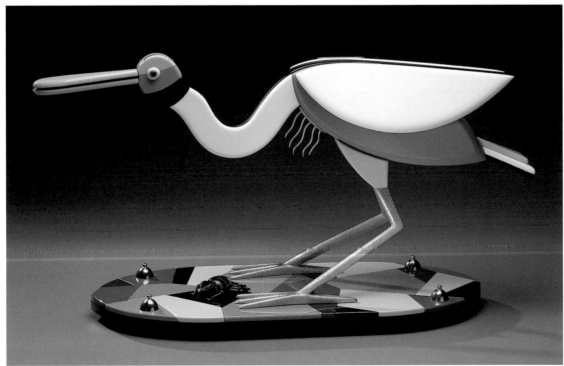

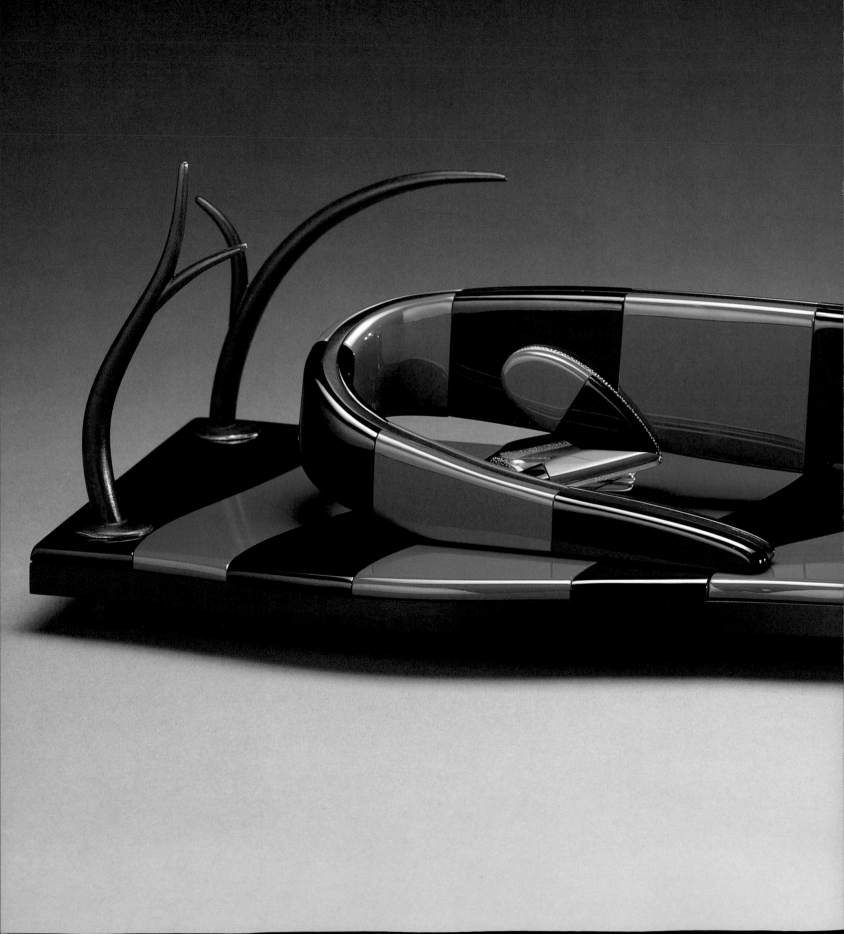

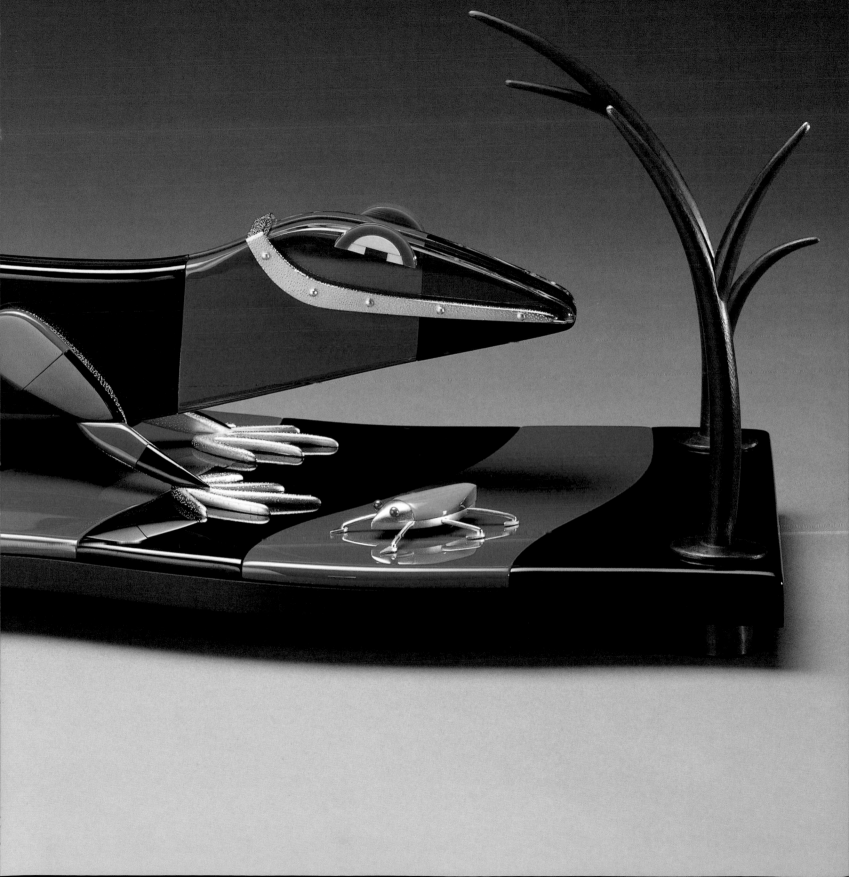

SCIENCE FICTION VASES
AUTOMOBILE VASES
TRAVEL VASES
PORTRAIT VASES

1983 – 1987

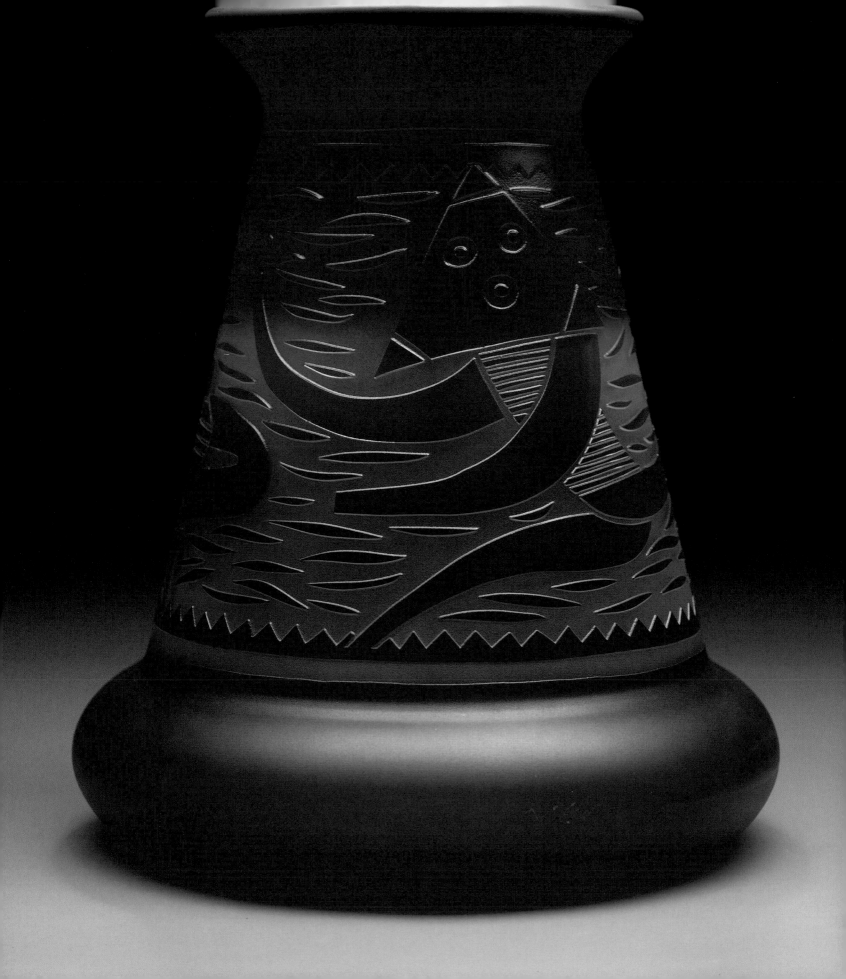

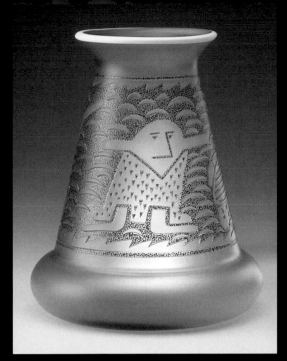

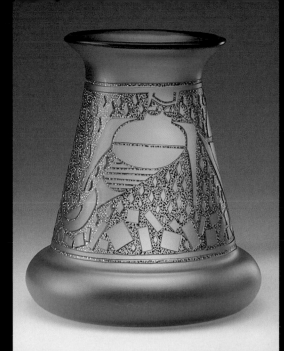

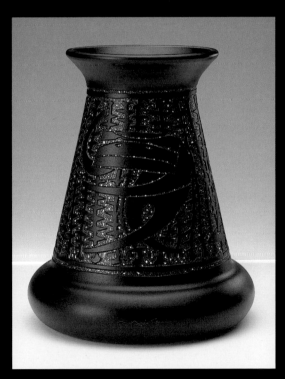

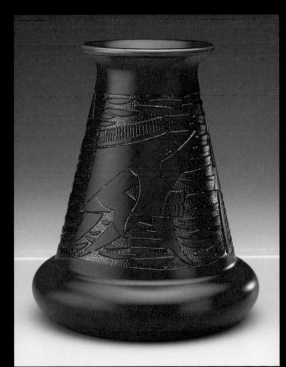

PREVIOUS AND OPPOSITE
Hot Wind
11H"
1984

ABOVE LEFT
Strange Terrain
11H"
1984

ABOVE RIGHT
Crystal Rain
11H"
1984

BELOW LEFT
Dense Growth
11.5H"
1984

BELOW RIGHT
Garden of Oddities
11H"
1985

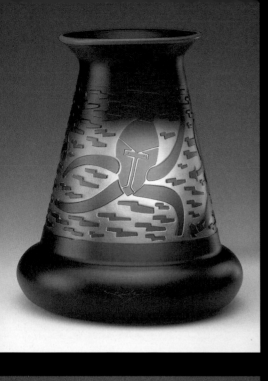
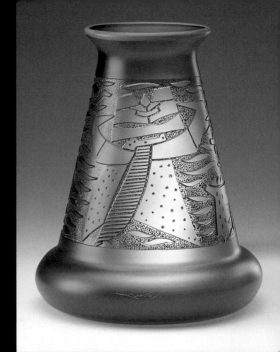
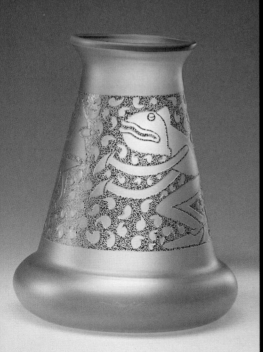
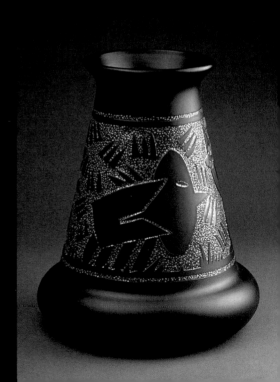

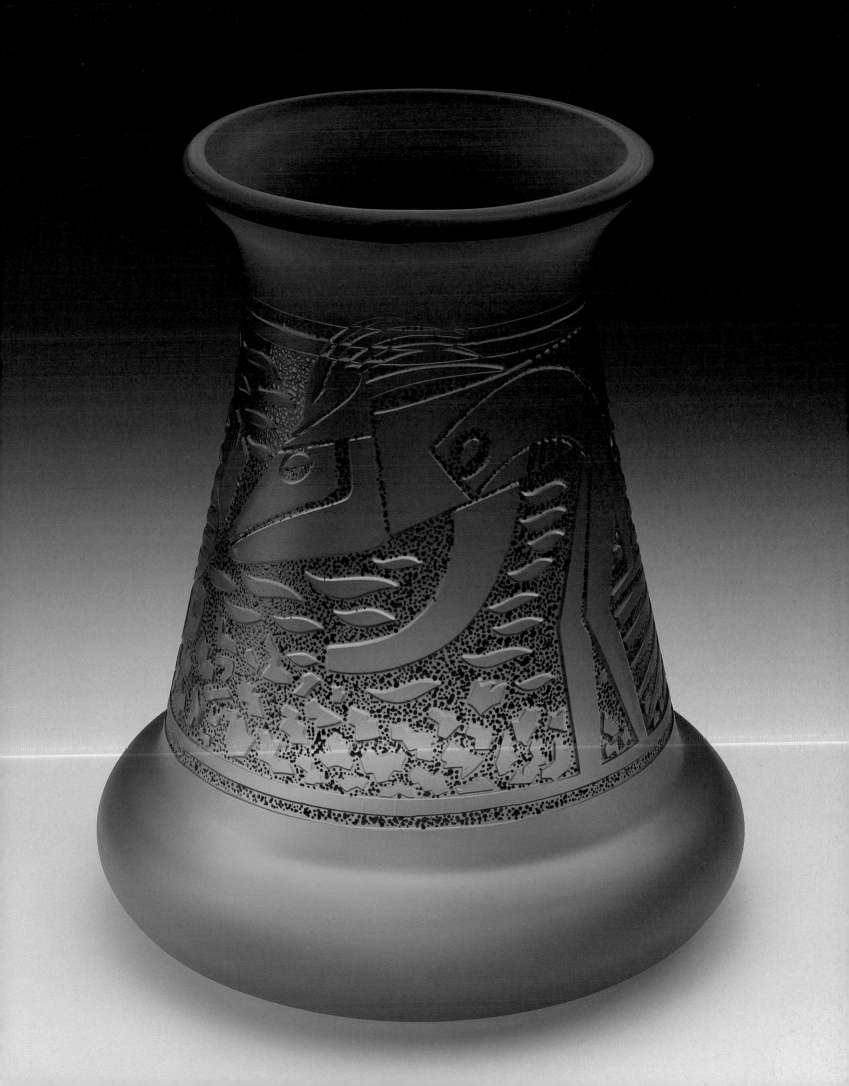

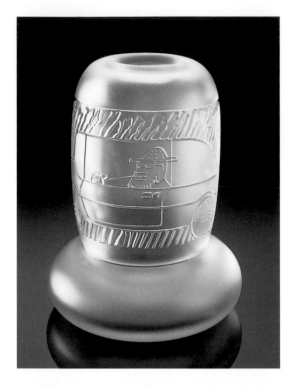

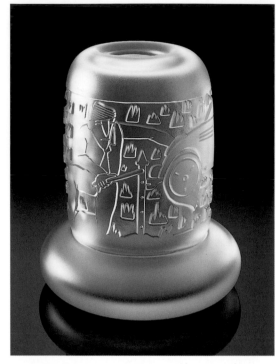

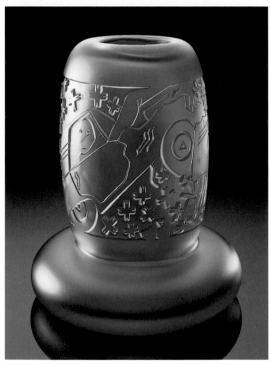

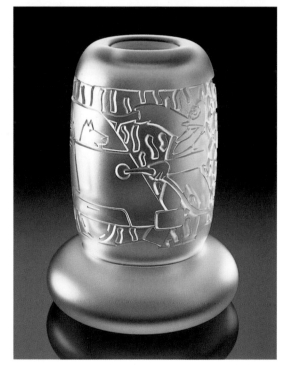

ABOVE LEFT
Safari
10H"
1983

ABOVE RIGHT
Flat
9H"
1983

BELOW LEFT
Collision
10H"
1983

BELOW RIGHT
Fill-up
9H"
1983

OPPOSITE
Drive-in Restaurant
9H"
1983

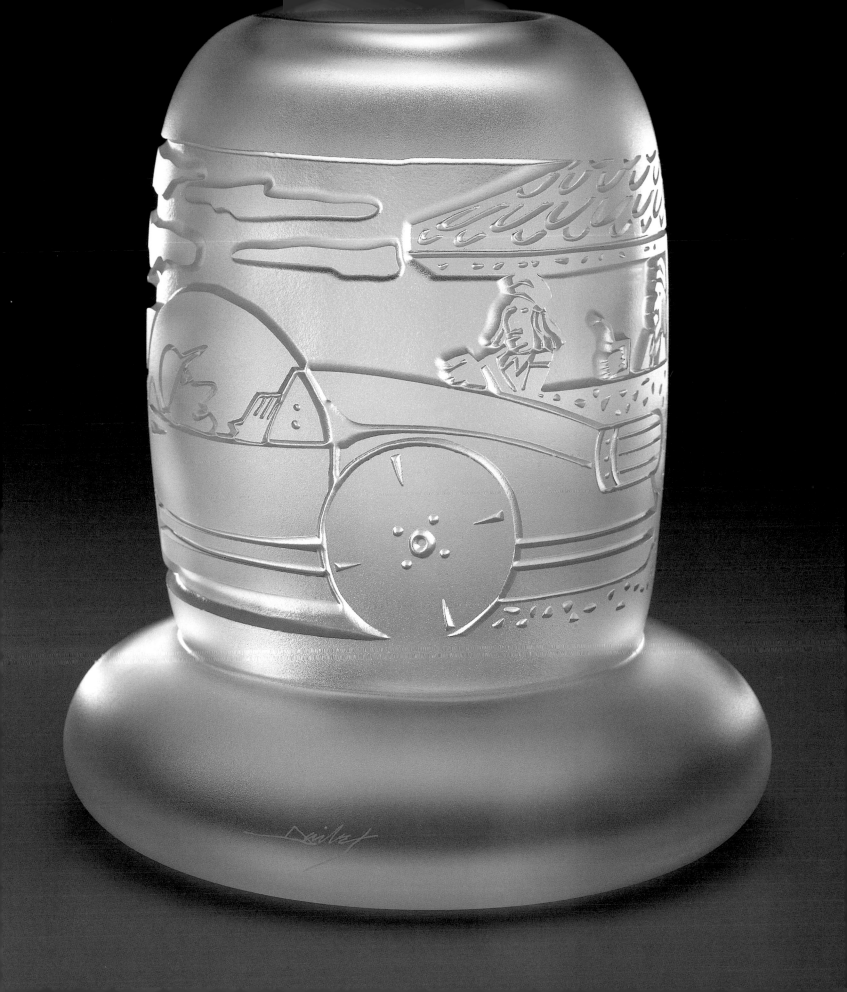

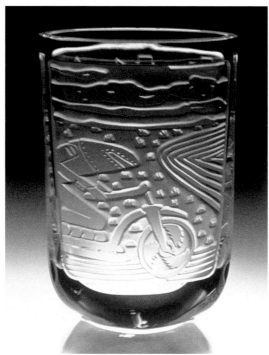
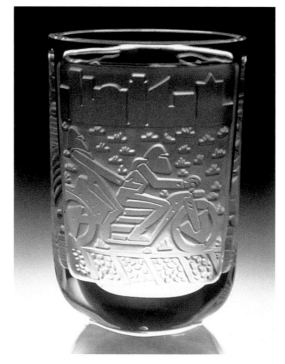

ABOVE: SIDE A/SIDE B
Fish/Speedboat
10H"
1982

BELOW: SIDE A/SIDE B
Cyclist/Tandem
10H"
1982

OPPOSITE
Tollbooth and Hitchhiker
11H"
1983

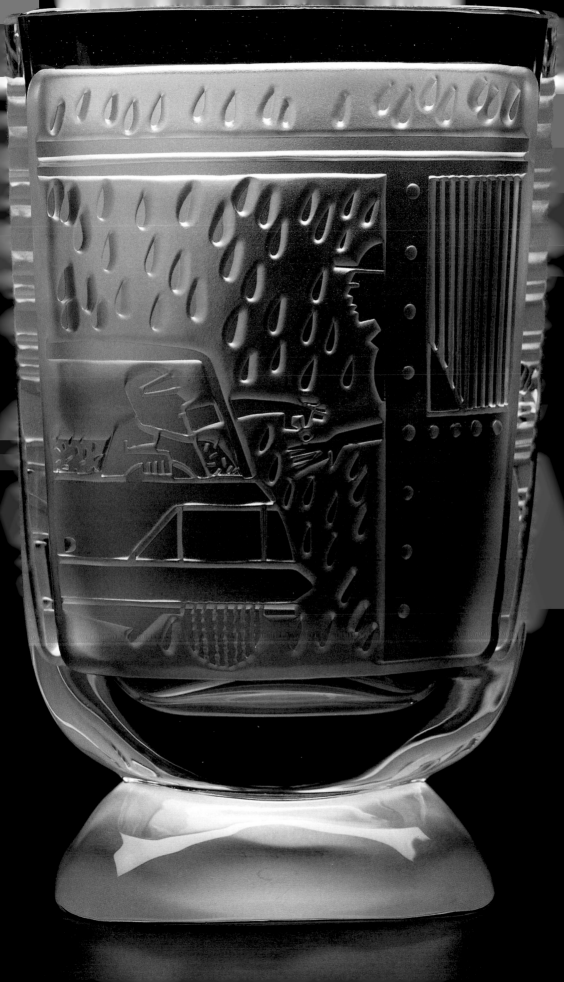

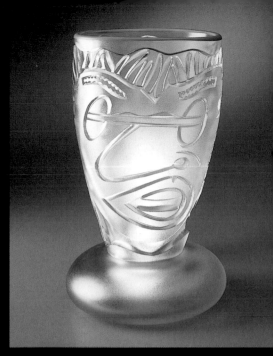

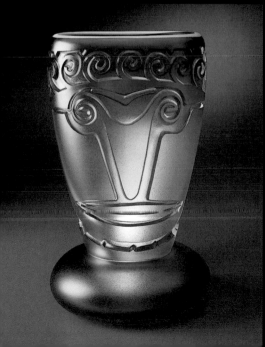

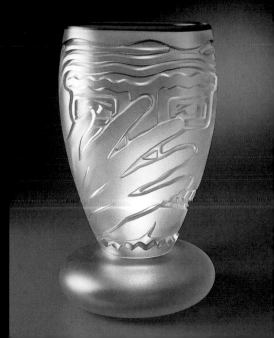

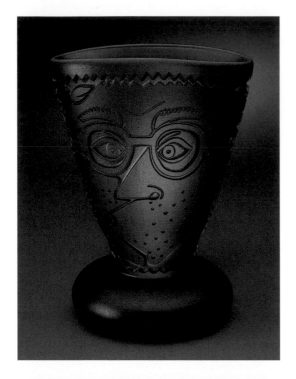

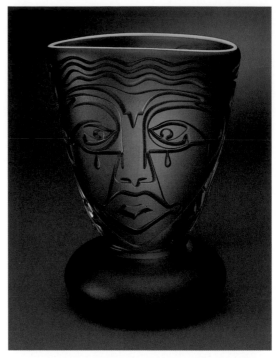

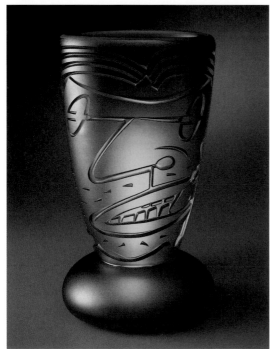

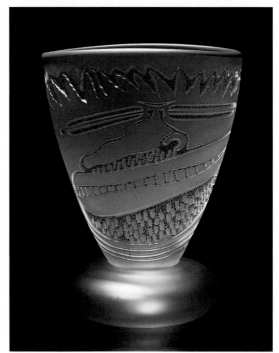

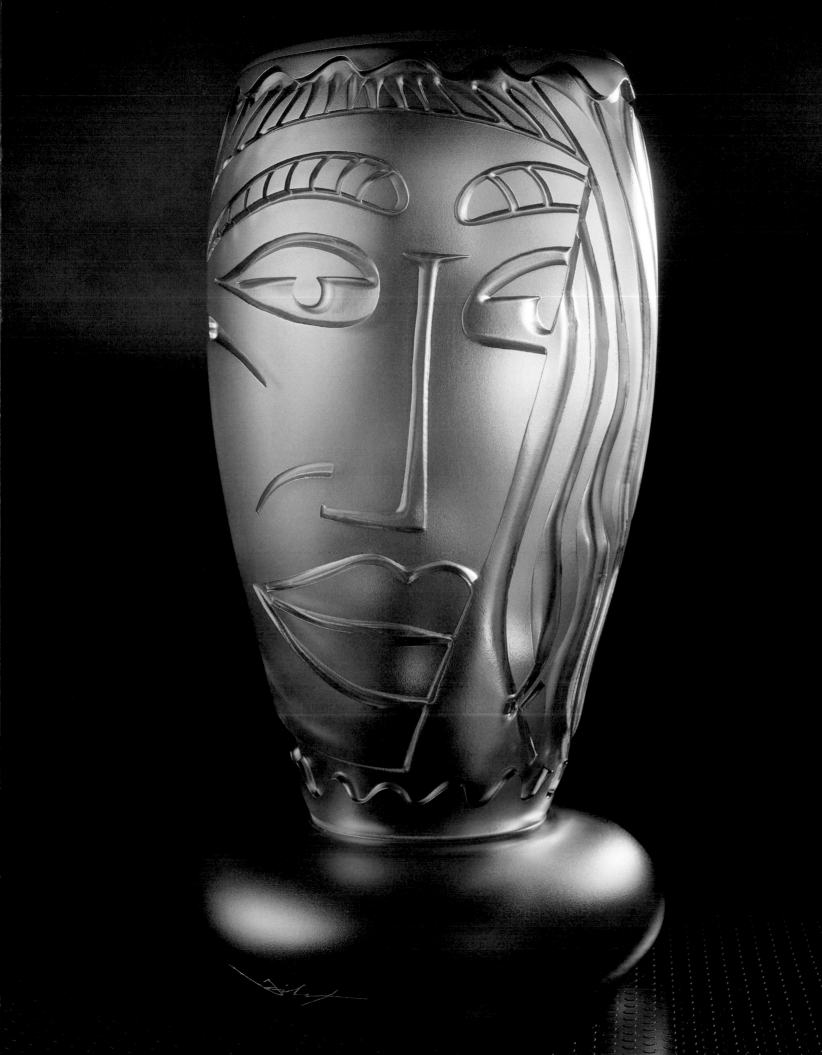

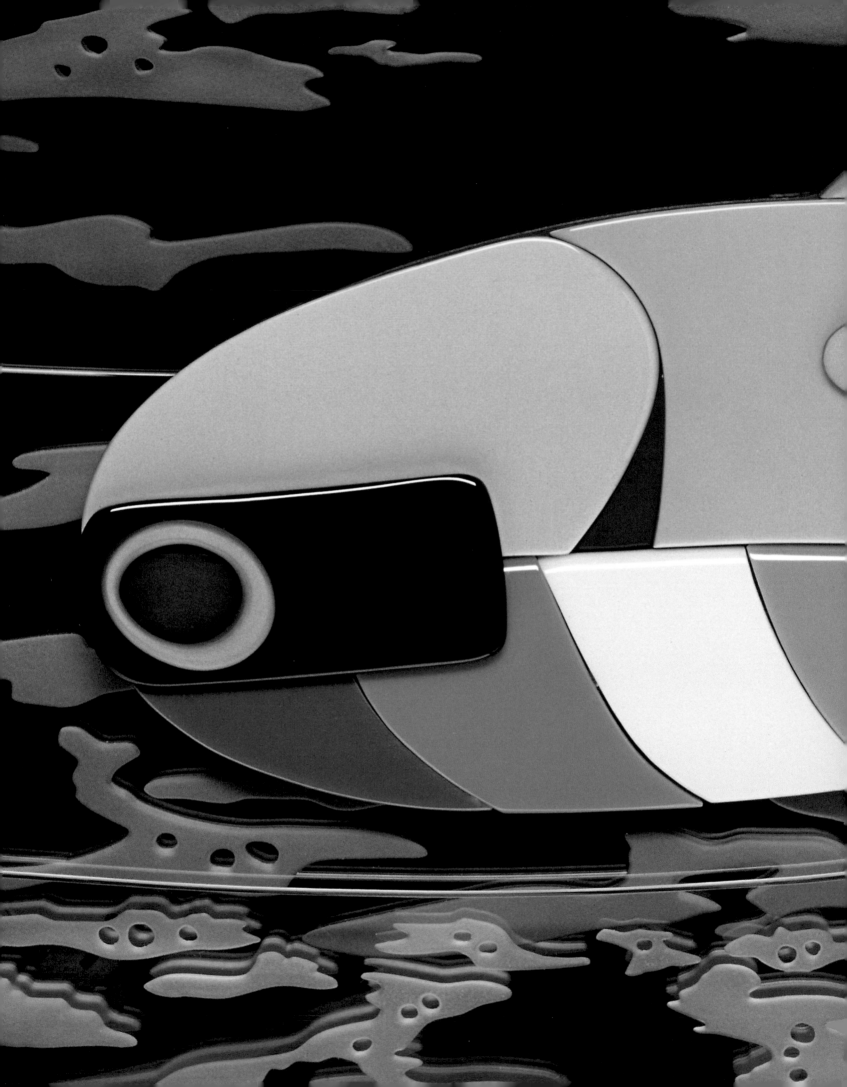

VITROLITE WALL RELIEFS

1982 – 2003

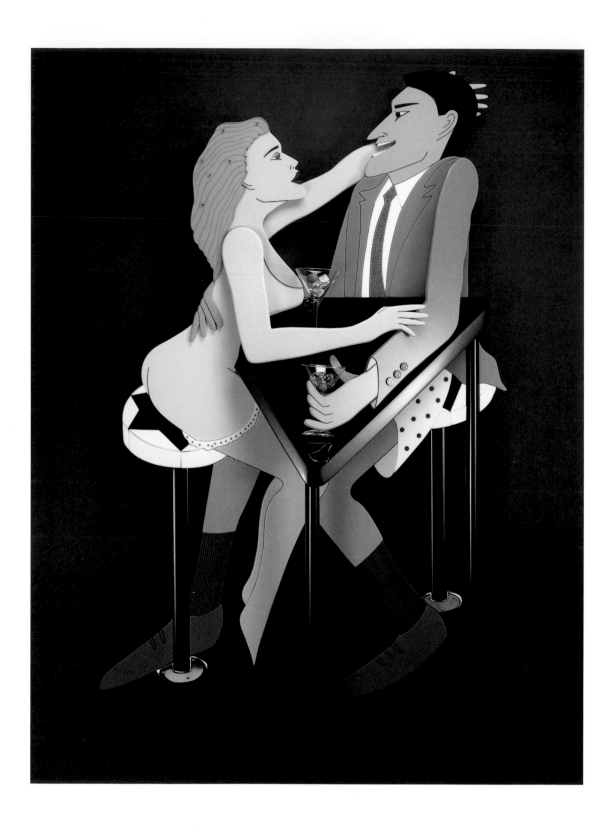

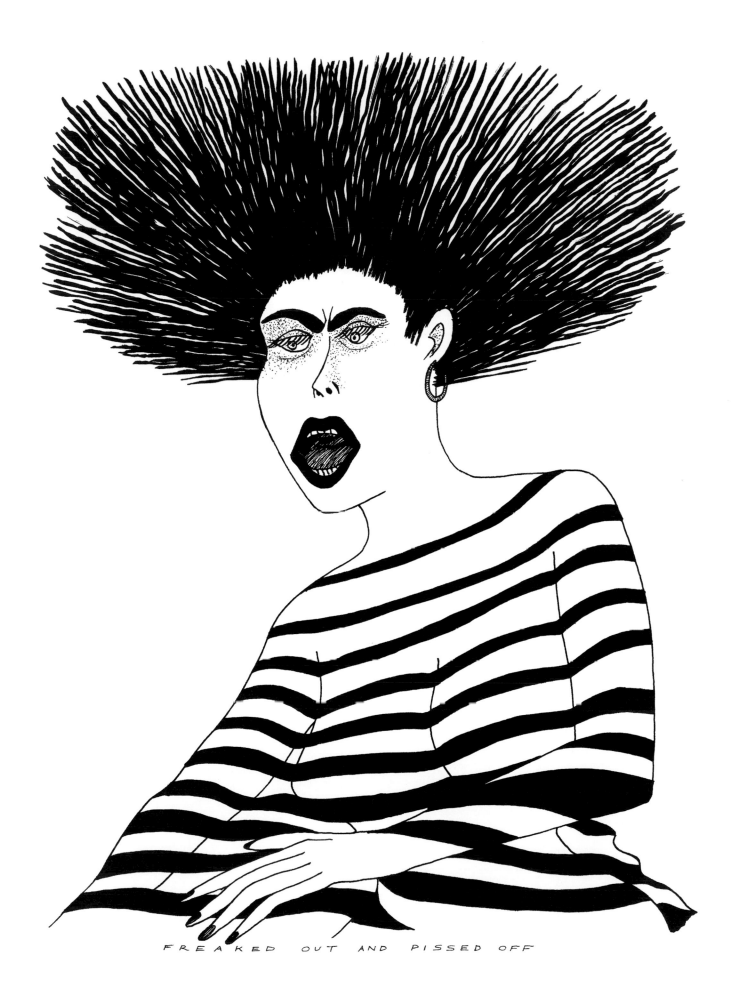

FREAKED OUT AND PISSED OFF

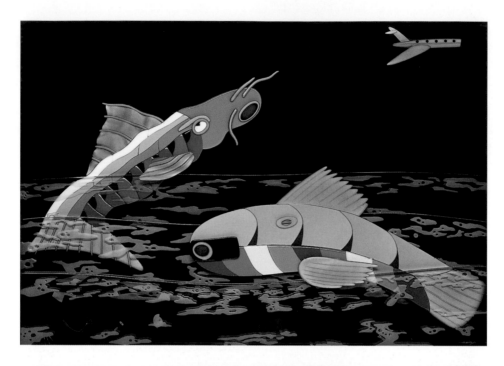

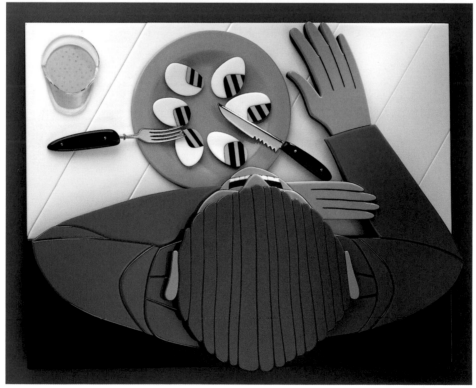

ABOVE
Night Fish
27.5H X 36.25W"
1987

BELOW
Eggs Prisonier
18H X 24W"
1984

OPPOSITE
Beaujolais
26H X 15W"
1984

108

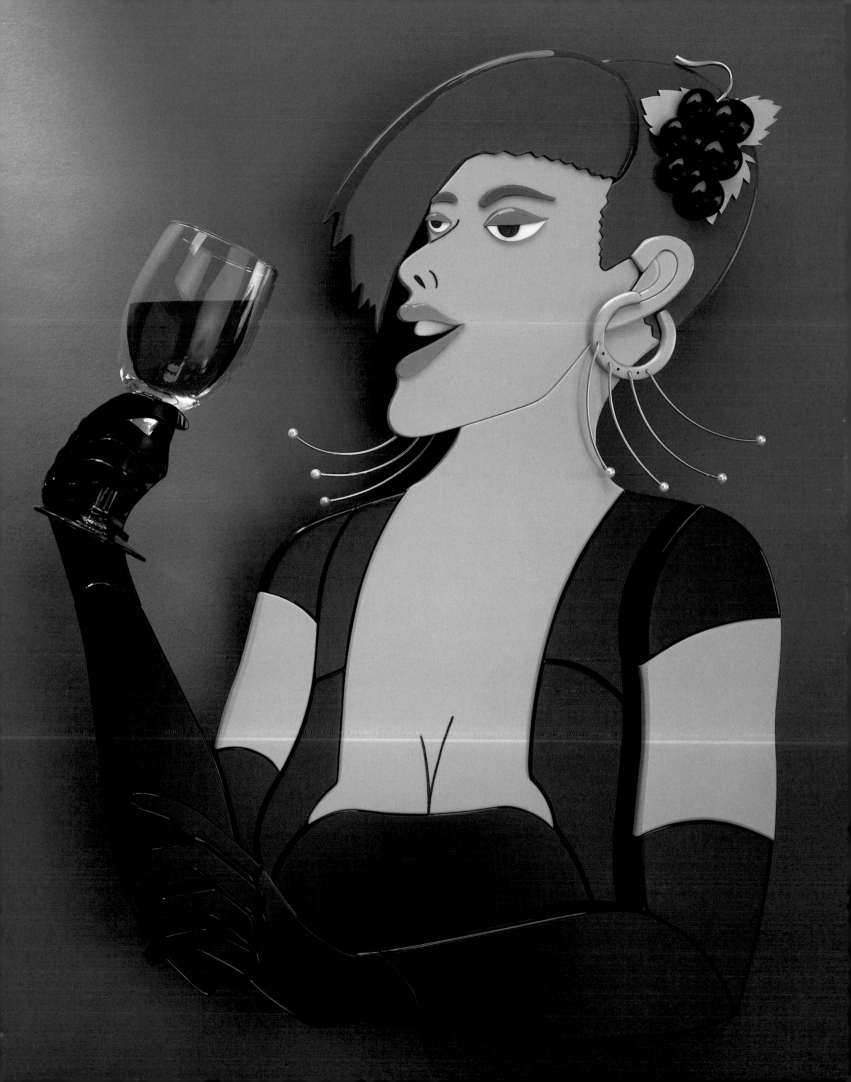

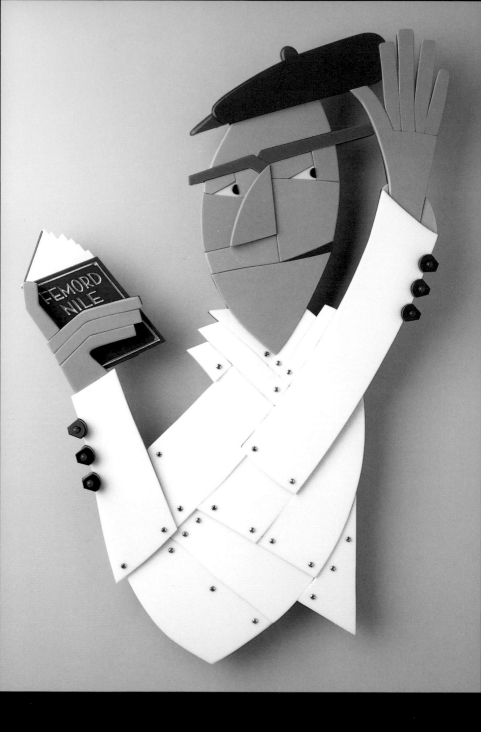

ABOVE
Cryptogram
26H X 14W"
1984

OPPOSITE
Nude on the Phone
55H X 38W"
1985

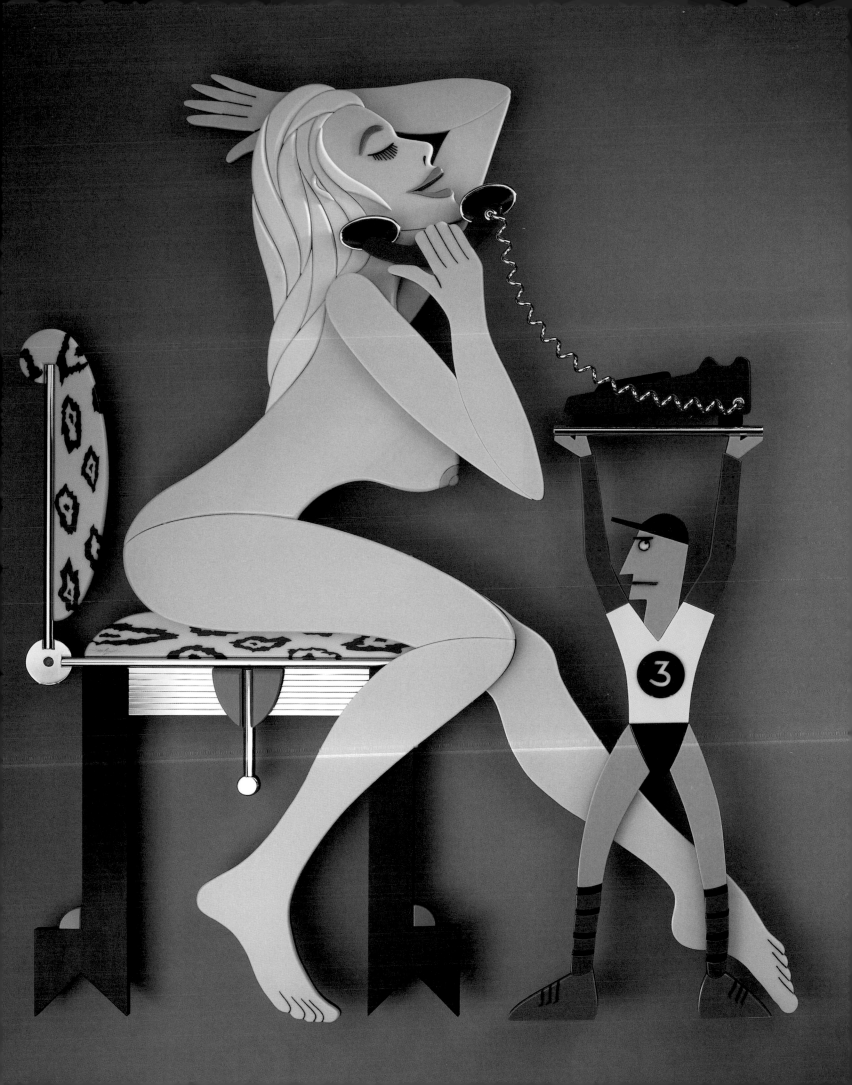

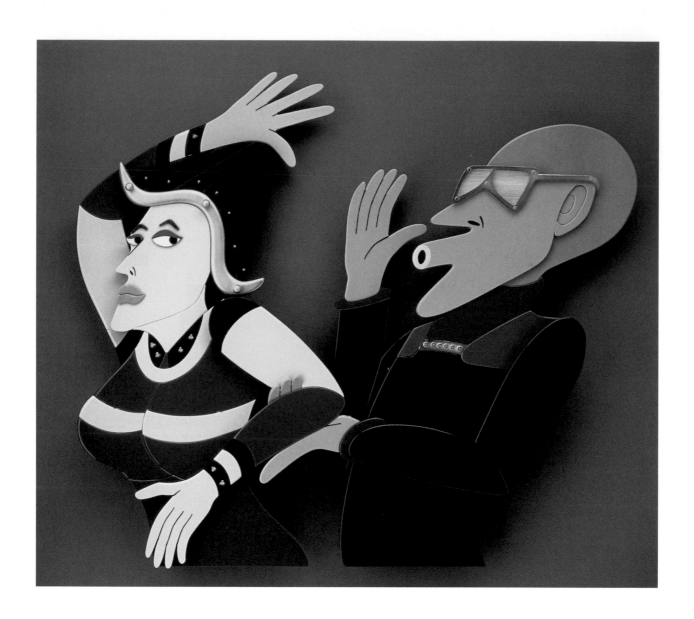

ABOVE
The Suitor
36H X 42W"
1985

OPPOSITE
Vanity
35H X 24W"
1986

112

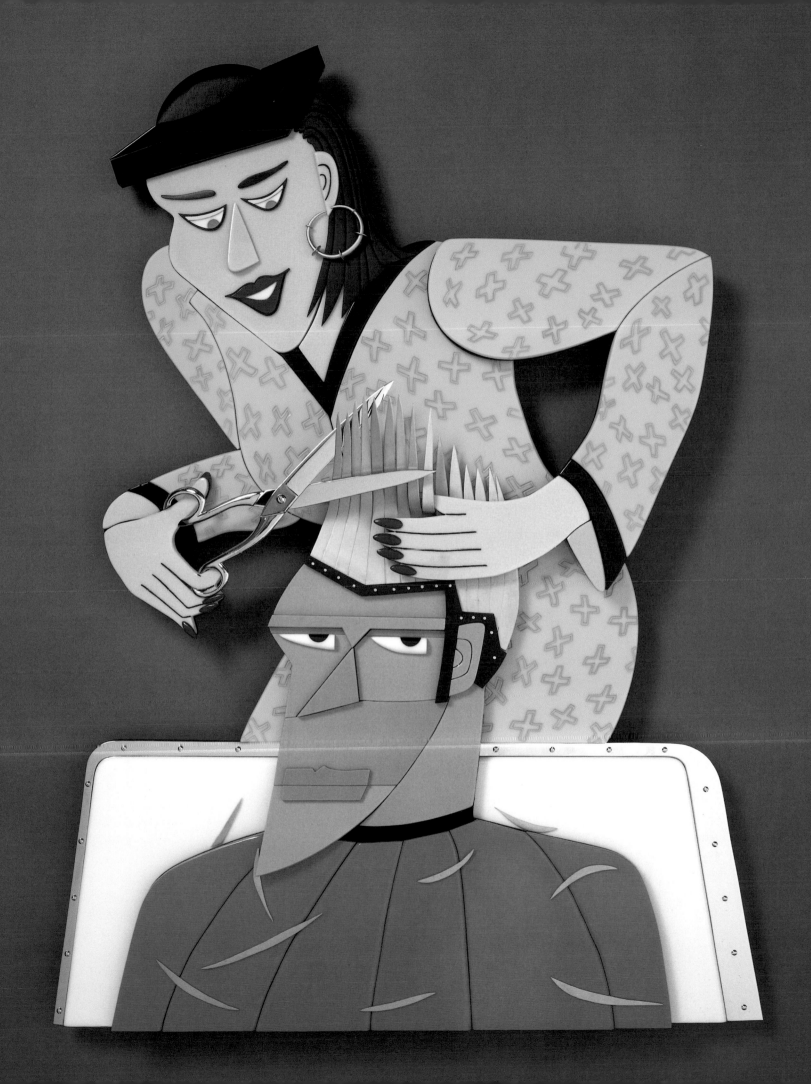

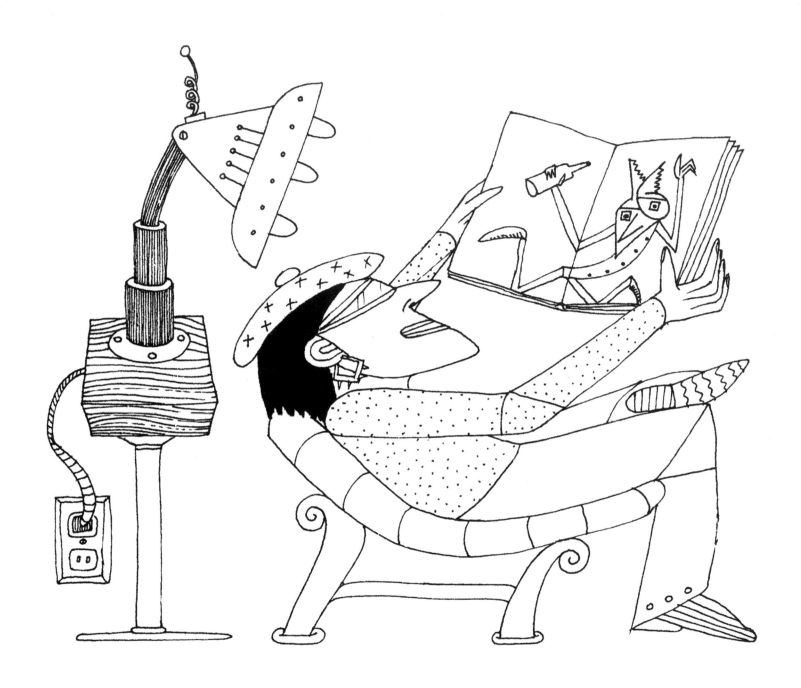

The Artist's Book

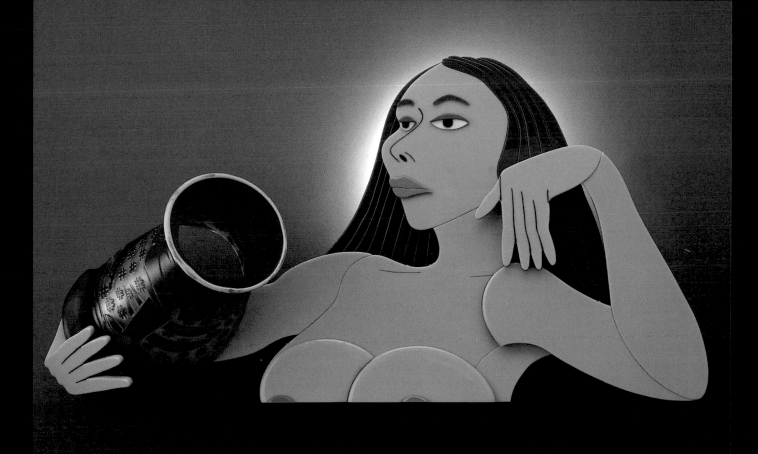

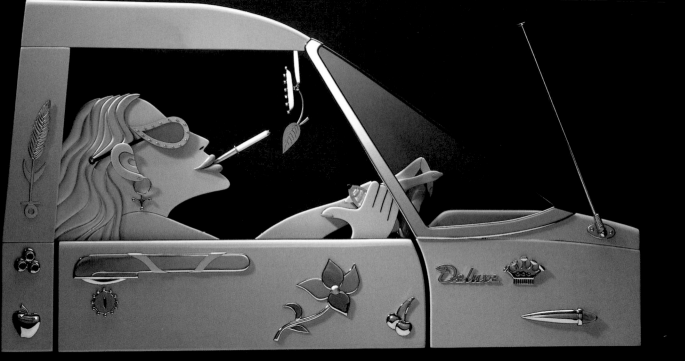

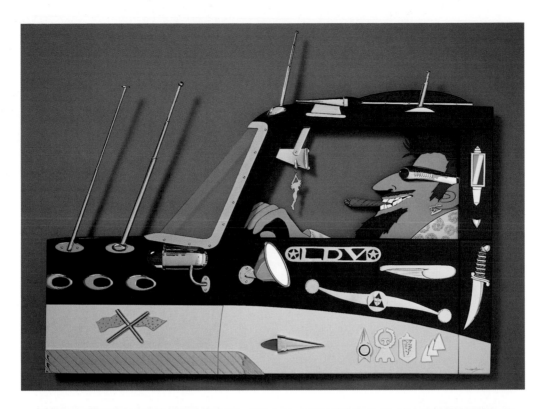

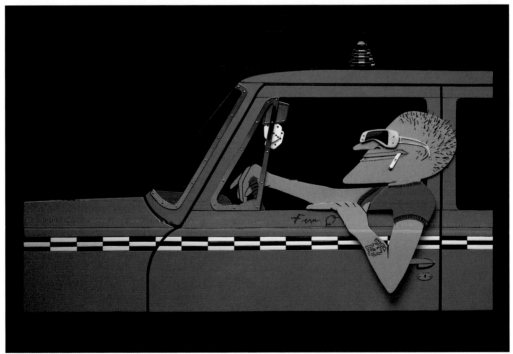

ABOVE
Latter Day Viking
26H x 42W"
1985

BELOW
Fern-O
31H x 56W"
1982

FOLLOWING
Voyeur
29H x 37.5W"
1988–2003

117

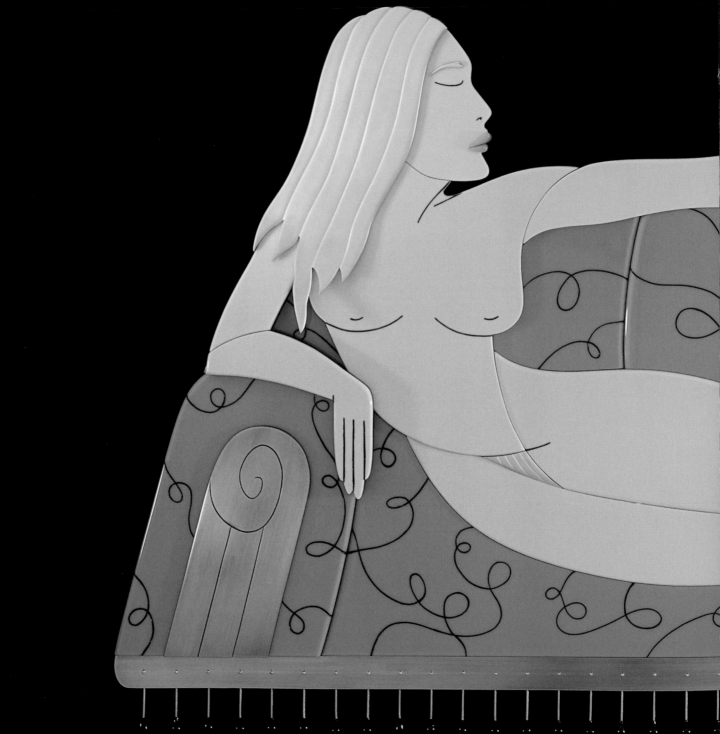

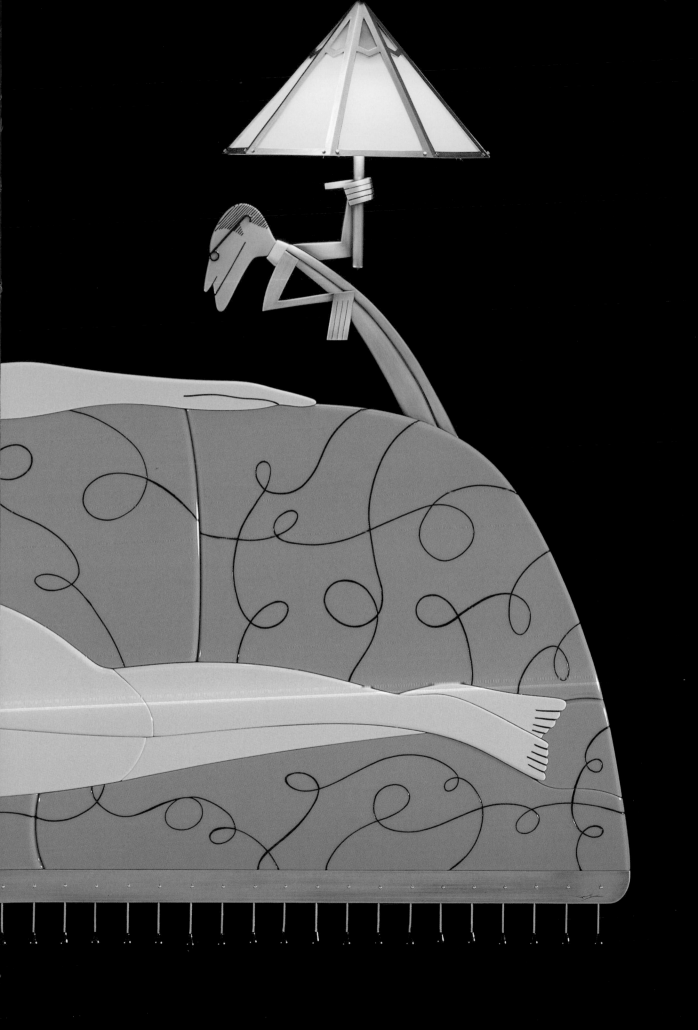

MALE/FEMALE VASES
SKYSCRAPER VASES

1989 – 1993

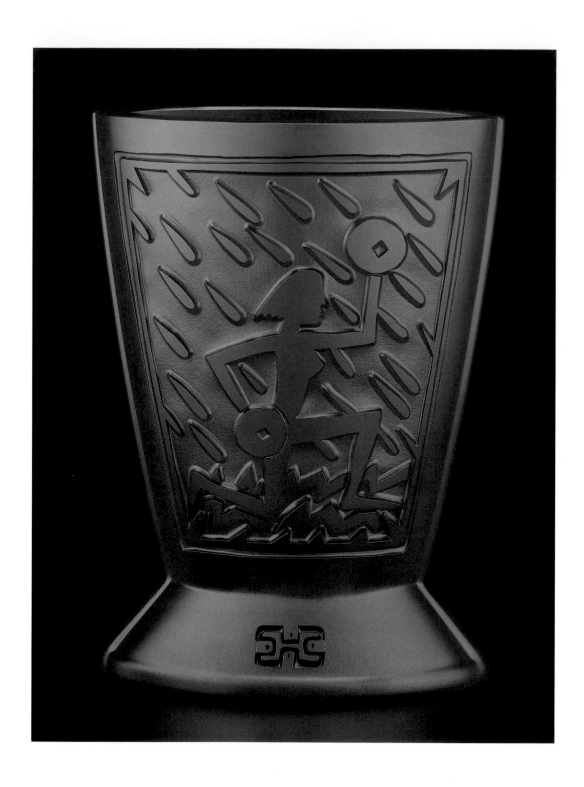

PREVIOUS AND ABOVE

Disc Revelers
10H X 8W X 4D"
1989

OPPOSITE

Dancers
10H X 7W X 5D"
1989

122

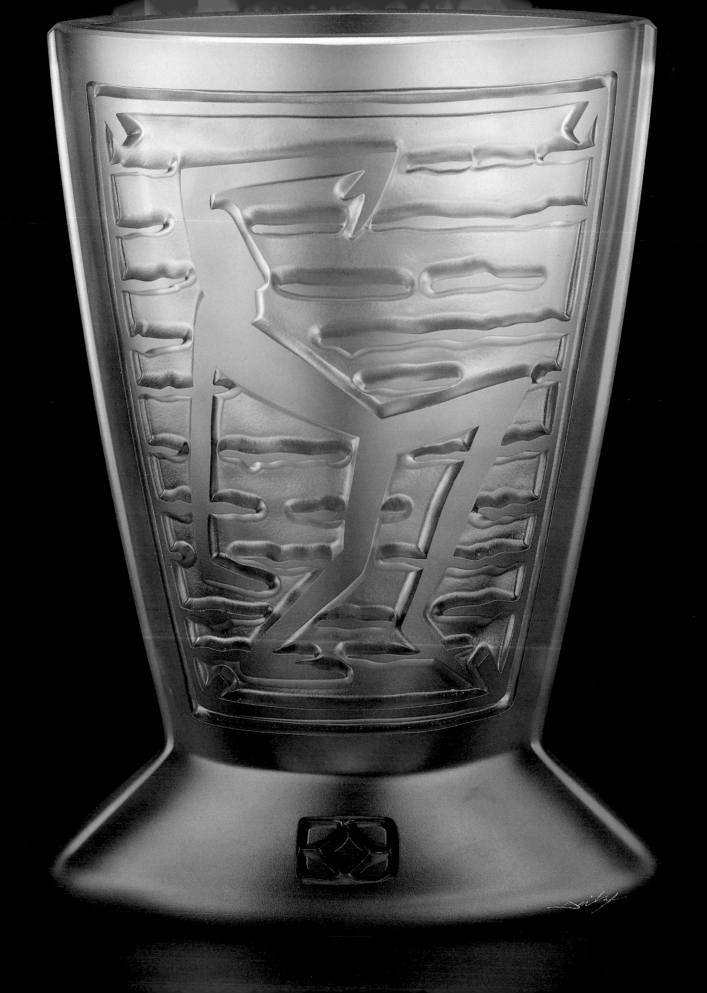

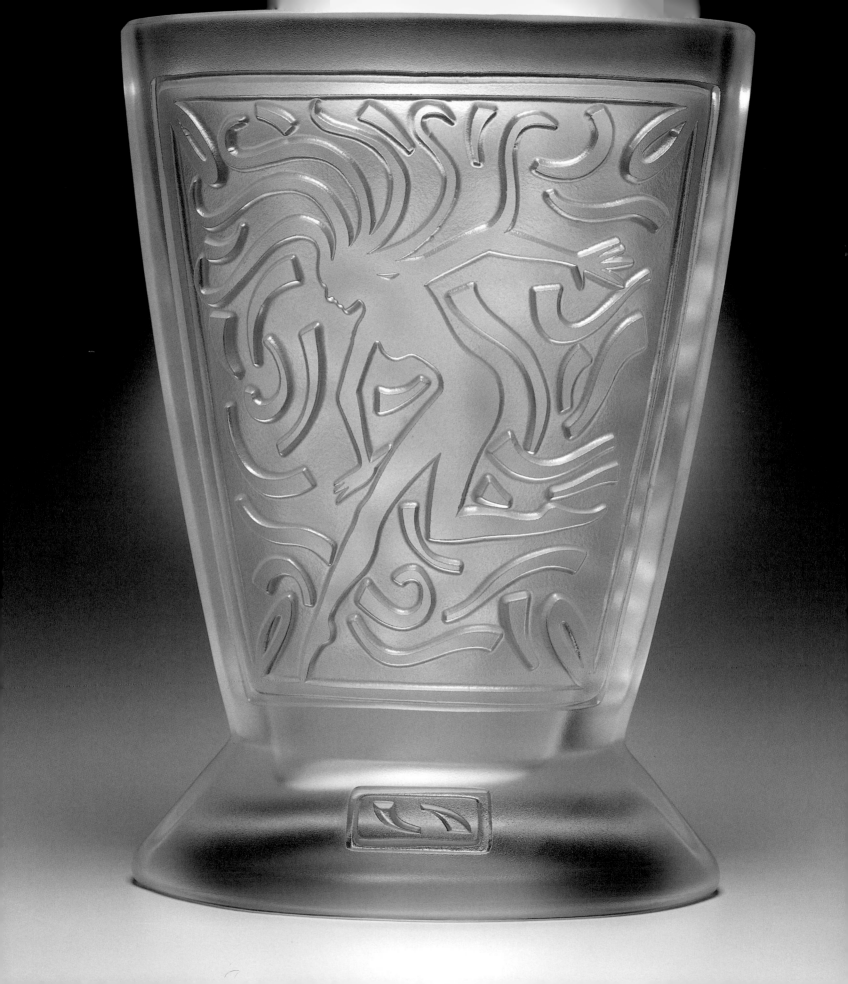

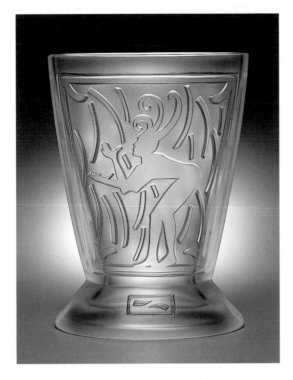

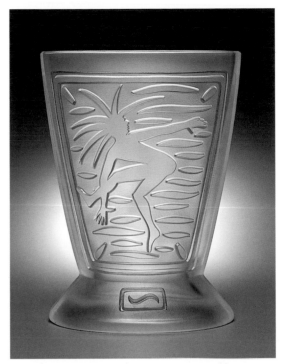

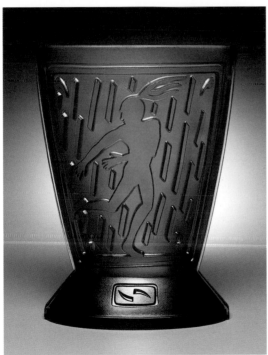

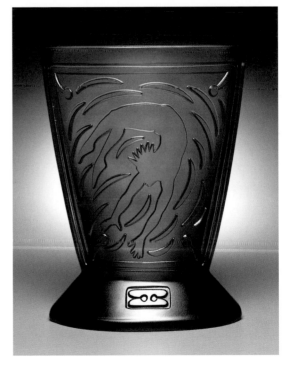

OPPOSITE
Nimble
11H x 8W x 5D"
1989

ABOVE LEFT
Waterfall
10.75H x 8W x 4.25D"
1993

ABOVE RIGHT
Startled
10.5H x 8W x 4D"
1993

BELOW LEFT
Downpour
10.5H x 8W x 4D"
1993

BELOW RIGHT
Acrobats
10.75H x 8W x 4D"
1993

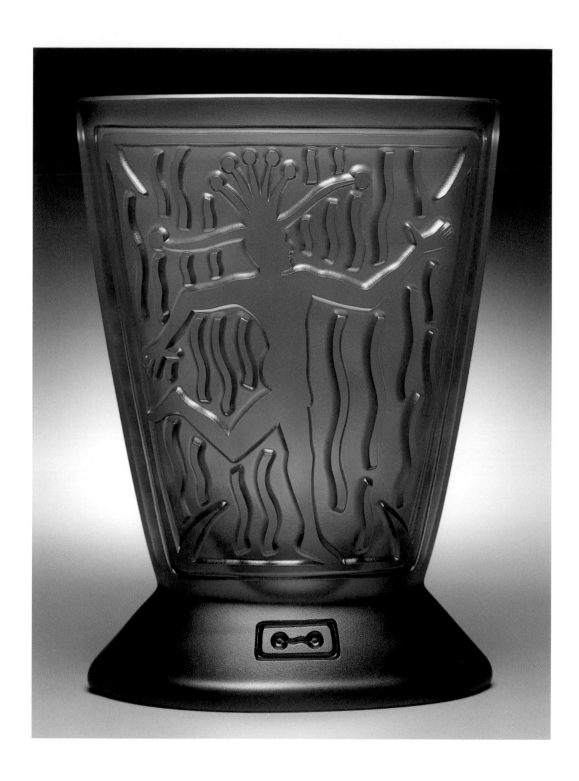

ABOVE
Jesters in Falling Water
11H x 8W x 4.25D"
1994

OPPOSITE
Electric Storm
10.5H x 7.75W x 4.75D"
1994

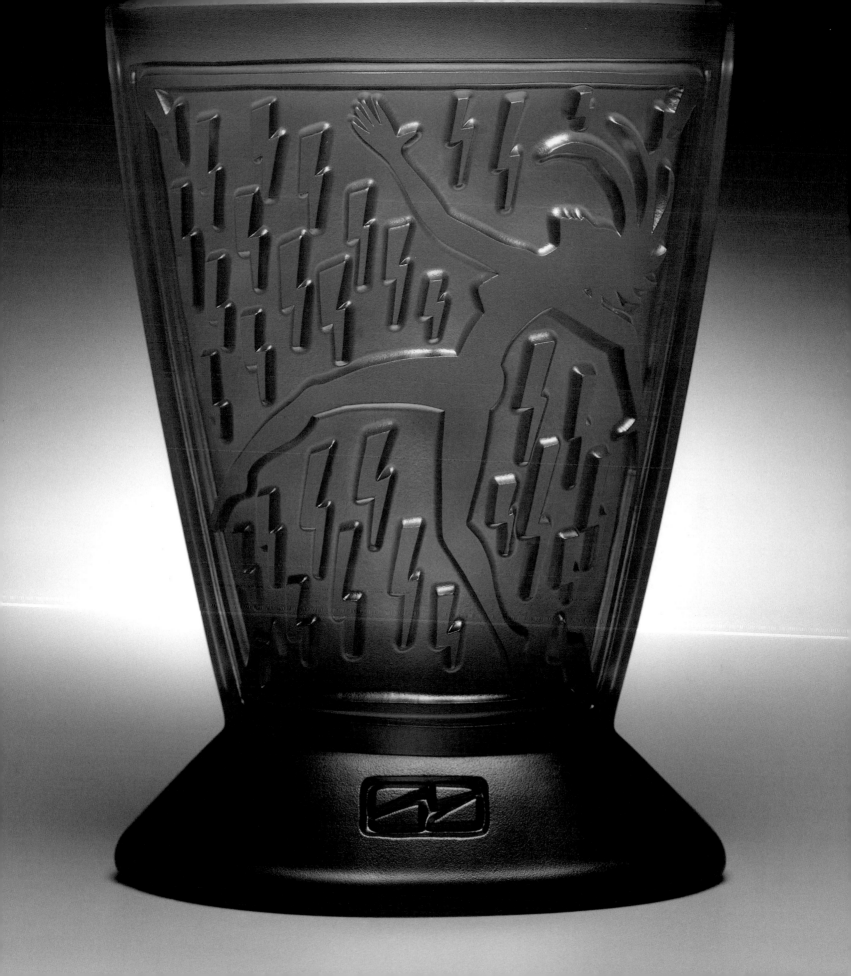

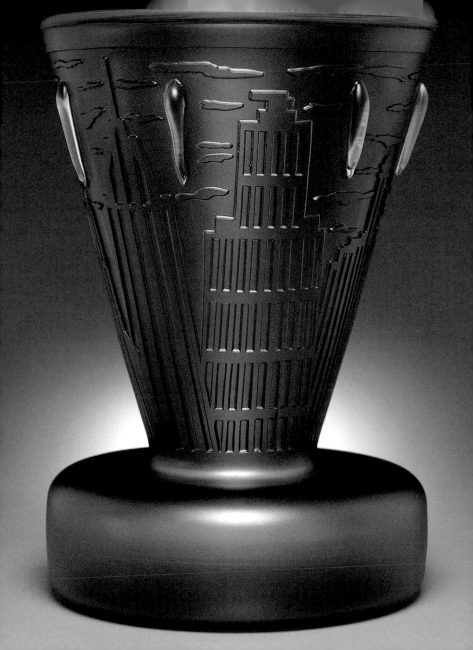

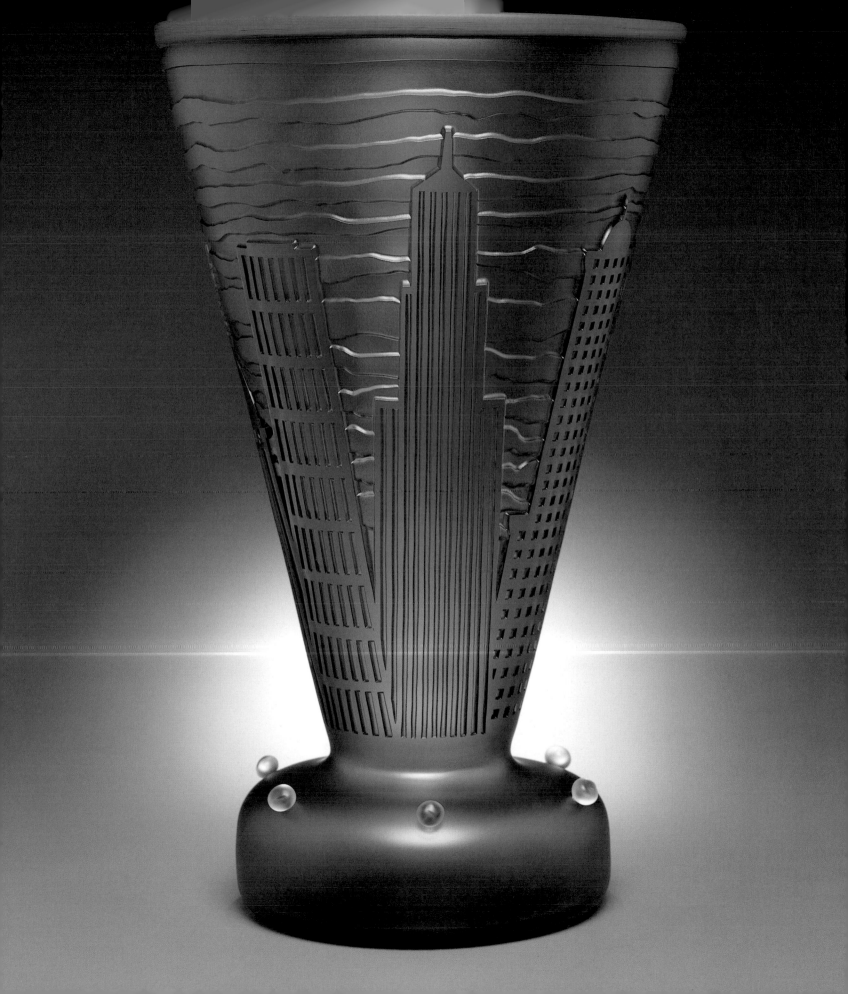

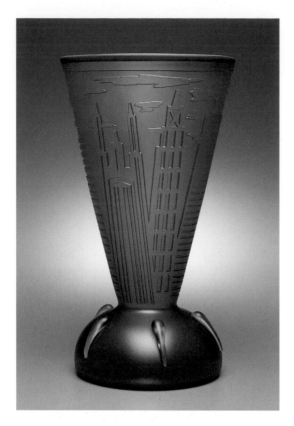

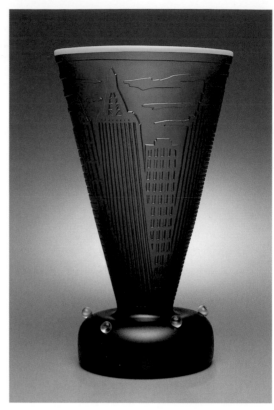

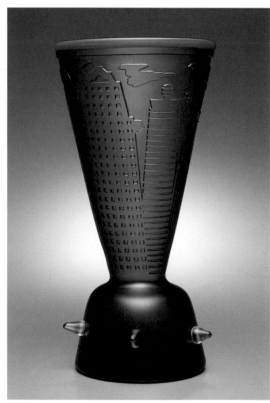

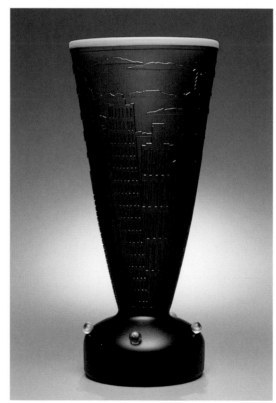

ABOVE LEFT
New York – 5
19.3H X 10D"
1994

ABOVE RIGHT
New York – 6
19H X 11D"
1994

BELOW LEFT
New York – 7
19H X 9D"
1994

BELOW RIGHT
New York – 8
21.3H X 10D"
1994

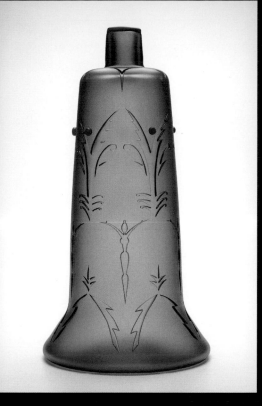

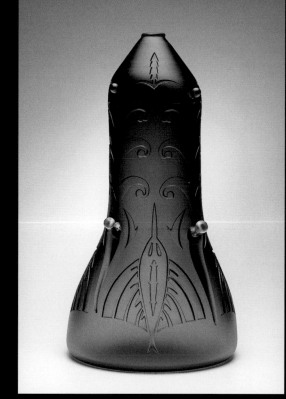

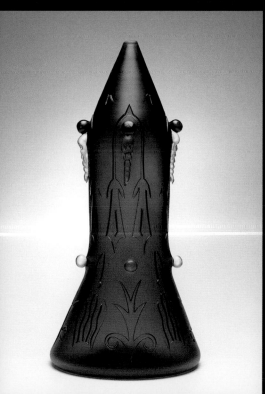

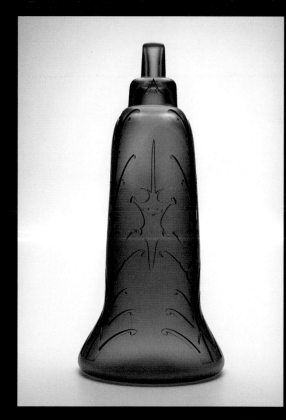

ABOVE LEFT
Deco Building Detail
21H X 10D"
1993

ABOVE RIGHT
Deco Building Detail
20H X 9.5D"
1993

BELOW LEFT
Deco Building Detail
20H X 8D"
1993

BELOW RIGHT
Deco Building Detail
22H X 9D"
1993

CHARACTER HEAD VASES
MYTHOLOGY HEAD VASES

1988 – 1990

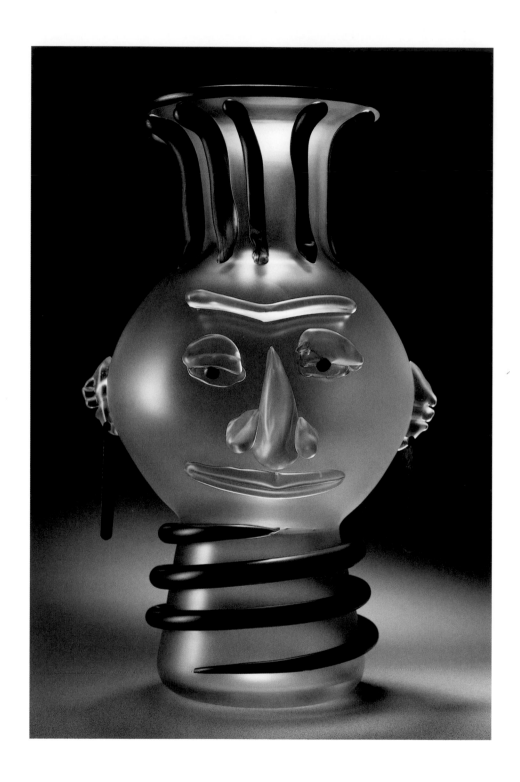

PREVIOUS AND ABOVE
The Chef
18H X 11.5D"
1988

OPPOSITE
The Prince
17H X 14D"
1988

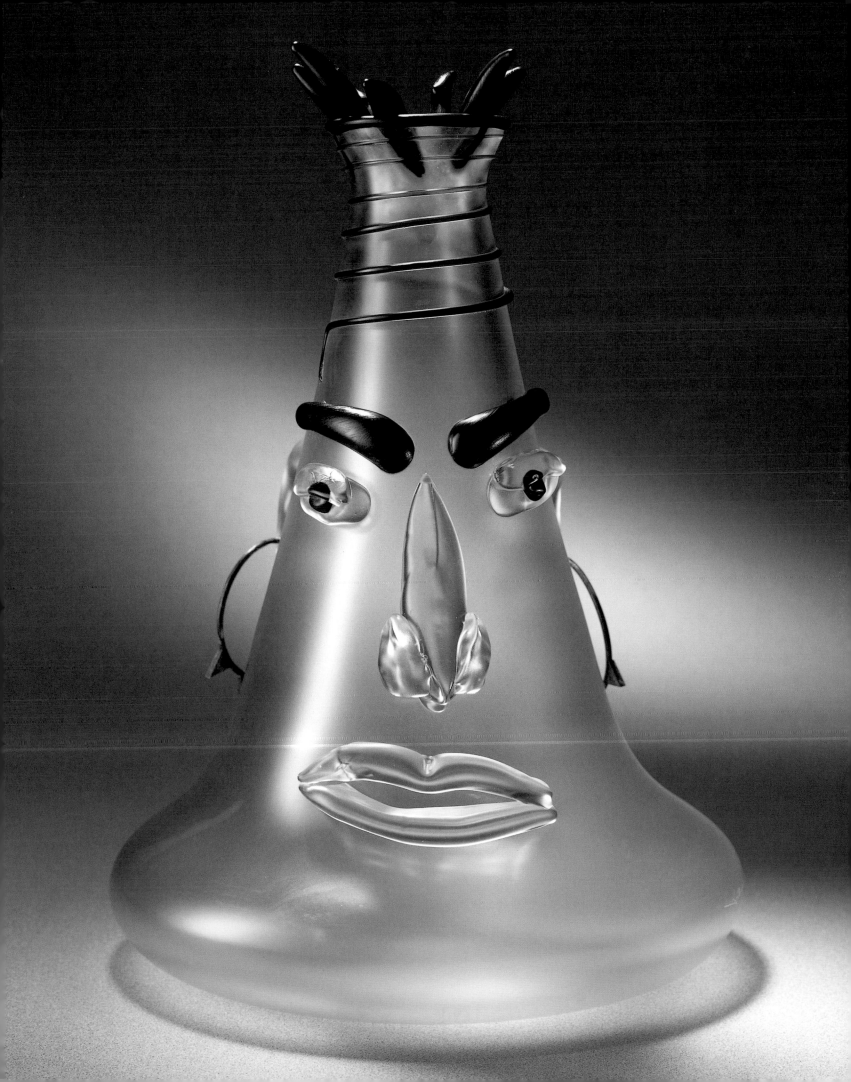

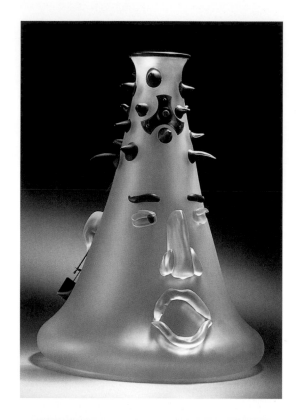

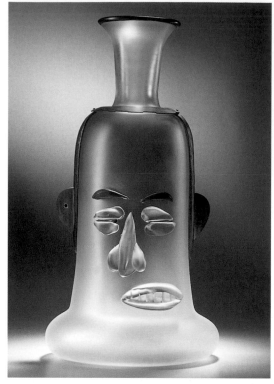

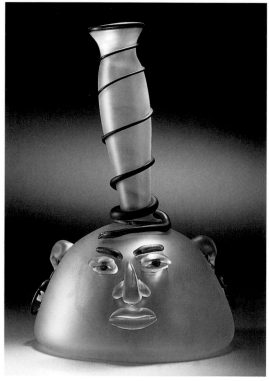

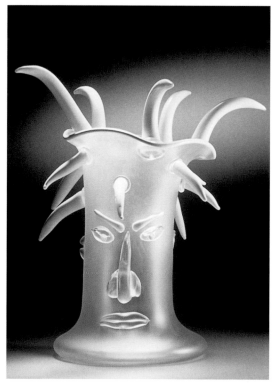

ABOVE LEFT
The Counselor
17H X 13D"
1988

ABOVE RIGHT
The Soldier
19H X 10D"
1988

BELOW LEFT
The Gourmand
17H X 11D"
1988

BELOW RIGHT
The Empress
17.5H X 13D"
1988

136

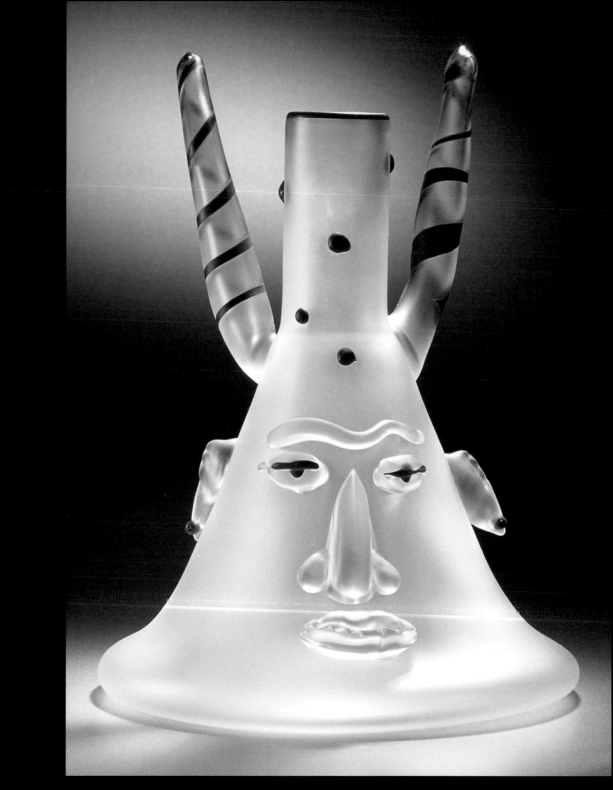

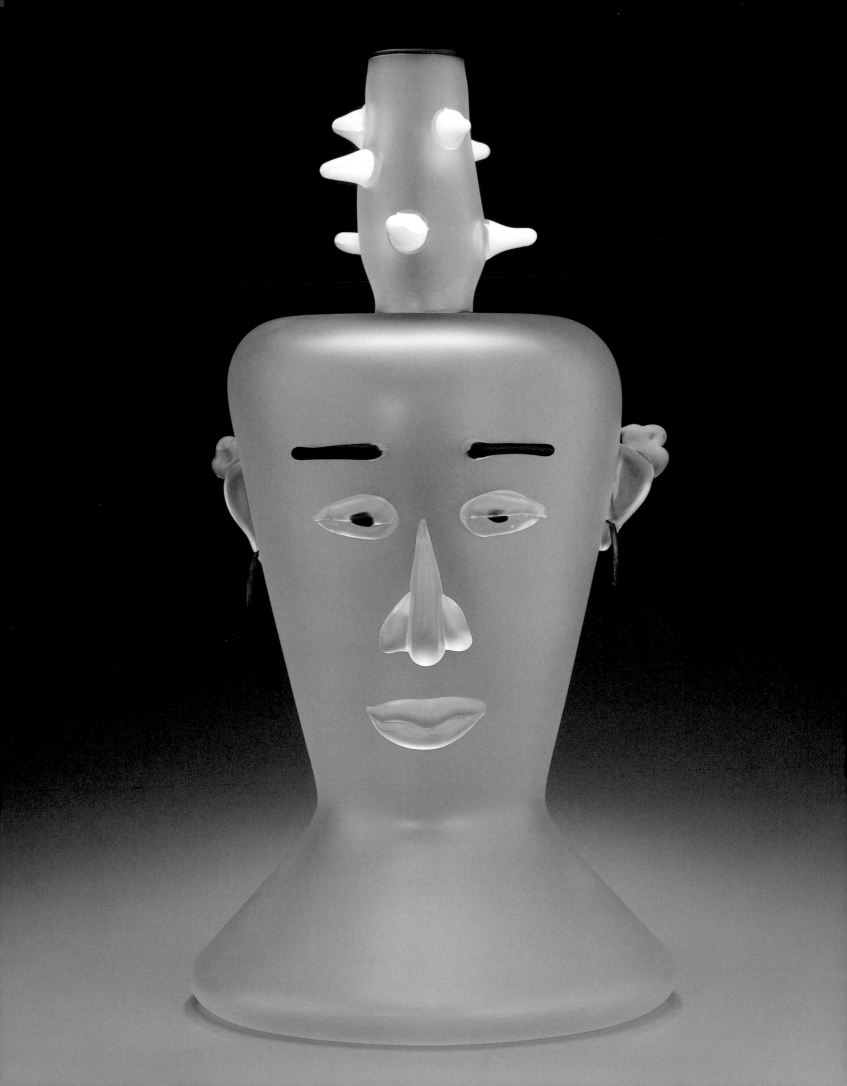

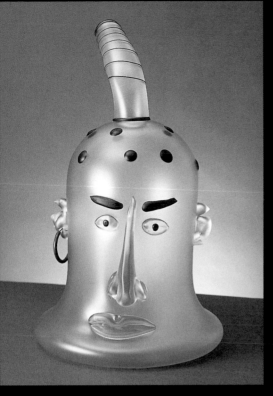

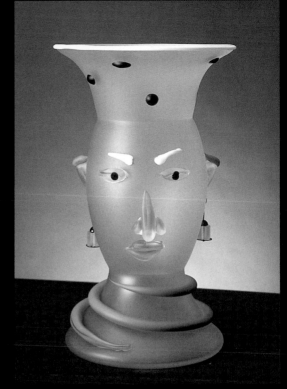

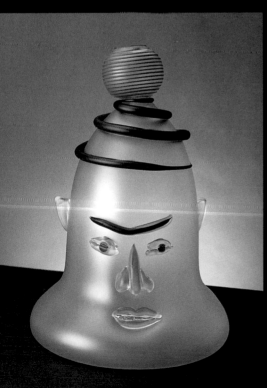

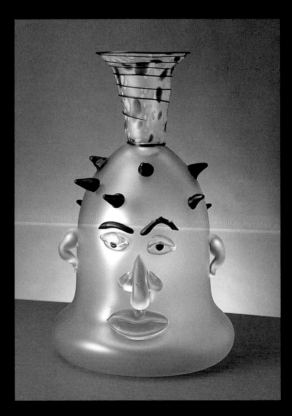

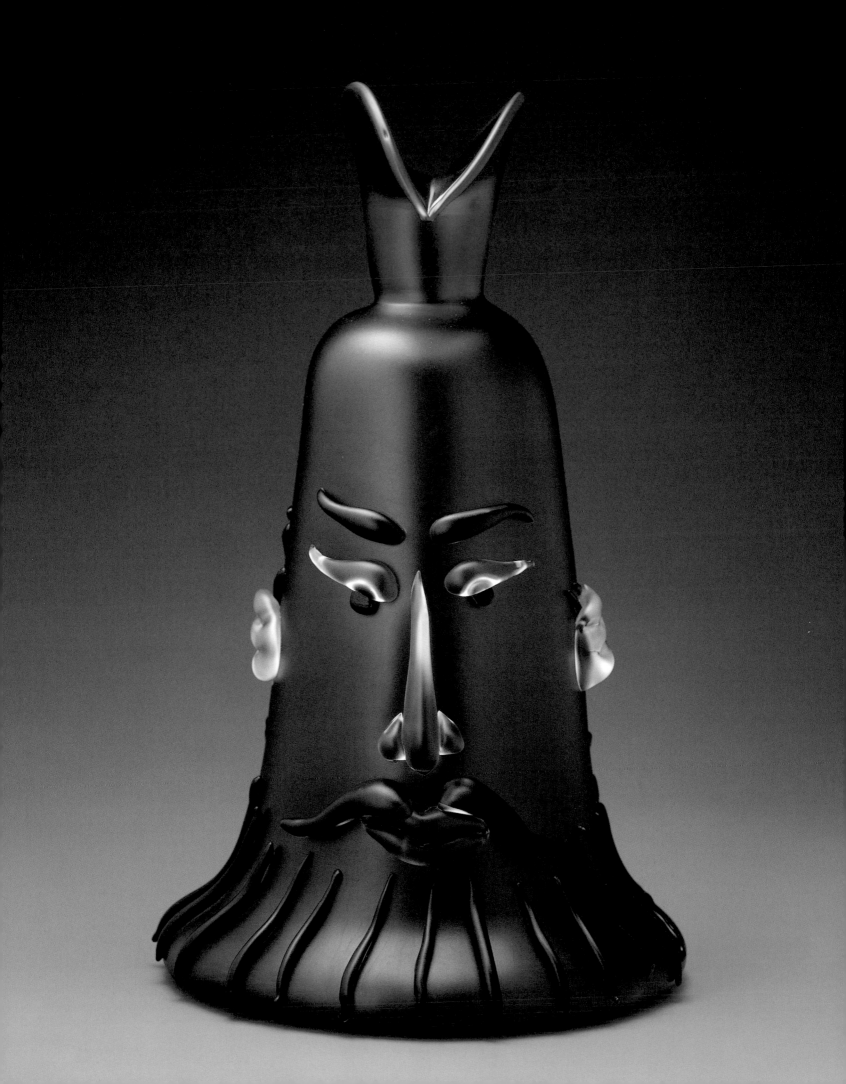

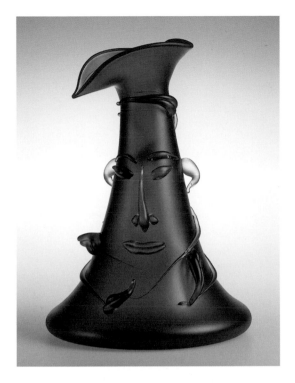

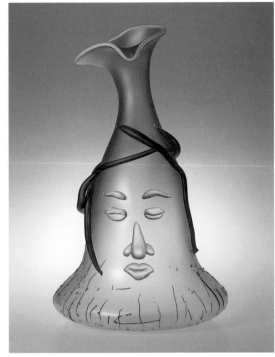

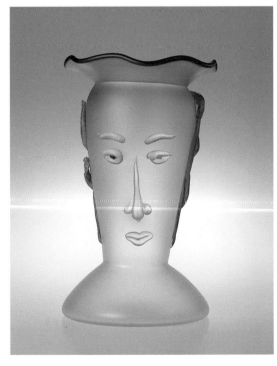

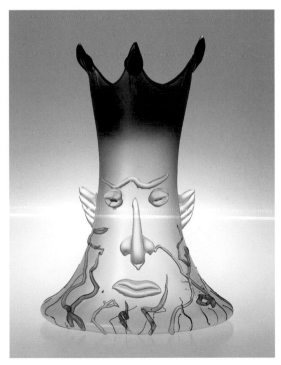

OPPOSITE
Mars
23H X 14D"
1990

ABOVE LEFT
Venus
21H X 15D"
1989

ABOVE RIGHT
Siren
25H X 13D"
1990

BELOW LEFT
Athena
24H X 12D"
1989

BELOW RIGHT
Poseidon
26H X 14D"
1989

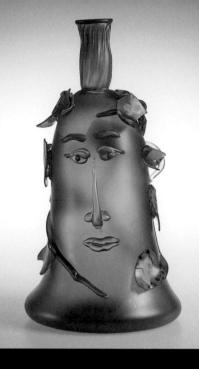

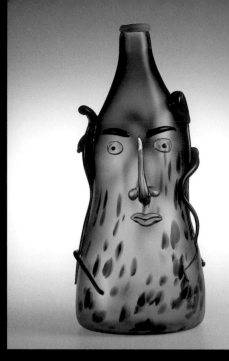

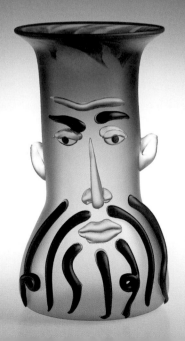

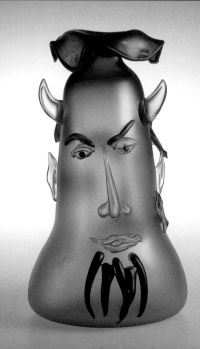

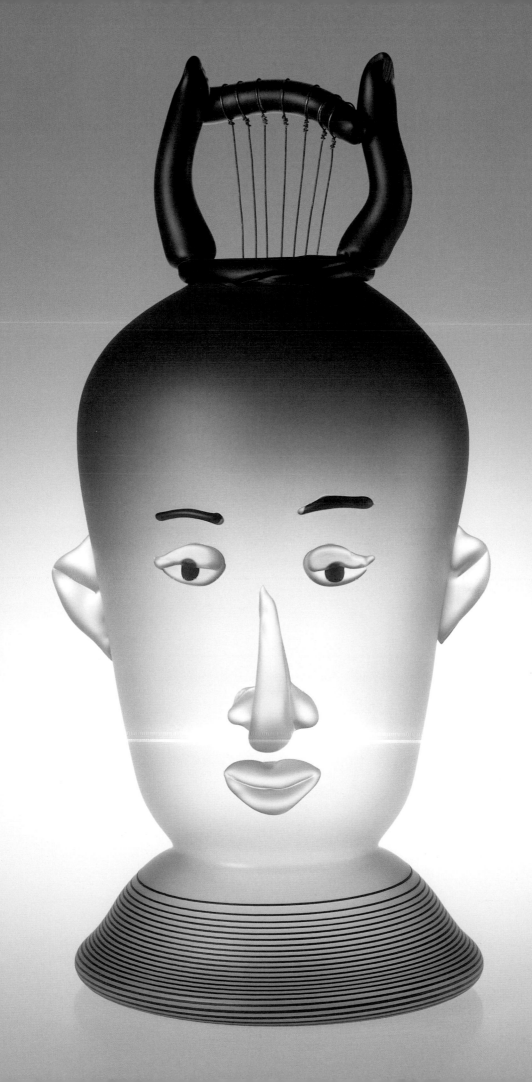

DAILEY/TAGLIAPIETRA

VASES

FACE VASES

1989 – 1996

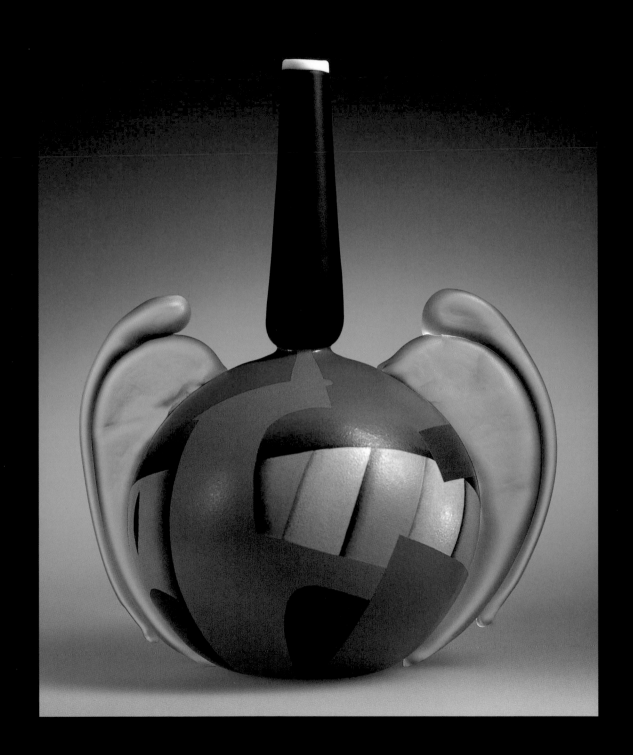

PREVIOUS AND ABOVE
Notte Freddo
15H X 7.5D"
1989

OPPOSITE
Viale
26.75H X 9D"
1989

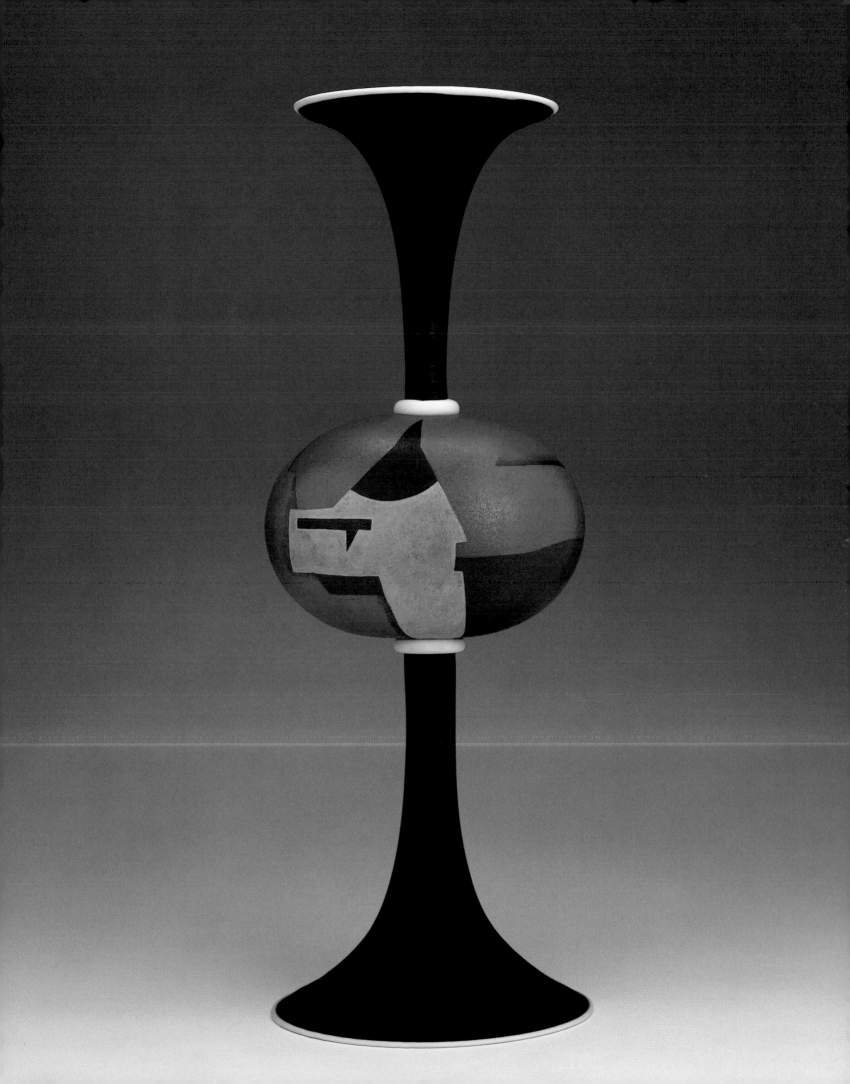

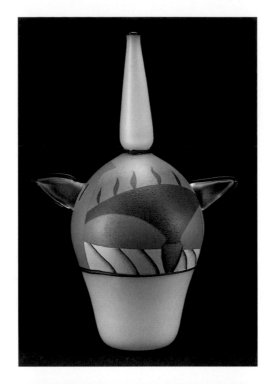

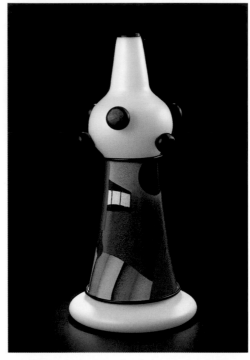

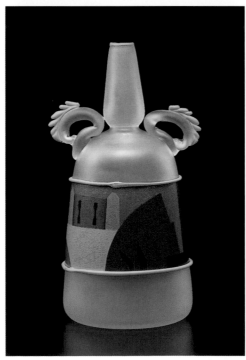

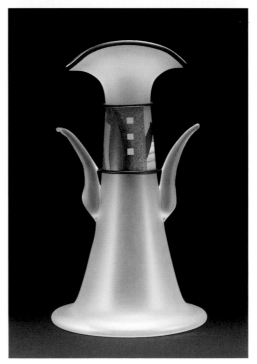

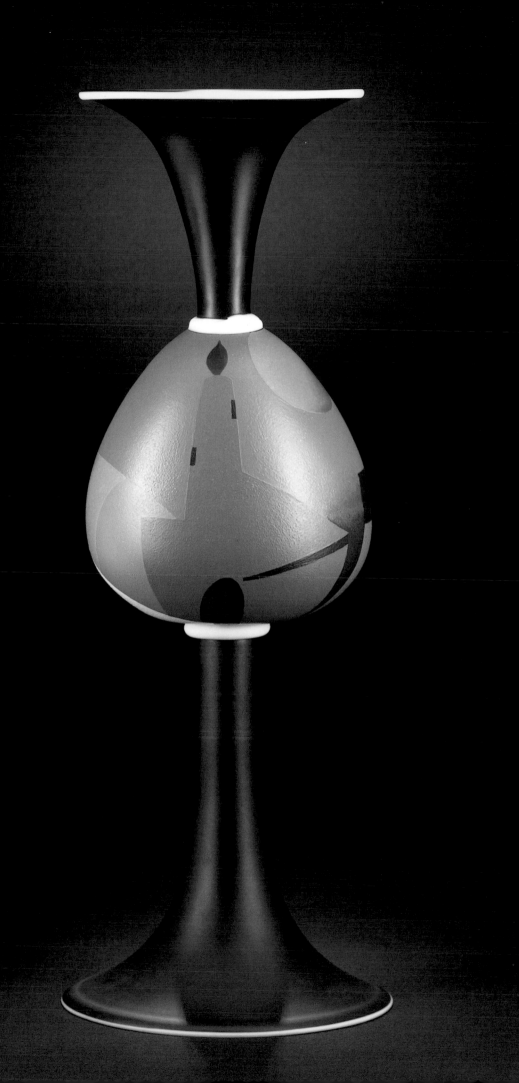

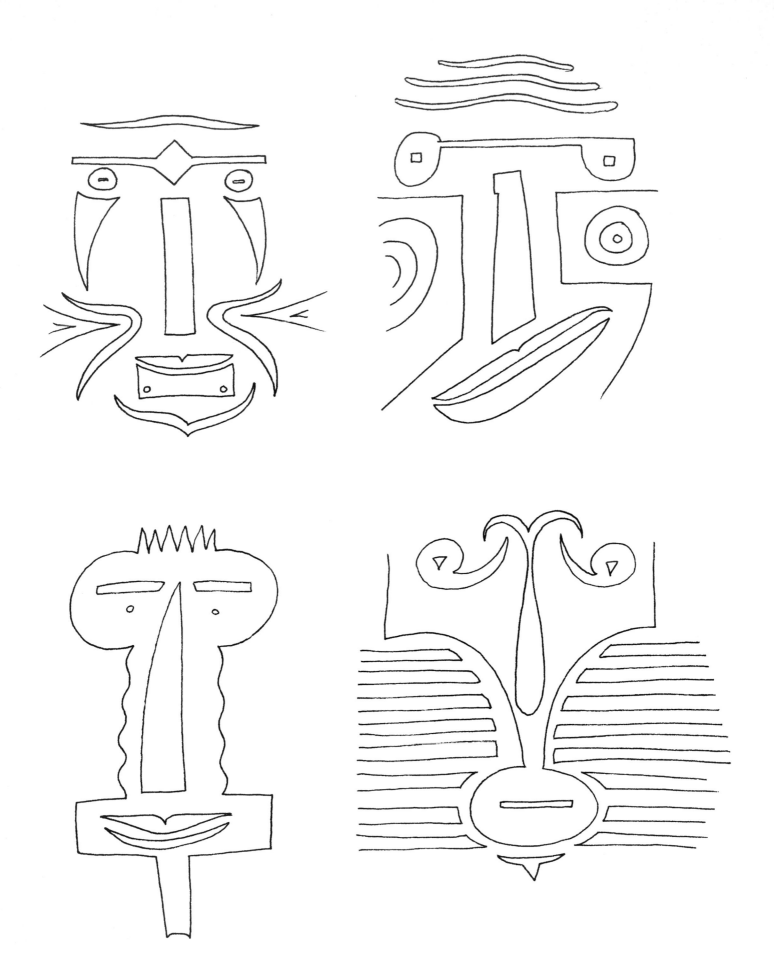

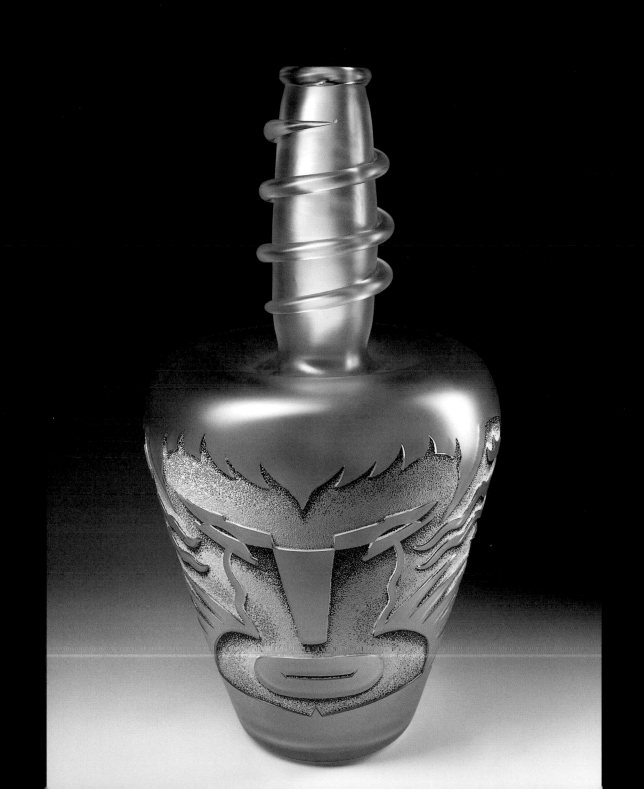

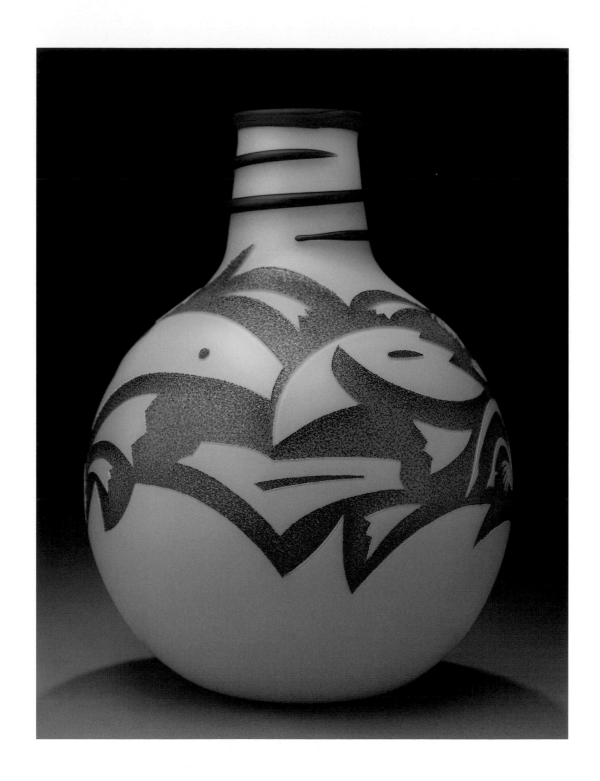

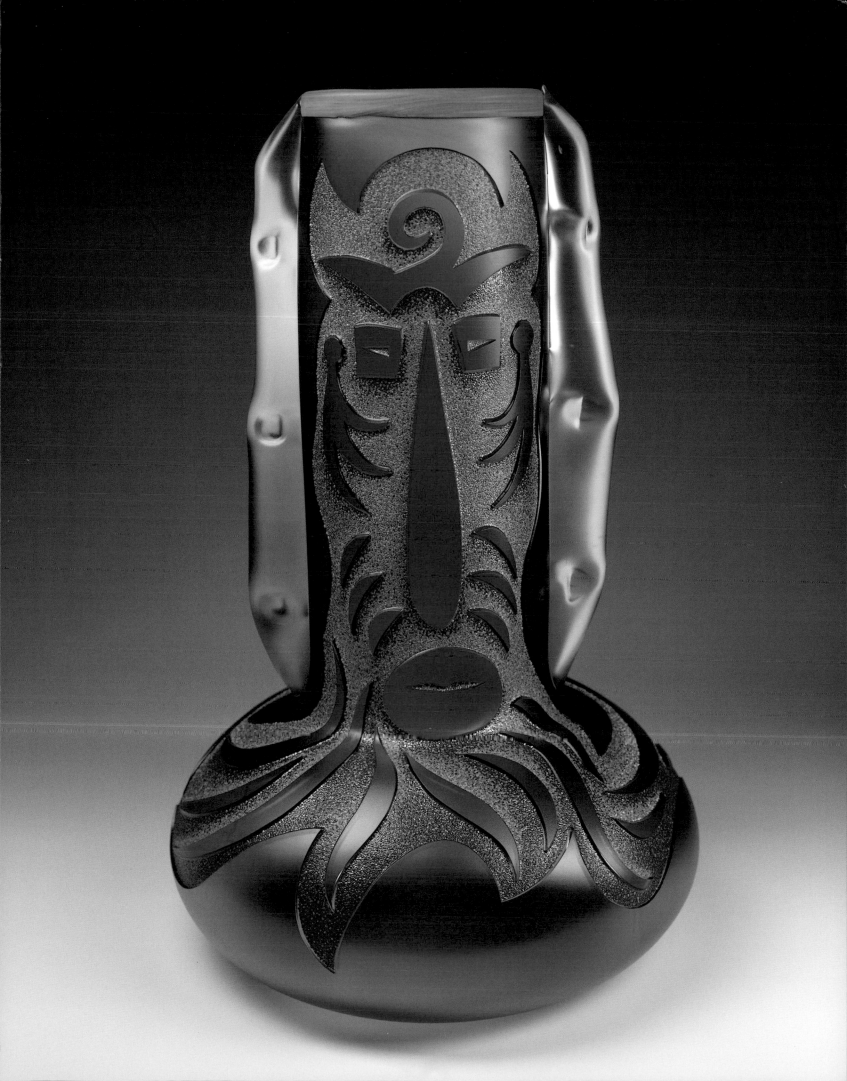

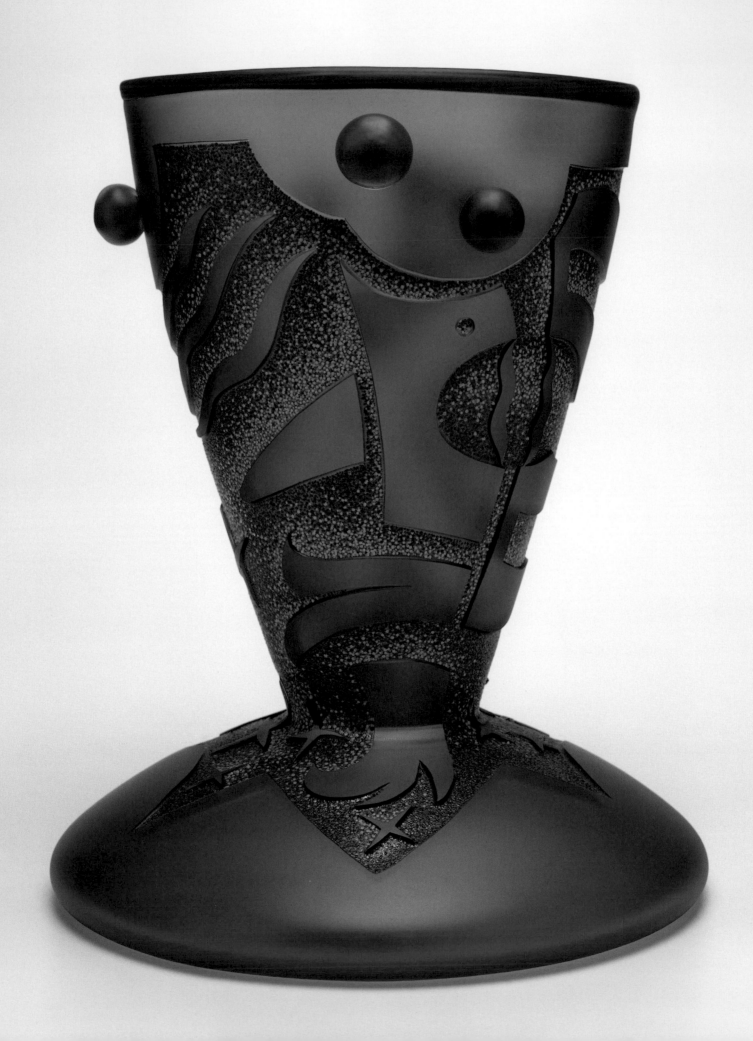

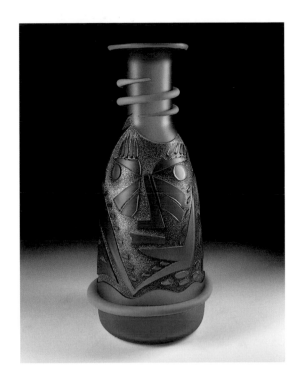

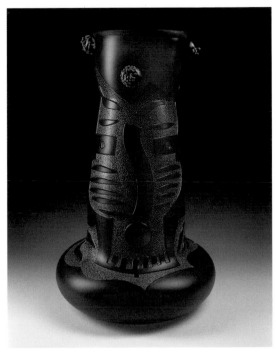

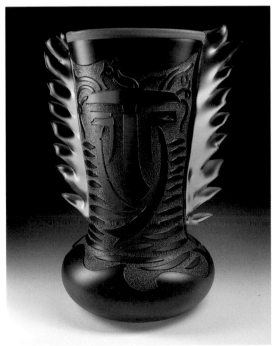

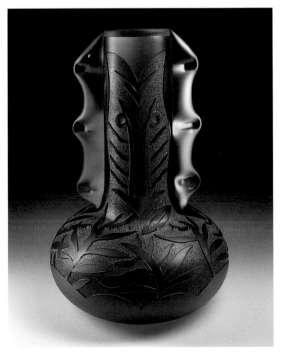

OPPOSITE
Star Man
21H x 14D"
1992

ABOVE LEFT
Corn Man
9H x 6D"
1990

ABOVE RIGHT
Firecracker Man
23H x 12D"
1991

BELOW LEFT
Carrot Man
21H x 15D"
1991

BELOW RIGHT
Two-Heart Woman
21H x 14D"
1991

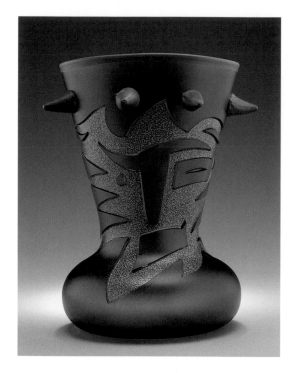

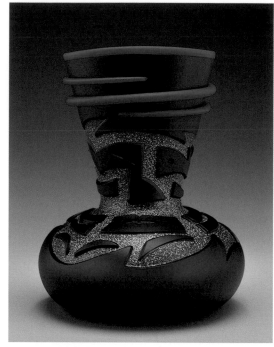

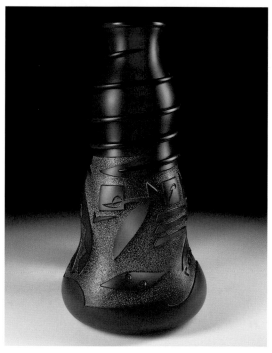

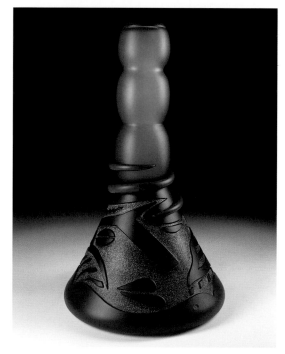

ABOVE LEFT
Ginko Man
7.5H X 6D"
1994

ABOVE RIGHT
Pine Tree Man
11.25H X 7.5D"
1994

BELOW LEFT
Dragonfly Man
22H X 12D"
1990

BELOW RIGHT
Planet Man
23H X 14D"
1990

OPPOSITE
Regal Woman
19H X 11D"
1992

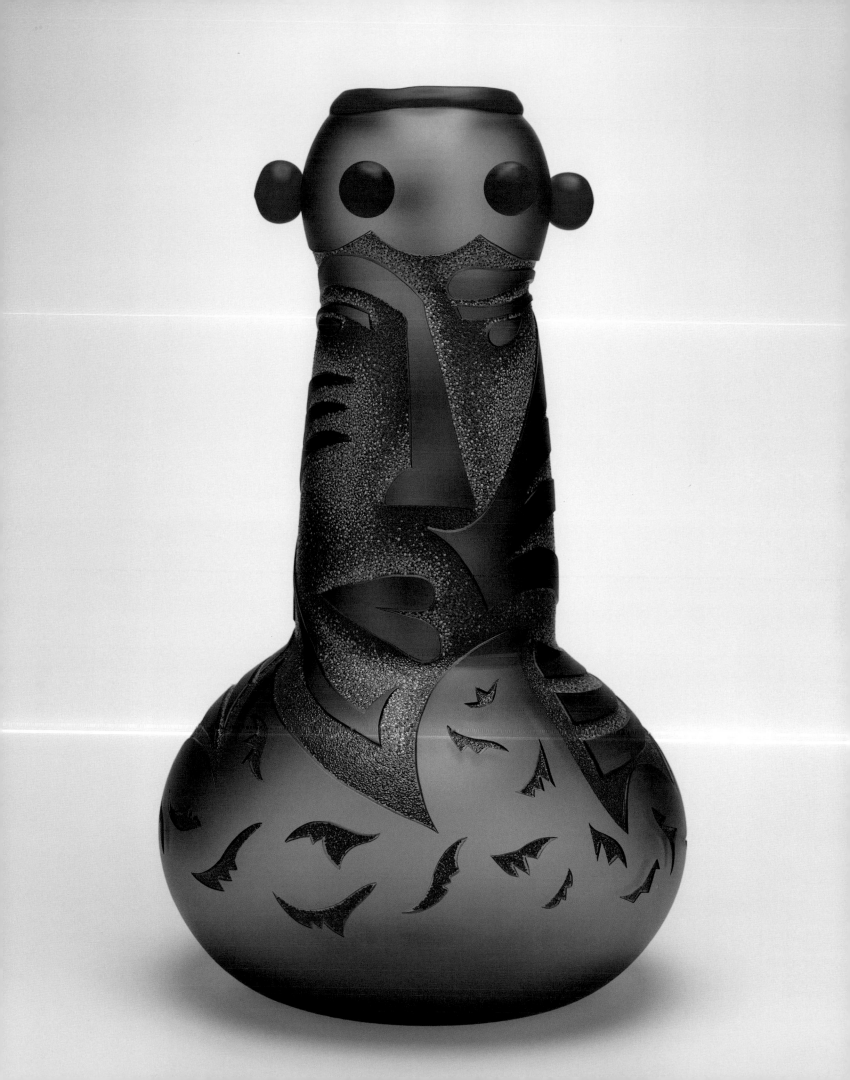

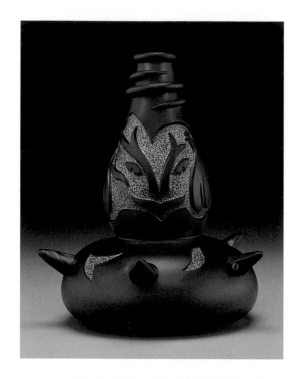

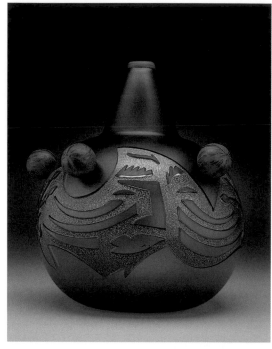

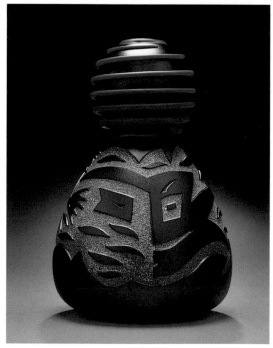

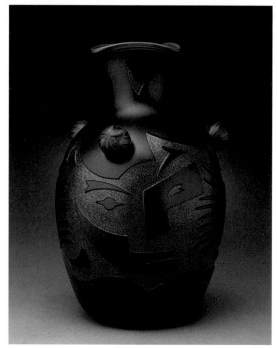

ABOVE LEFT
Three Fig Man
7H x 6D"
1996

ABOVE RIGHT
Prickly Man
11H x 9D"
1995

BELOW LEFT
Bullfrog Man
9H x 6D"
1995

BELOW RIGHT
Rug Man
17H x 10D"
1996

OPPOSITE
Poison Ivy Man
22H x 12D"
1995

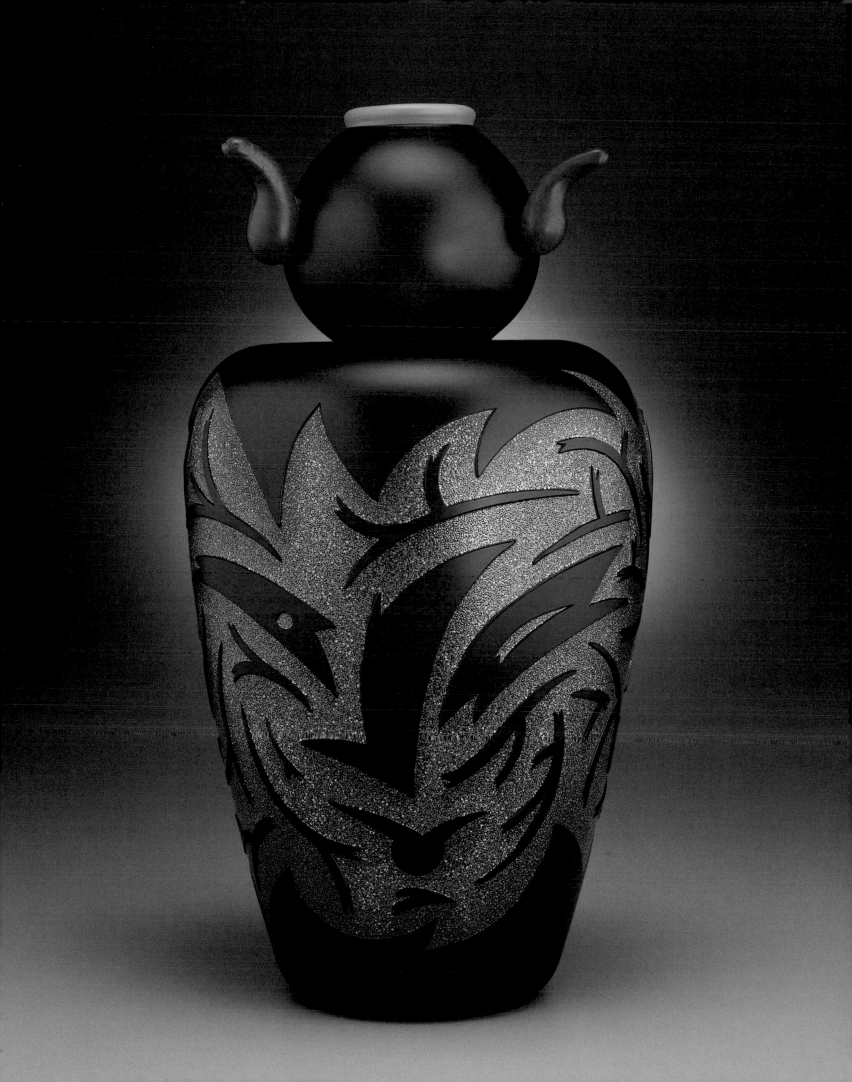

ABSTRACT HEADS

1990 – 1994

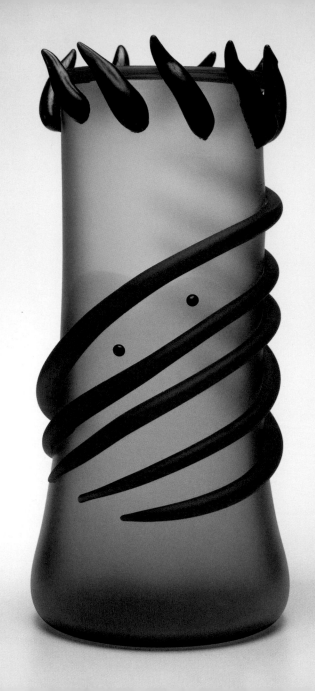

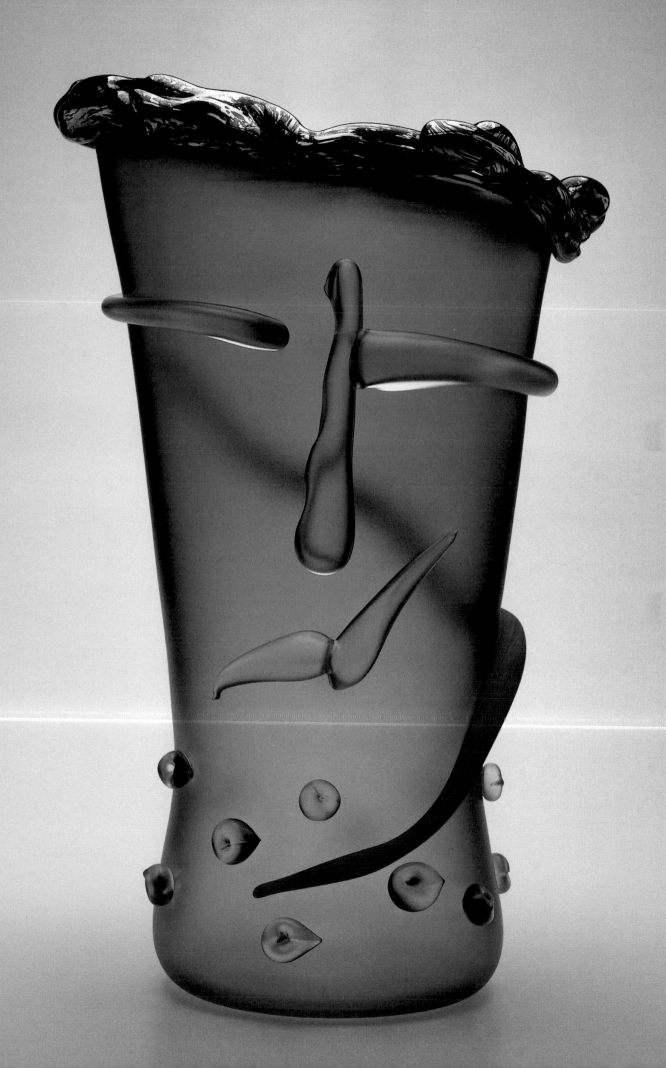

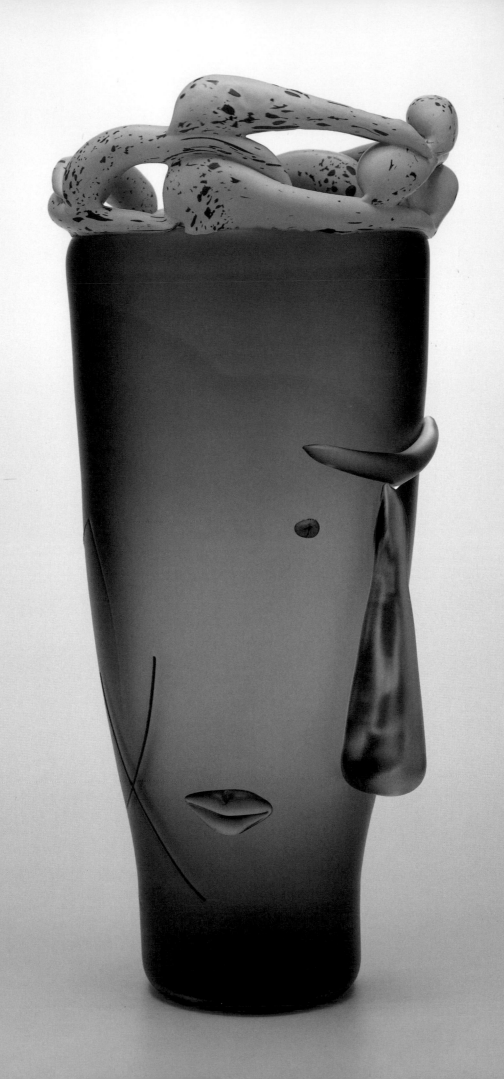

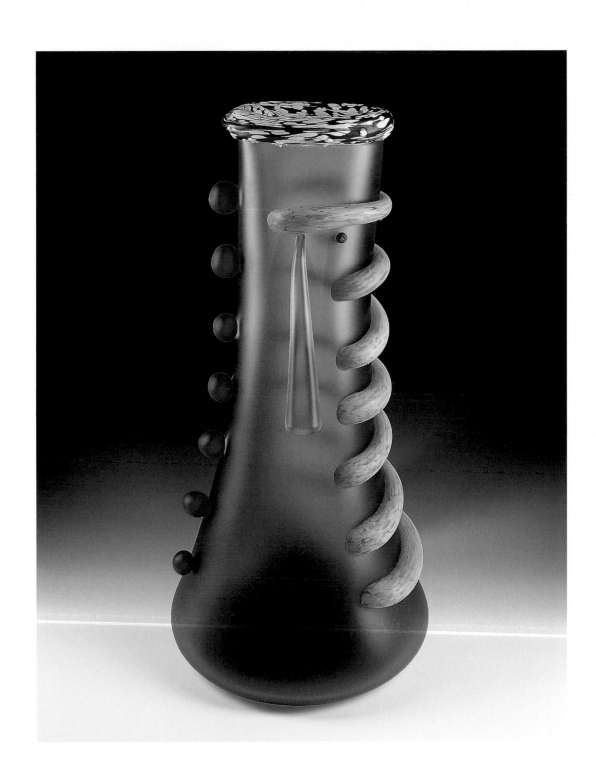

OPPOSITE
Absent
23H X 11D "
1992

ABOVE
Statue
20H X 11.5D "
1992

165

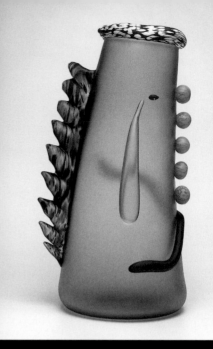

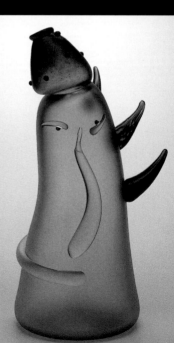

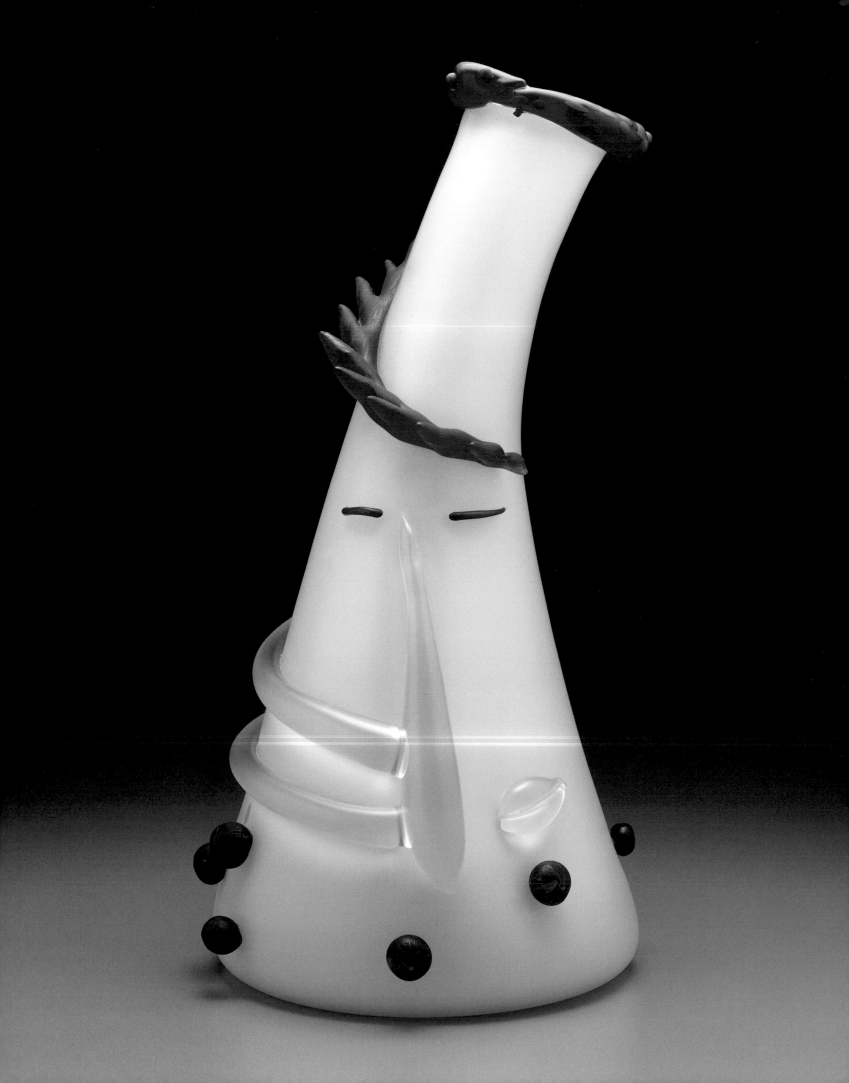

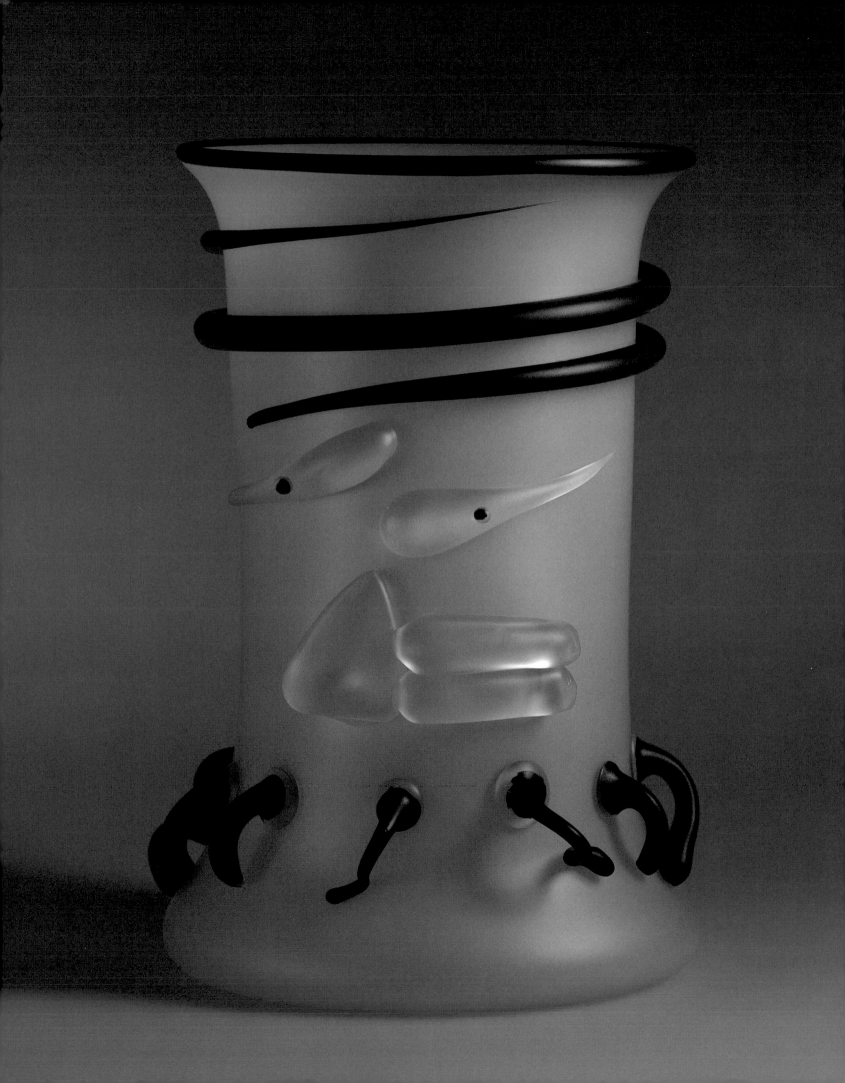

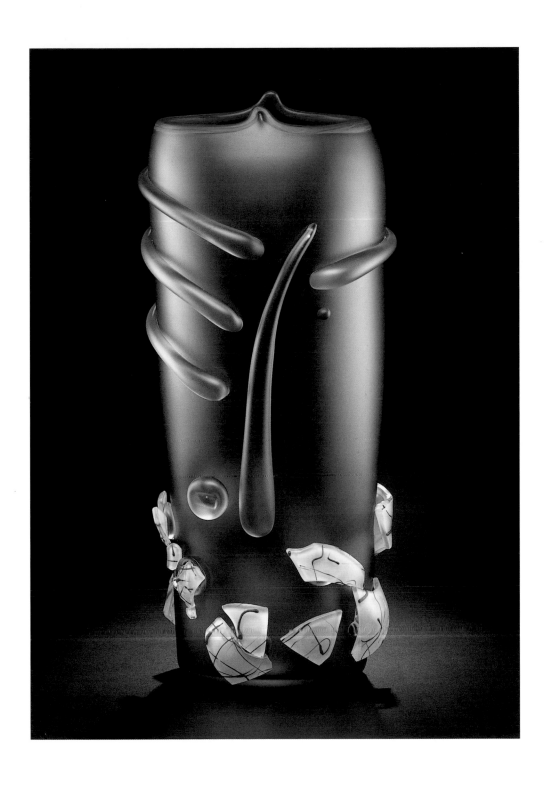

OPPOSITE
Chill
16.5H X 11D"
1990

ABOVE
Vogue
22H X 10D"
1991

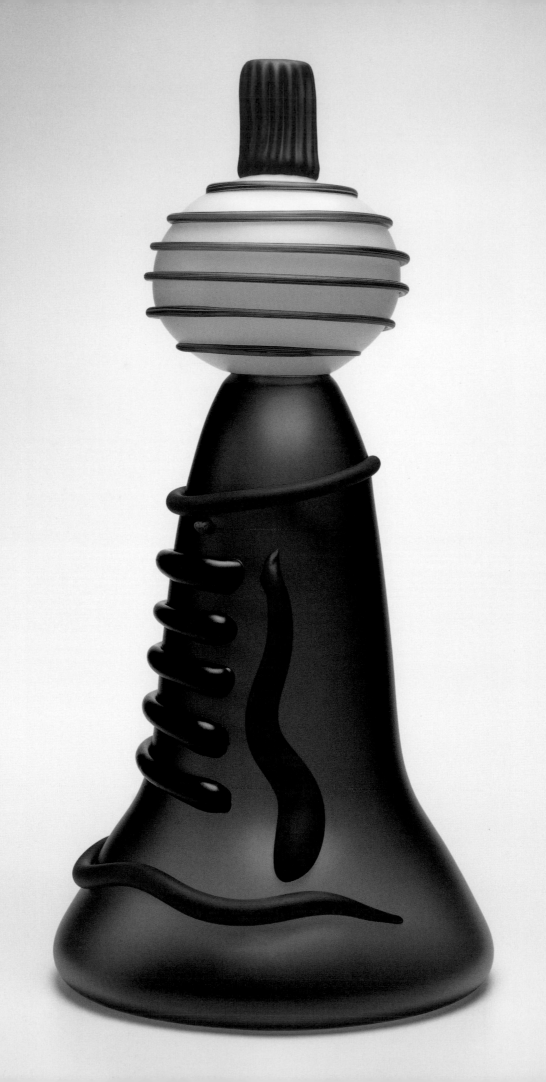

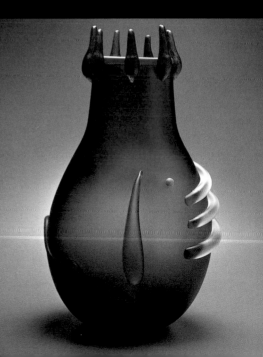

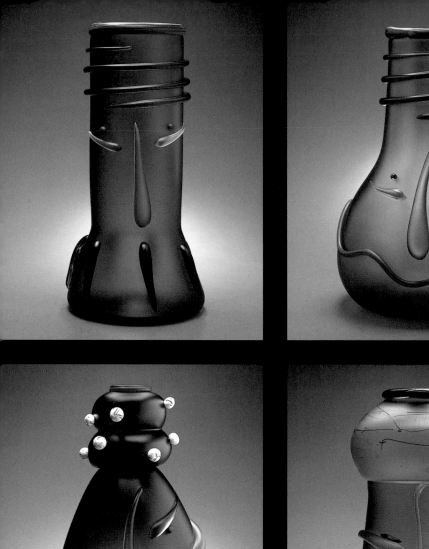
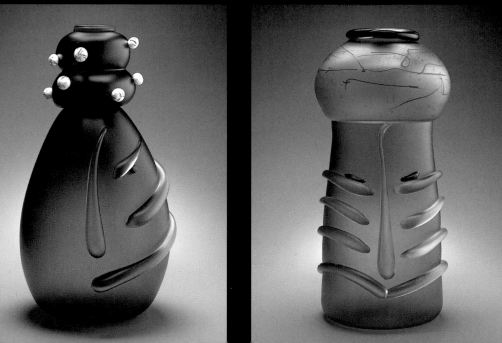

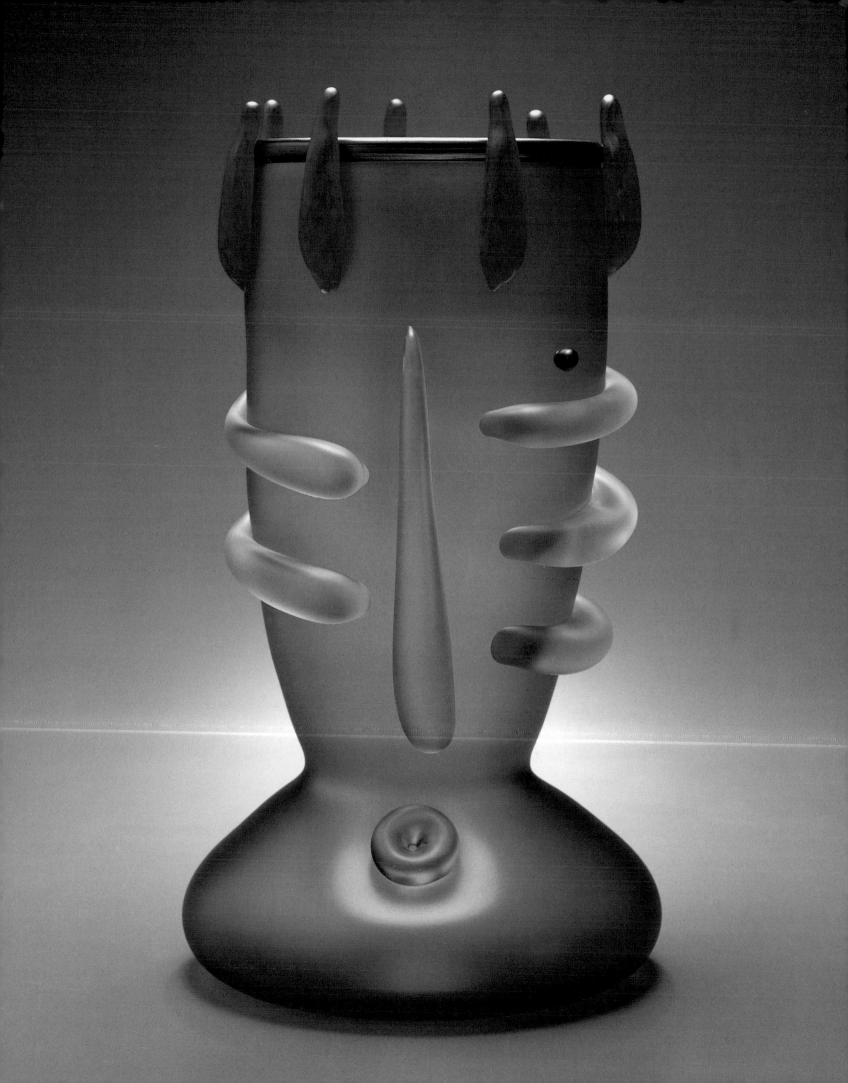

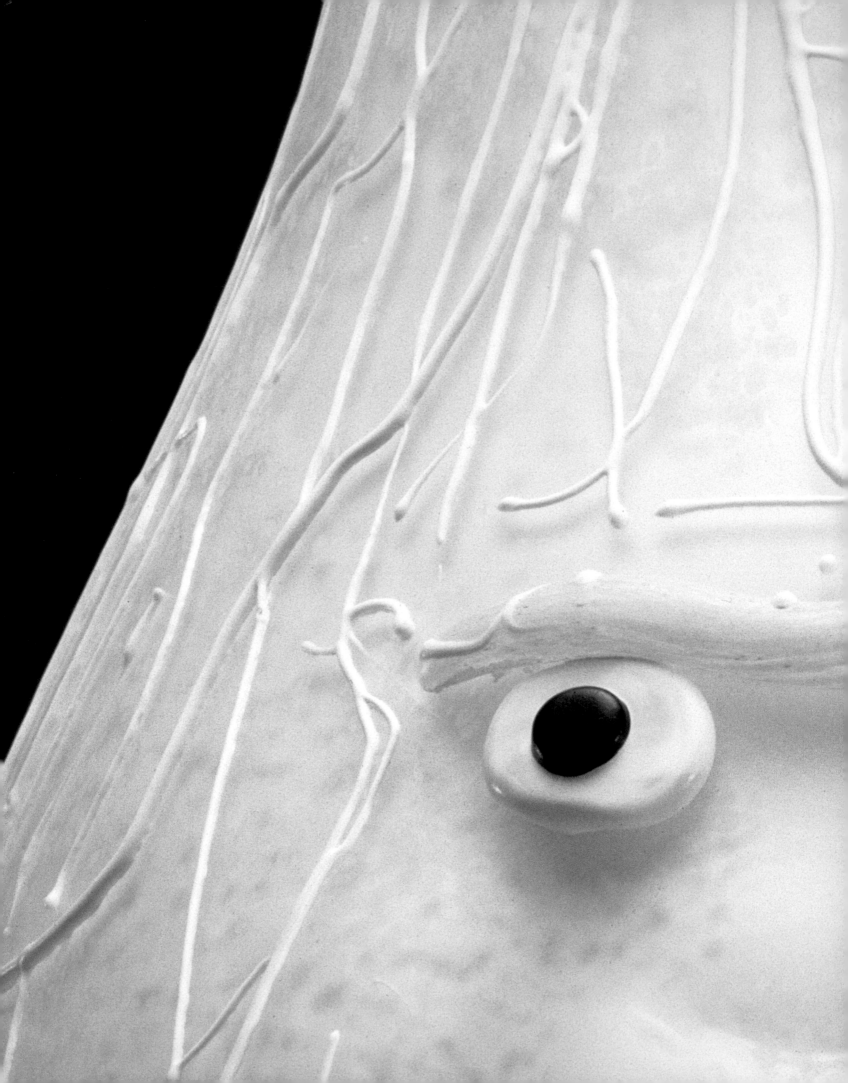

ANIMAL VASES

1992 – 1998

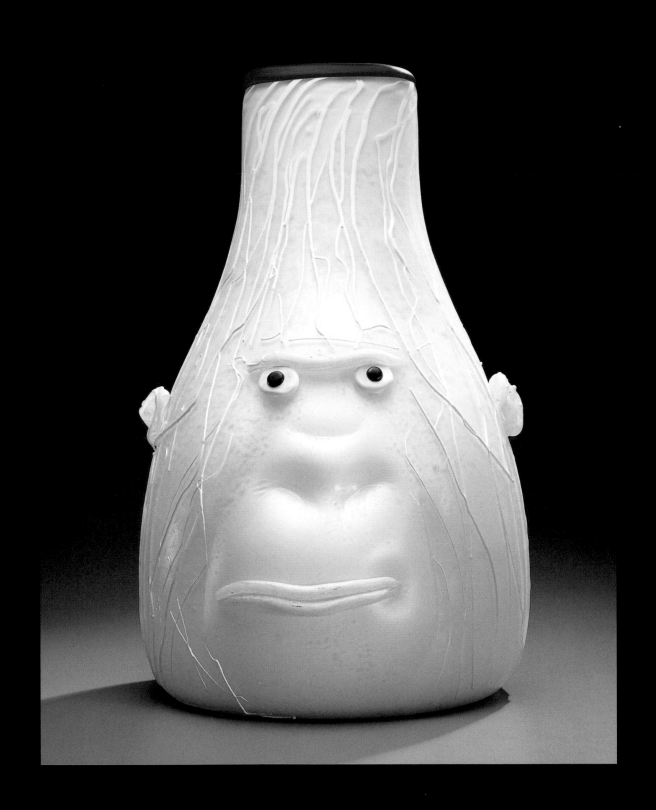

PREVIOUS AND ABOVE
White Gorilla
19H X 13D"
1994

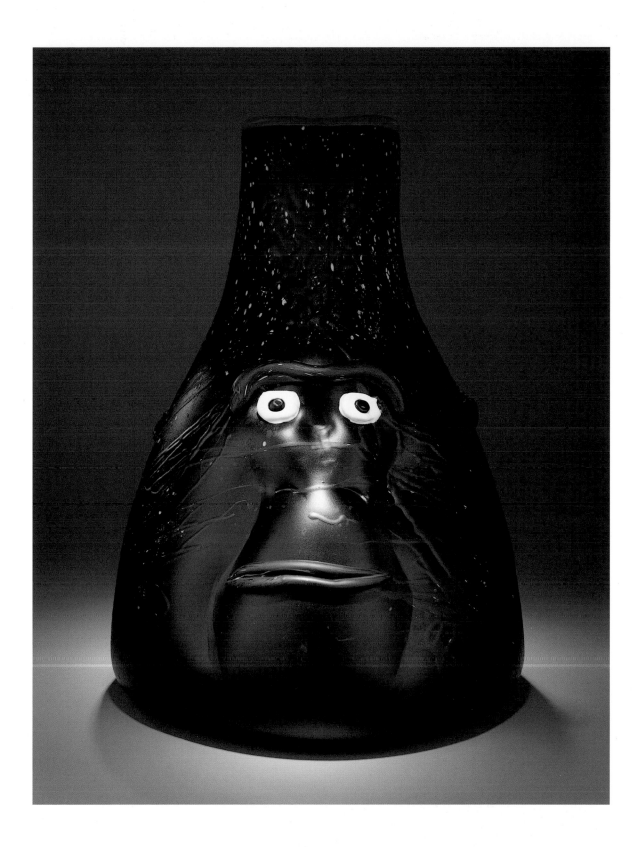

Gorilla
19H X 13D"
1992

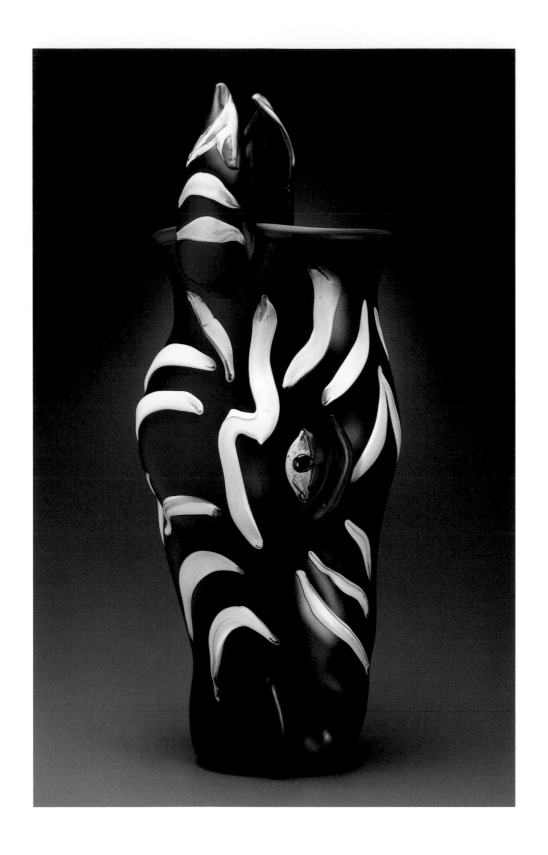

Zebra
19H X 10D"
1992

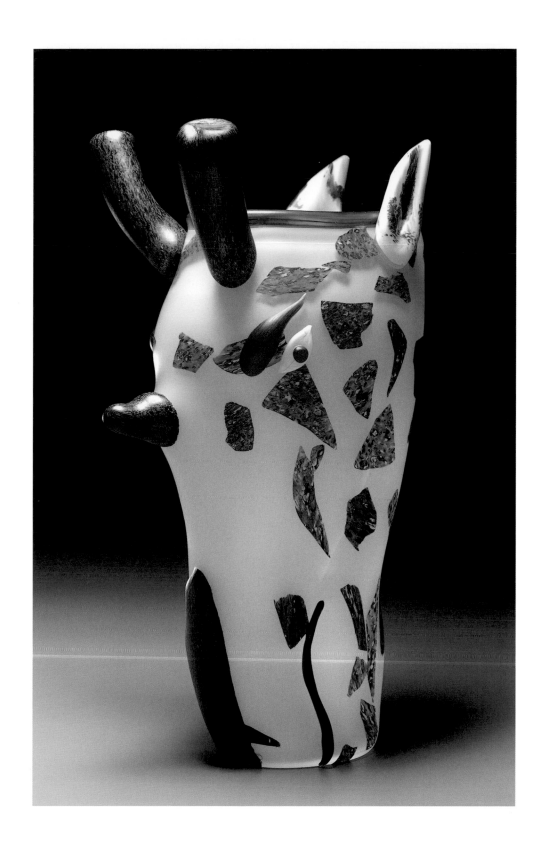

Giraffe
20H x 12D"
1992

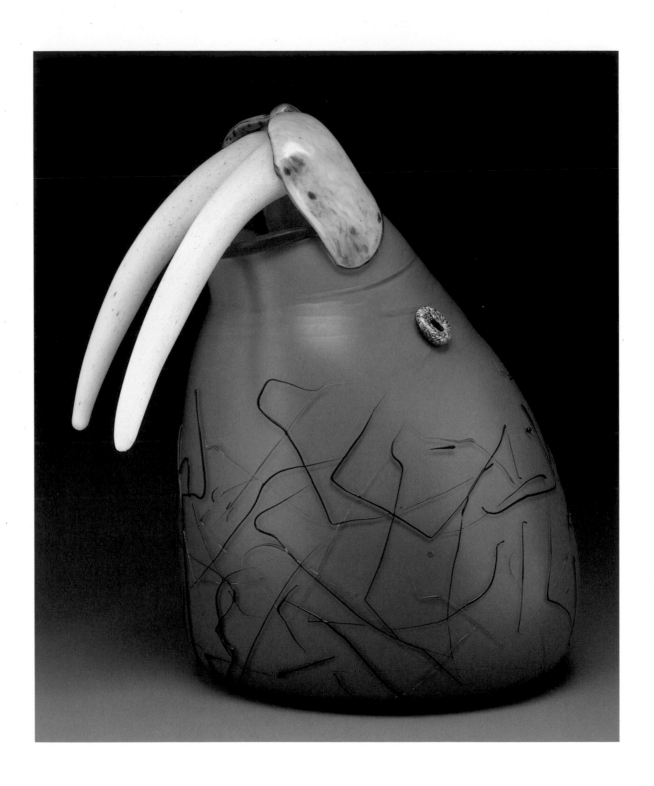

ABOVE

Walrus
19H X 10D"
1993

OPPOSITE

Toad
15H X 12D"
1997

180

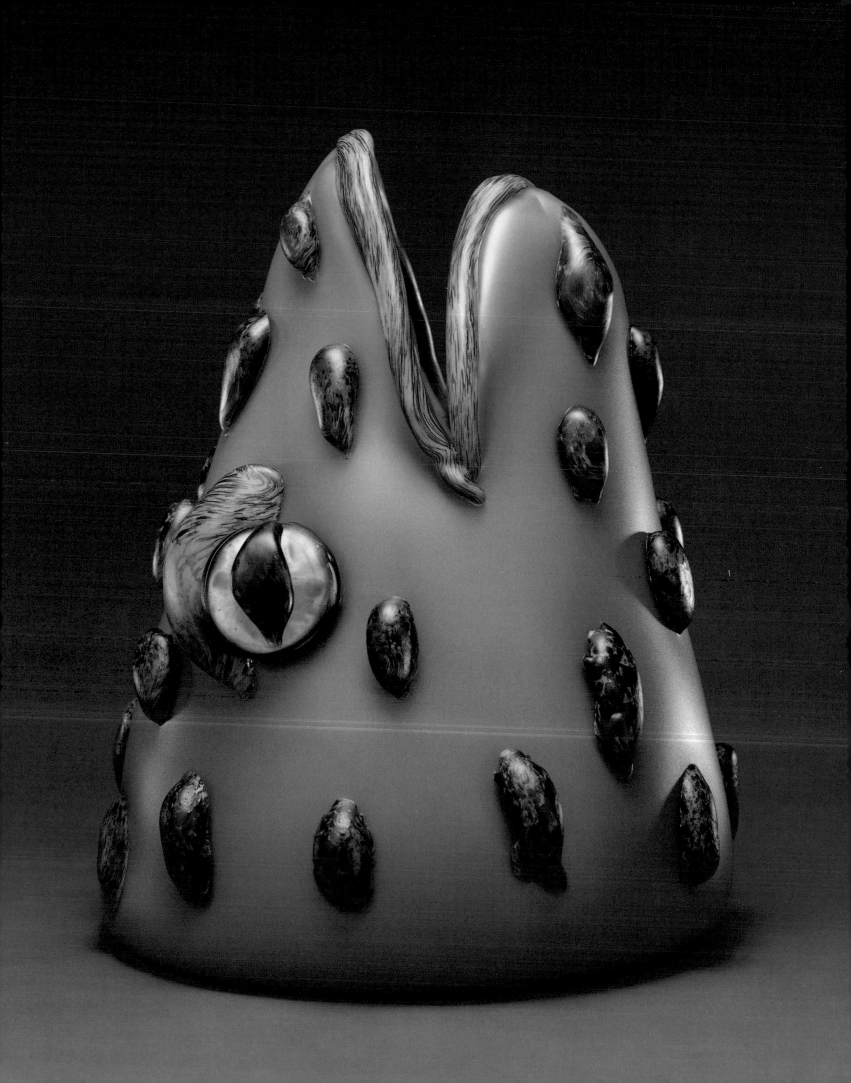

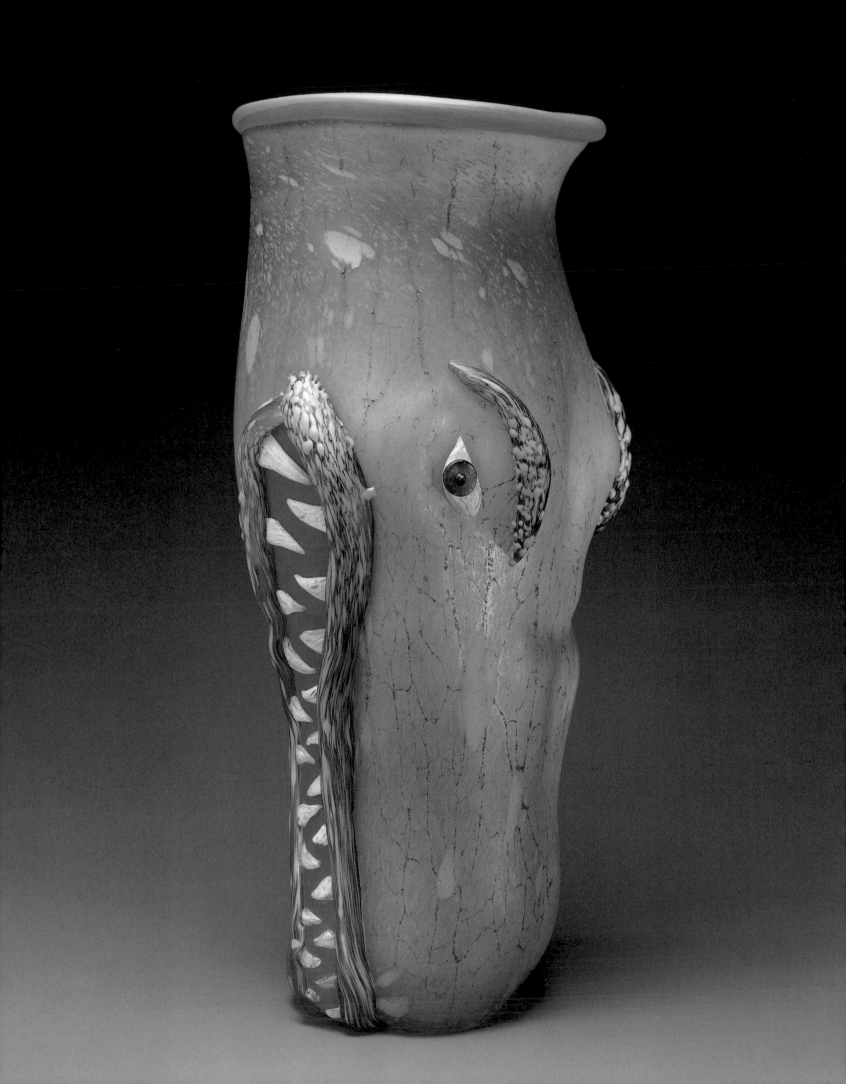

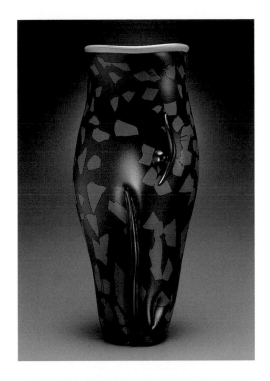

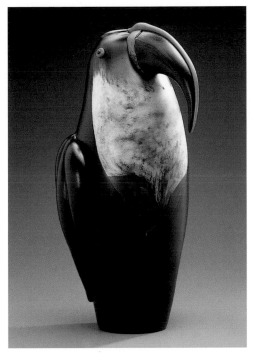

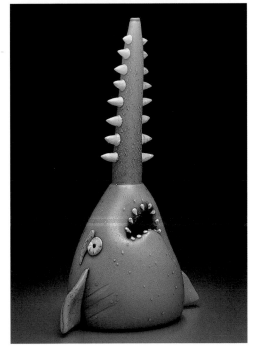

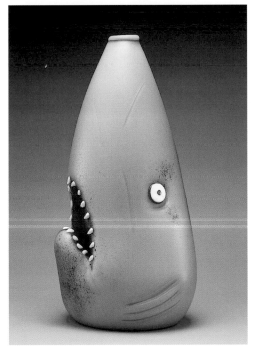

OPPOSITE
Alligator
20H X 8D"
1995

ABOVE LEFT
Lizard
20H X 8D"
1995

ABOVE RIGHT
Toucan
21.5H X 12.25D"
1994

BELOW LEFT
Sawfish
29H X 12D"
1997

BELOW RIGHT
Shark
20H X 10D"
1997

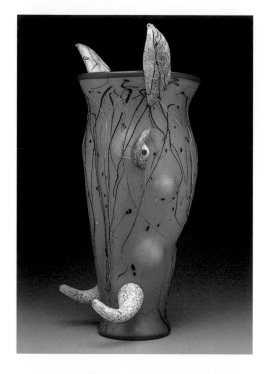

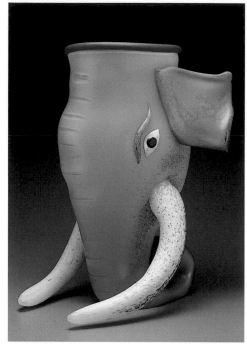

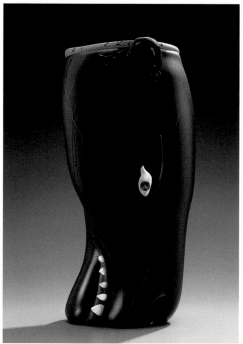

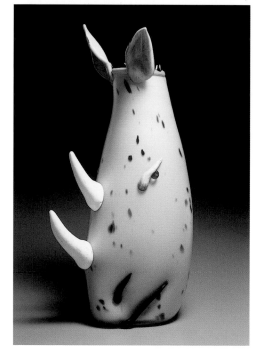

ABOVE LEFT
Warthog
22H X 10D "
1998

ABOVE RIGHT
Elephant
19H X 14D "
1995

BELOW LEFT
Panther
18H X 10.25D "
1994

BELOW RIGHT
Rhinoceros
25.5H X 15D "
1992

OPPOSITE
Dog
20H X 9D "
1992

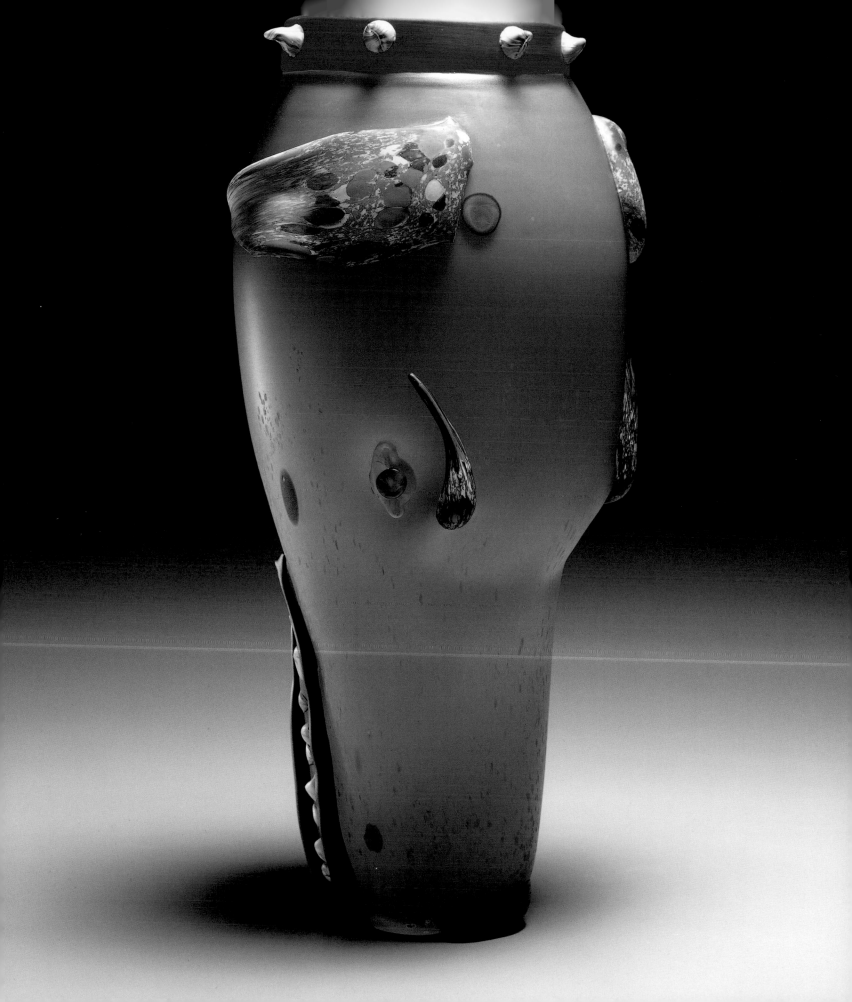

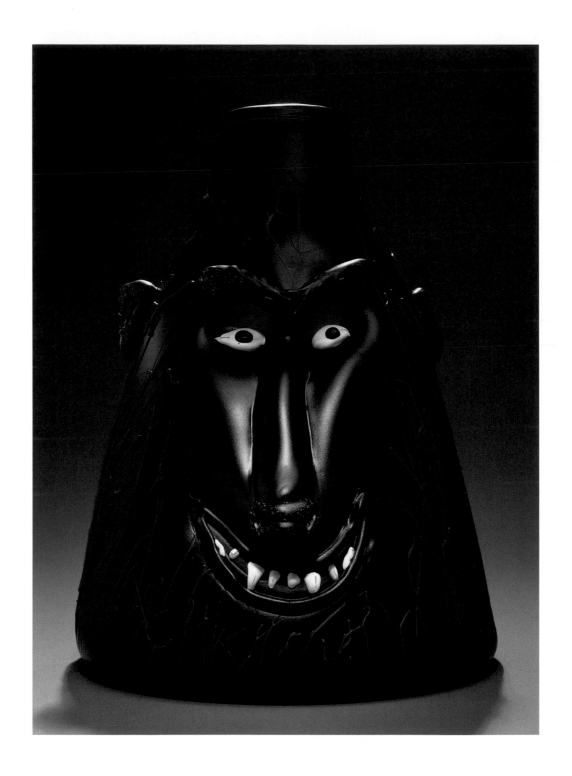

ABOVE
Baboon
14.25H X 11.75D"
1994

OPPOSITE
Black Mandril
18H X 10D"
1993

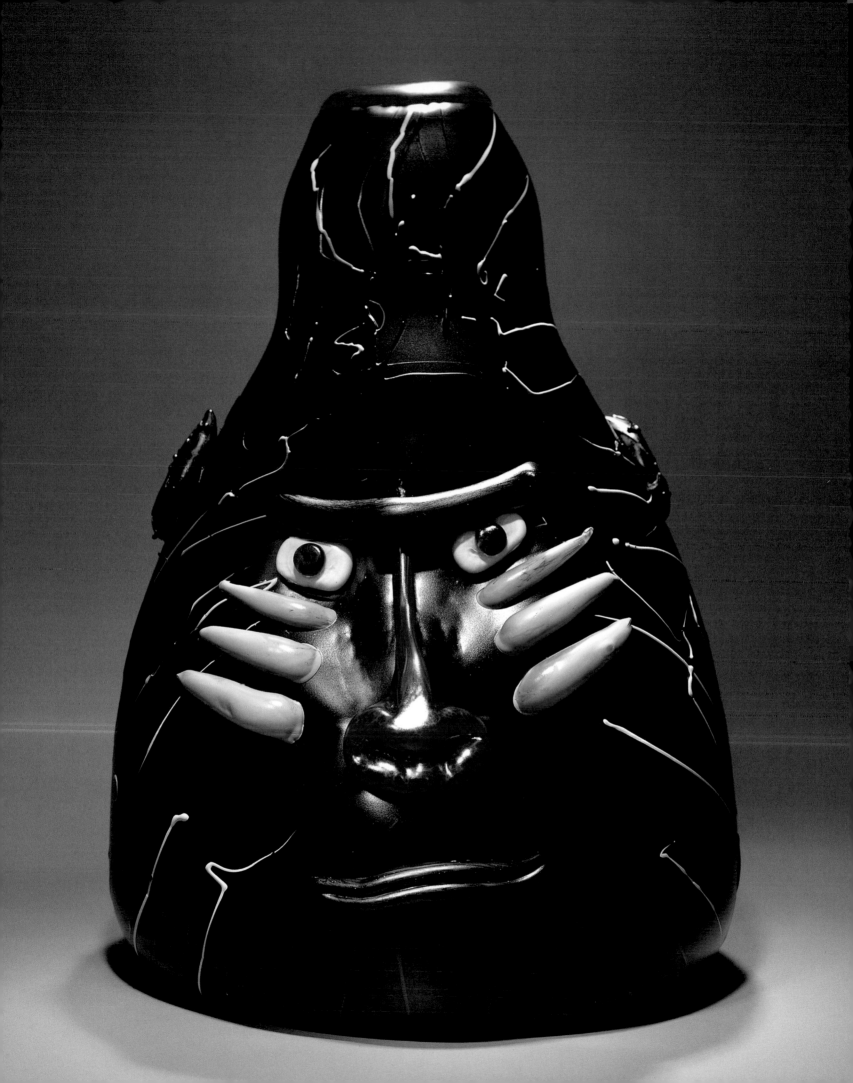

FIGURATIVE LAMPS

1986 – 2006

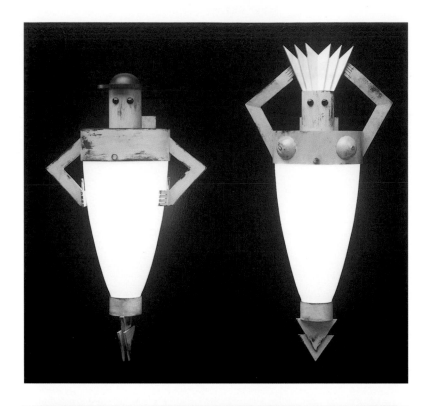

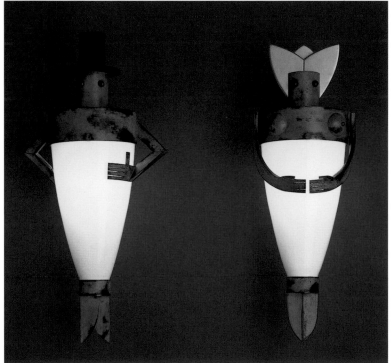

PREVIOUS
Balustrade Man (detail)

ABOVE
Man Lamp and Woman Lamp
18H X 8.5W X 10D"
1986

BELOW
Man Lamp and Woman Lamp
20H X 10W X 8.5D"
1987

OPPOSITE
Balustrade Man
27.25H X 20W X 9.75D"
1990

190

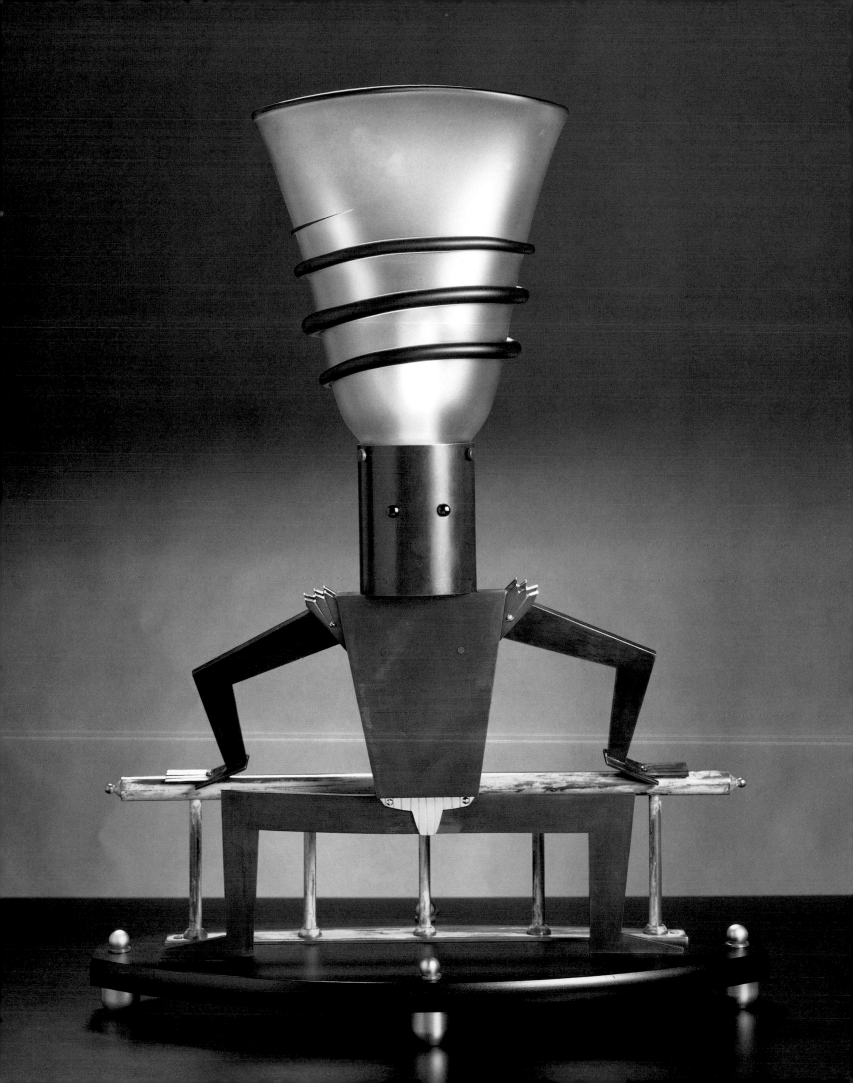

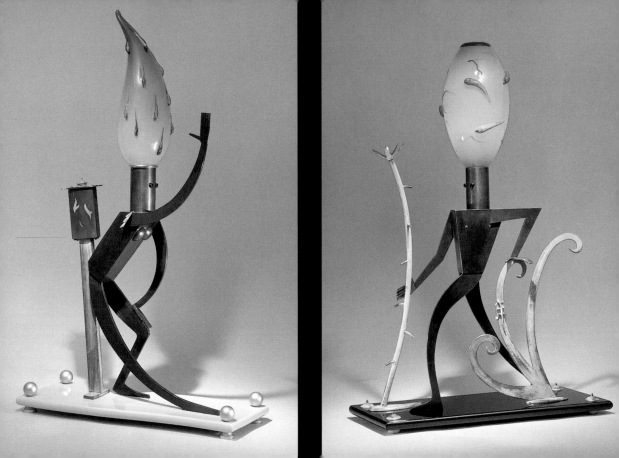

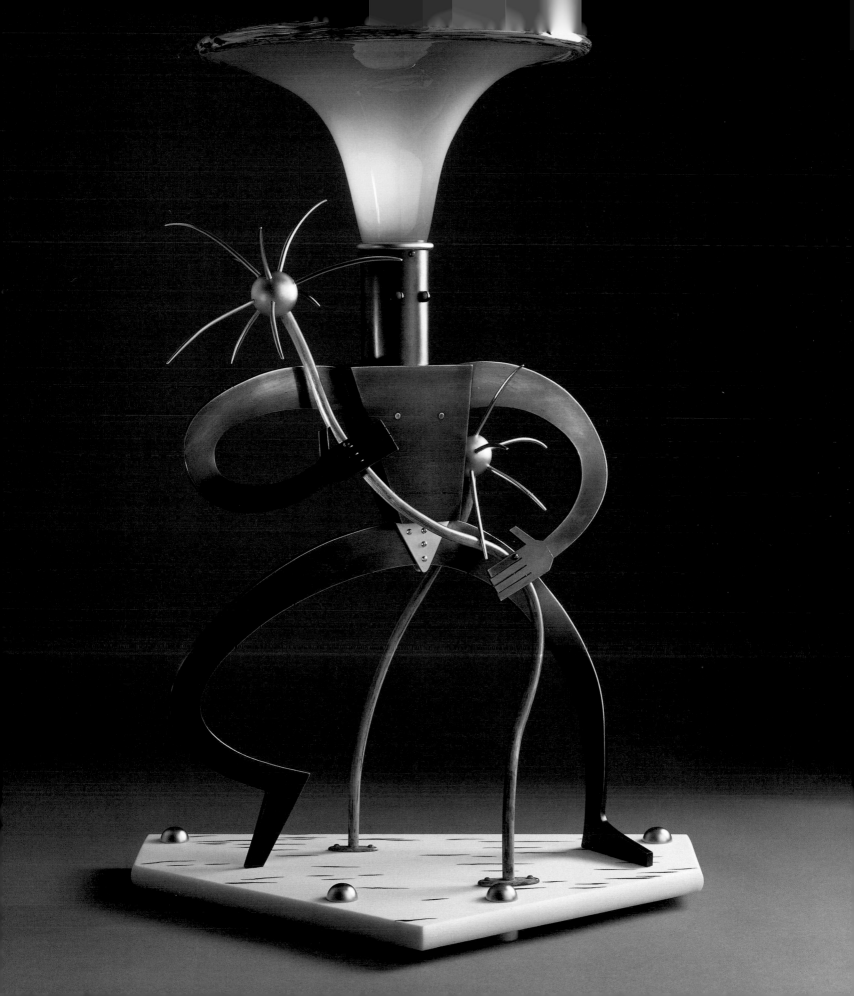

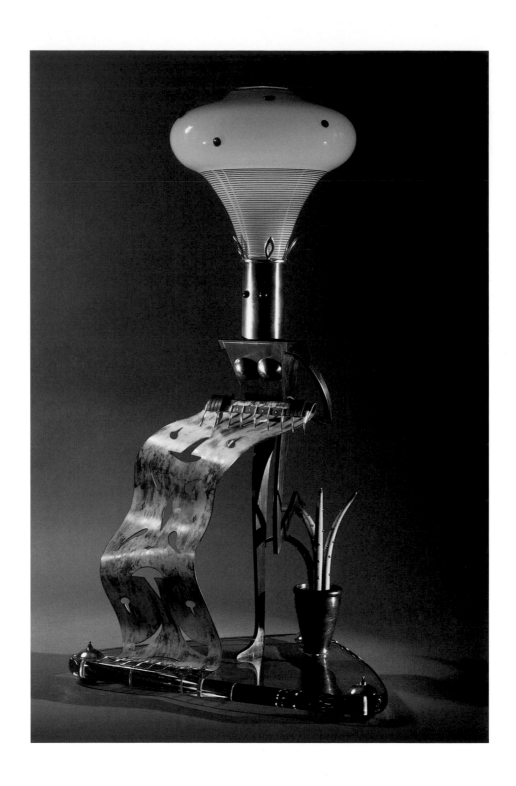

ABOVE
Nude with Green Rug
34.5H x 18W x 15D"
1995

OPPOSITE
Nude Skulking in Weeds
29H x 24W x 10D"
1995

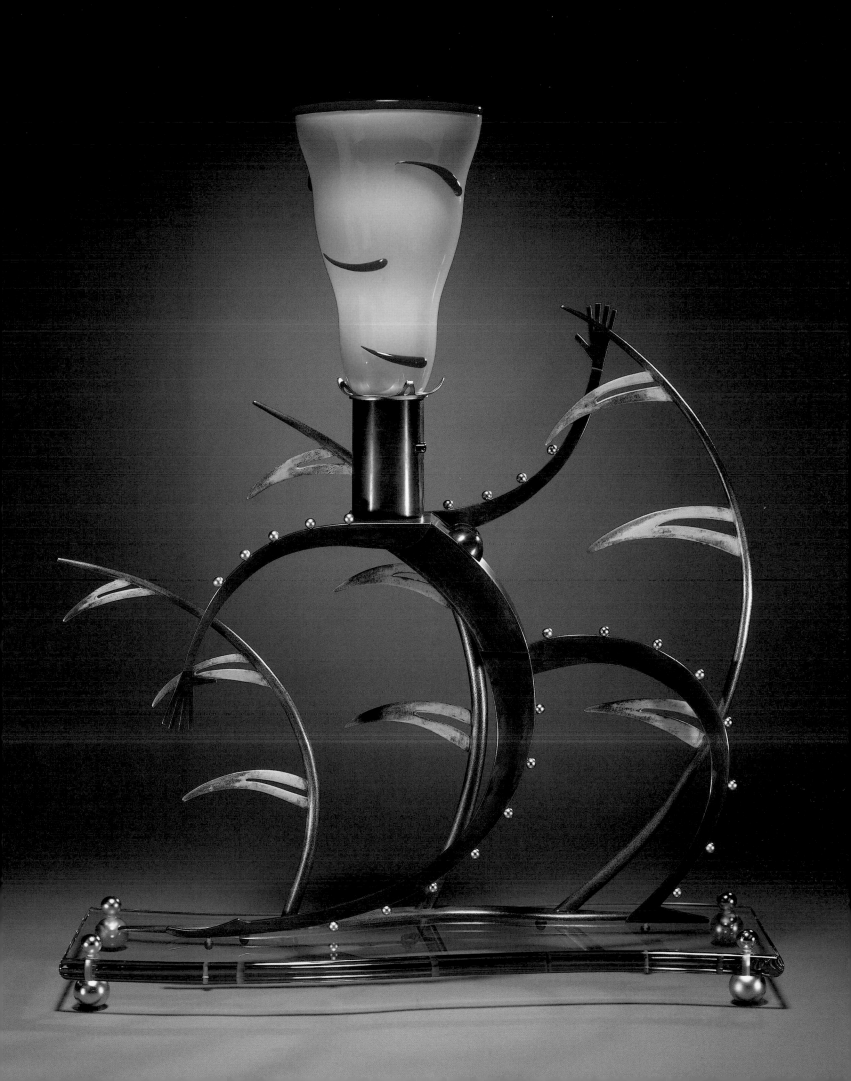

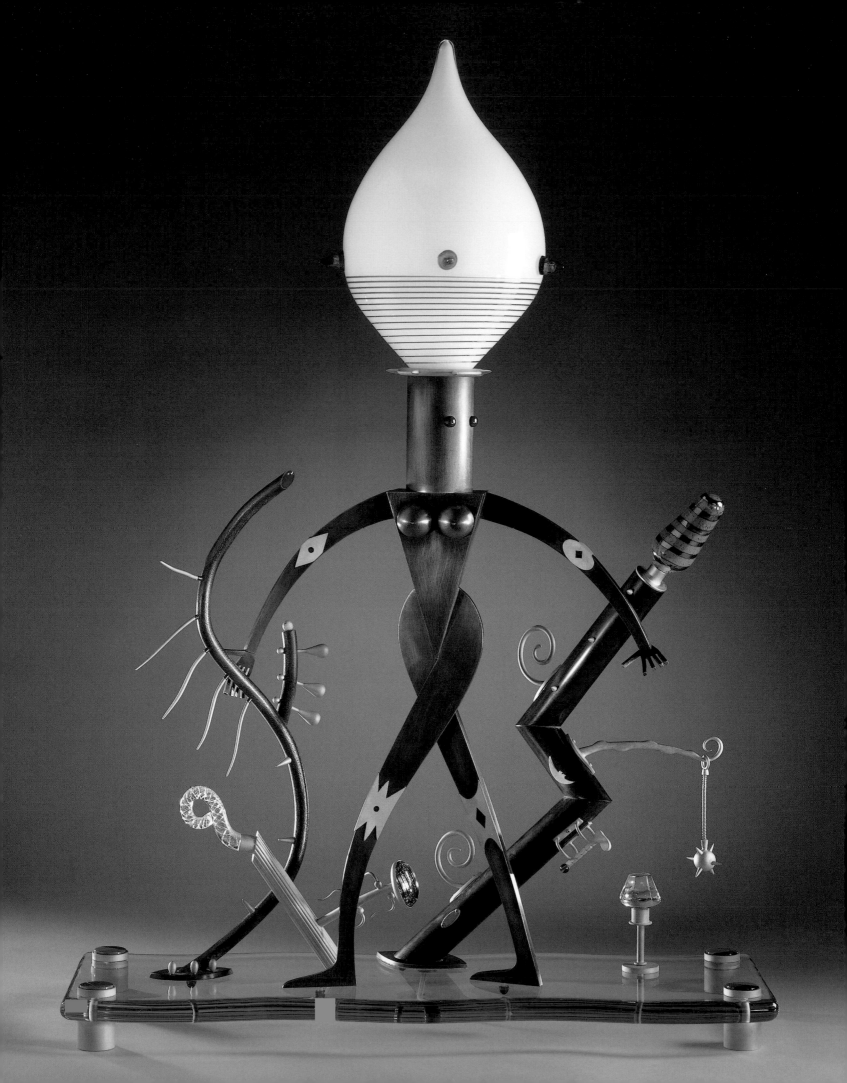

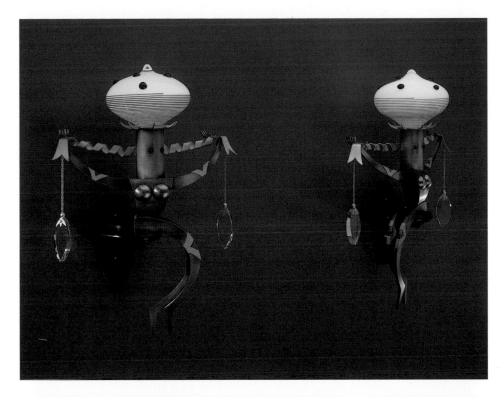

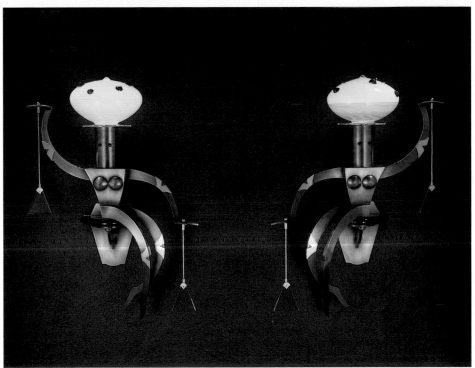

OPPOSITE
Nude in Junk
34H X 24W X 9D"
1997

ABOVE
Nudes with Scarf and Prisms
21H X 15W X 6.5D"
1998

BELOW
Seated Nudes with Prisms
14H X 18W X 13D"
2000

197

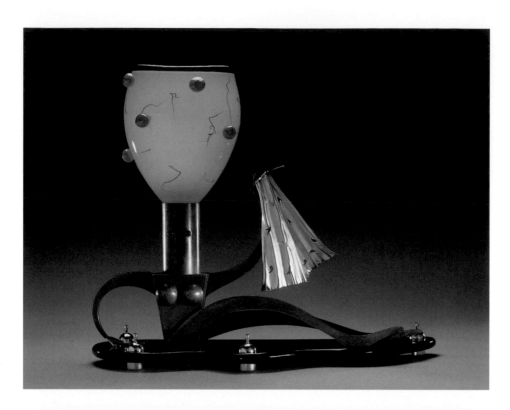

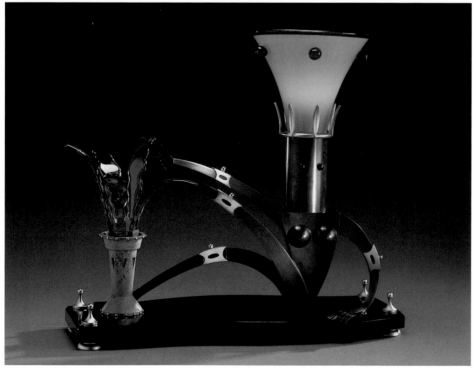

ABOVE
Nude with Scarf
17.25H x 21W x 6.75D"
1993

BELOW
Nude with Illuminated Plant
17H x 18W x 8D"
1996

198

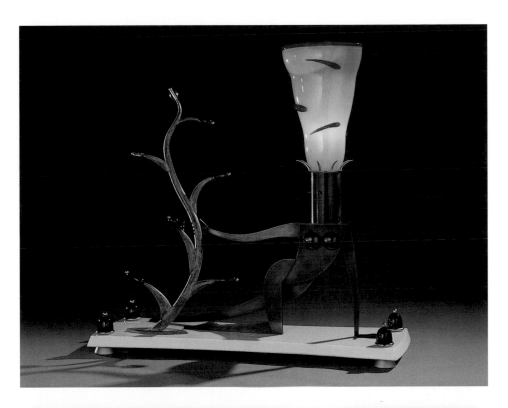

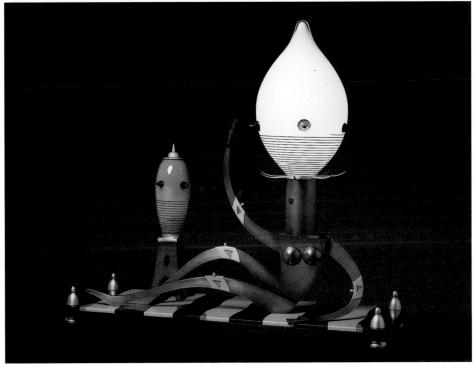

ABOVE
Nude with Fruit Tree
25H X 26W X 8.5D"
1996

BELOW
Nude with Vase on Stand
22H X 24W X 8D"
1996

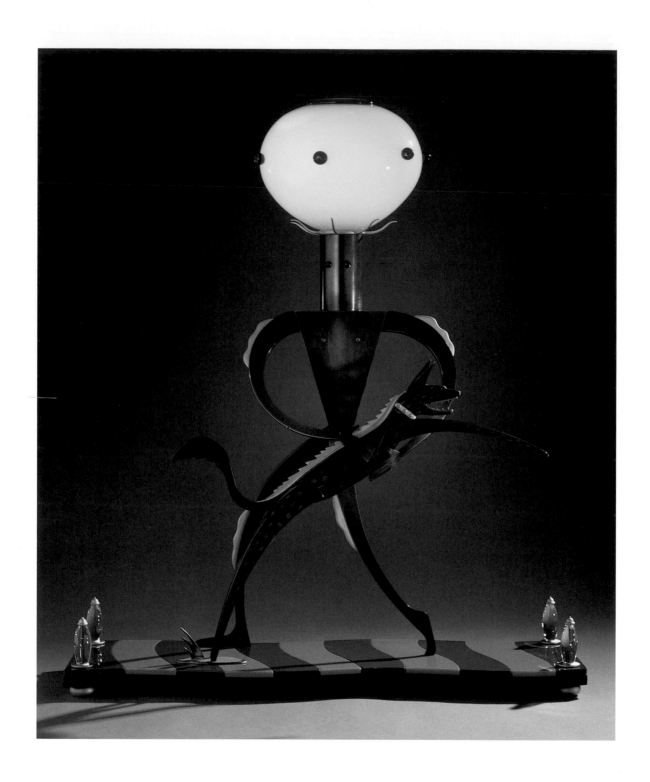

ABOVE
Man with Hyena
30H X 26W X 9D"
1996

OPPOSITE
Nude in Glass Foliage
31H X 24W X 9D"
1997

200

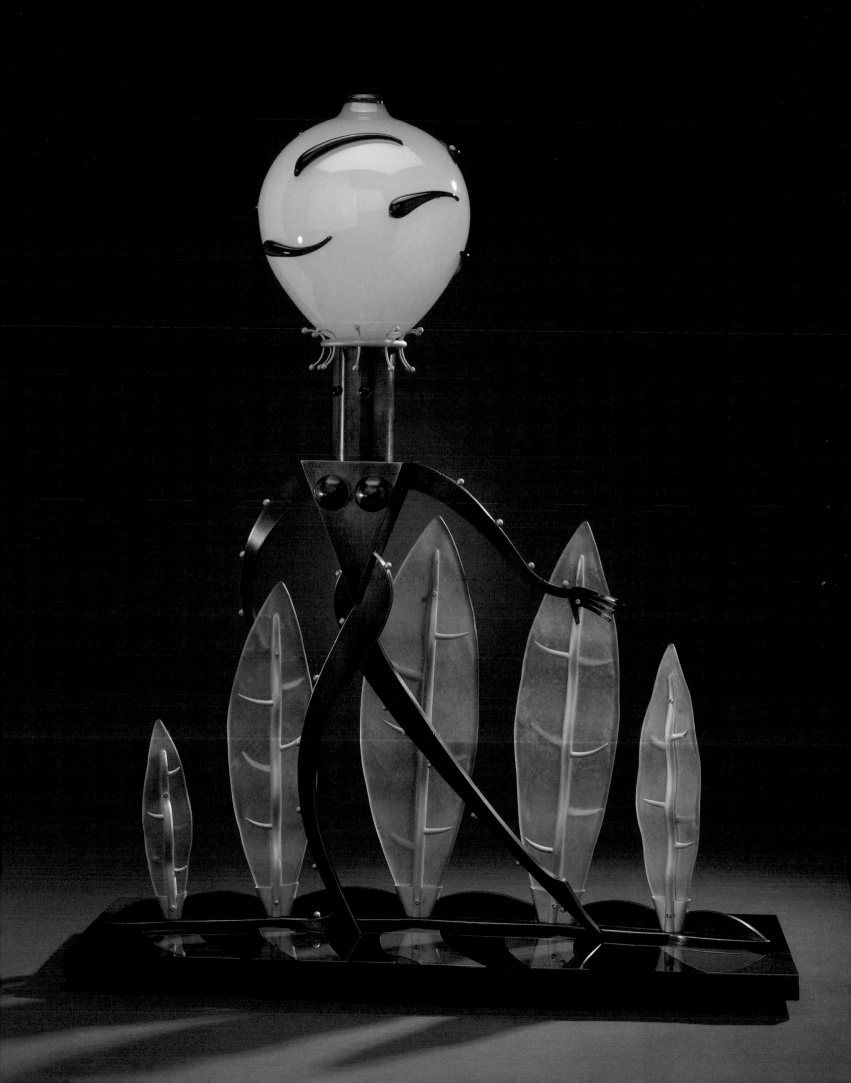

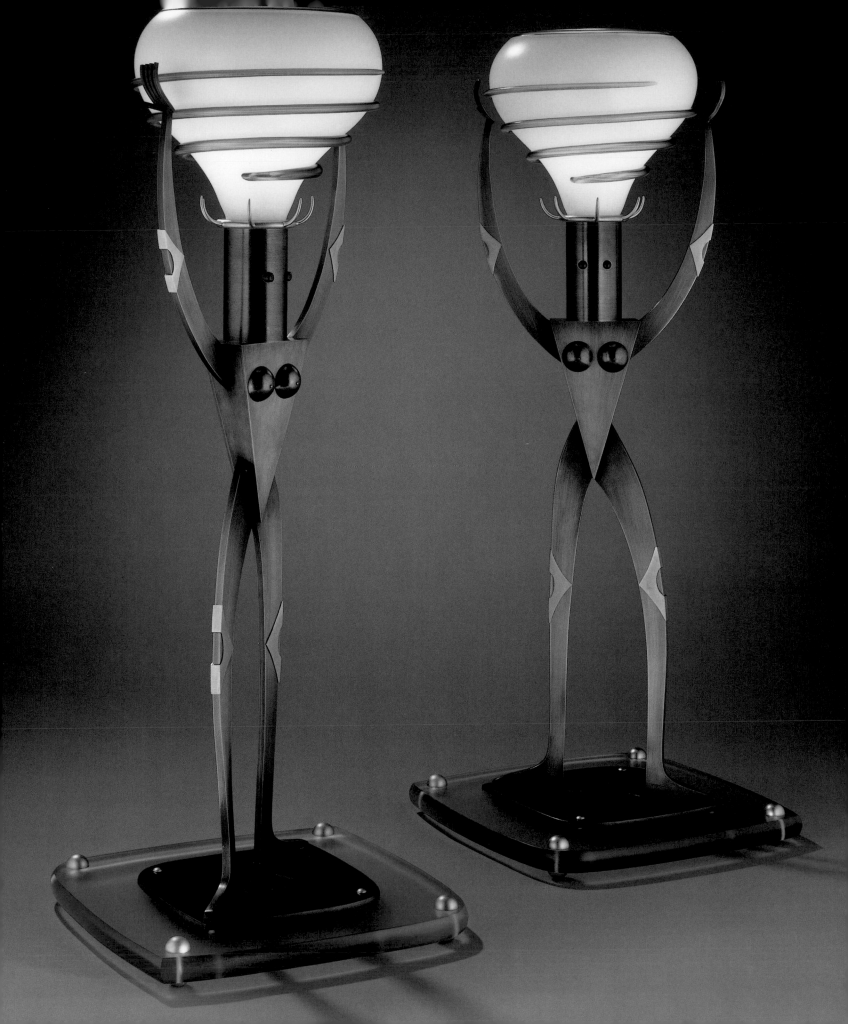

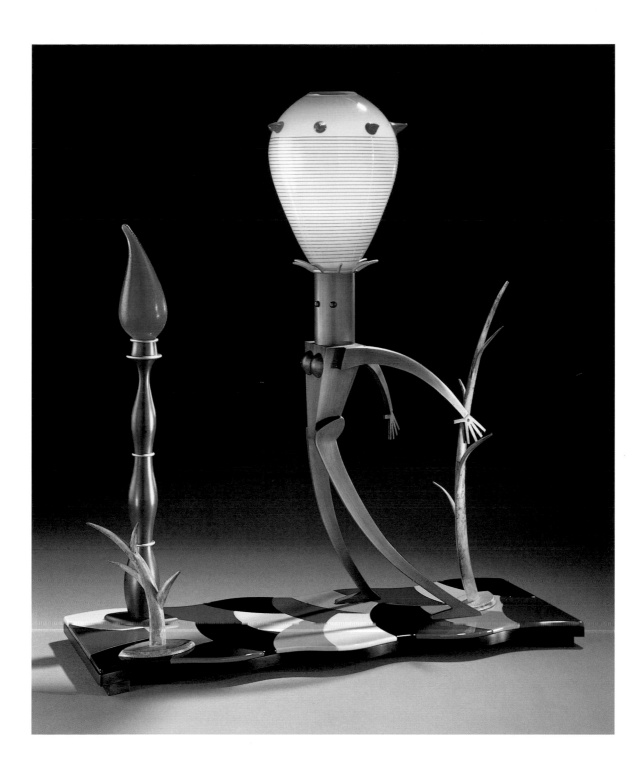

OPPOSITE
Light Bearers
29H X 7.25W X 7.25D"
1998

ABOVE
Nude Surprised in the Garden
25H X 25W X 9D"
1998

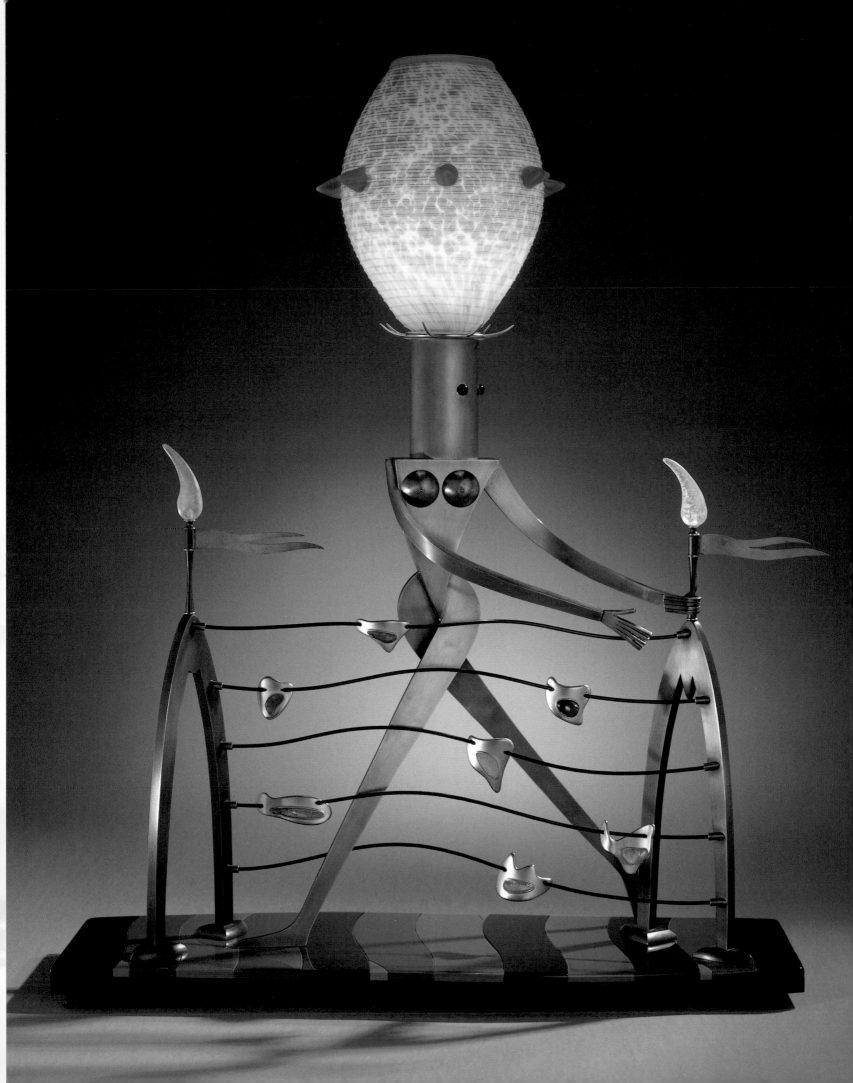

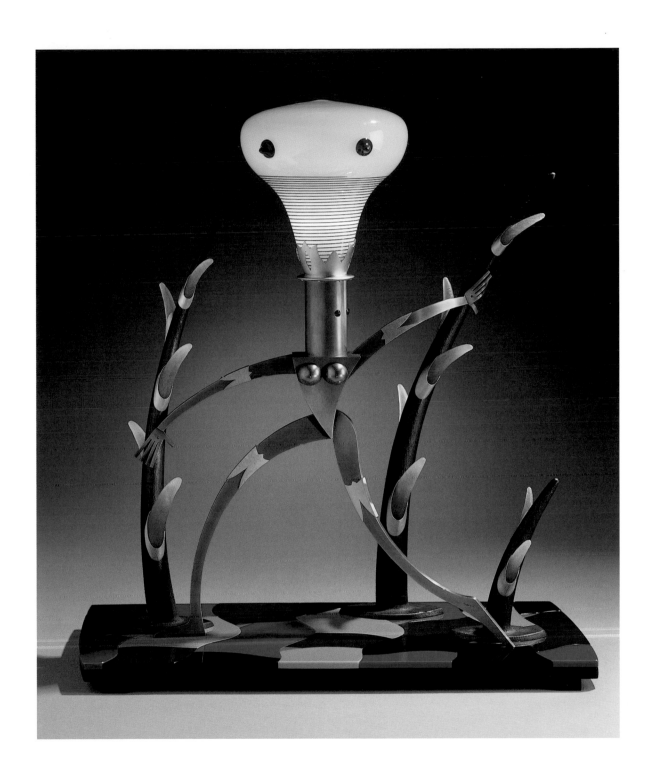

OPPOSITE
Nude with Fence of Jewels
30H X 24W X 8D"
1998

ABOVE
Nude Looking
26H X 23W X 9D"
1998

207

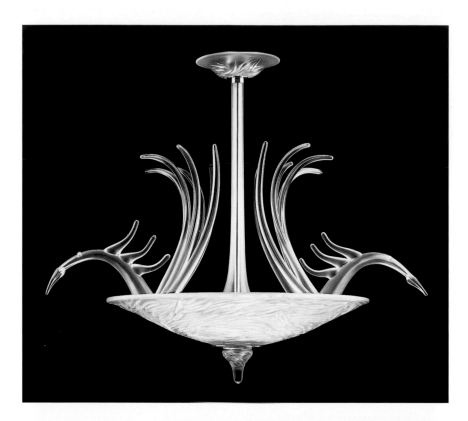

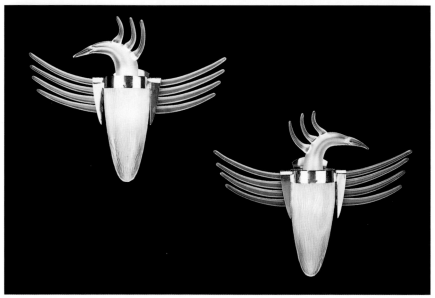

ABOVE
Birds in Flight
40H X 36W X 30D"
1999

BELOW
Bird Sconces
21H X 26W X 7D"
1999

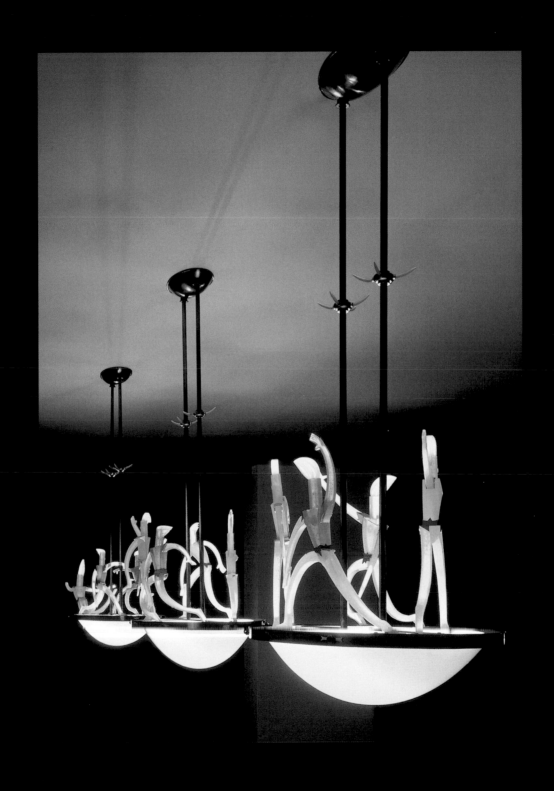

Dance of Light
19H X 38.5W X 20.25D" EACH
1999

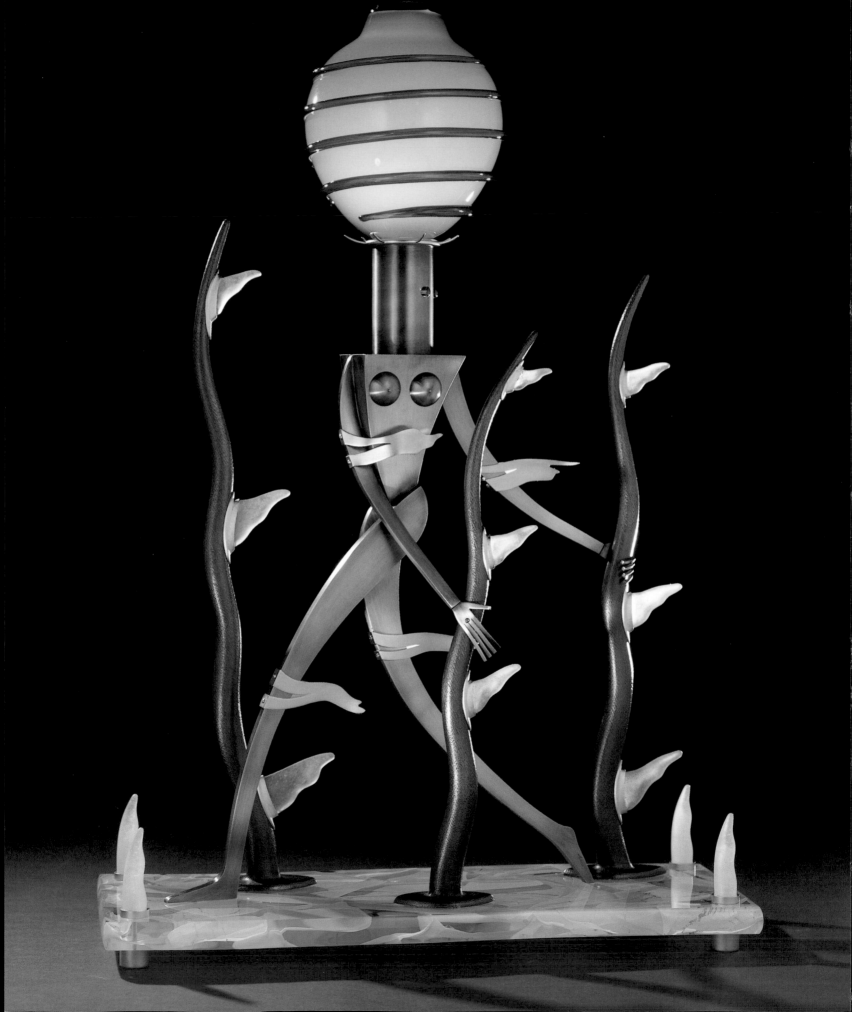

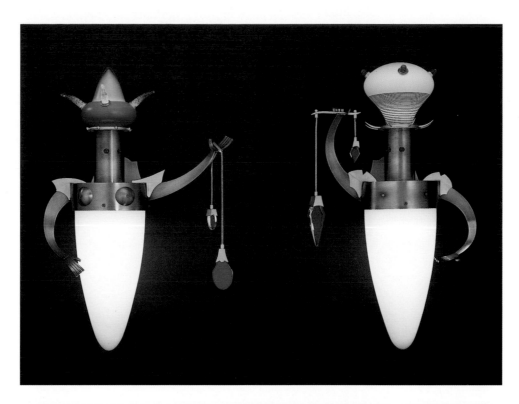

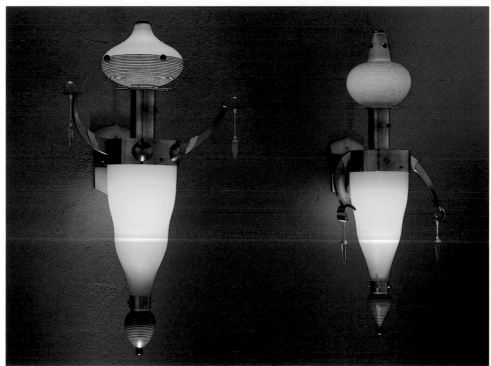

OPPOSITE
Nude in a Breeze
34H X 24W X 19D"
2000

ABOVE
Receivers
21H X 12.25W X 7D"
2001

BELOW
Greetings
28H X 15W X 7D"
2002

211

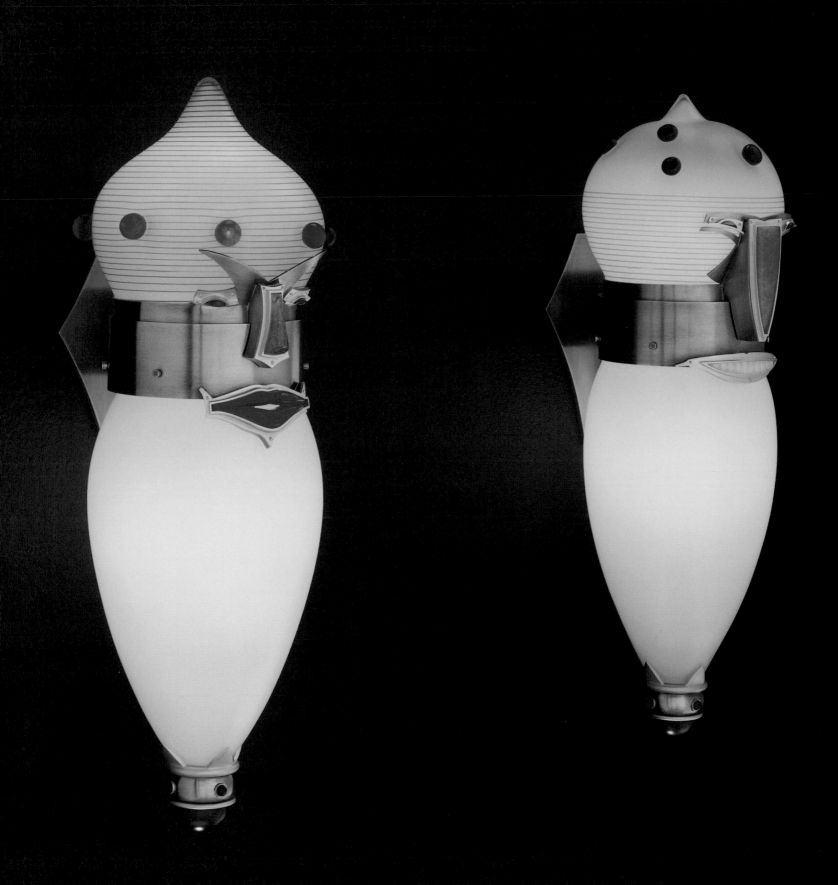

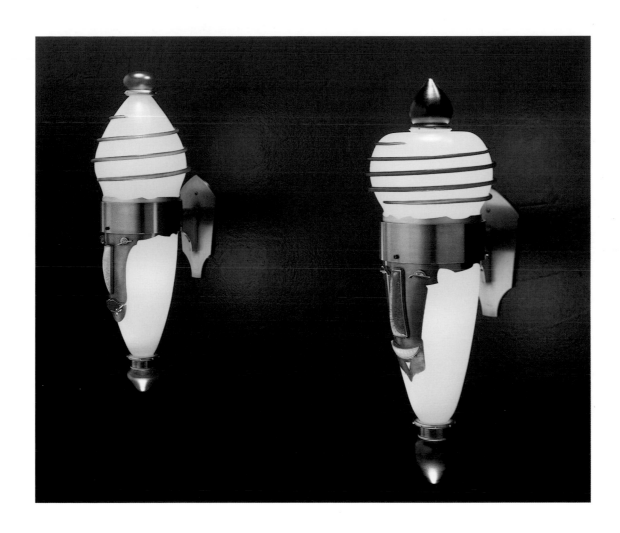

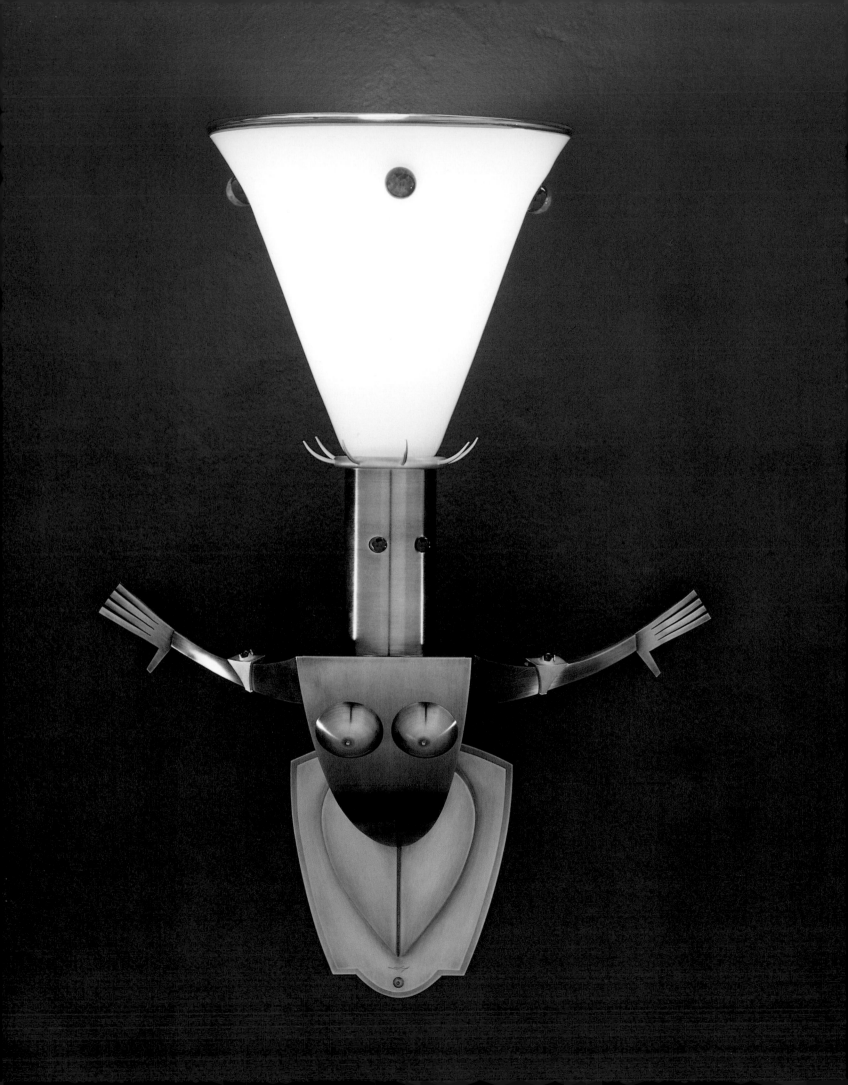

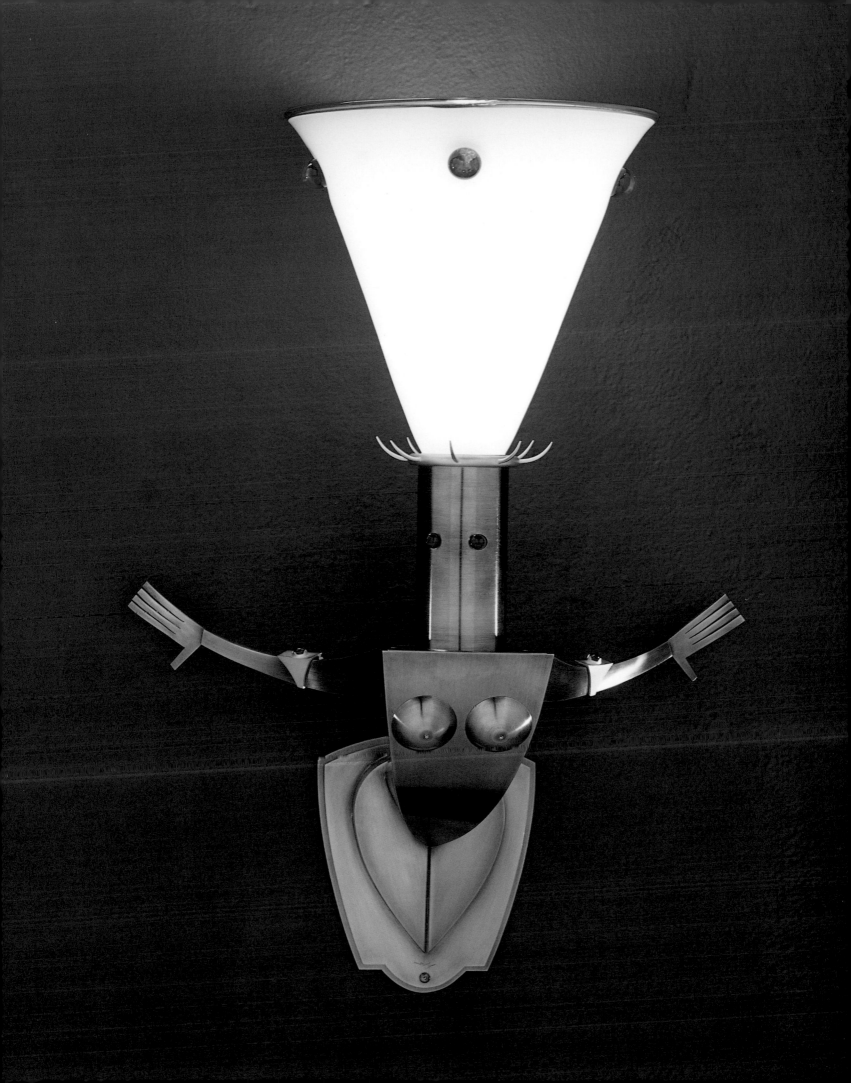

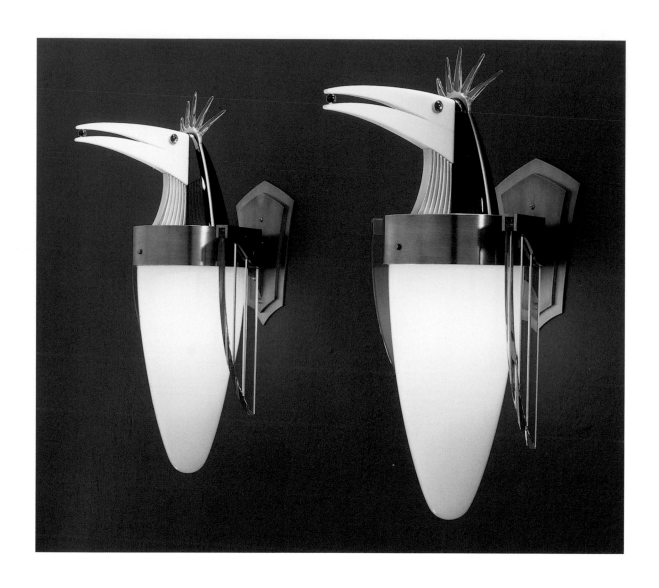

Serene Birds
22H X 12W X 11D"
2004

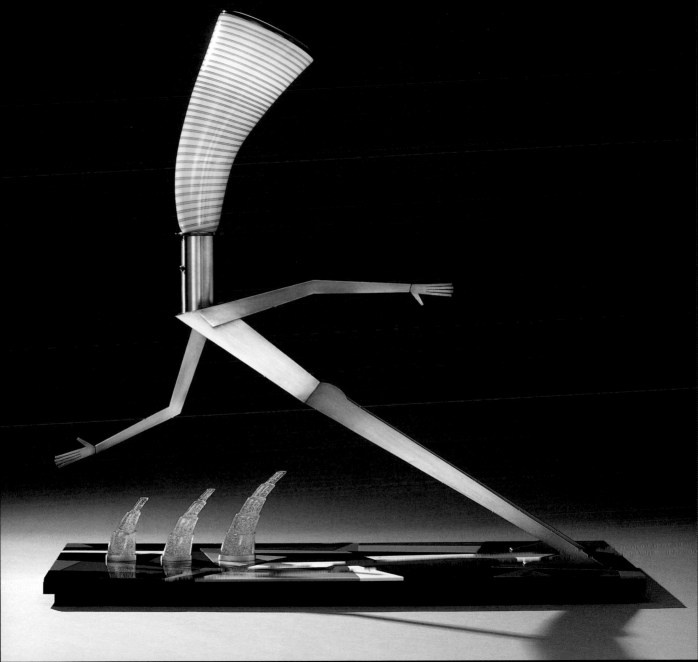

CIRCUS VASES

1995 – 2003

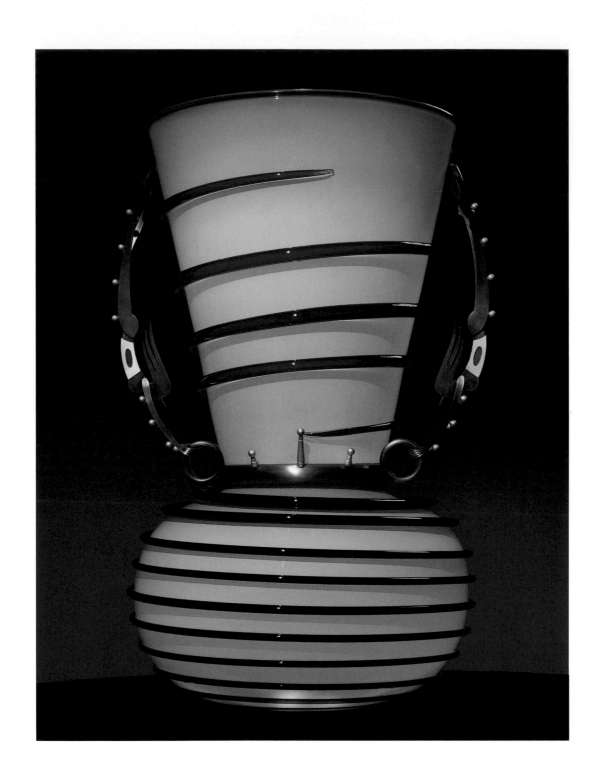

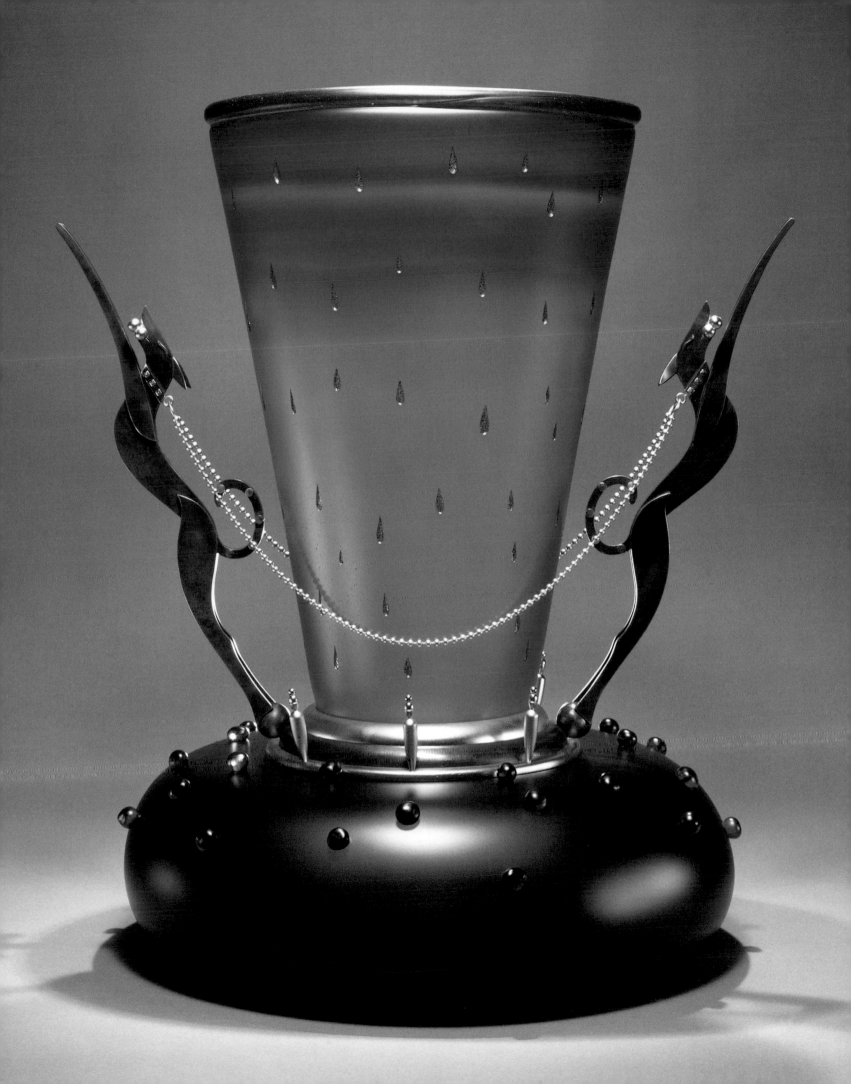

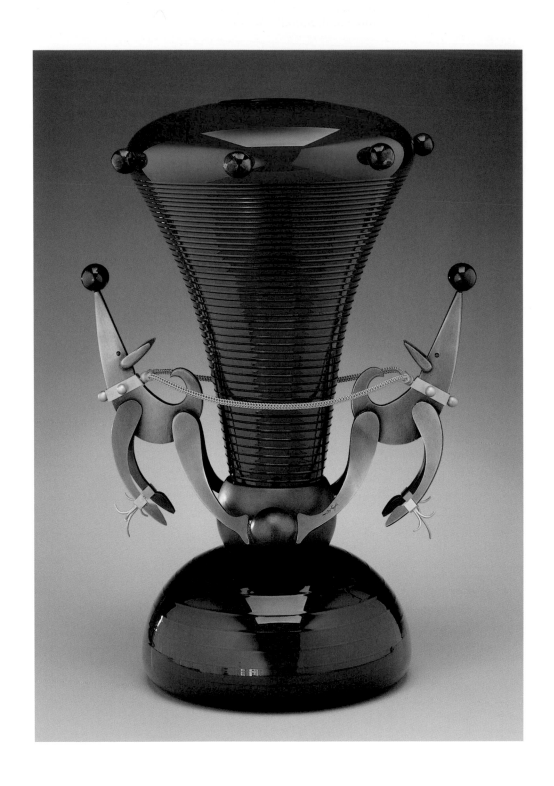

ABOVE
Ball Dogs
12.5H X 8W X 7.5D"
1997

OPPOSITE
Elephant Jump
17H X 16W X 12D"
1997

222

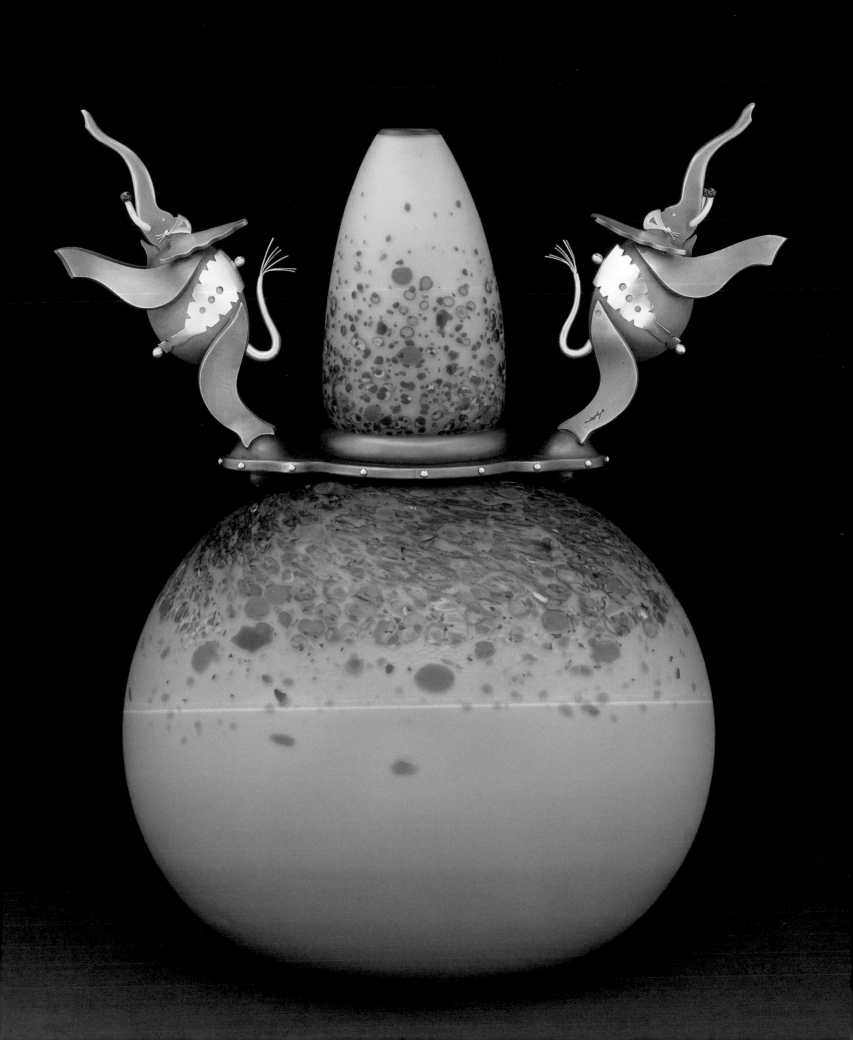

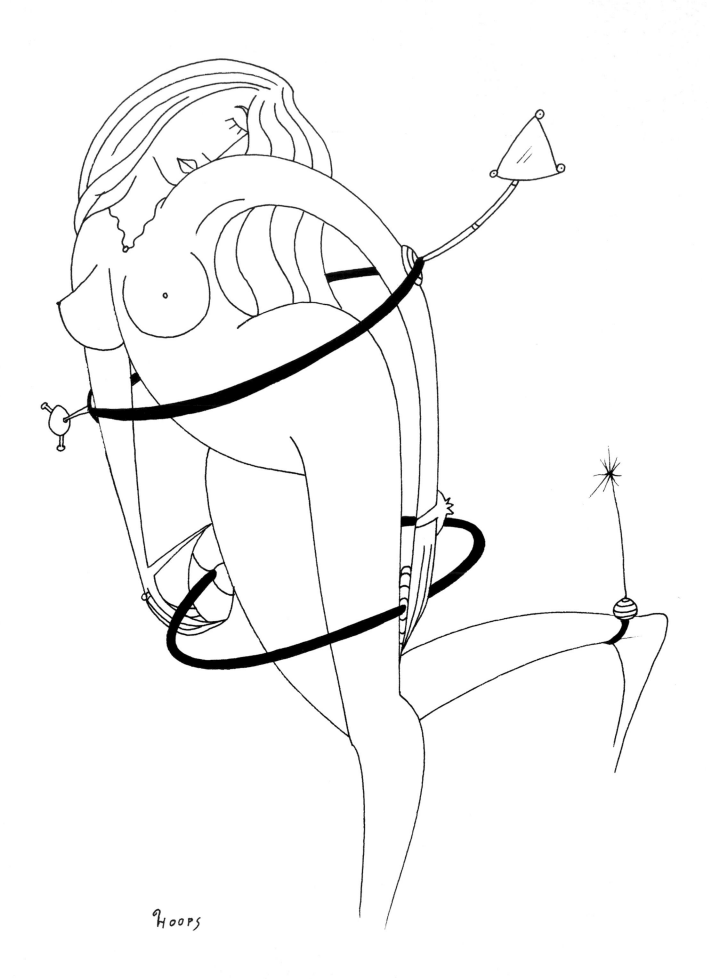

HOOPS

ABOVE
Ball Balancers
26H X 19W X 10D"
1997

ABOVE
Cubist Clowns
14H X 7.75W X 11.25D"
1998

OPPOSITE
Celebration
34H X 20W X 15D"
1999

226

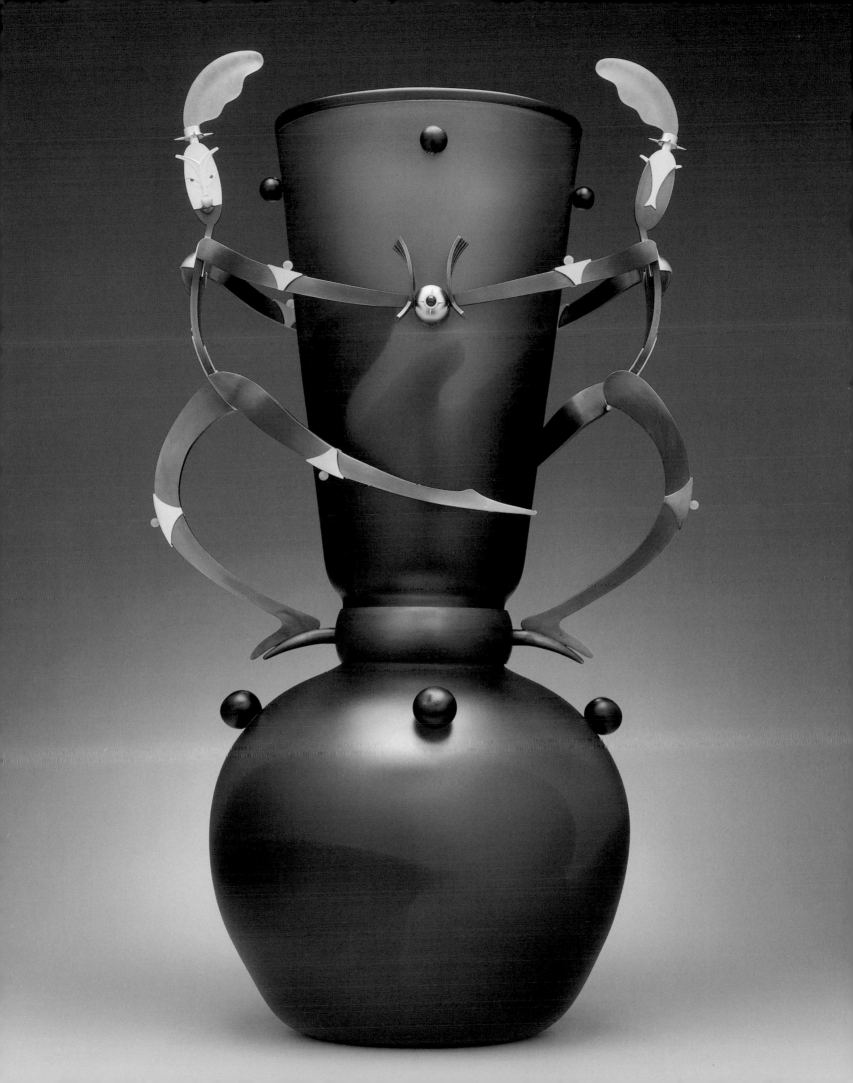

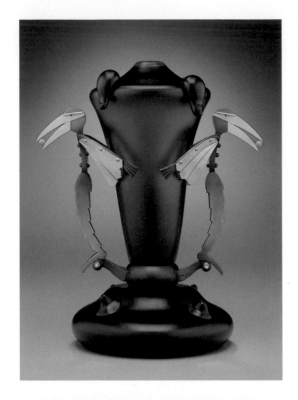

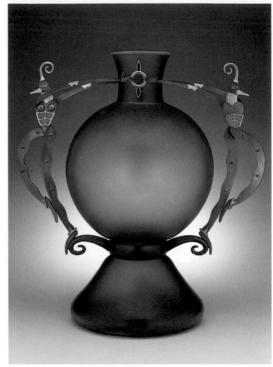

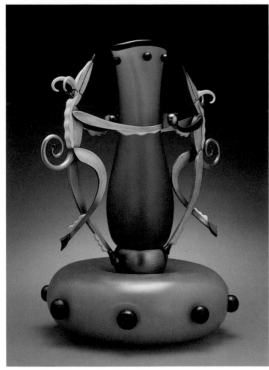

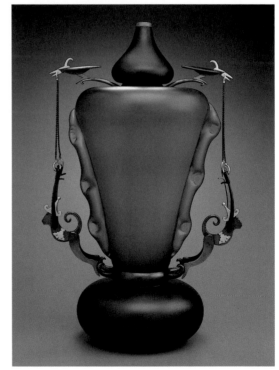

ABOVE LEFT
Bird Men
12H X 10W X 7D"
1998

ABOVE RIGHT
Avian Aerialists
27H X 24W X 13D"
1999

BELOW LEFT
Antelope Dance
18H X 16W X 14D"
1999

BELOW RIGHT
Falcons and Monkeys
28.5H X 18W X 11D"
1998

OPPOSITE
Minotaur
14.5H X 14.5W X 11D"
1997

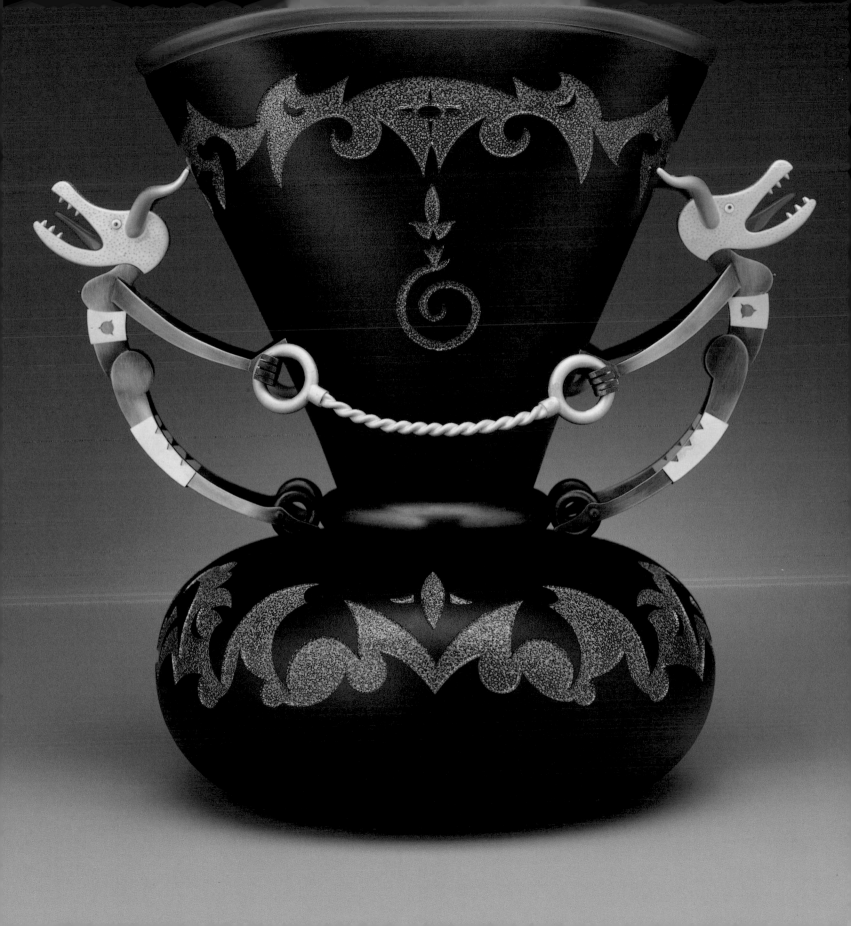

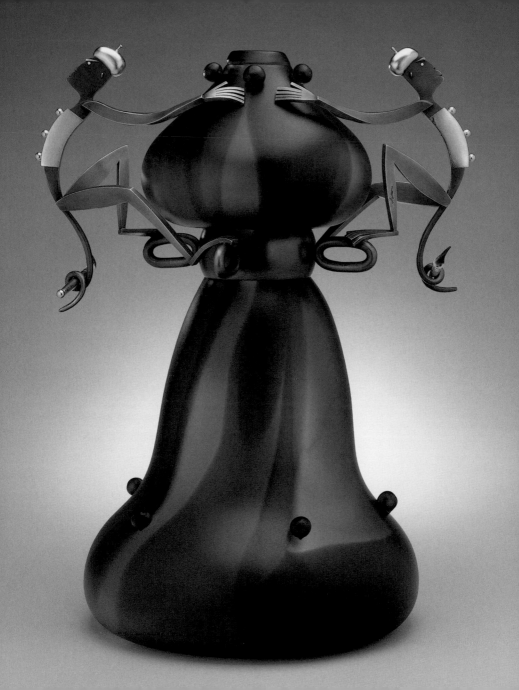

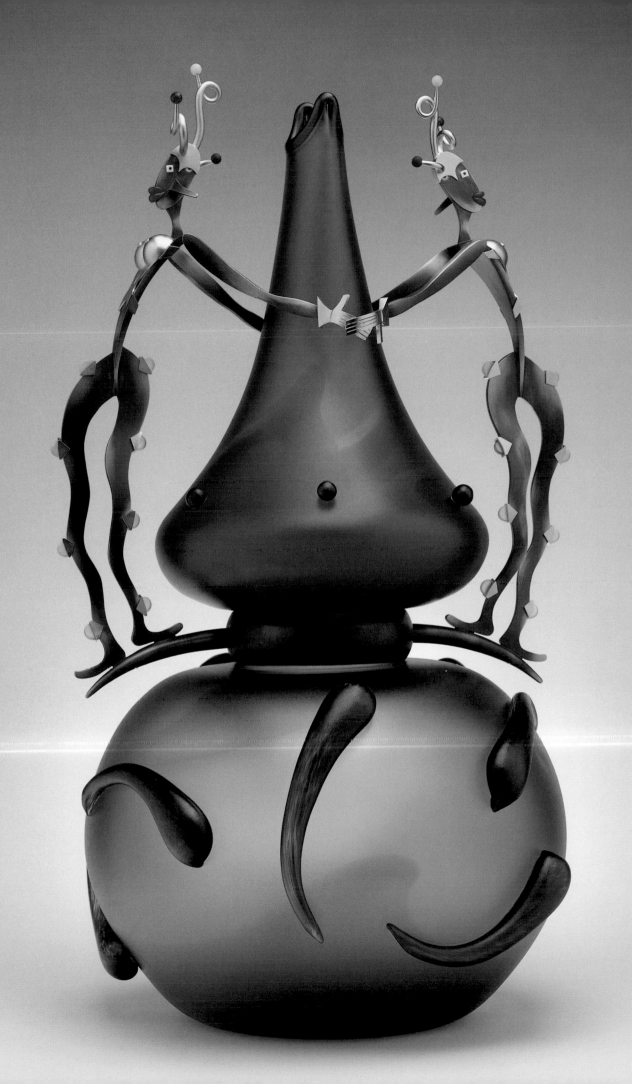

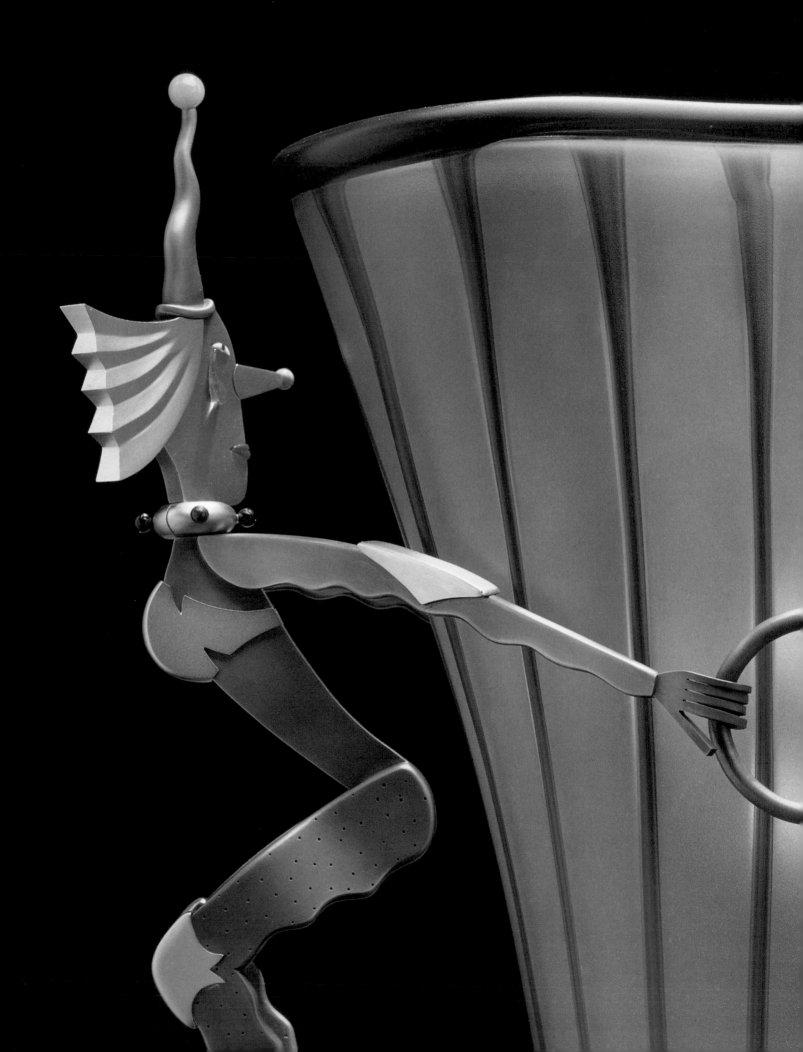

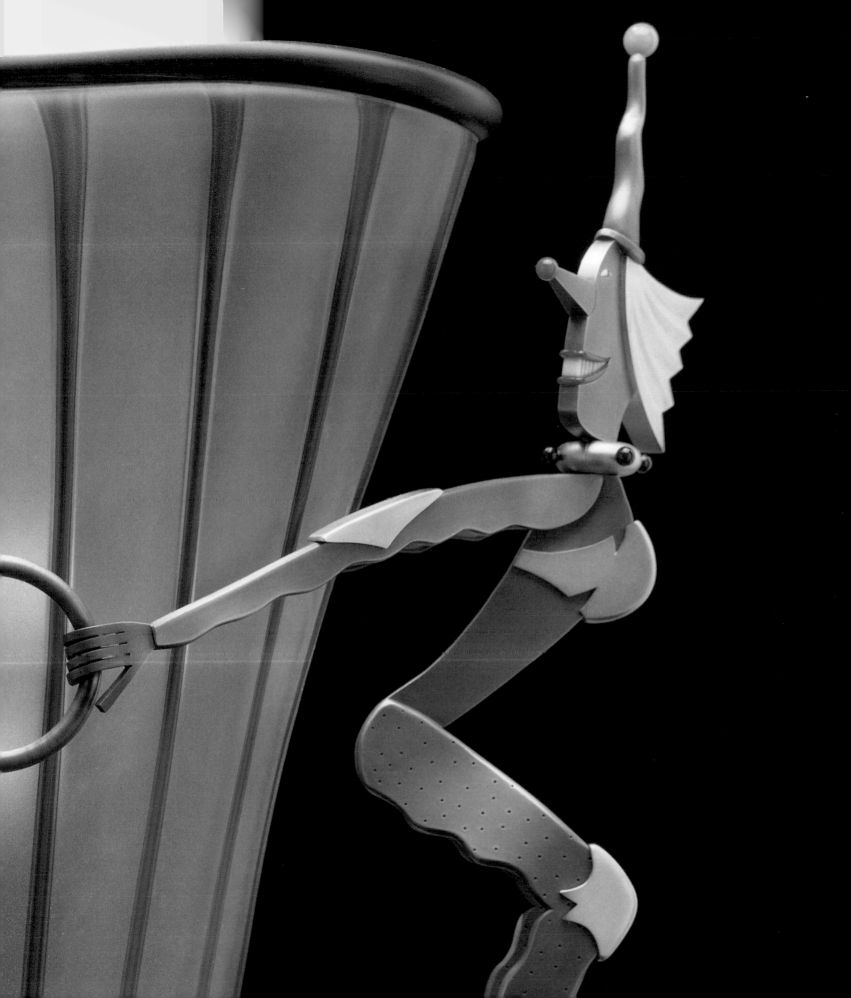

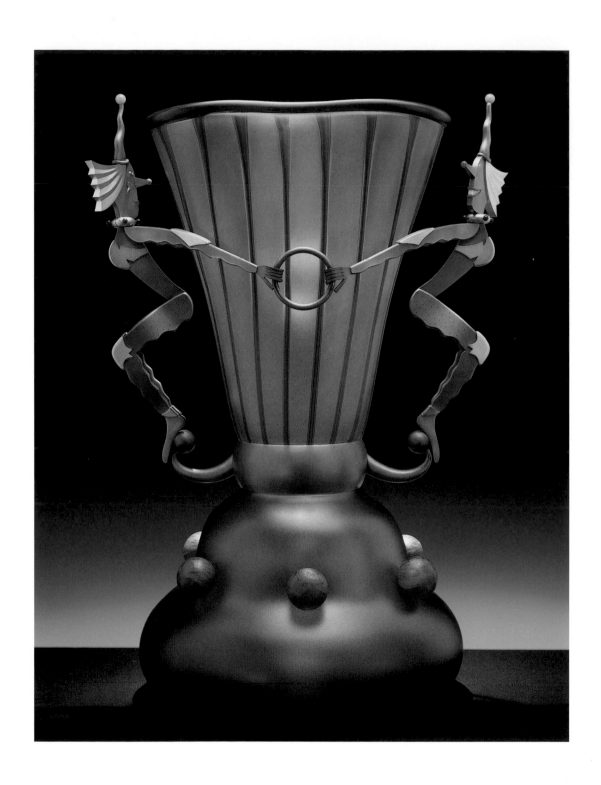

PREVIOUS AND ABOVE
Glee and Remorse
25H X 18W X 18D"
1999

OPPOSITE
Juggling Devils
16.25H X 15.25W X 13D"
1999

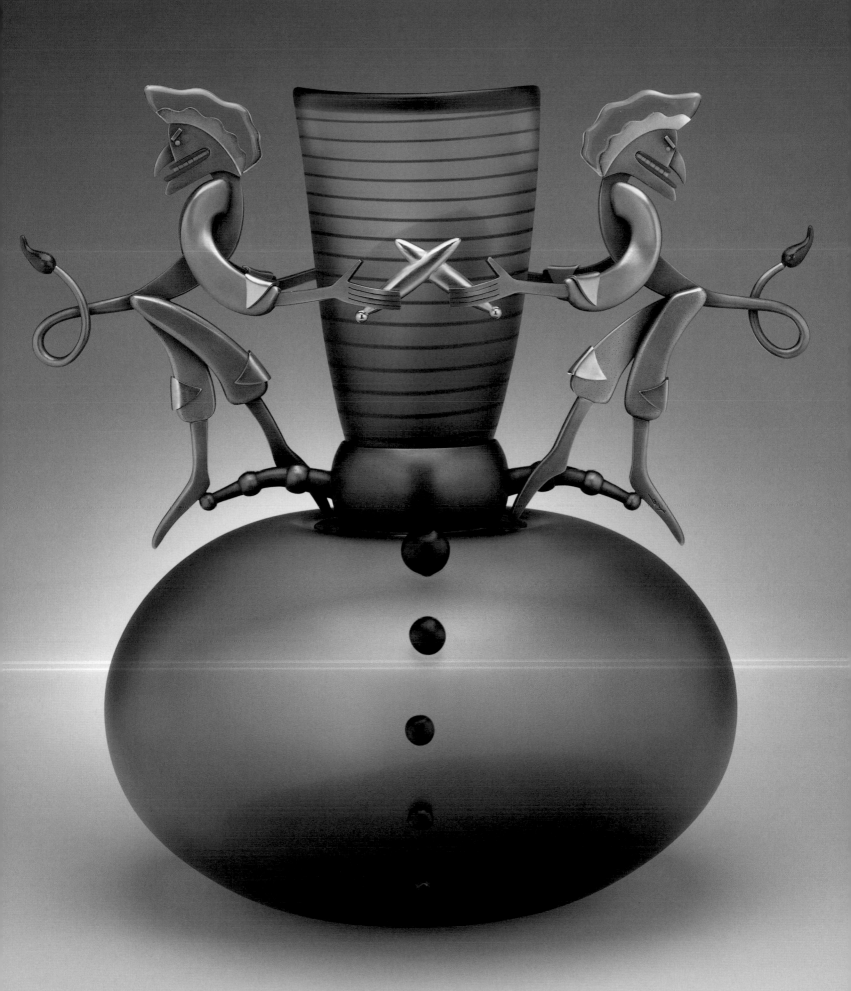

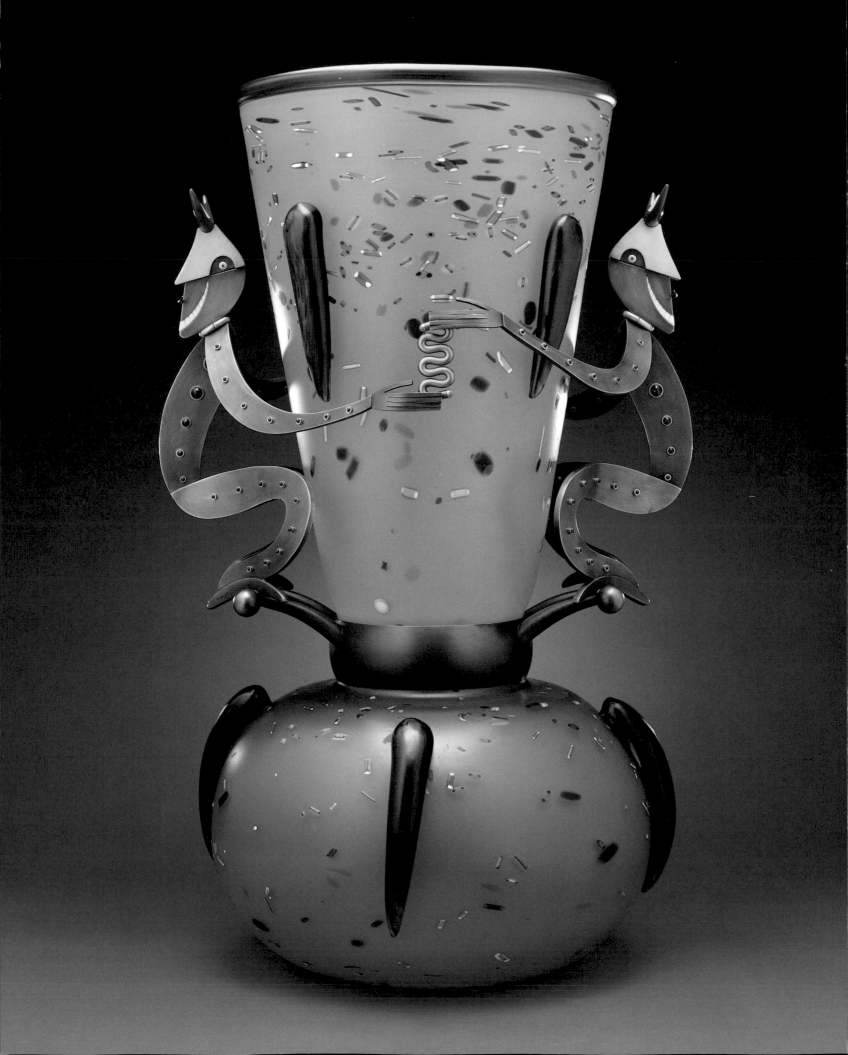

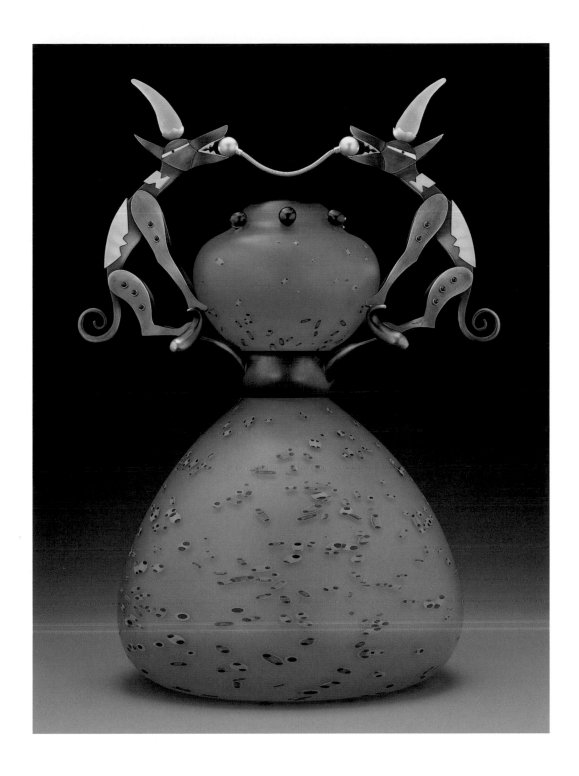

OPPOSITE
Zany Actors
27H X 17W X 14D"
1999

ABOVE
Tug of Dogs
18H X 15W X 15D"
1999

237

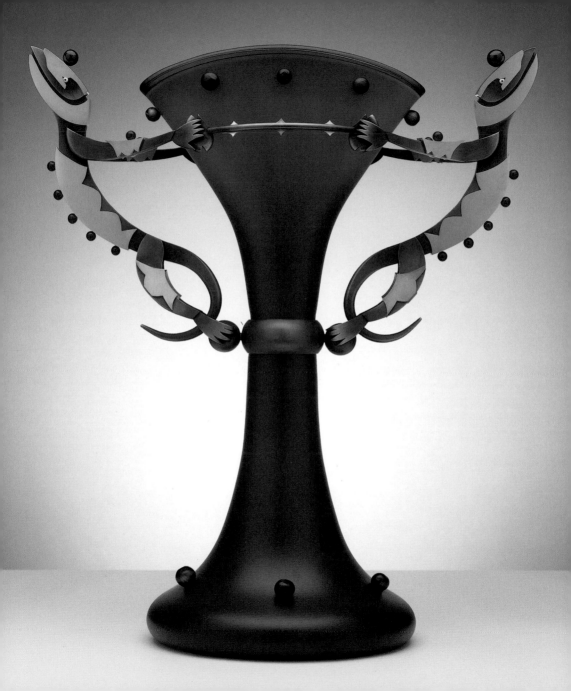

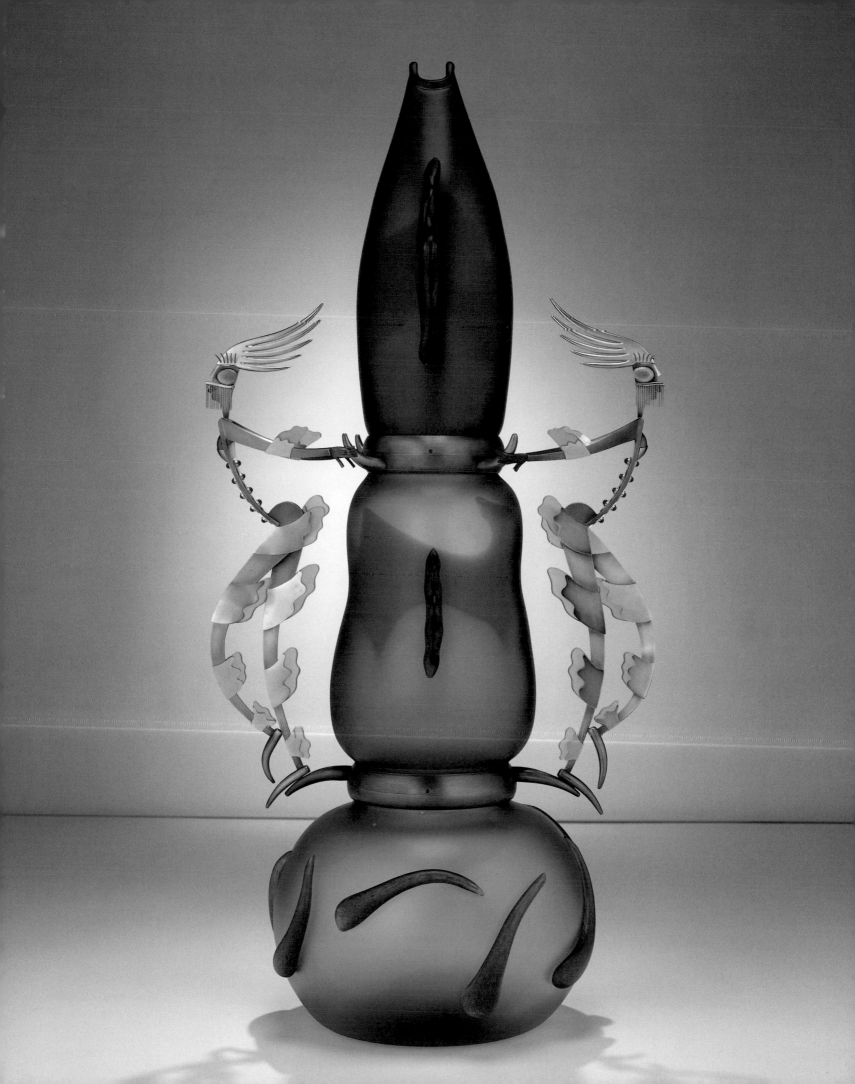

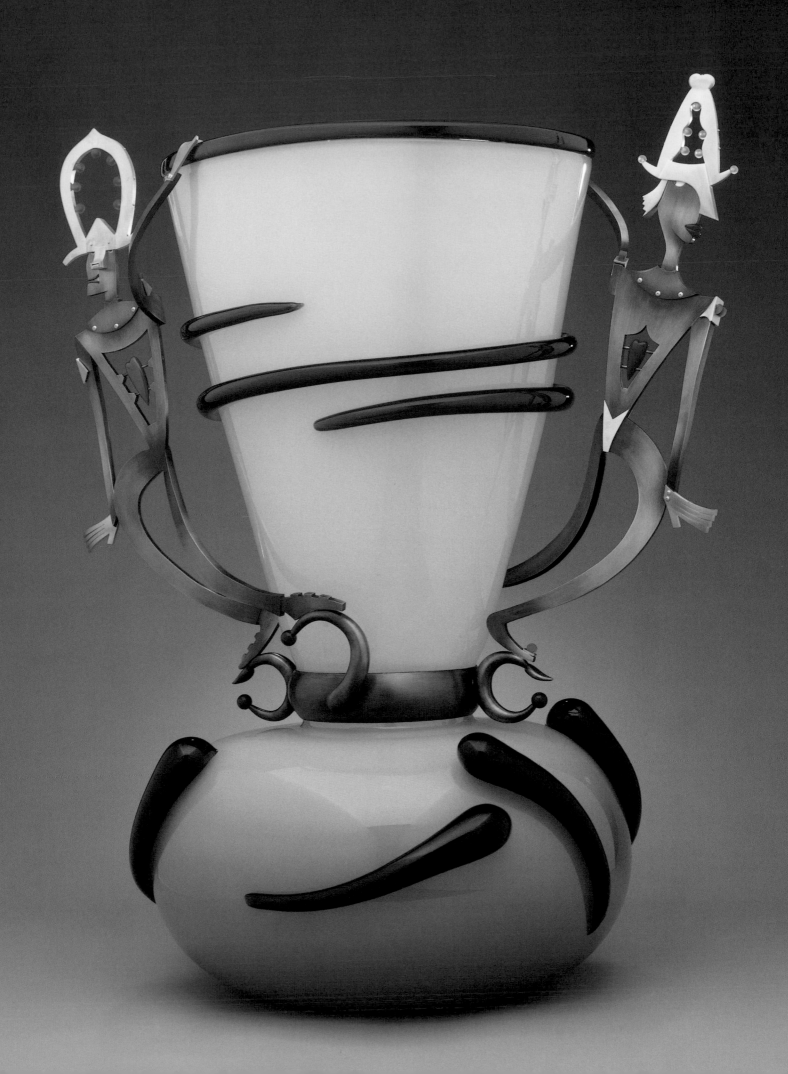

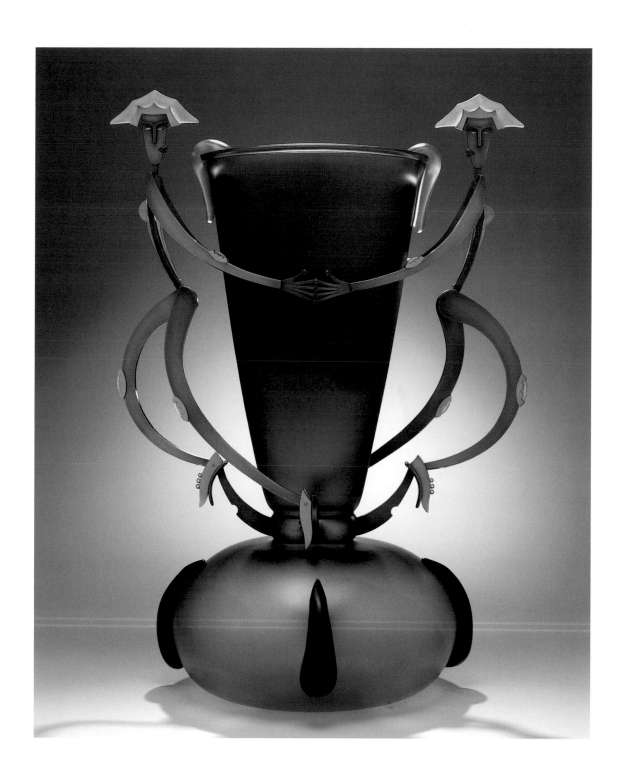

OPPOSITE
Circus Lovers
30H X 22.5W X 18D"
2000

ABOVE
Queens of Guile
31H X 21W X 17D"
2000

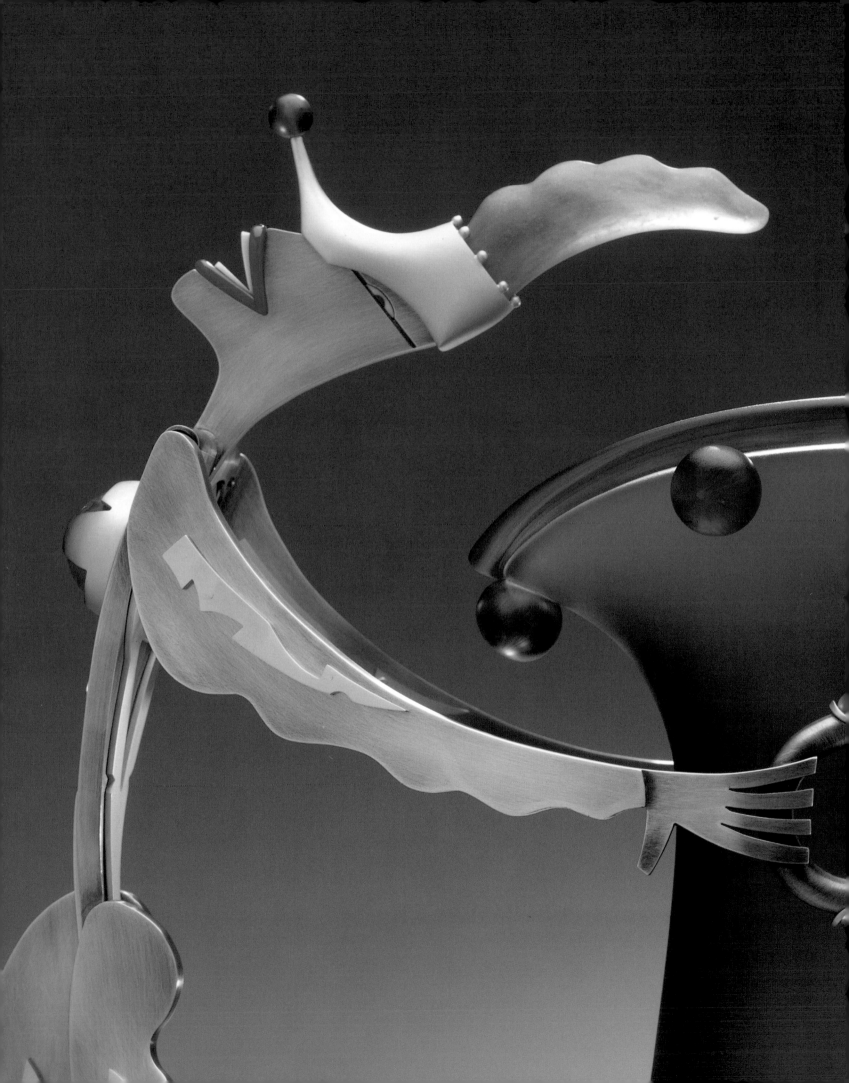

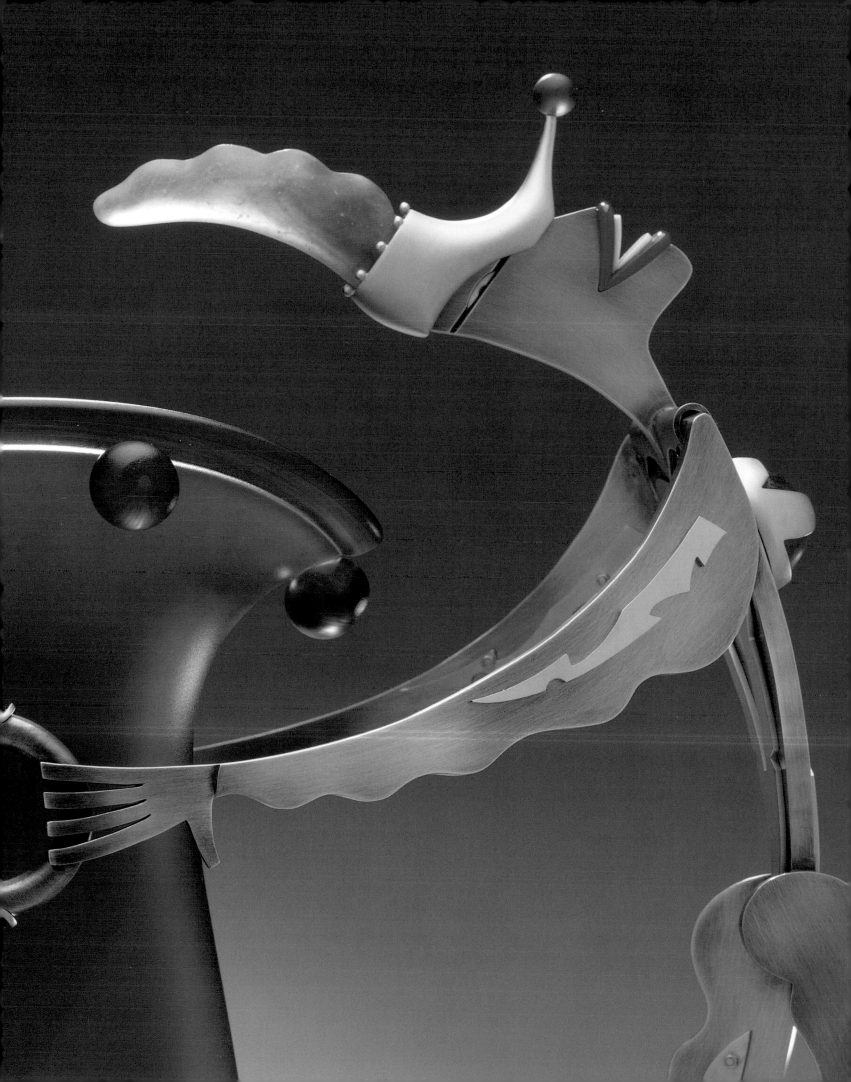

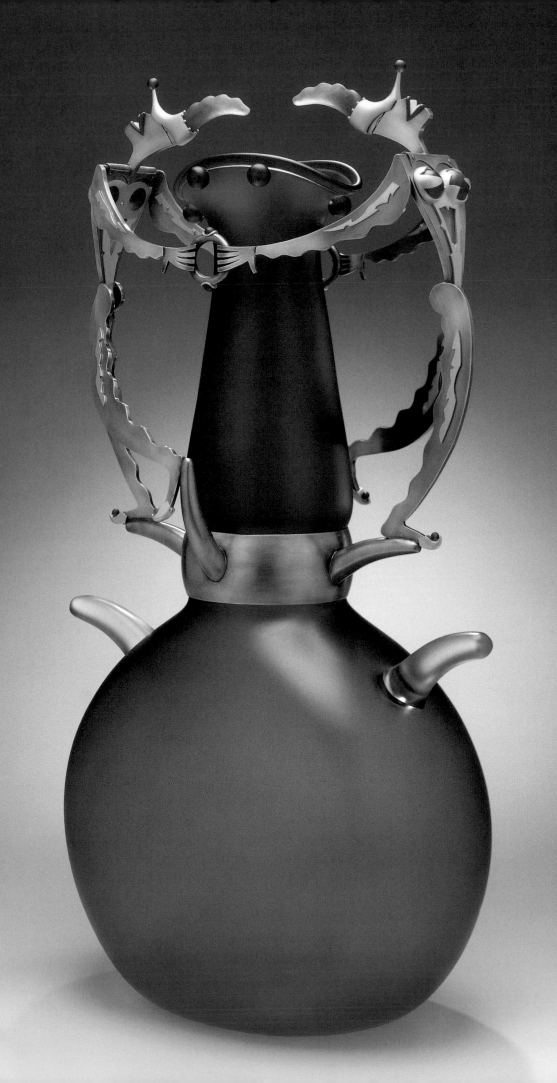

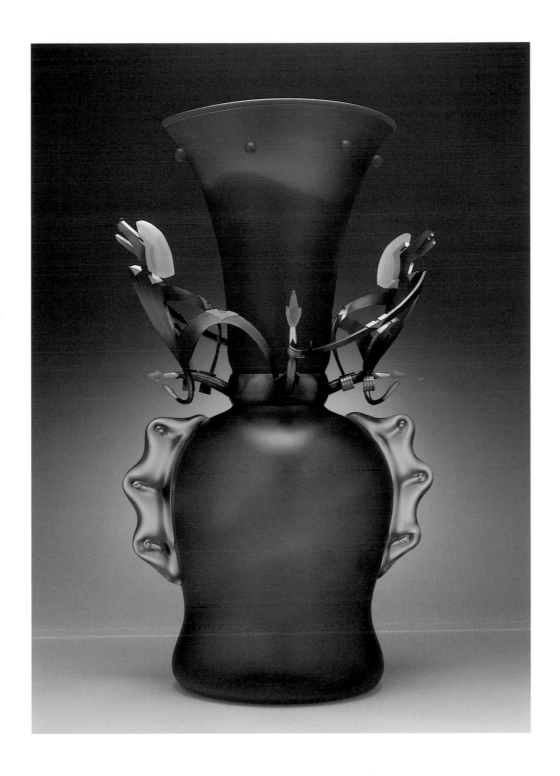

PREVIOUS AND OPPOSITE
Chanteuses
34H x 18W x 10D"
2000

ABOVE
Golden Baboons
36H x 26W x 15D"
2000

247

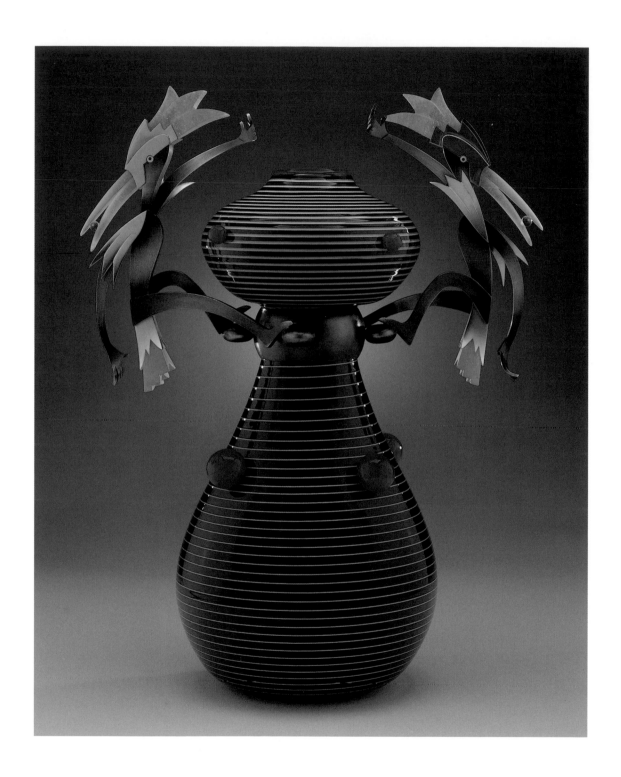

ABOVE
Harlequins
18H X 13W X 8D"
2000

OPPOSITE
The Good Grandees
34H X 19.5W X 14D"
2000

248

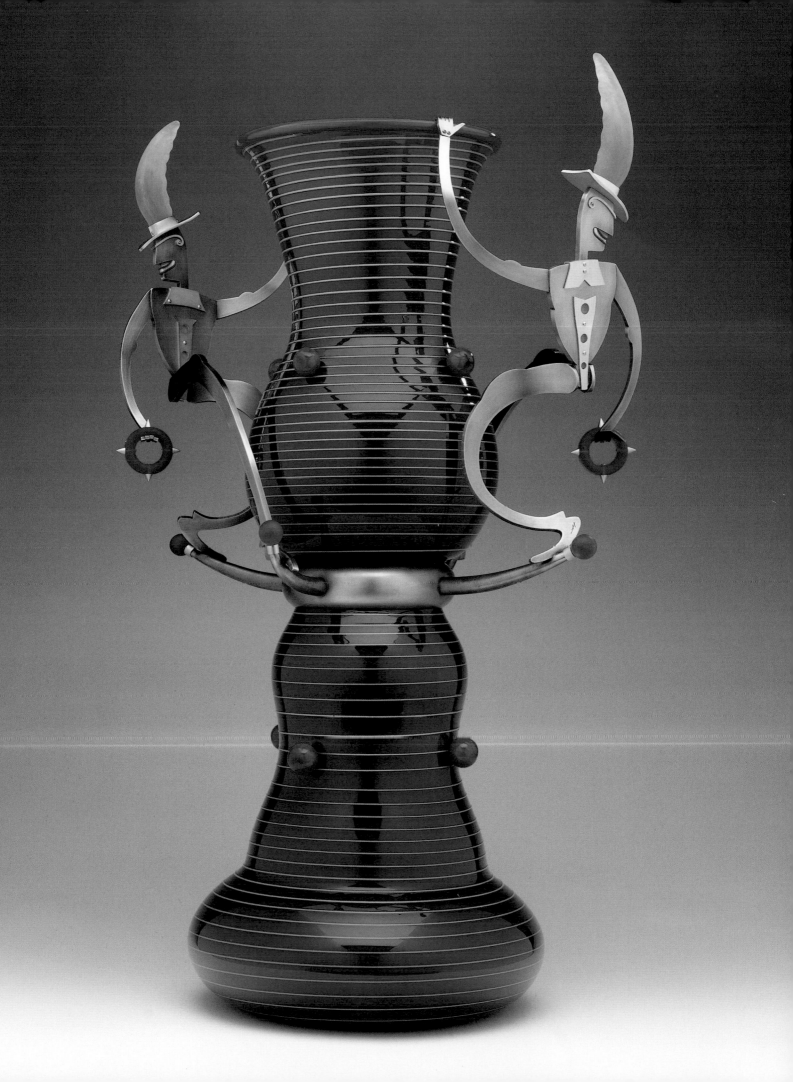

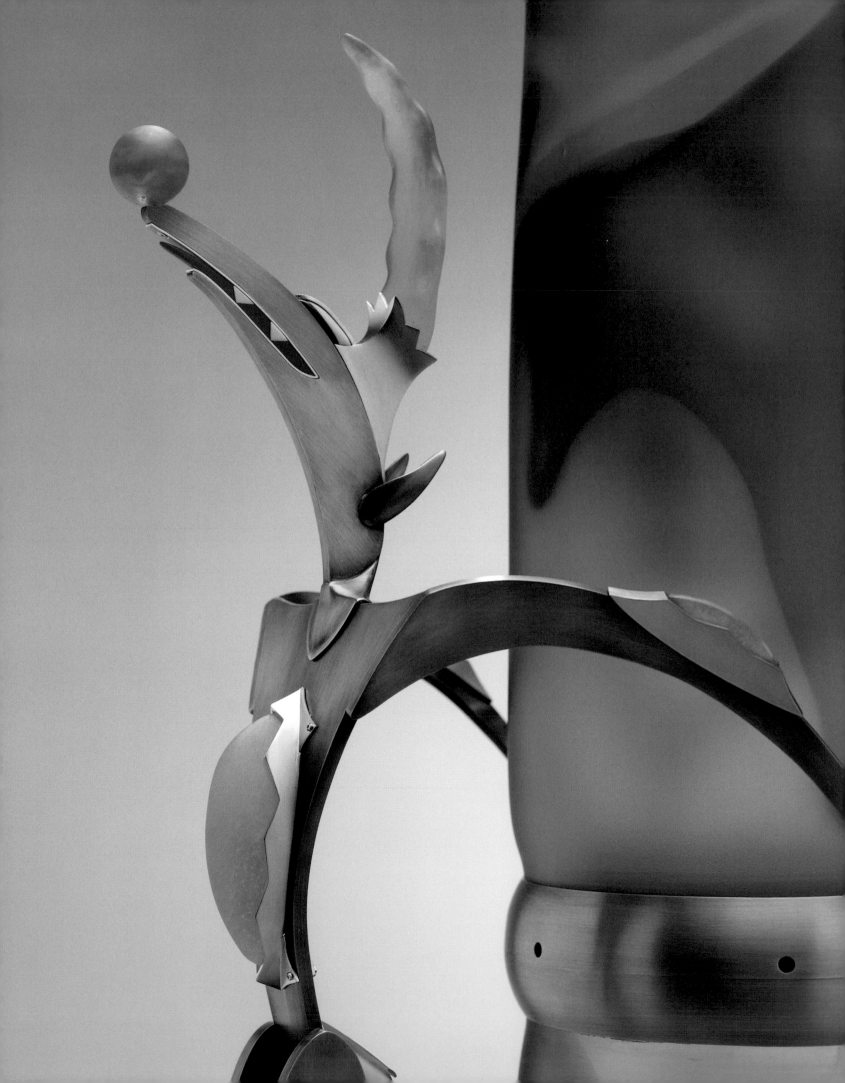

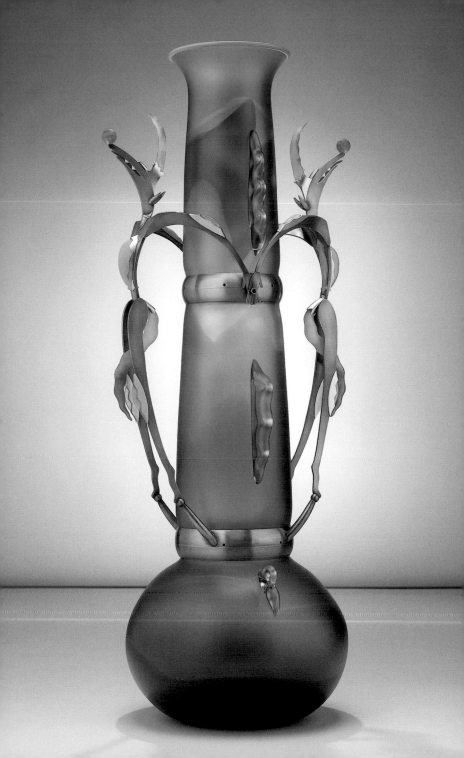

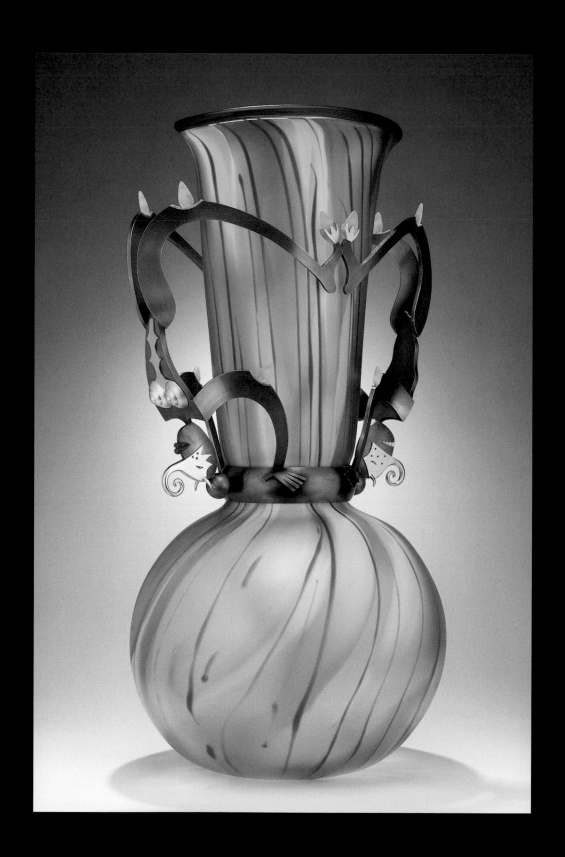

Tumbling Devils
30H X 19W X 15D"
2000

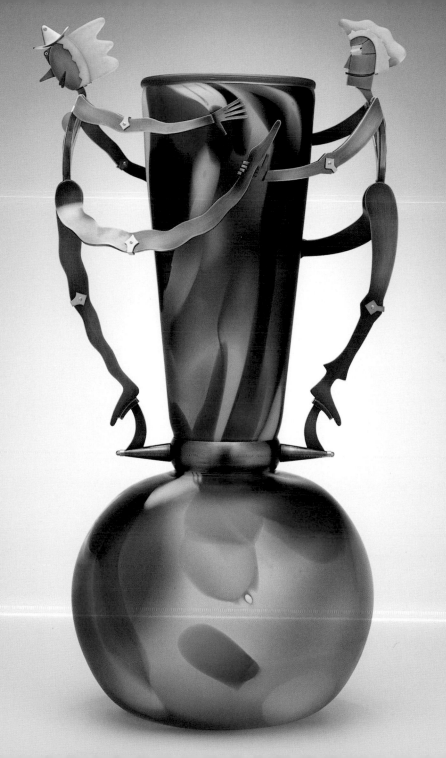

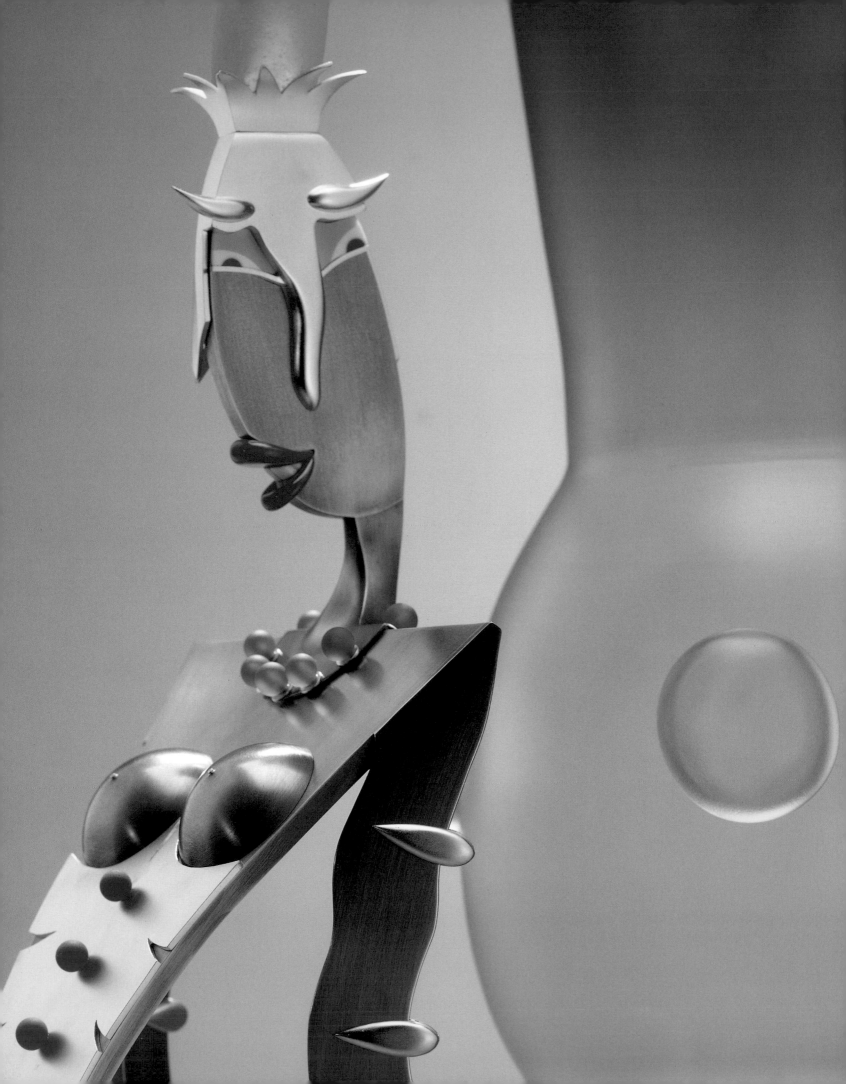

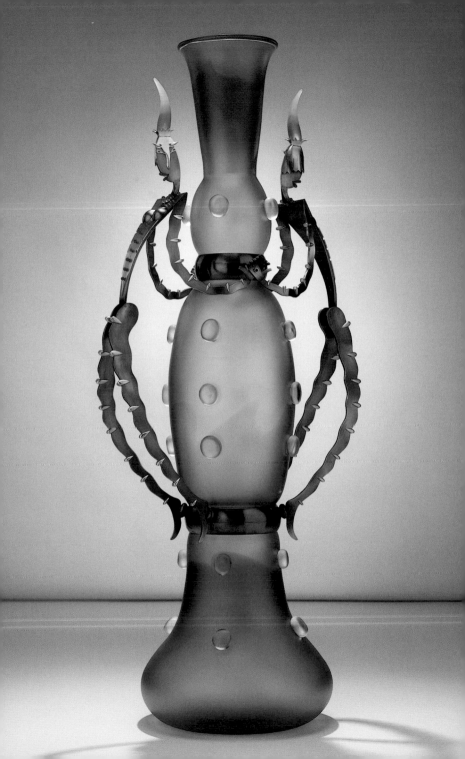

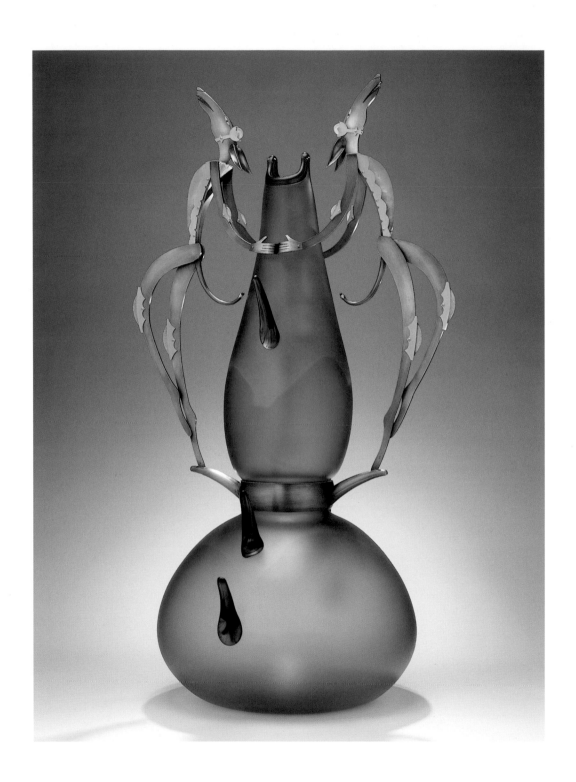

ABOVE
Dog Pageant
42H X 22.5W X 17D"
2001

OPPOSITE
Musicians
30H X 19.5W X 14D"
2001

256

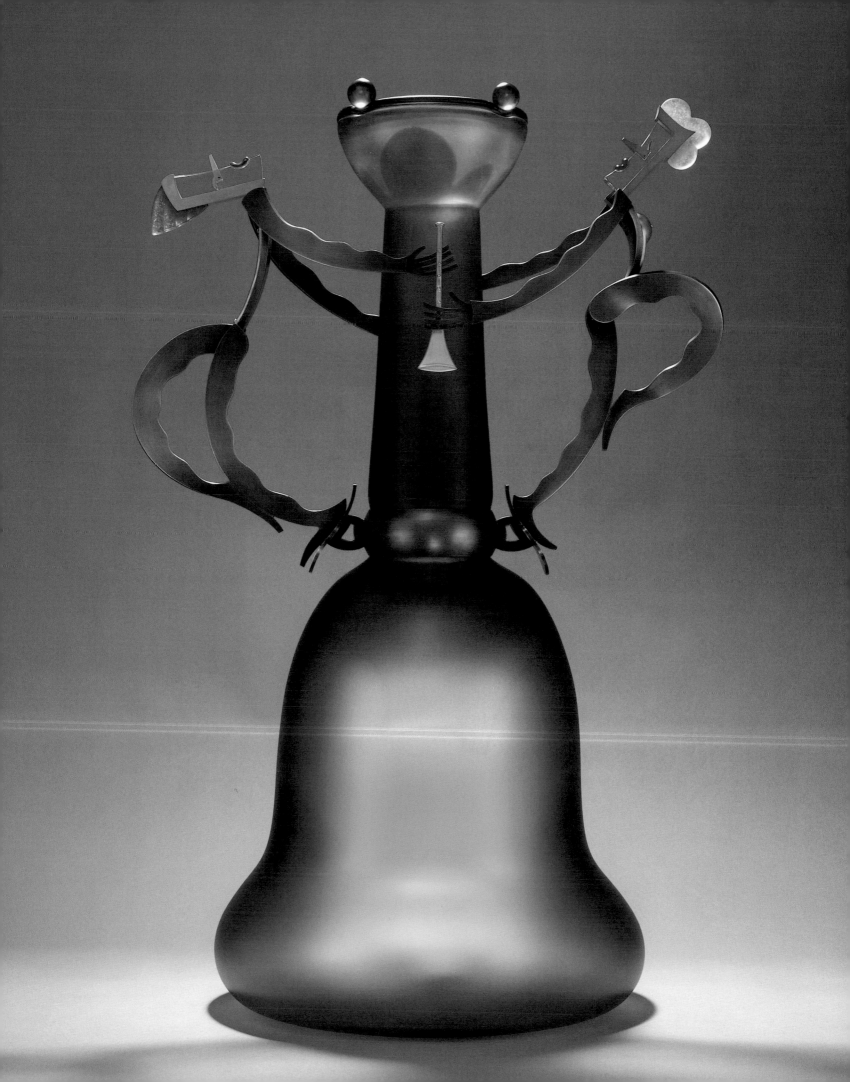

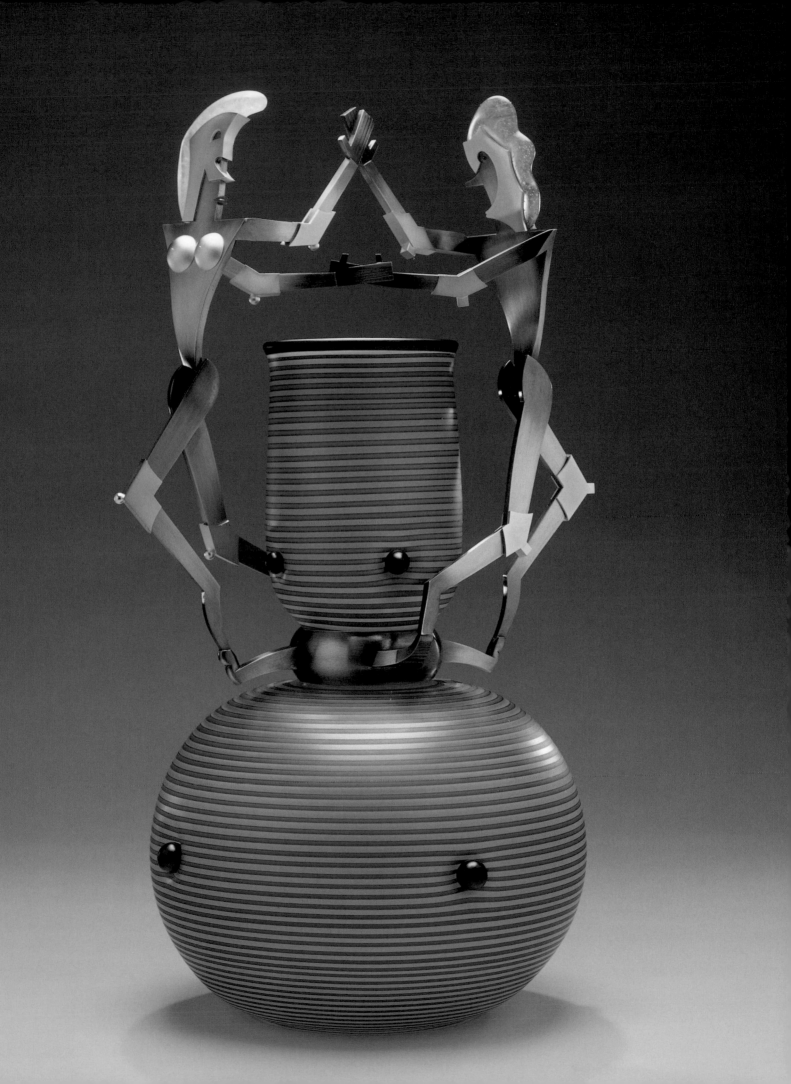

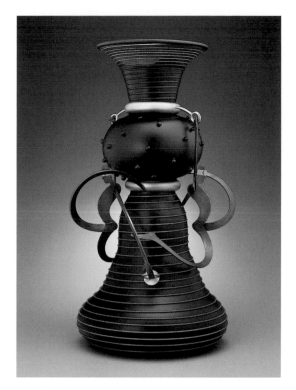

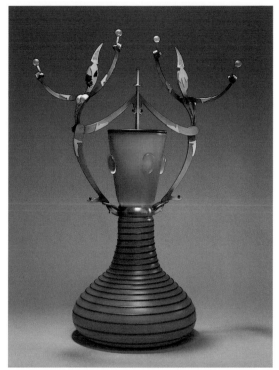

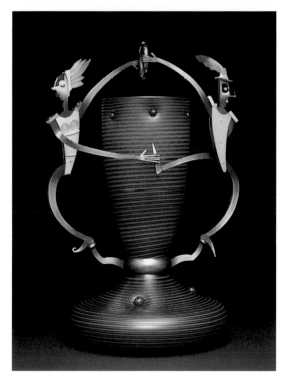

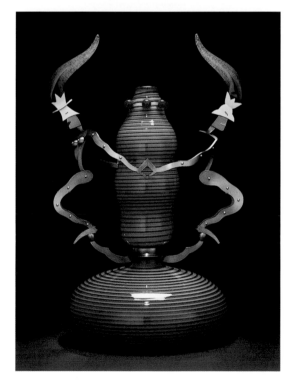

OPPOSITE
Pantomime
16H X 11.5W X 9.5D"
2002

ABOVE LEFT
Human Pretzels
26.5H X 15.5W X 13.75D"
1997

ABOVE RIGHT
Trance
35H X 24W X 15D"
2001

BELOW LEFT
Hoopla
22H X 14.5W X 10.5D"
2001

BELOW RIGHT
Bittersweet
20H X 13W X 11D"
2003

259

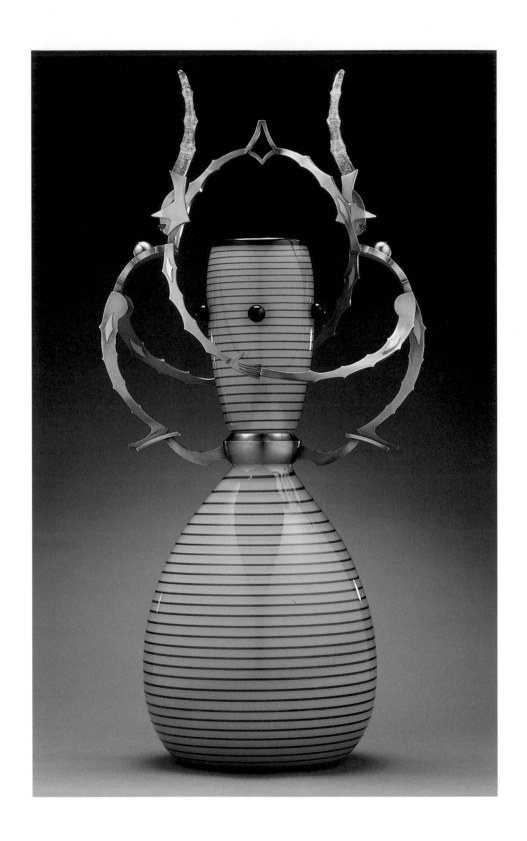

ABOVE
Transfixion
23.5H X 11W X 8D"
2003

OPPOSITE
Sparklers
30H X 17W X 15D"
2003

260

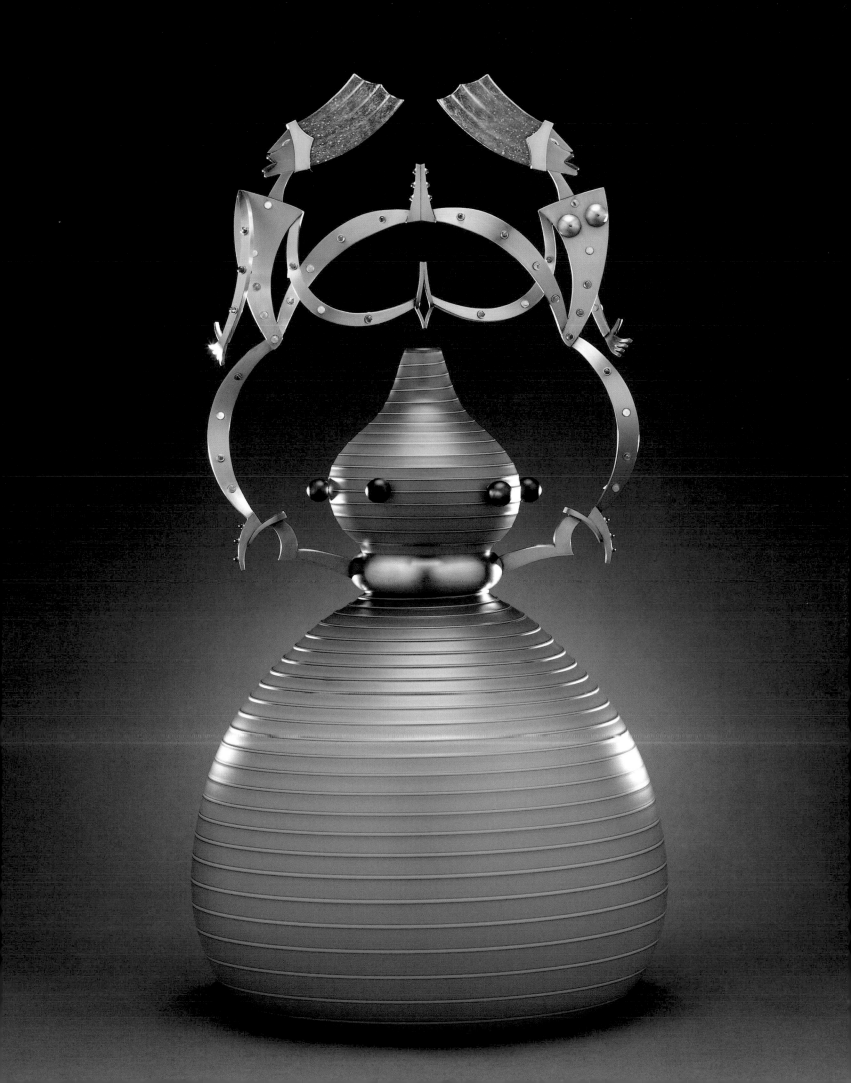

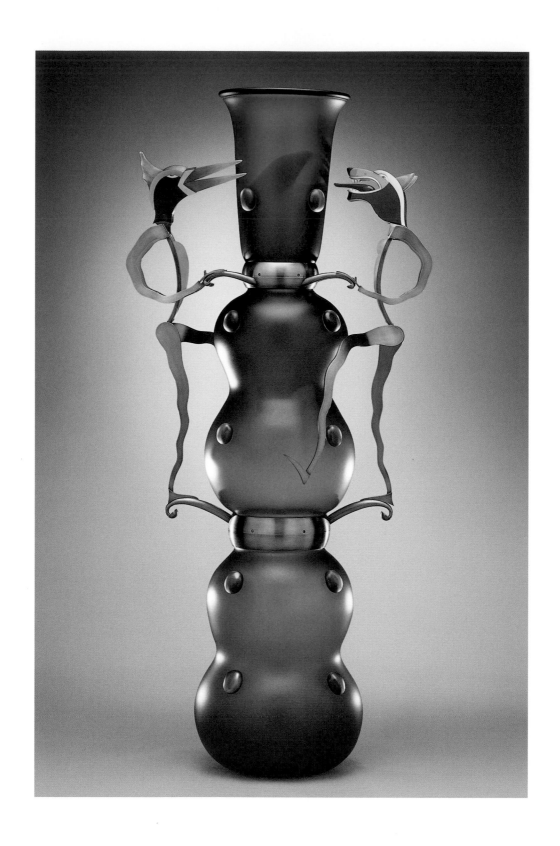

ABOVE AND OPPOSITE
Passion
55.5H X 26W X 15D"
2003

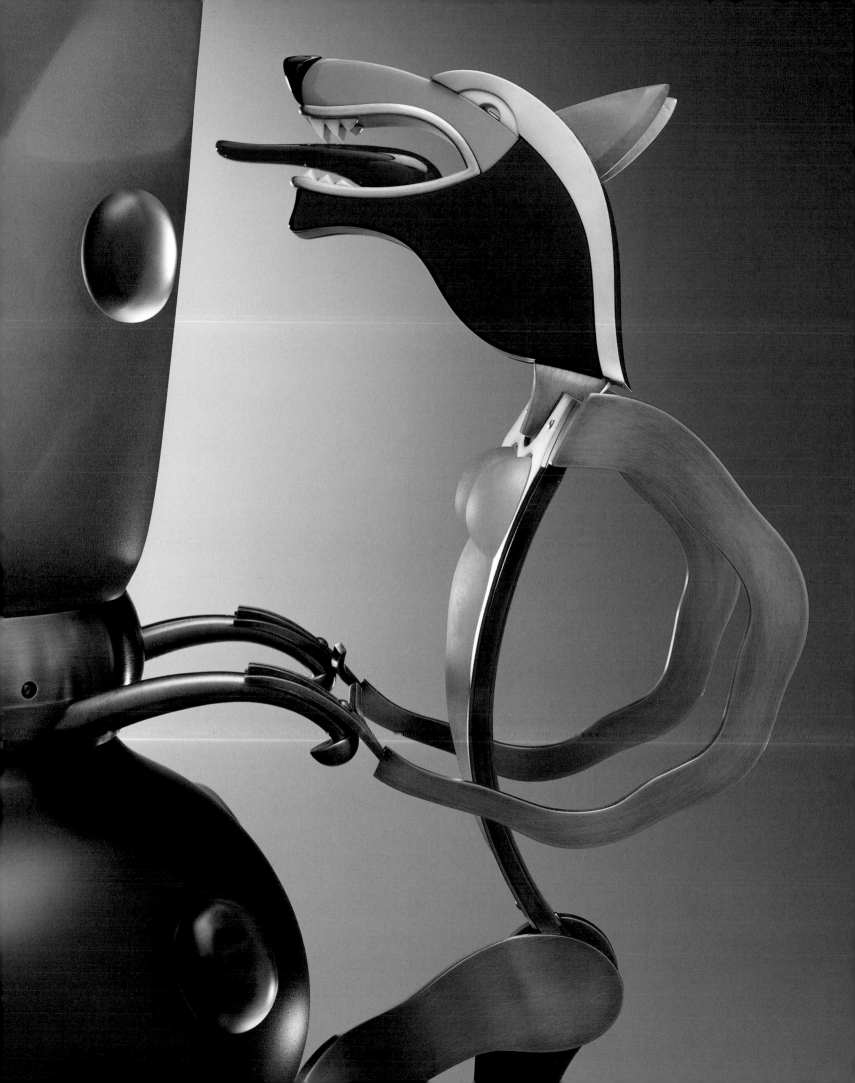

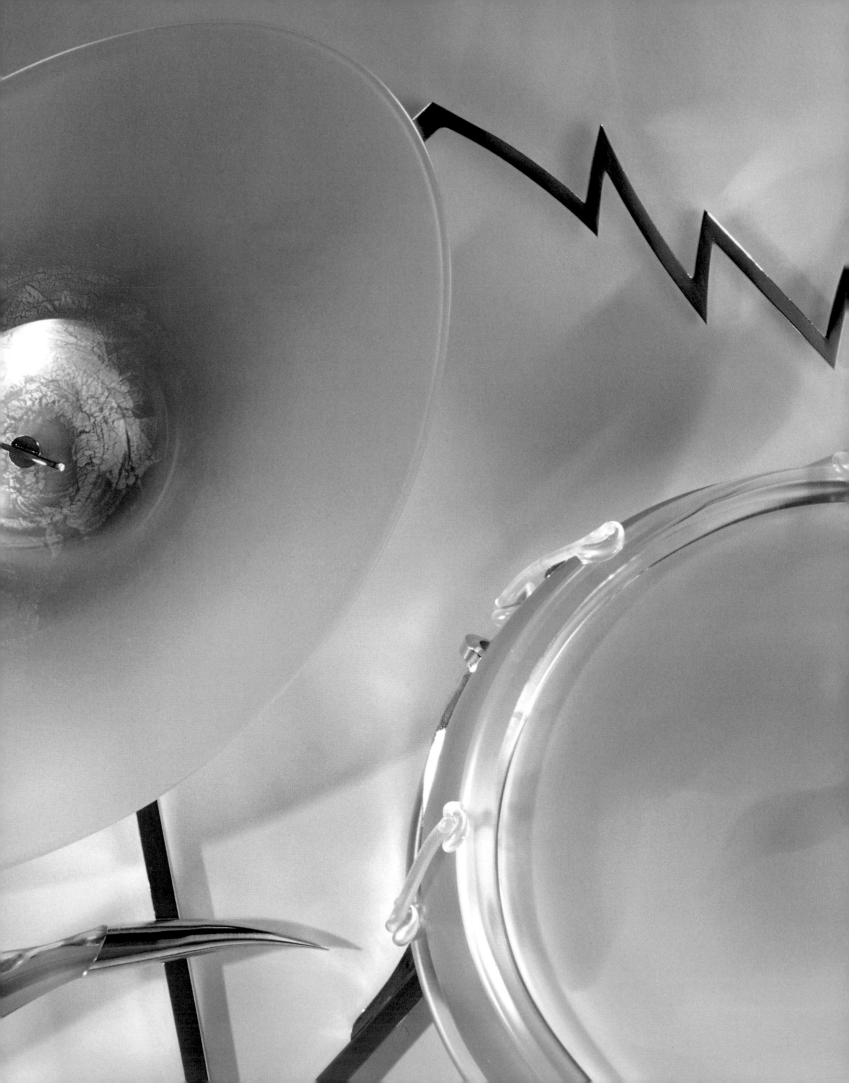

FABRICATED MUSIC

2001 – 2003

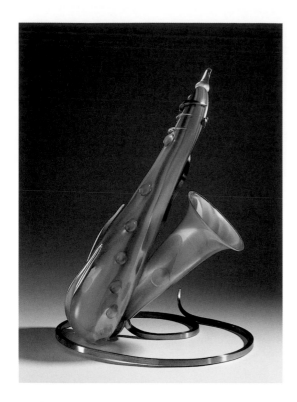

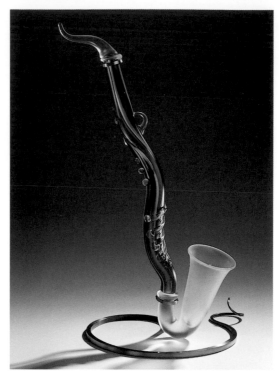

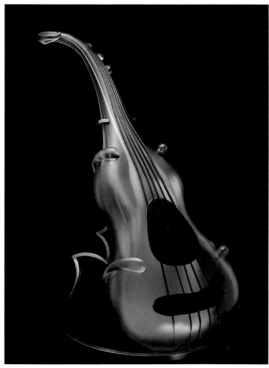

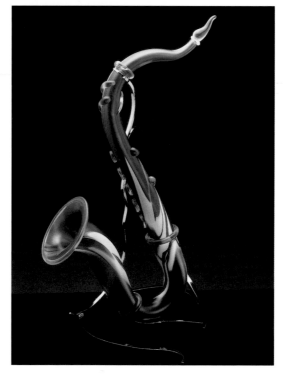

PREVIOUS
Paradiddle (detail)
31H X 62W X 5D"
2002

ABOVE LEFT
Tender
27H X 20W X 18D"
2001

ABOVE RIGHT
Featherfall
33H X 20W X 20D"
2001

BELOW LEFT
Colortone
24H X 16W X 21D"
2002

BELOW RIGHT
Synthesis
28H X 13W X 20D"
2002

266

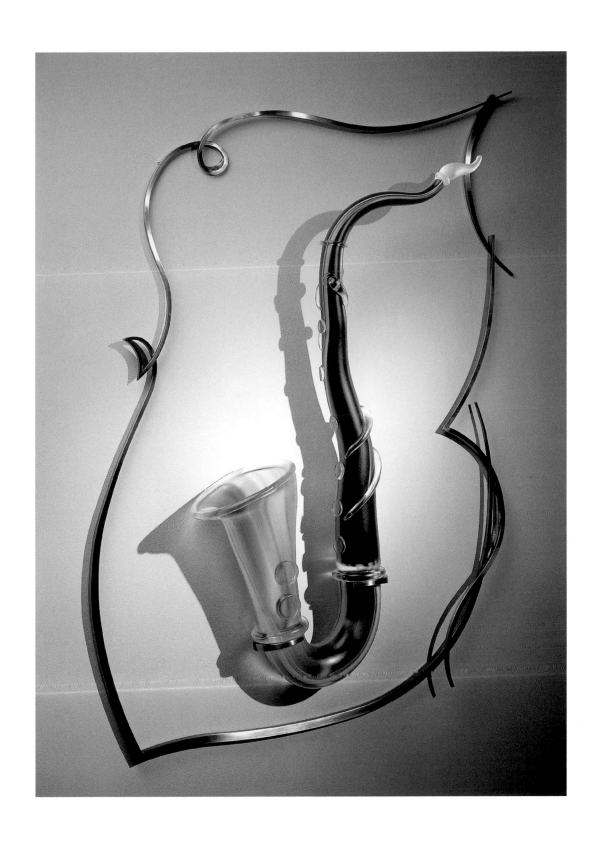

ABOVE

Wistful
42H X 26W X 6D"
2003

FOLLOWING

My Favorite Things
32H X 48.5W X 7.5D"
2001

267

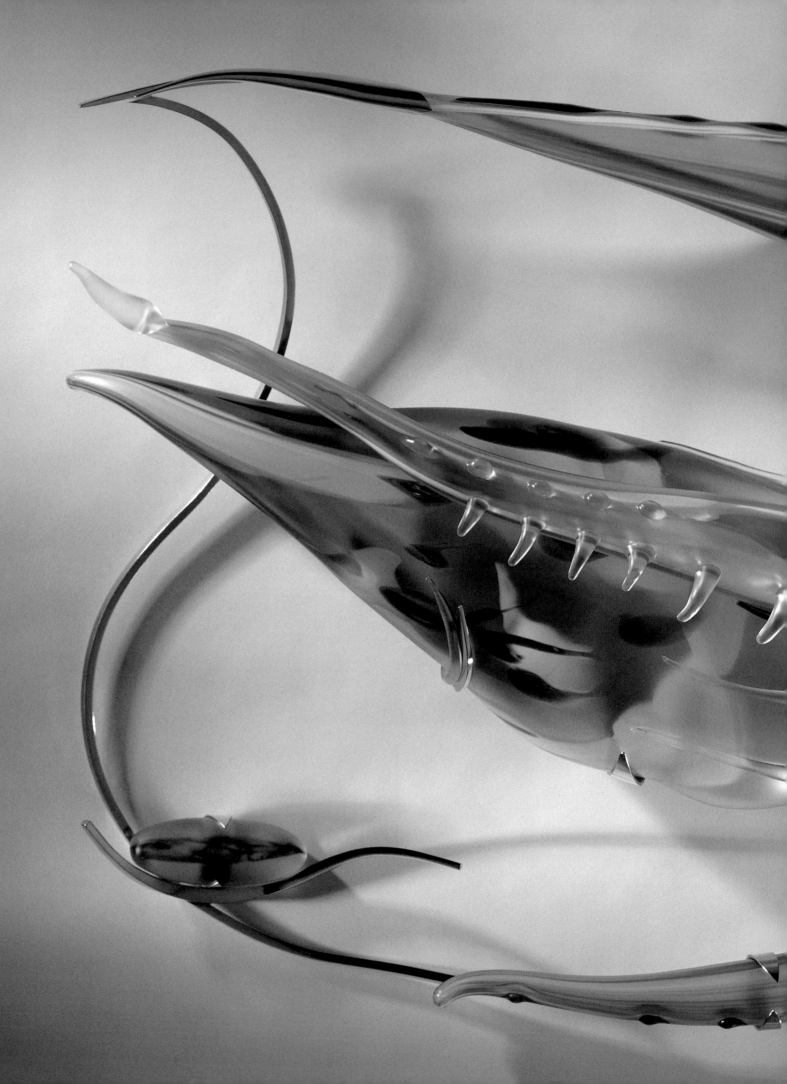

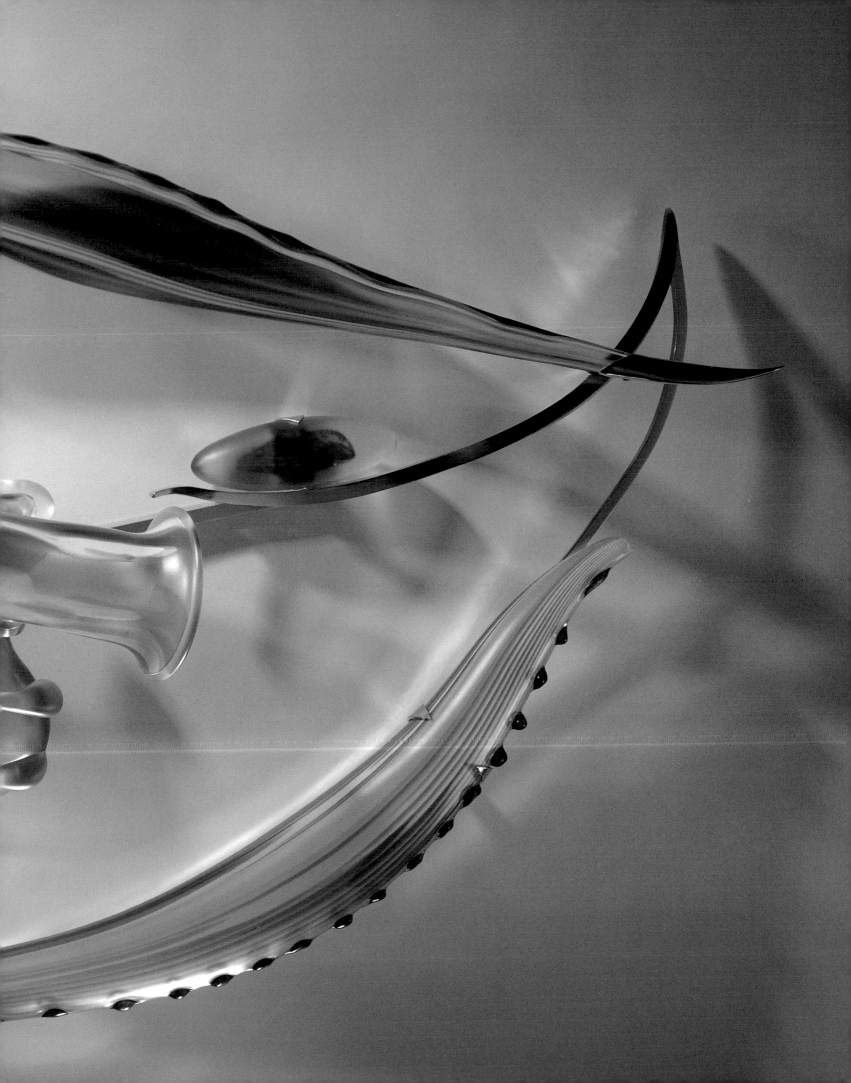

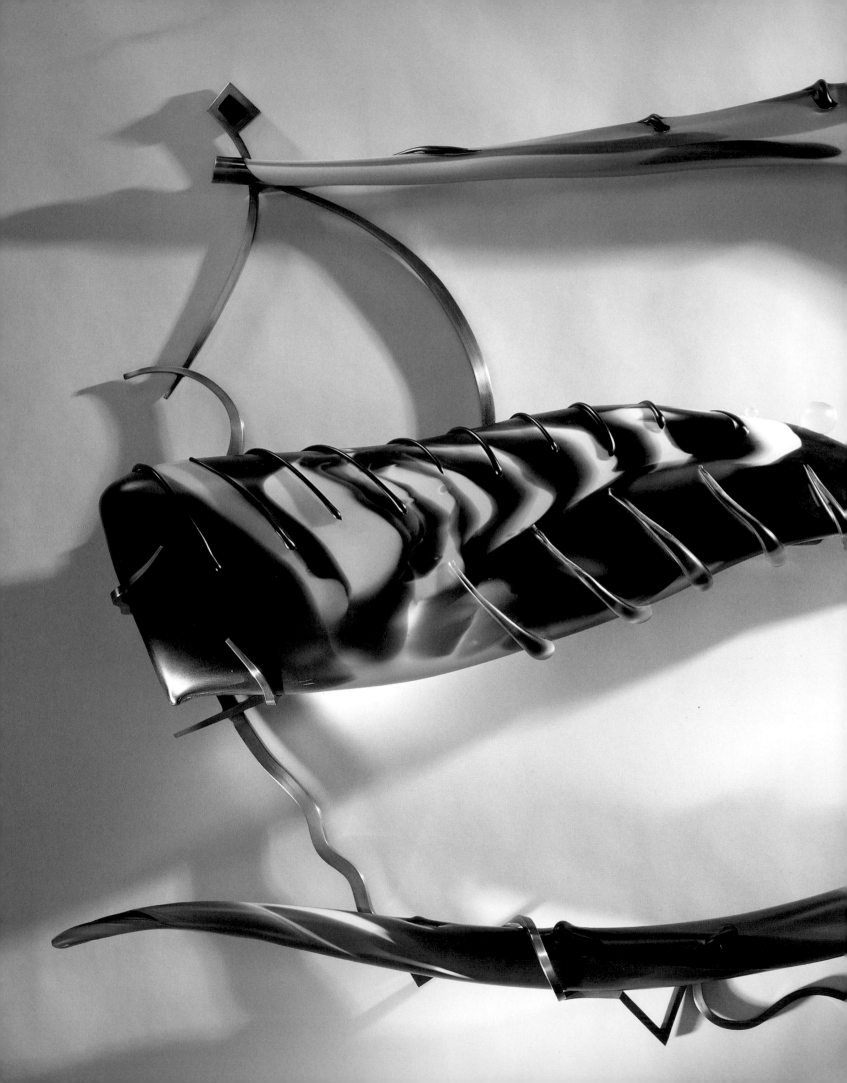

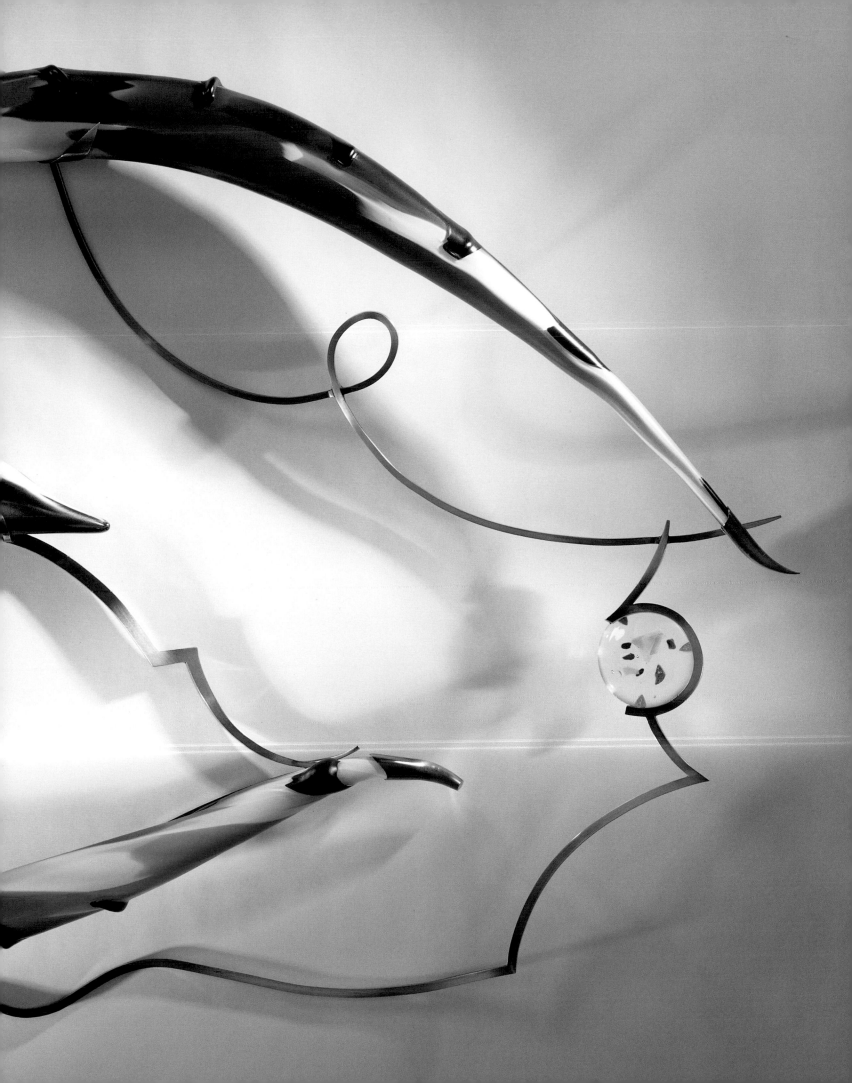

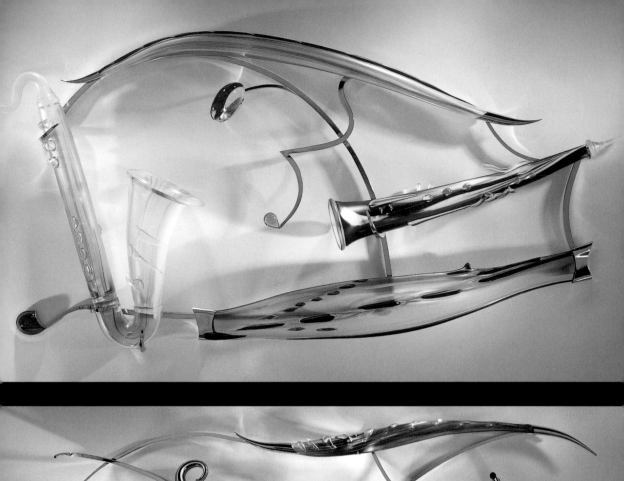

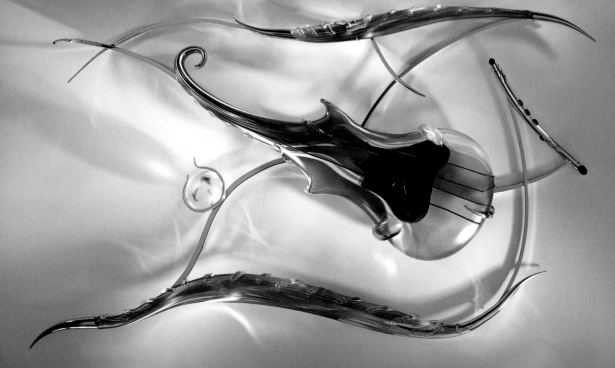

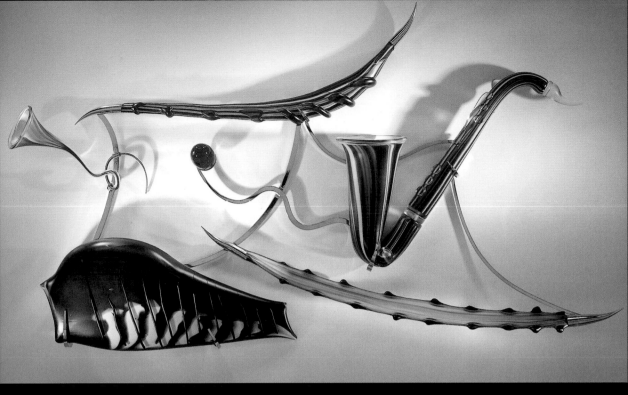

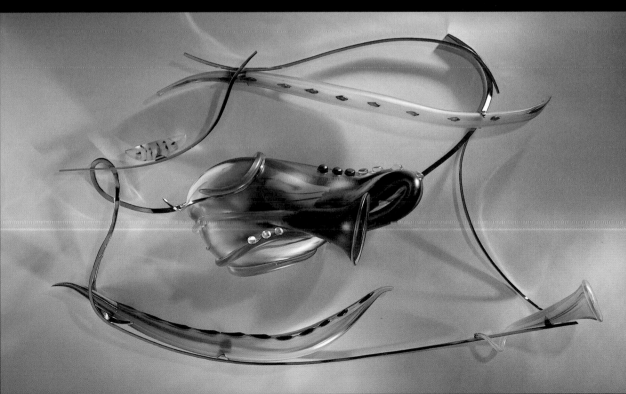

ABOVE
Sum Sum
33H X 55.5W X 7.5D"
2002

BELOW
All Blues
33H X 54.5W X 7.5D"
2001

FOLLOWING
Four on Six
32H X 51W X 6.5D"
2001

PAGE 276
Ralph's New Blues
32H X 51W X 5.5D"
2001

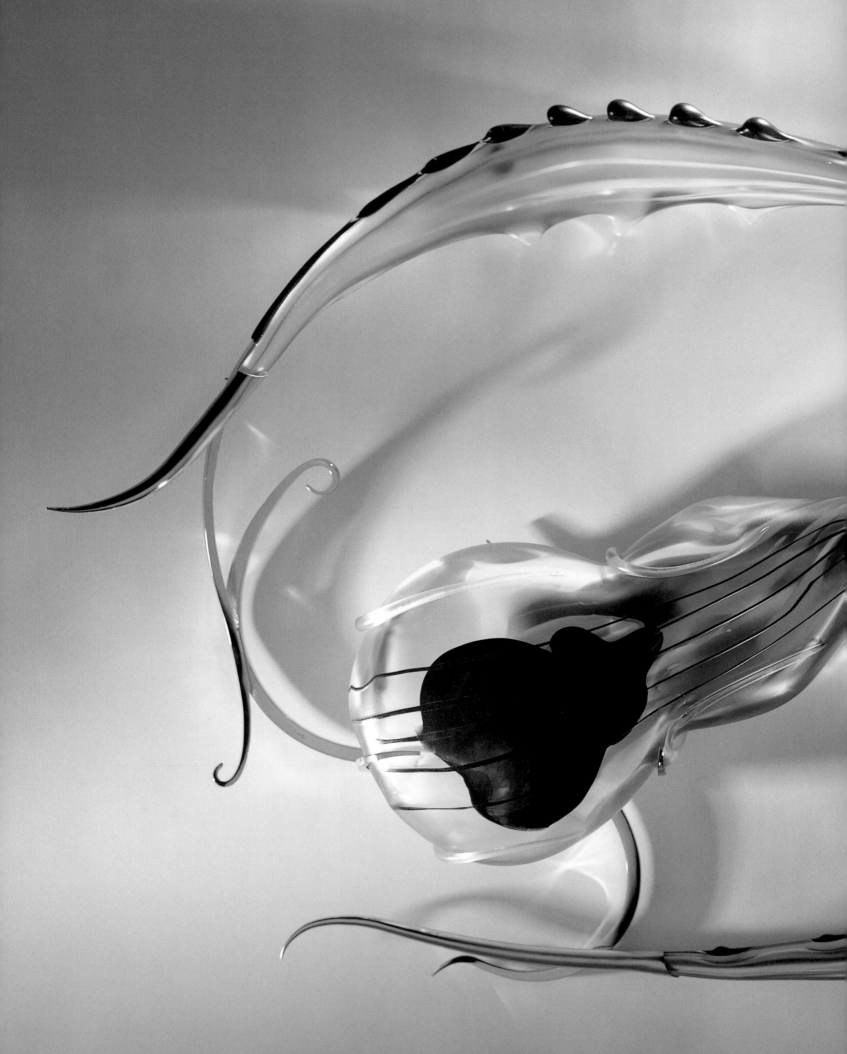

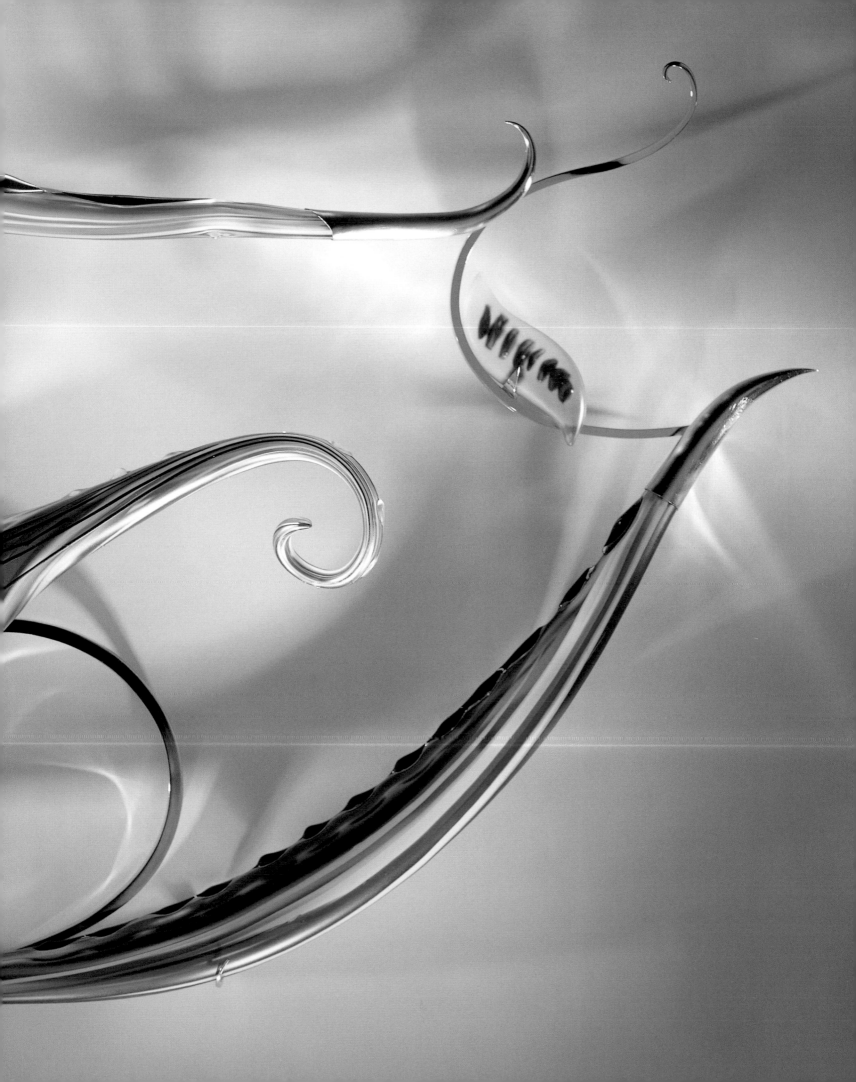

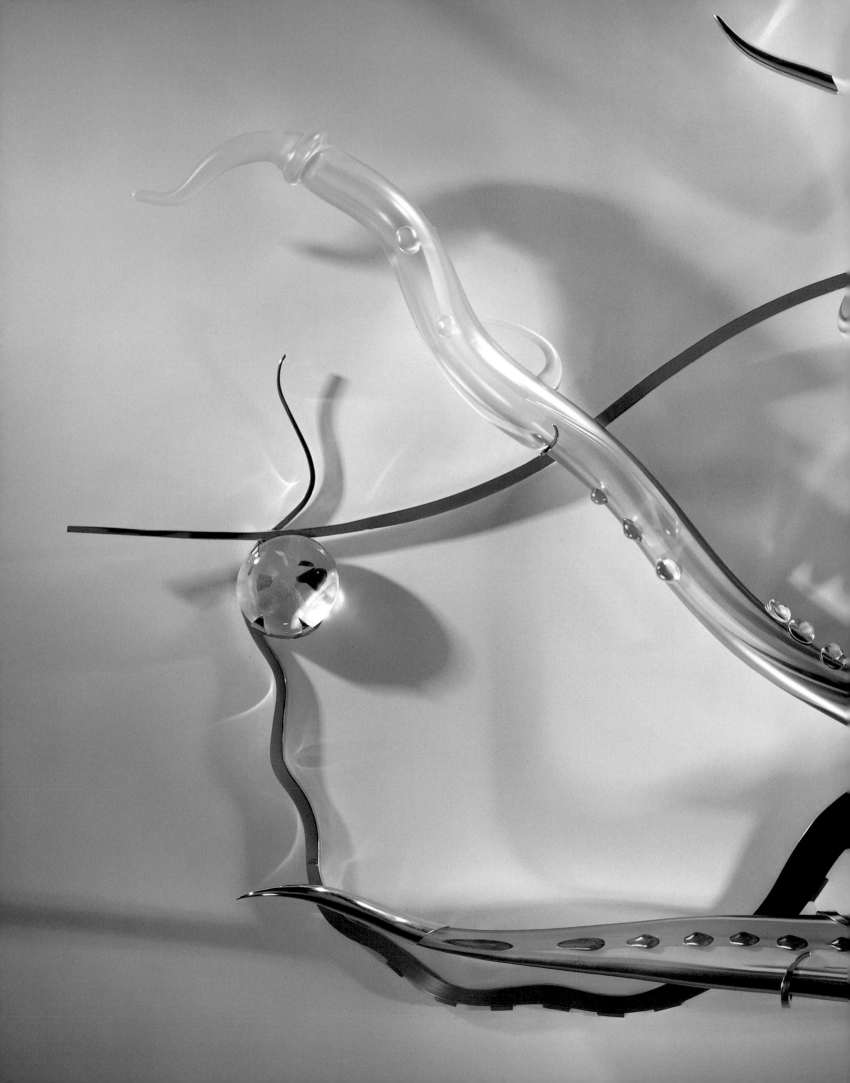

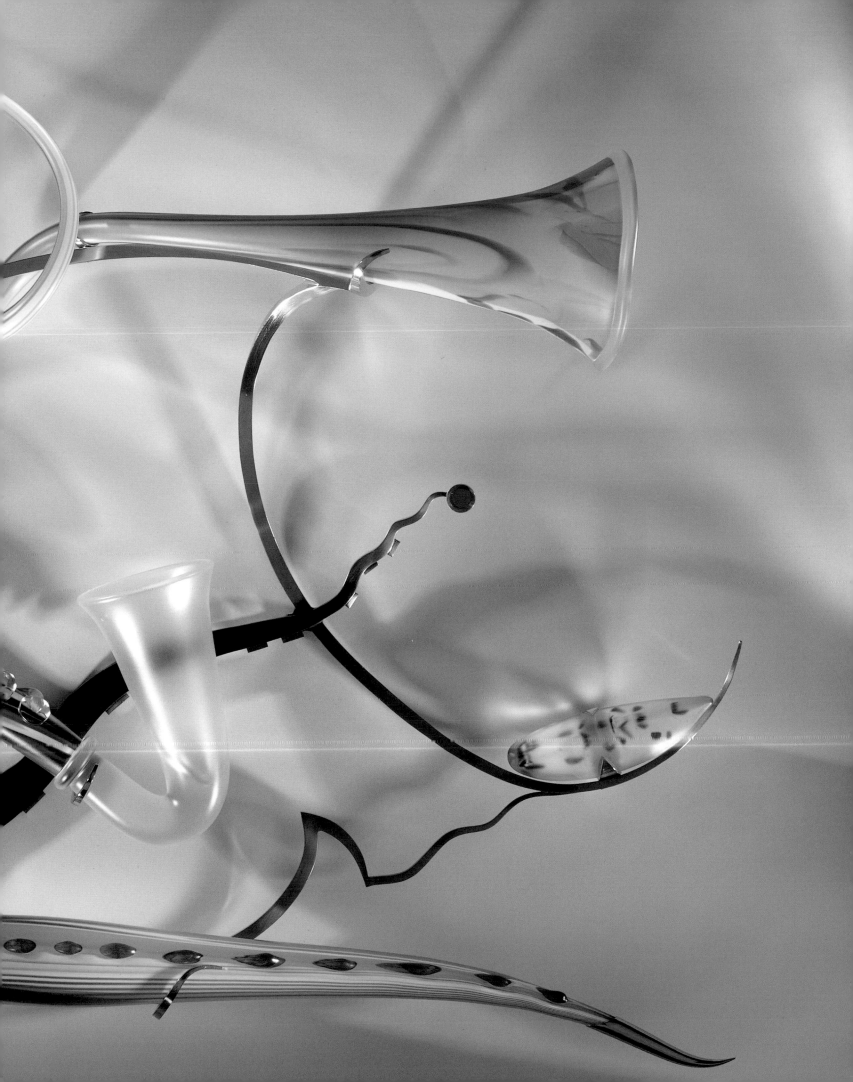

INDIVIDUALS

2004 – 2006

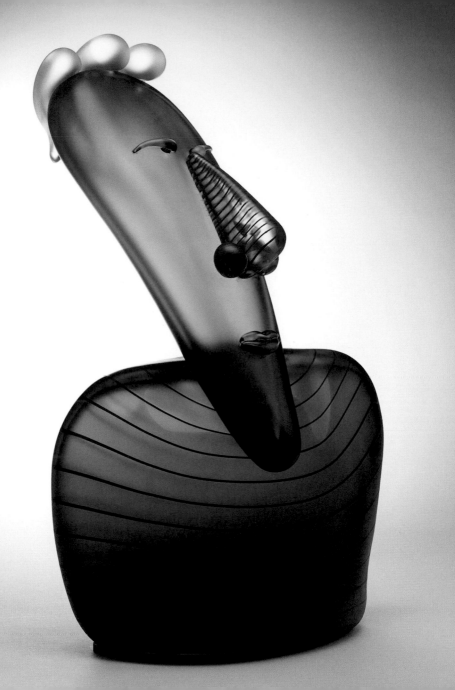

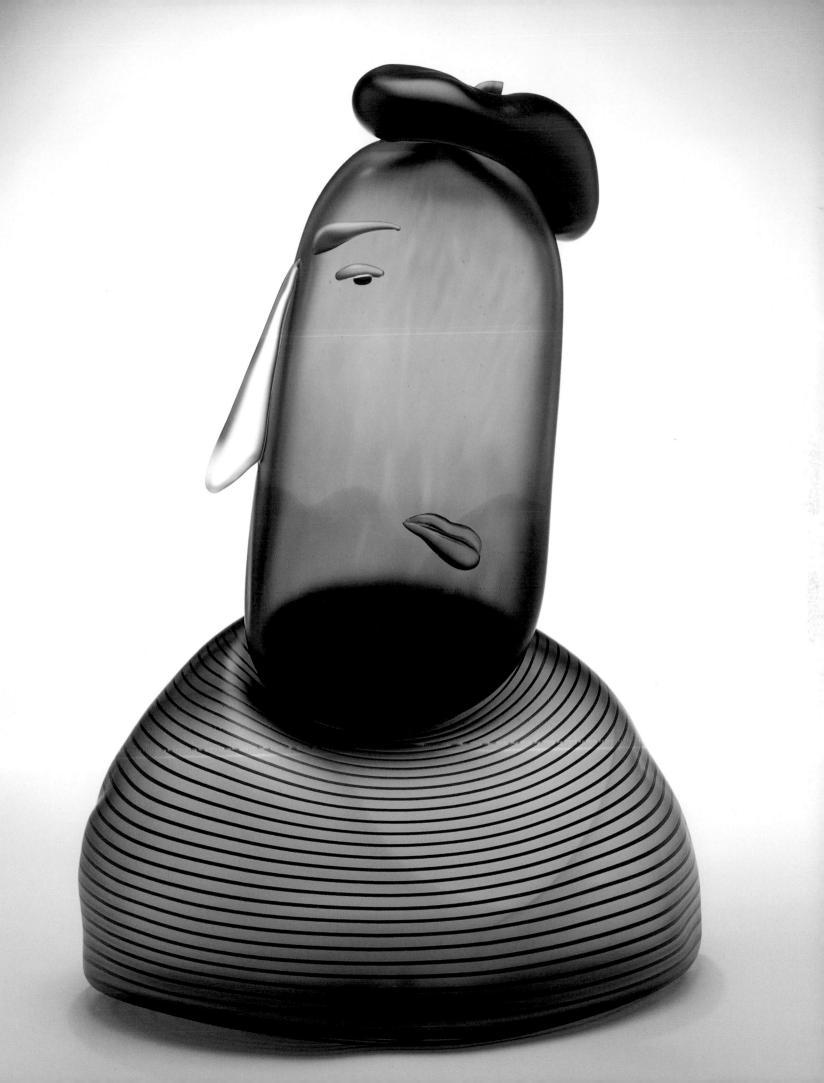

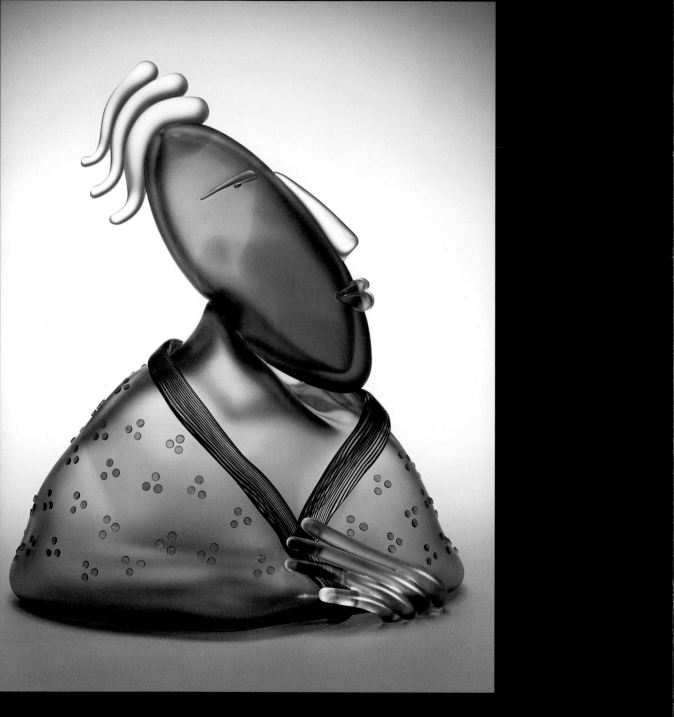

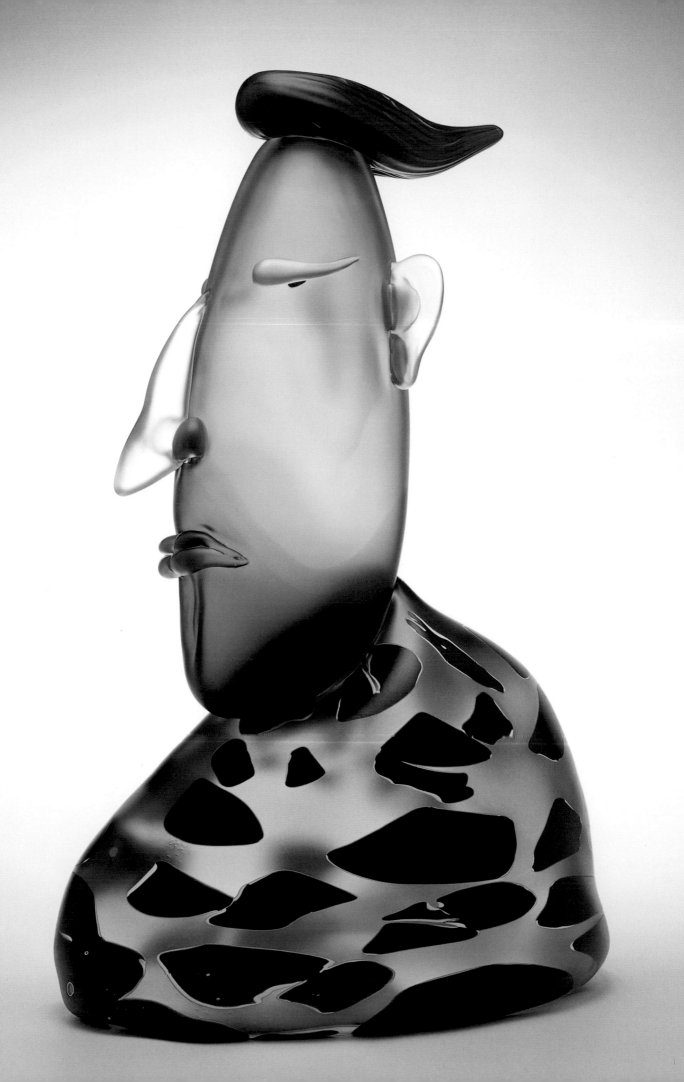

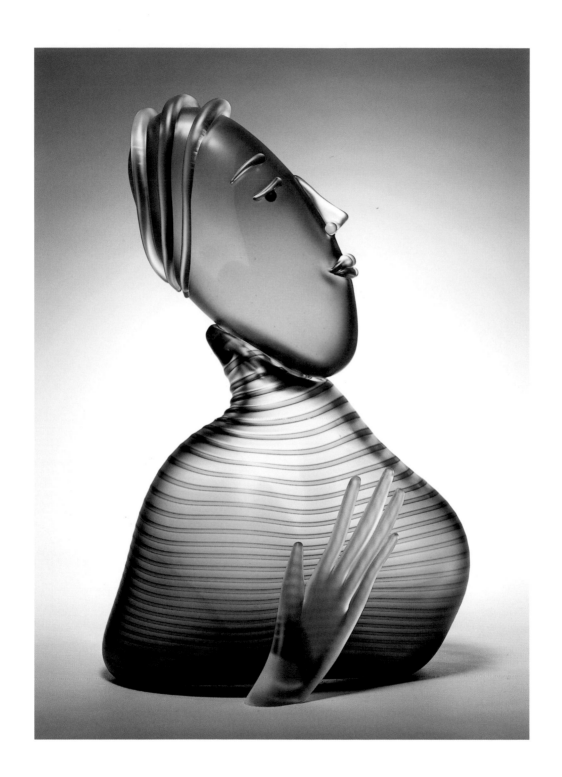

ABOVE
Touched
22H X 13W X 8D"
2004

OPPOSITE
Oblivious
20H X 15W X 7.5D"
2005

284

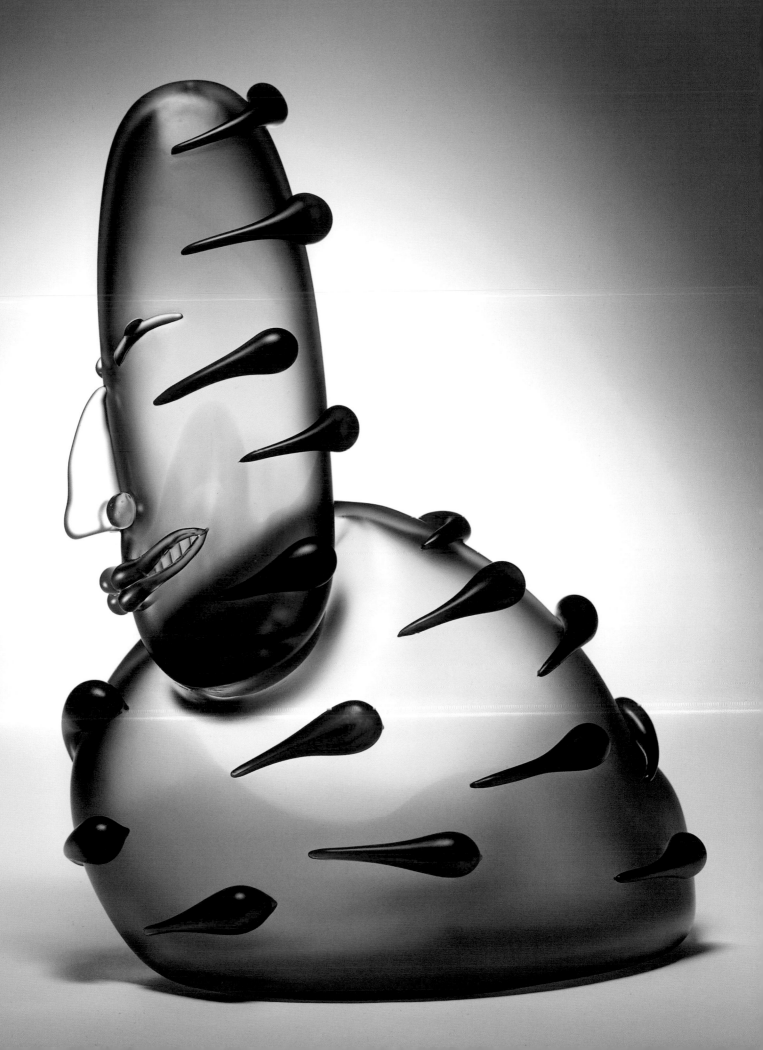

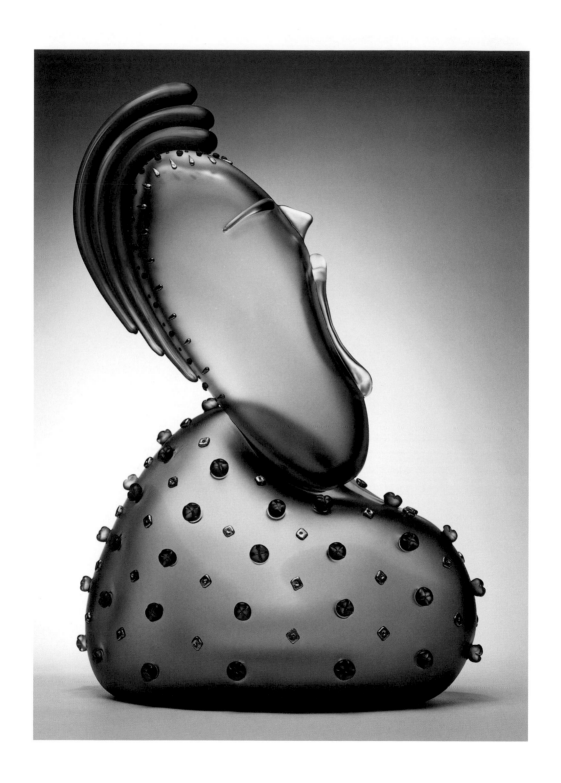

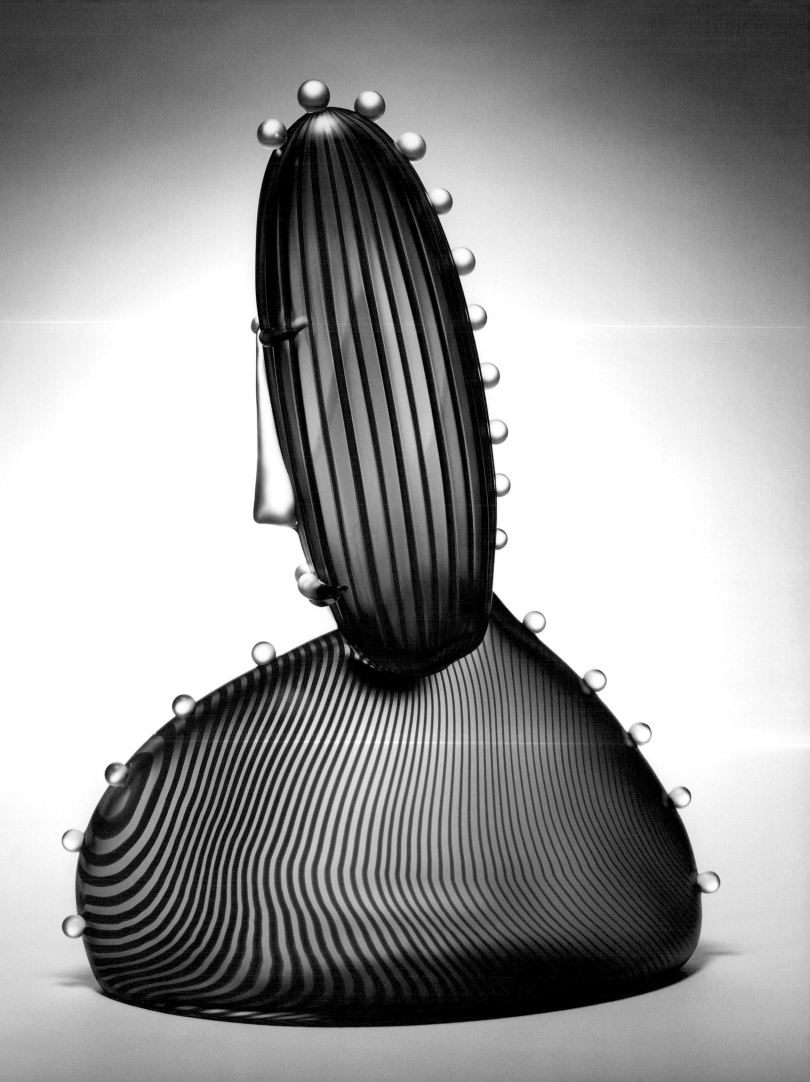

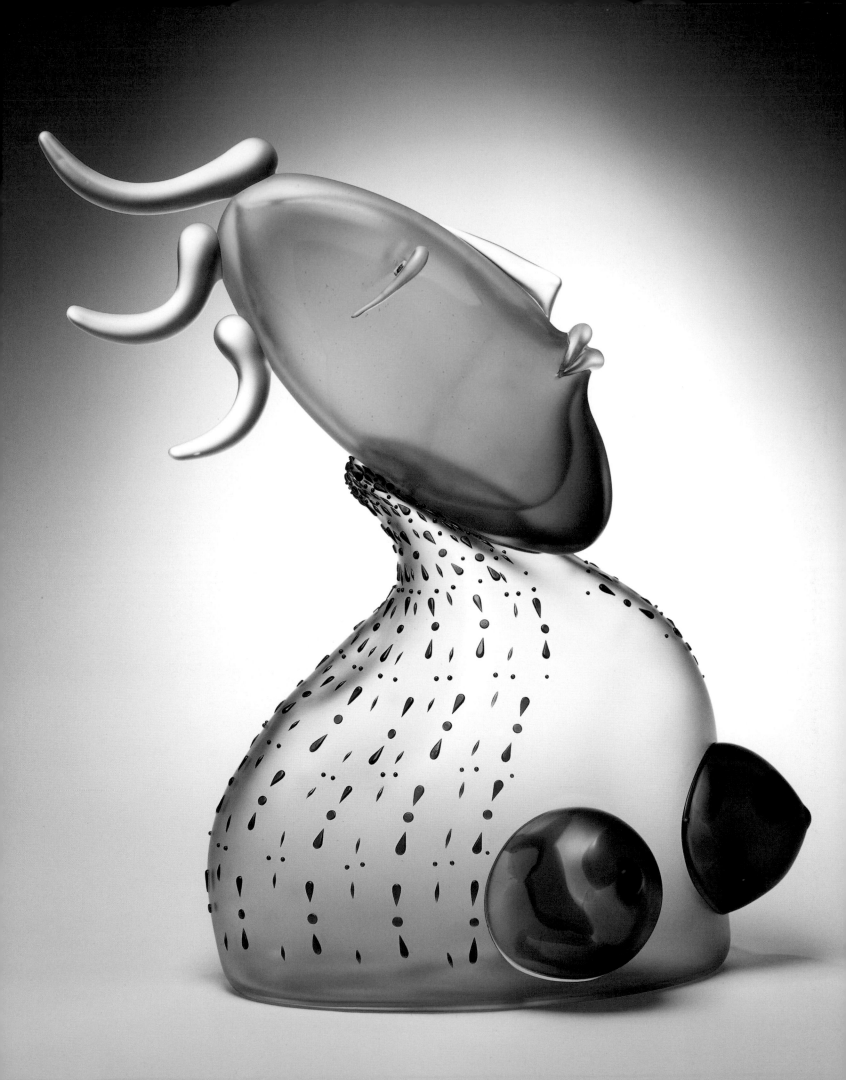

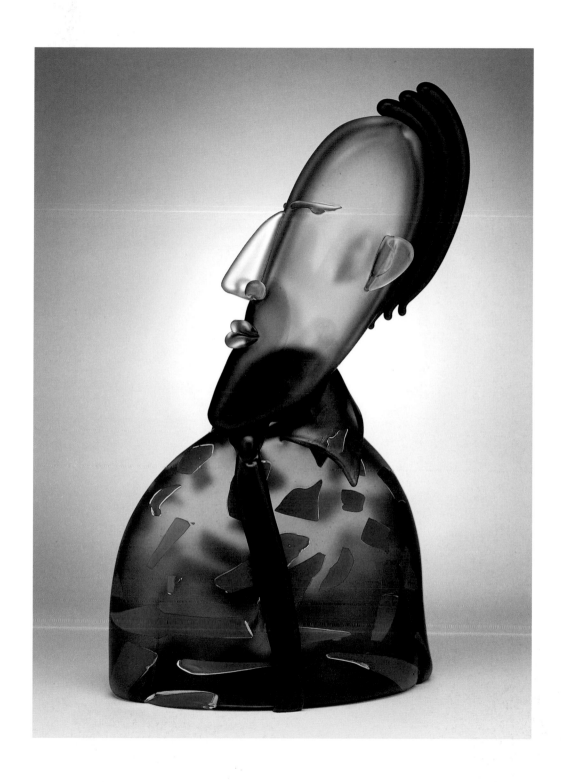

OPPOSITE
Woman with Colorful Breasts
23H X 16.5W X 10.5D"
2005

ABOVE
Impostor
26H X 15W X 7.5D"
2005

289

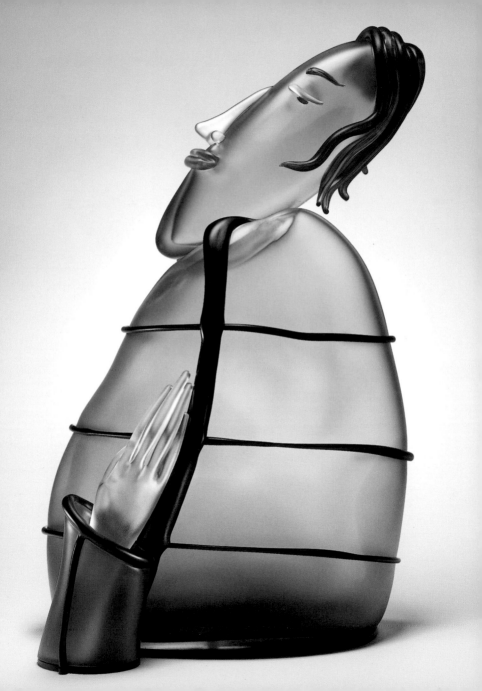

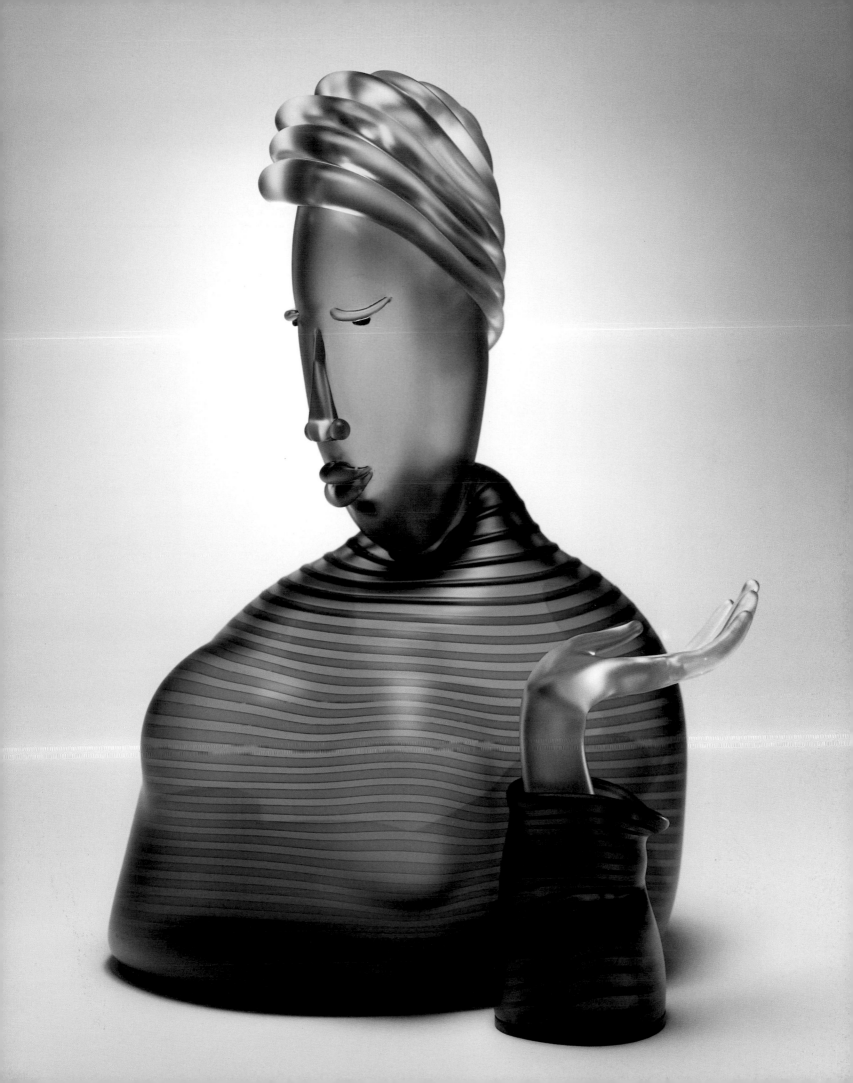

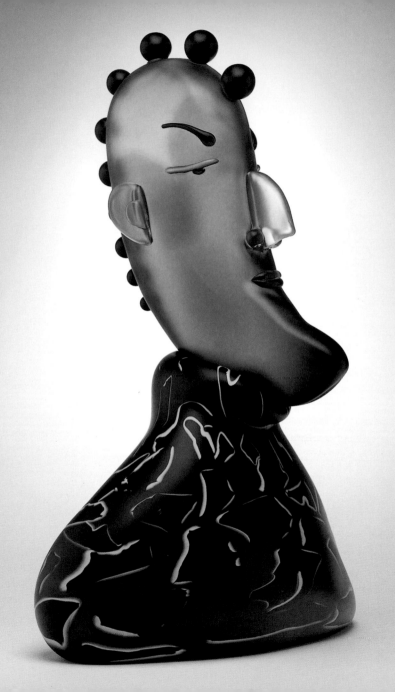

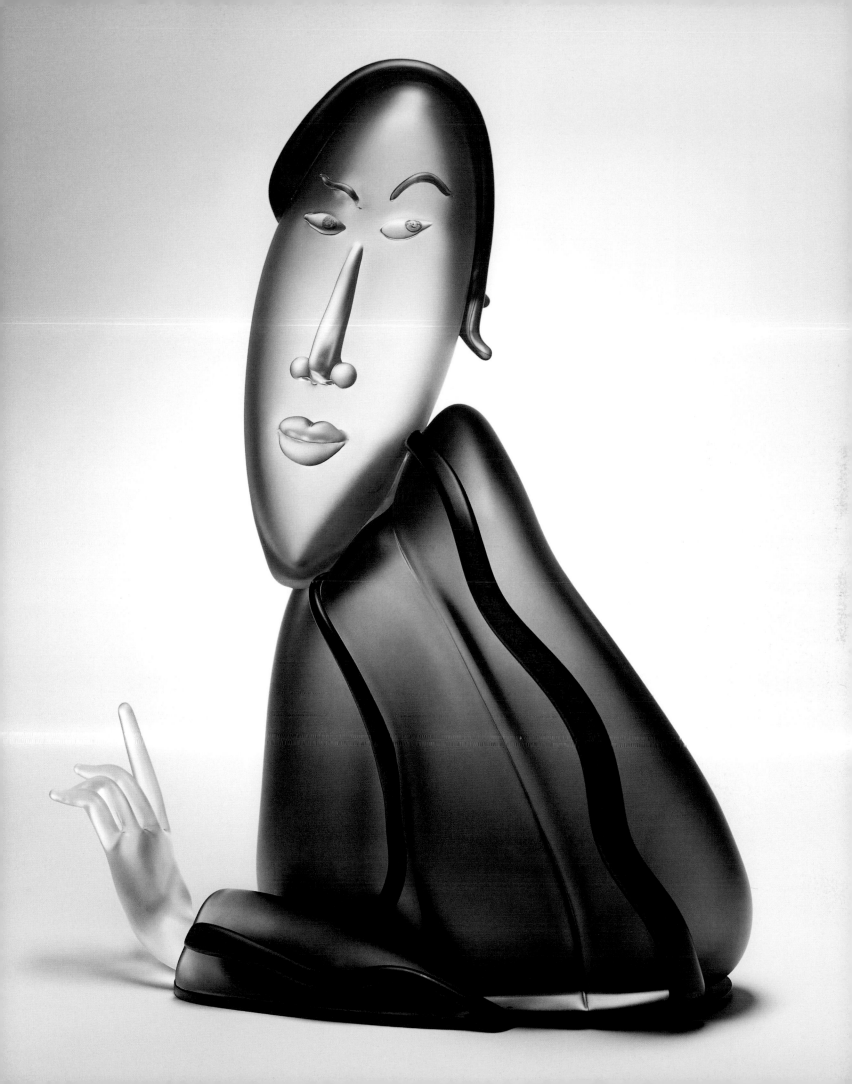

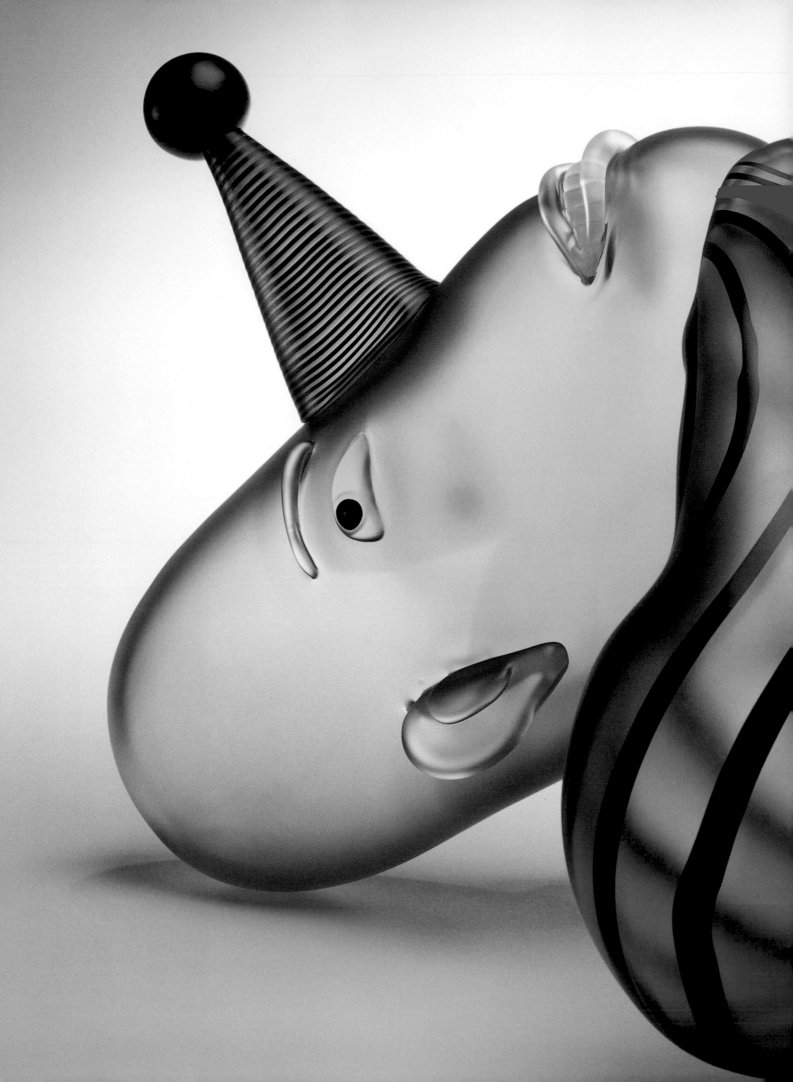

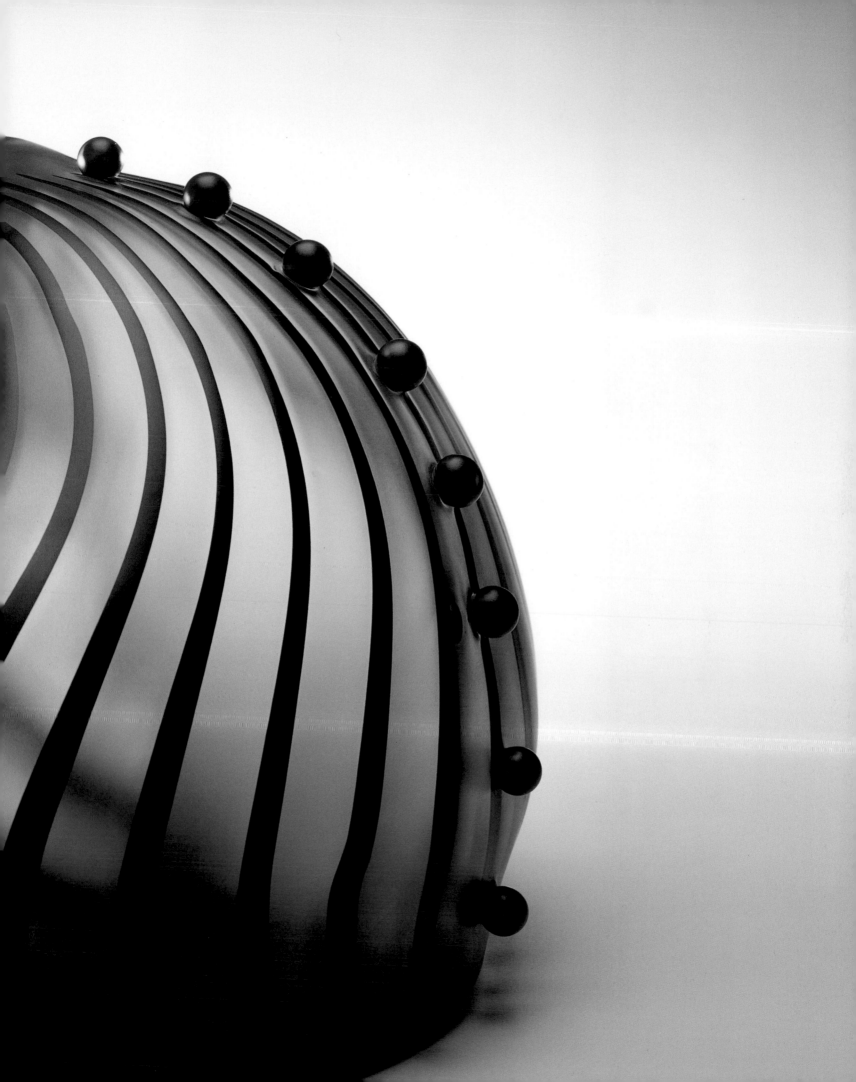

COMMISSIONED AND
SITE SPECIFIC WORKS

1988 – 2004

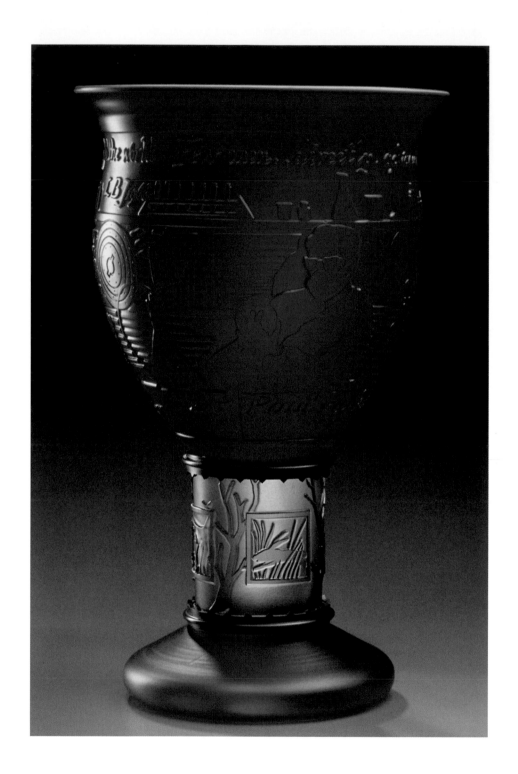

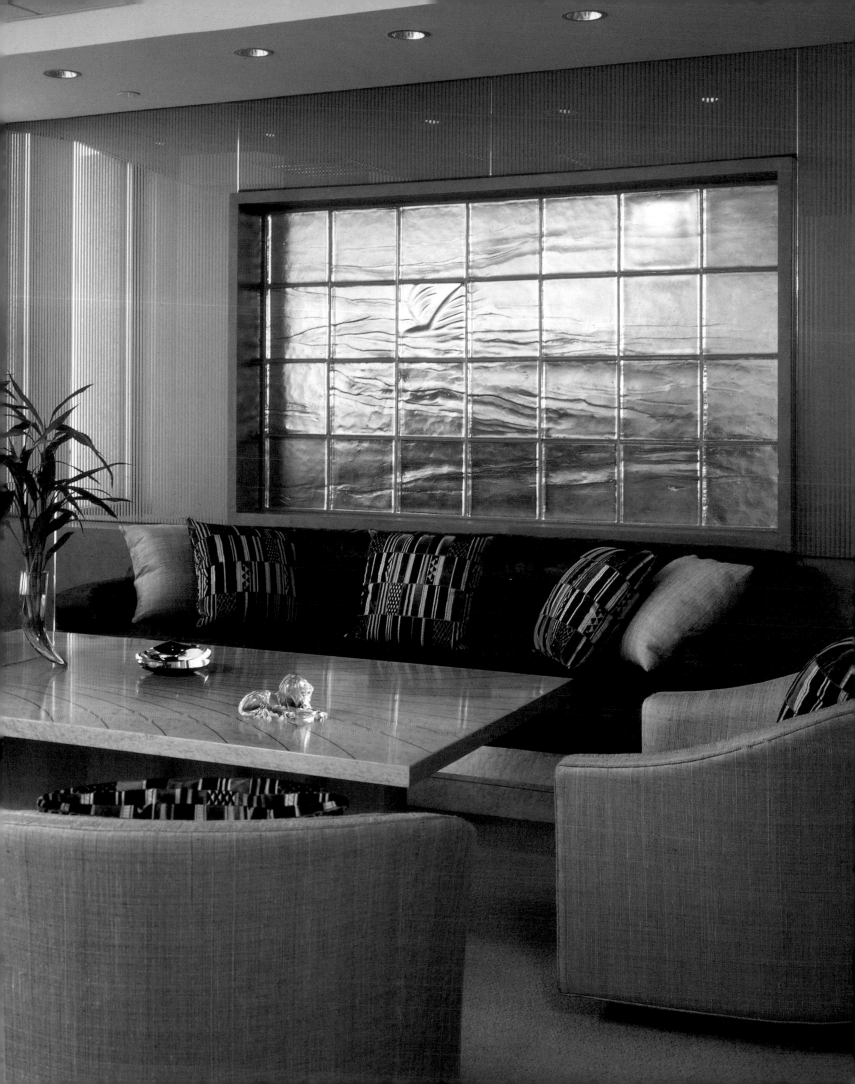

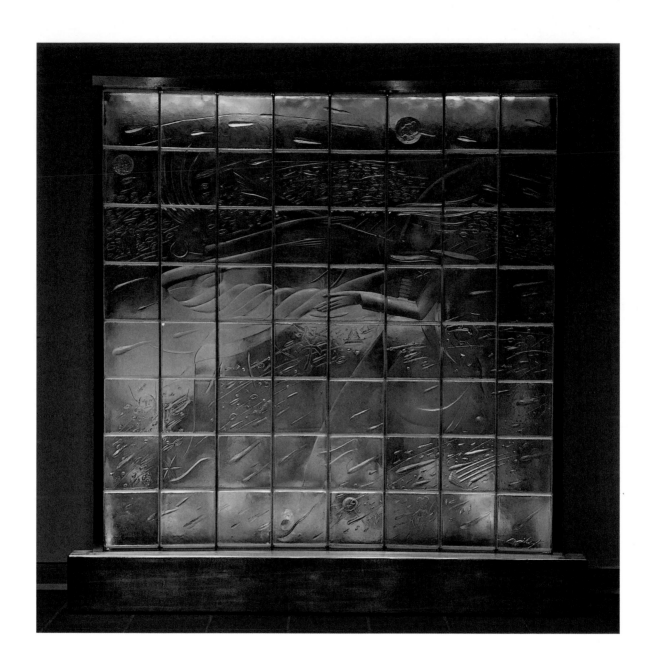

Fantasy Mural
96ʜ x 96ᴡ"
1988

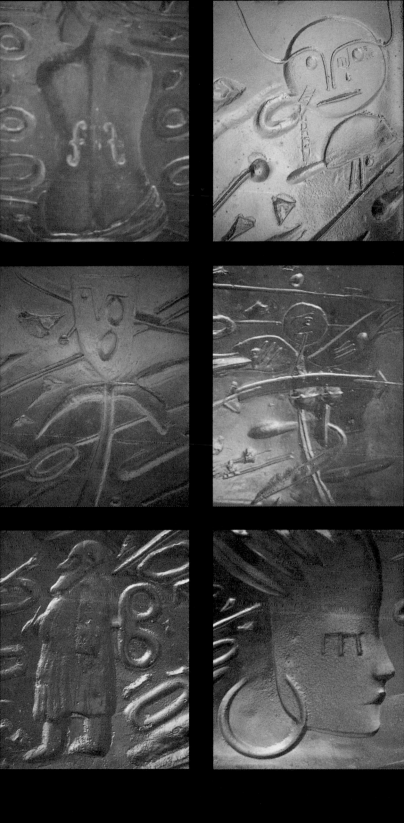

Fantasy Mural (details)
12H x 12W"
1988

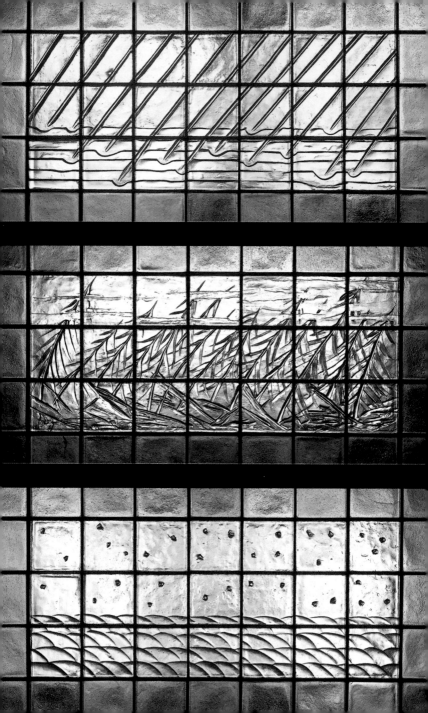

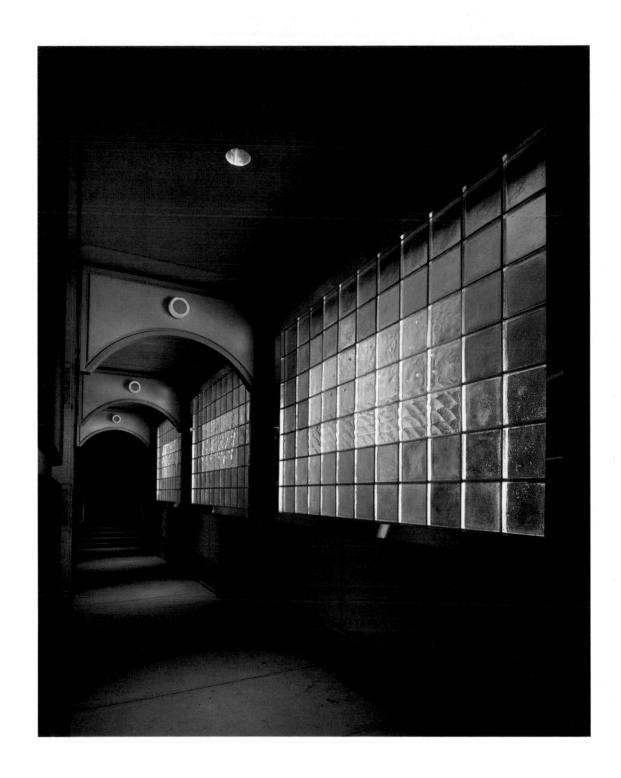

OPPOSITE AND ABOVE
Boston Children's Hospital
RAIN ON WATER, TREES IN WIND, ROLLING FIELDS
1989

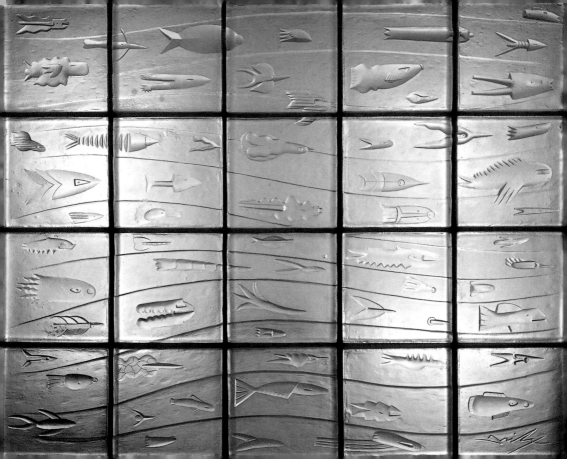

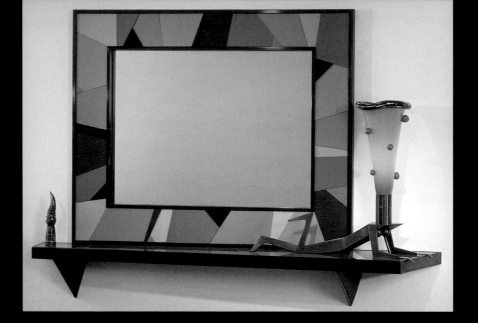

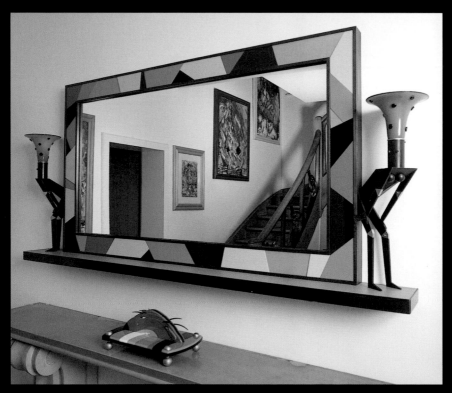

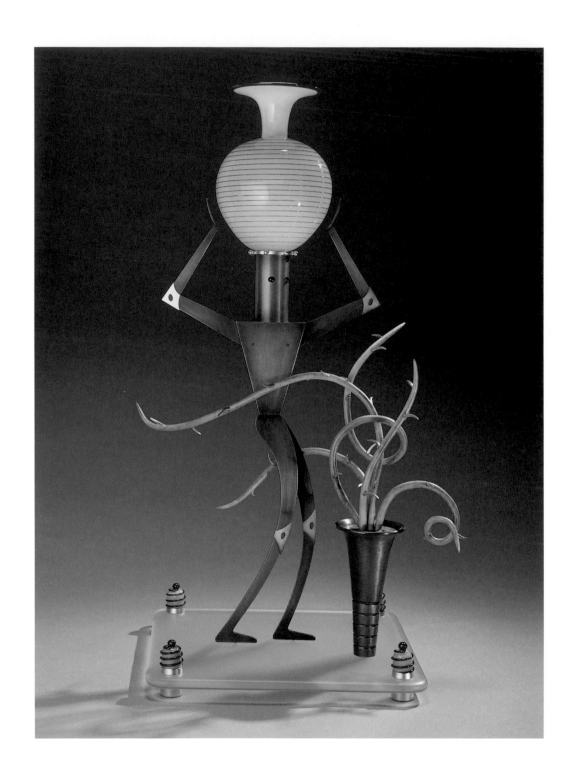

Nude Male with Cactus
41H X 19W X 19D"
1995

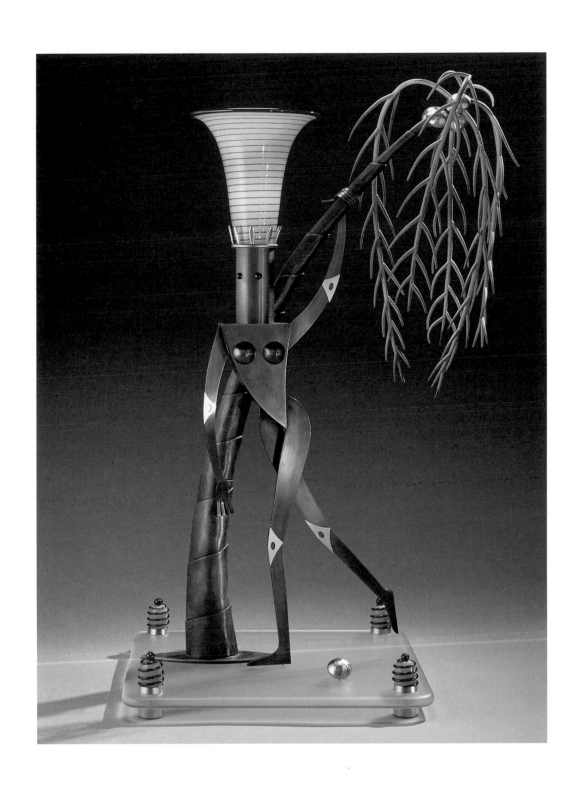

Nude Female with Palm Tree
44H X 19W X 19D"
1995

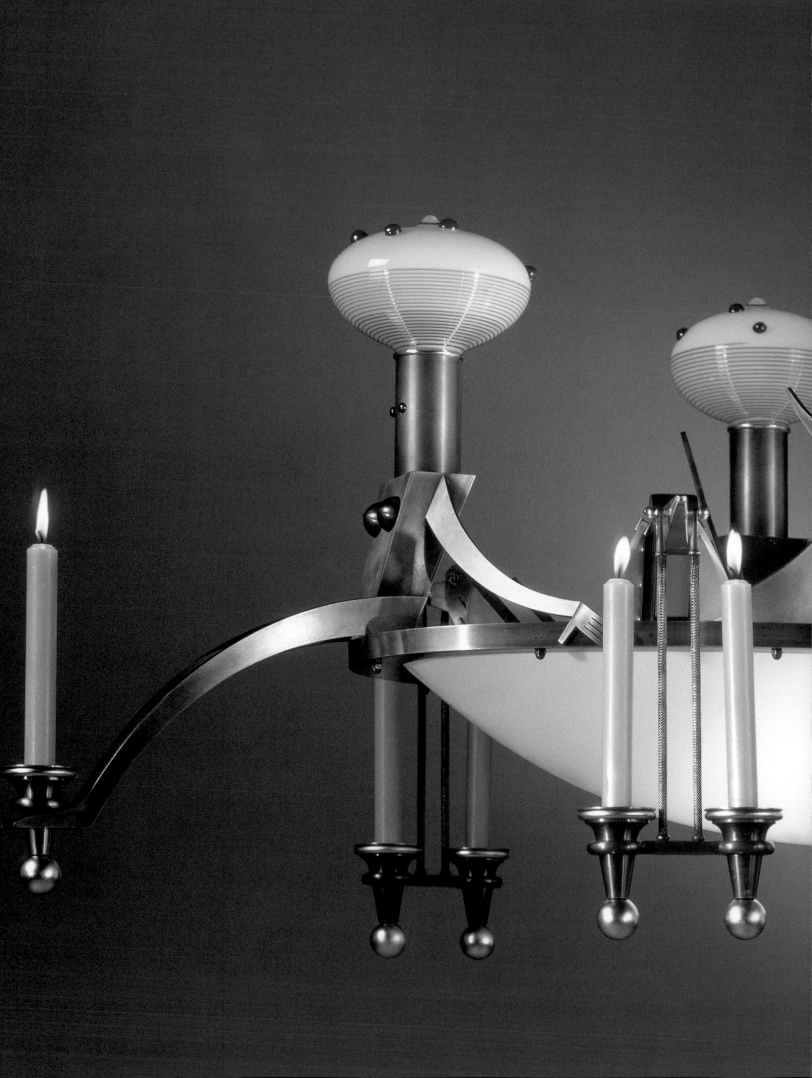

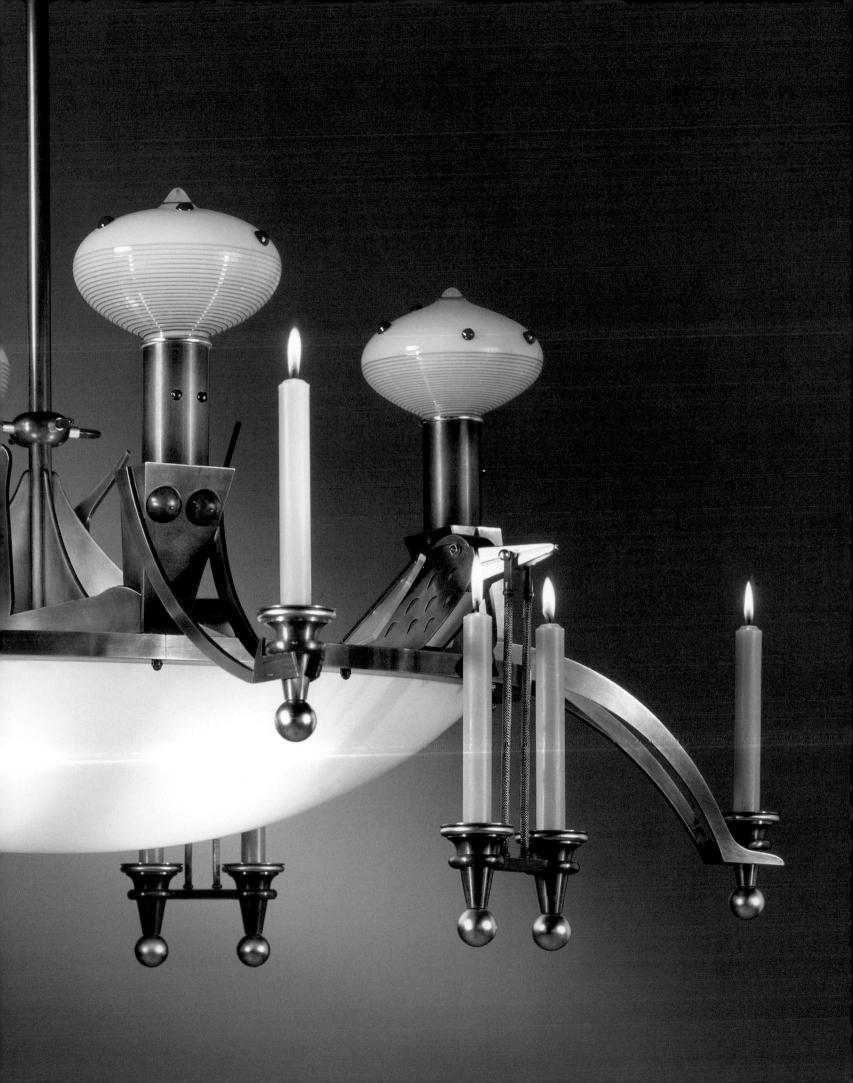

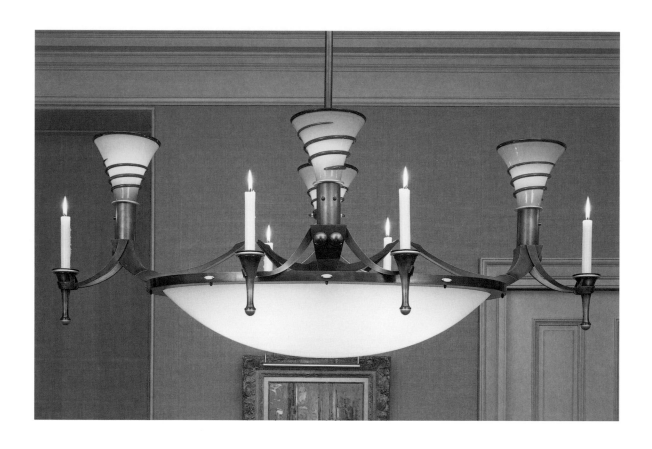

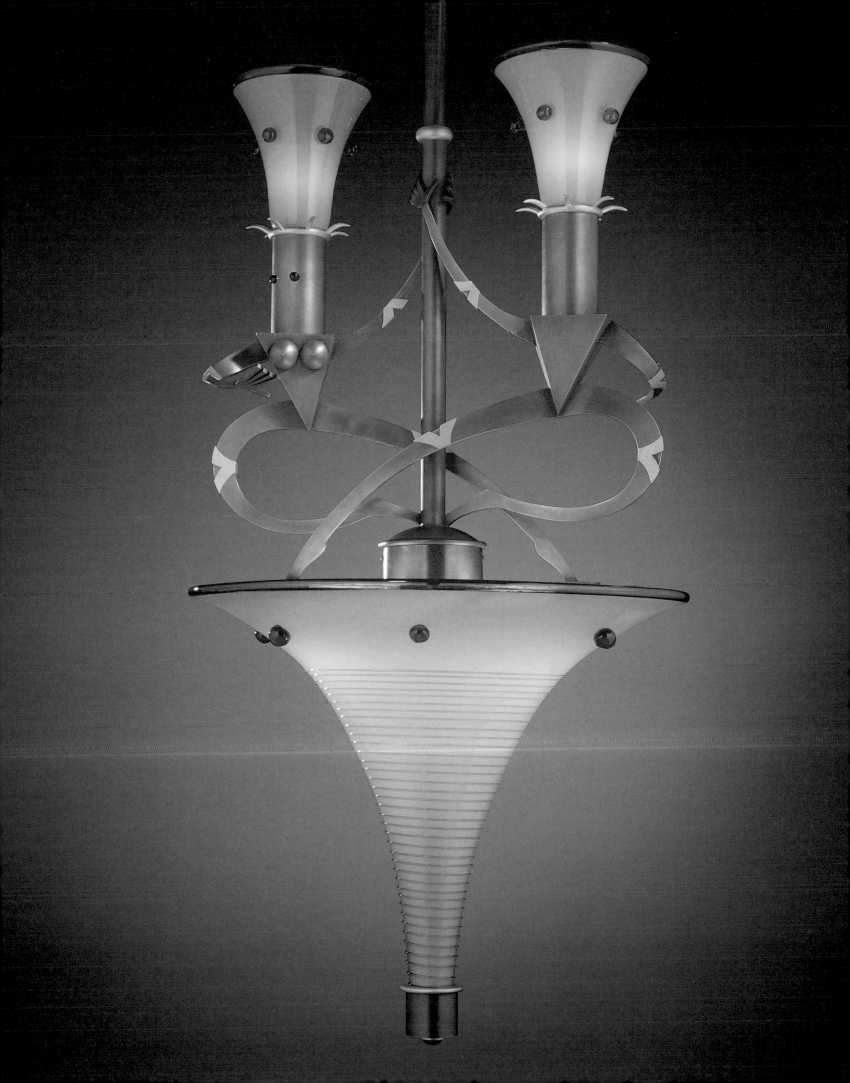

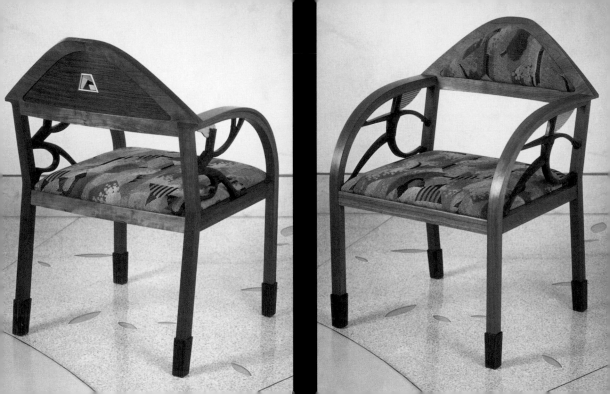

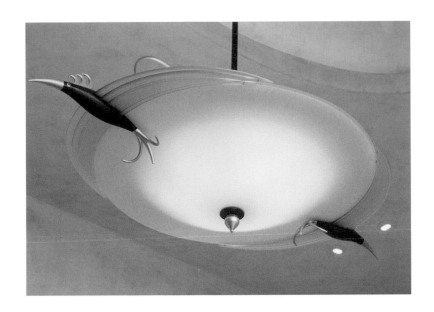

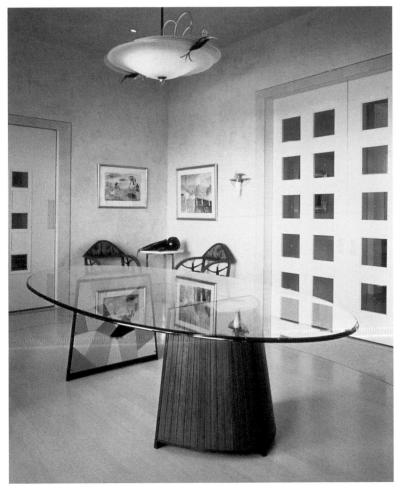

ABOVE
Chandelier
15H X 32W X 22D"
1996

BELOW
Bird Wall Sconces
13H X 12W X 5D"
1996

BELOW
Dining Table
120L X 60W"
1996

315

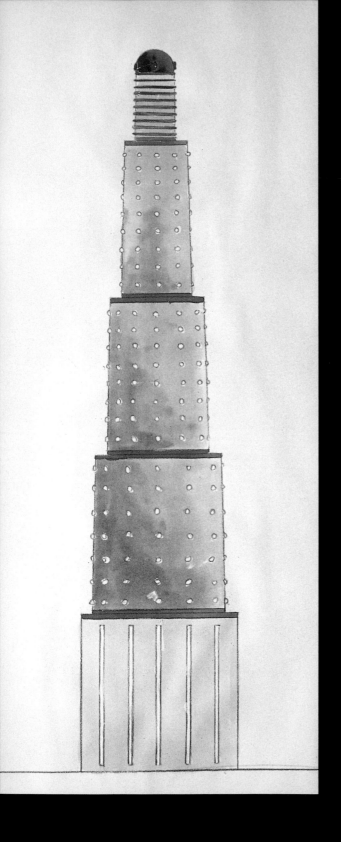
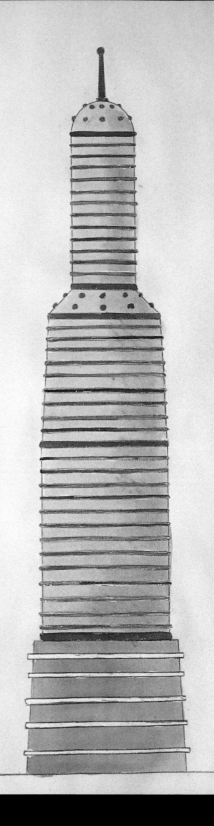

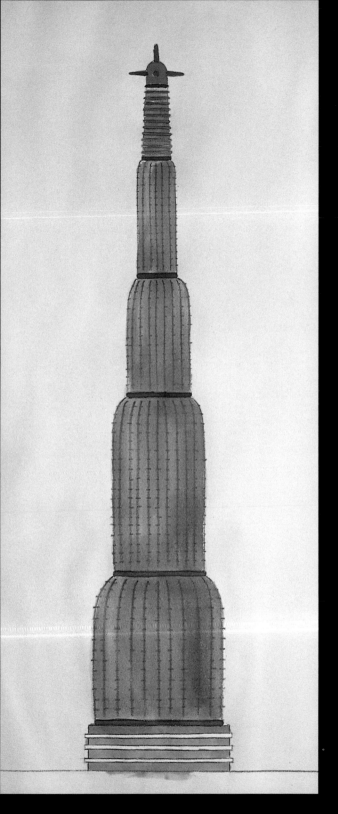

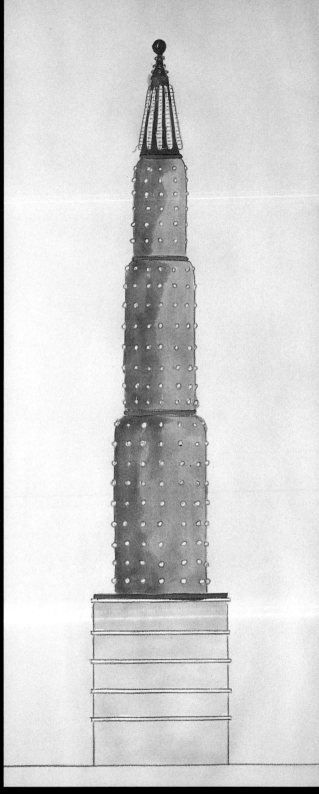

OPPOSITE AND ABOVE
Skyscraper Studies
WINDOWS ON THE WORLD
16H X 7W"
1995

FOLLOWING
Topaz Skyscraper
TONY BIANCO, DAILEY, PAUL CUNNINGHAM,
BEN MOORE, BRIAN PIKE, RICH ROYAL
BEN MOORE'S STUDIO
SEATTLE, WA

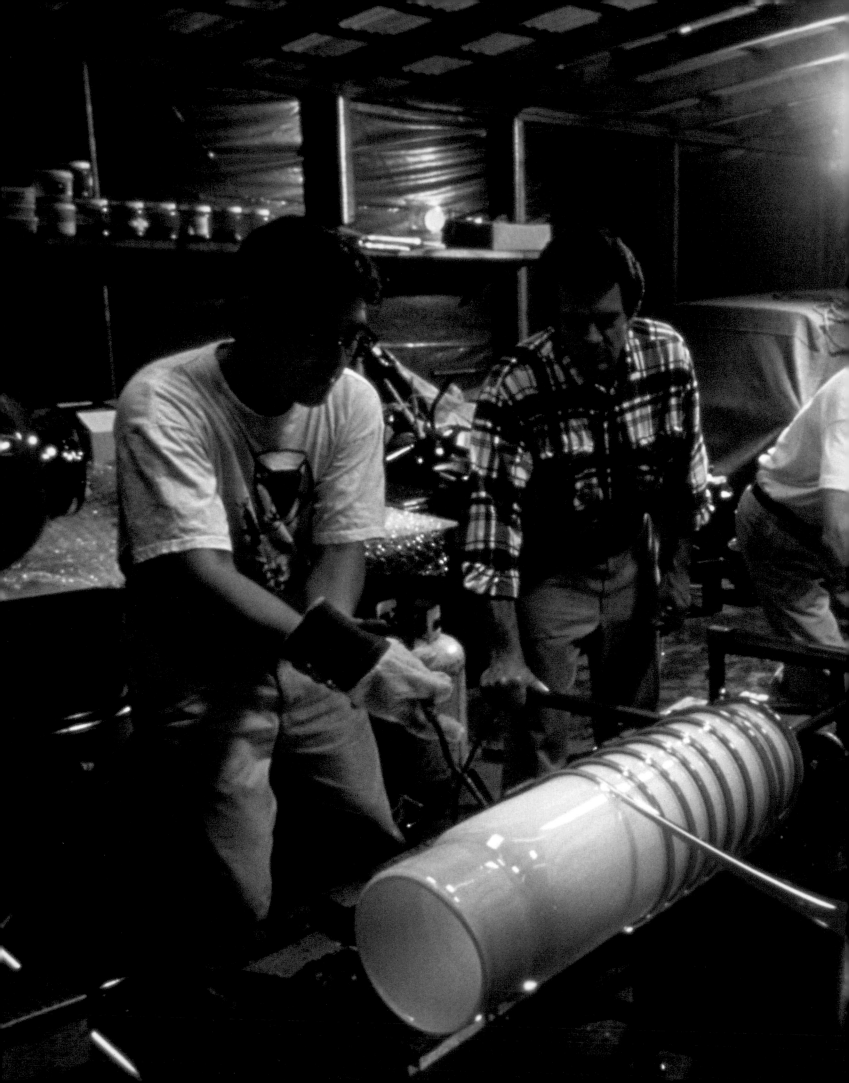

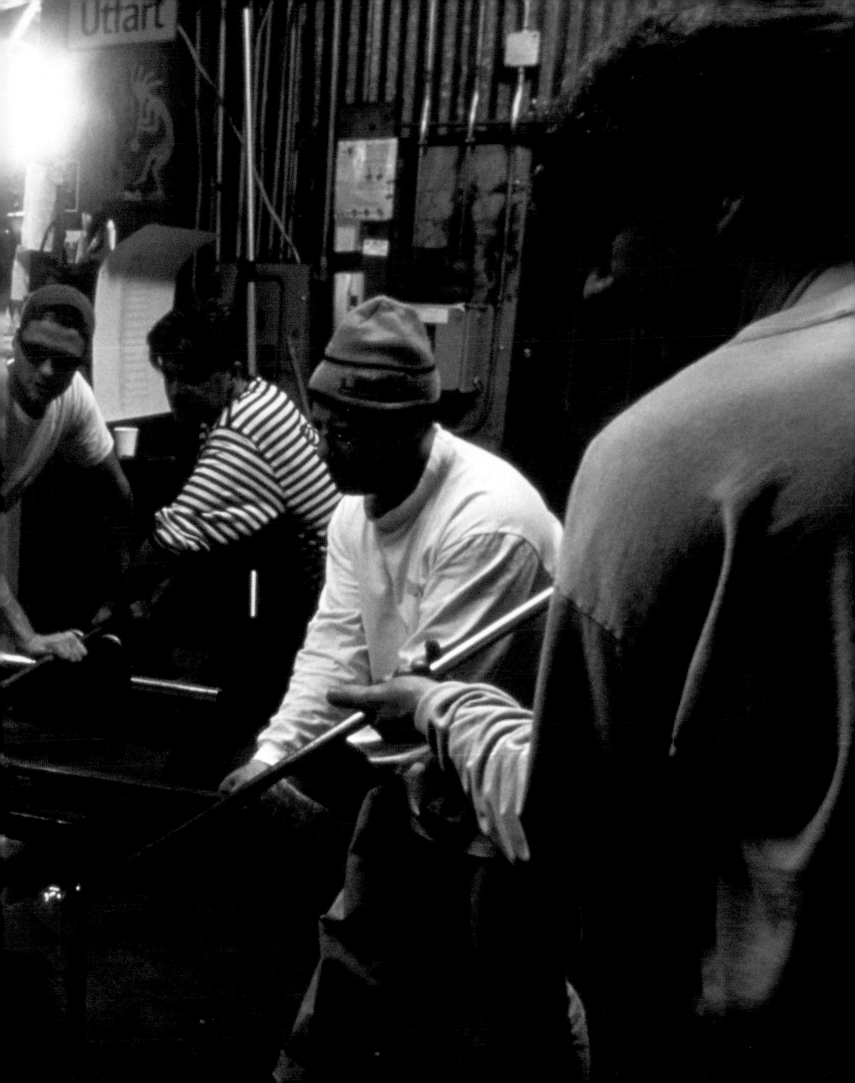

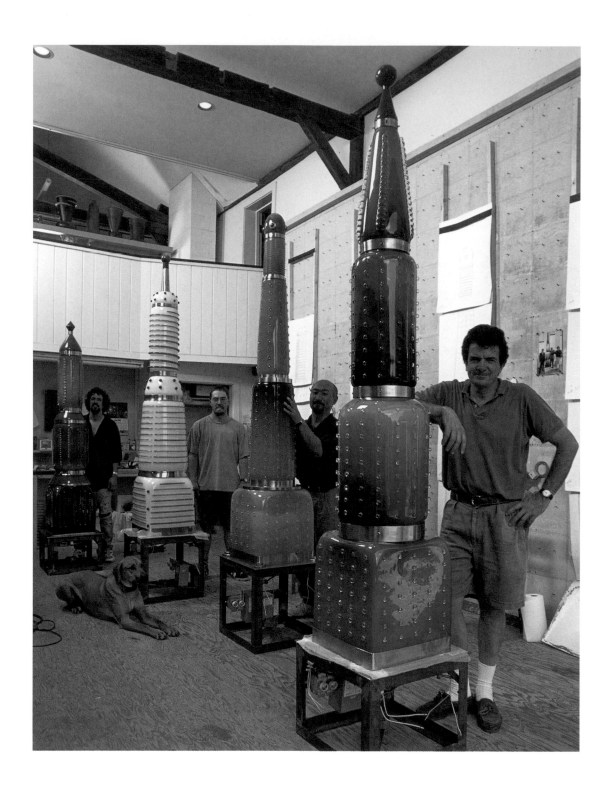

ABOVE LEFT
Olive and Red Skyscraper
120H"
1996
L. TO R. ROB PEACOCK, SEAN ALDRICH,
HITOSHI KAKIZAKI, DAN DAILEY

CENTER LEFT
Topaz Skyscraper
120H"
1996

CENTER RIGHT
Celadon Skyscraper
120H"
1996

RIGHT AND OPPOSITE
Blue Skyscraper
WINDOWS ON THE WORLD
WORLD TRADE CENTER, NYC
114H"
1996

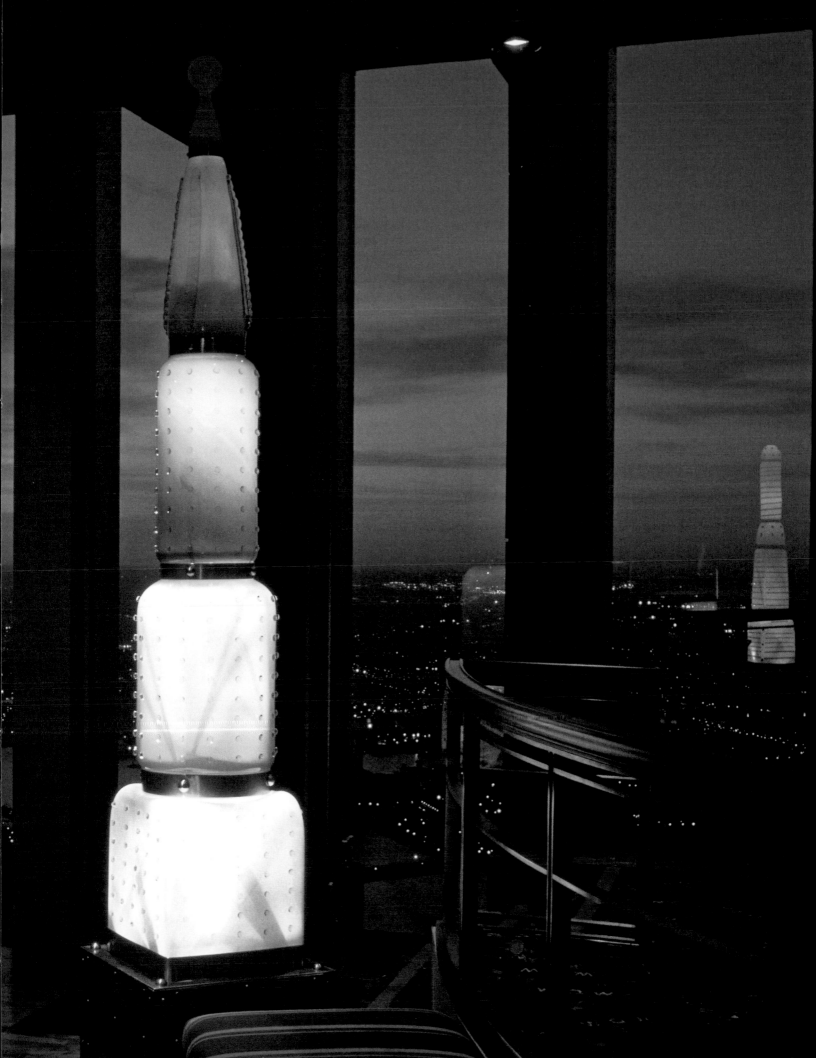

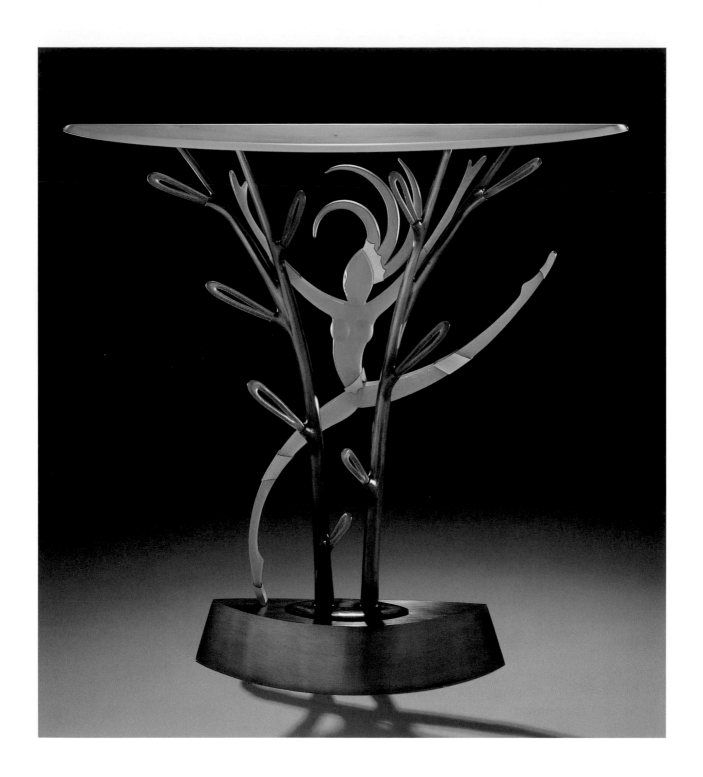

ABOVE AND OPPOSITE
Jungle Dancer
36H X 38W 12D"
1997

322

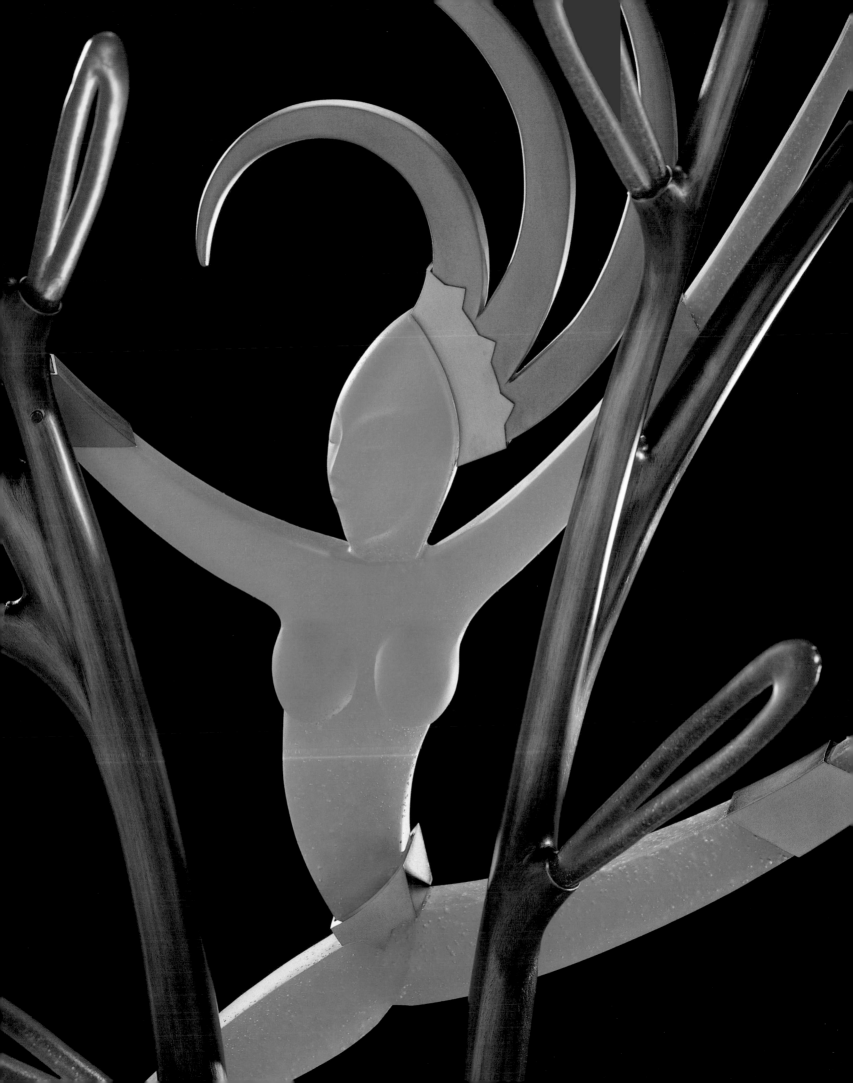

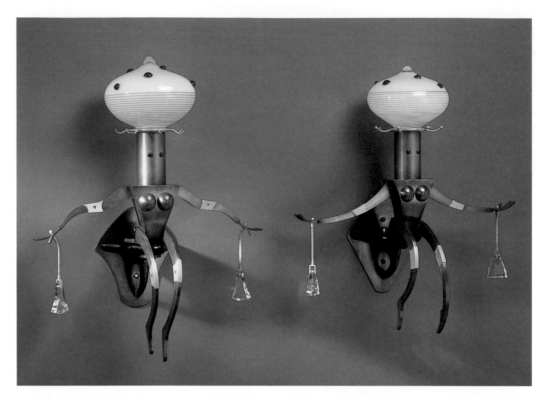

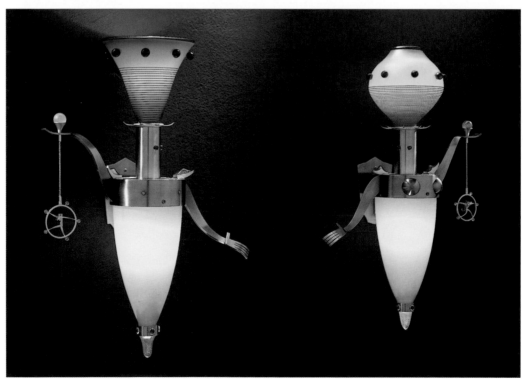

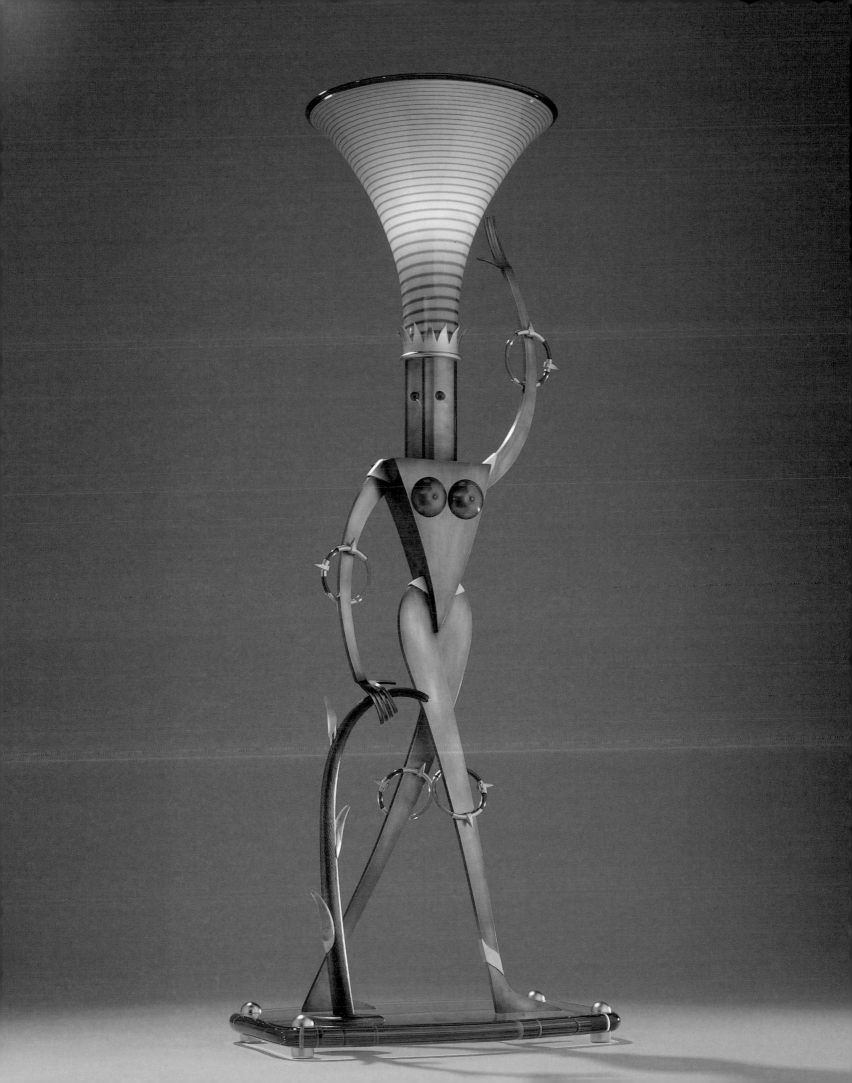

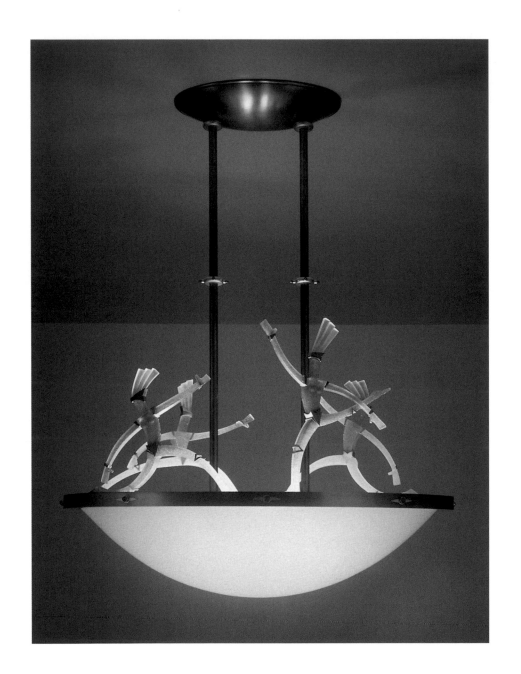

Chandelier
39H X 47W X 22D"
1999

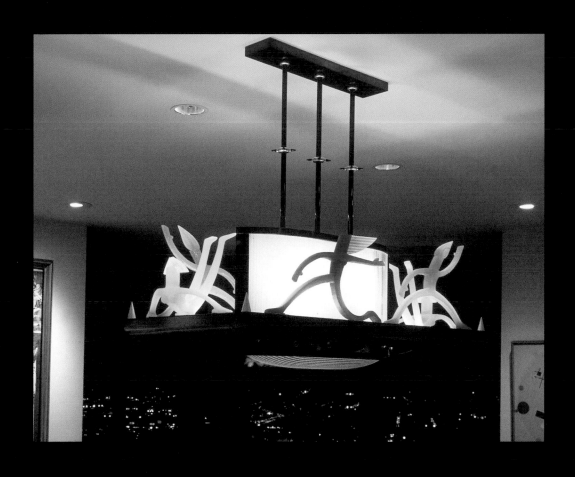

Chandelier
36H X 42W X 20D"
1999

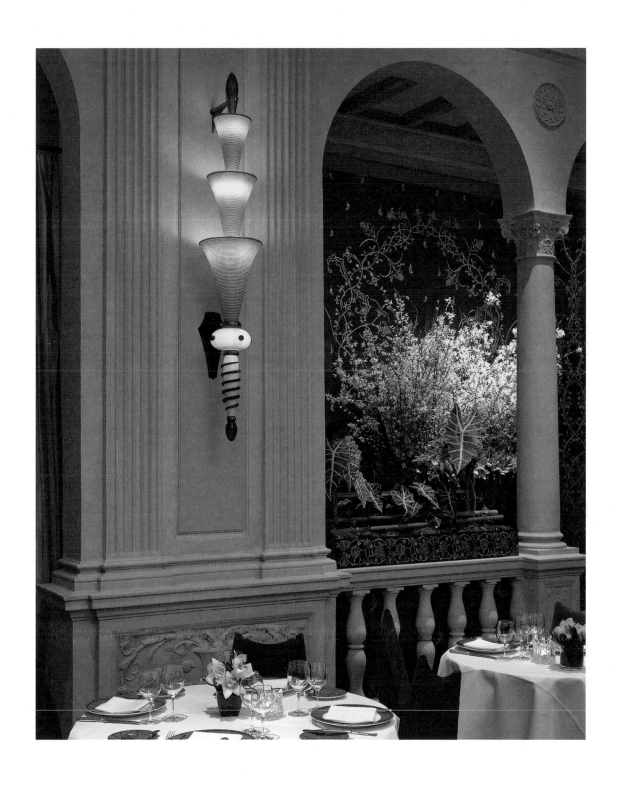

Sconces
96H x 12W x 12D"
2000

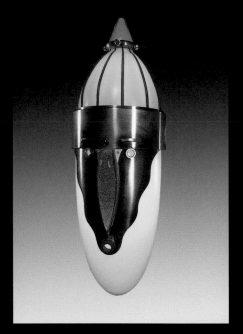

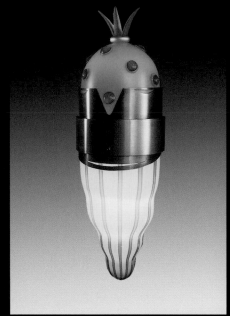

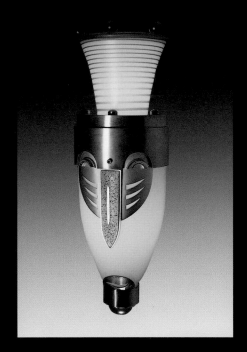

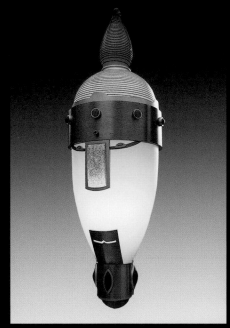

Mask Sconces
15H X 7D"
2000-2003

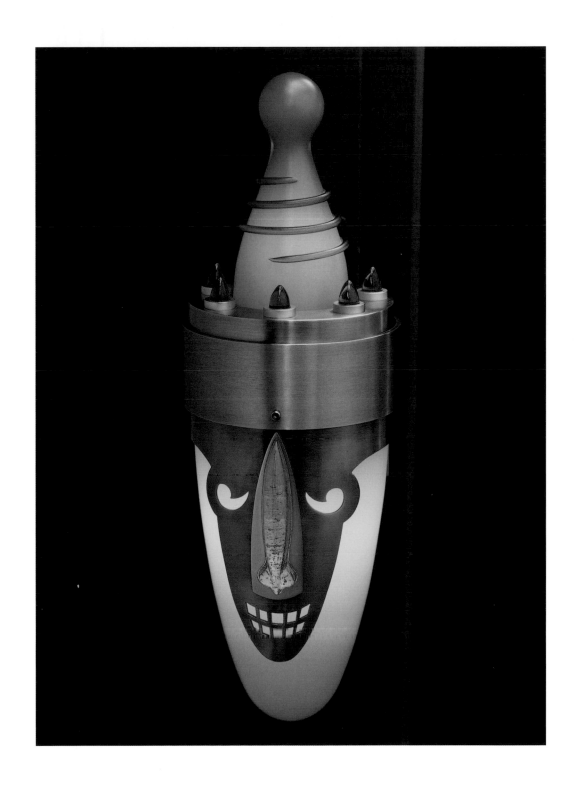

Mask Sconce
15H X 7D"
2000-2003

ABOVE AND OPPOSITE
Tribute
18.5H x 14W'
2004

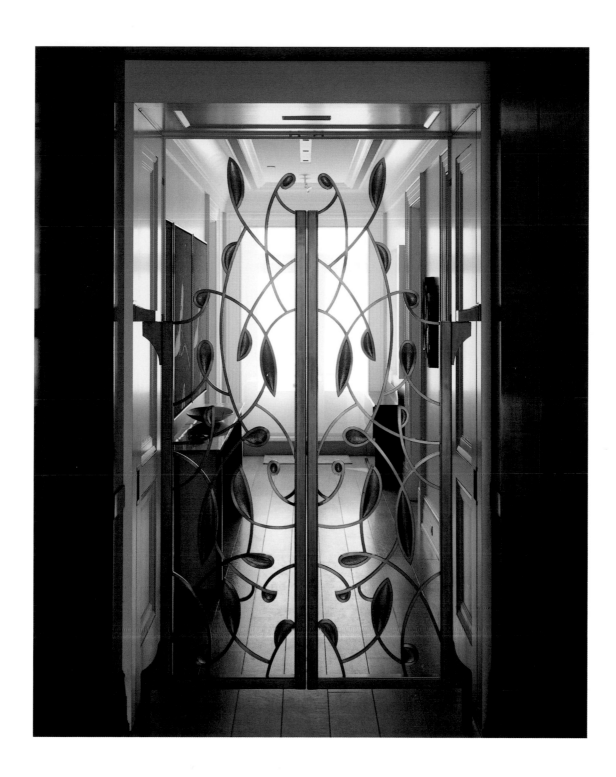

OPPOSITE
Fall
VESTIBULE GATES
116H X 82W"
2004

ABOVE
Spring
CORRIDOR GATES
93H X 54W"
2004

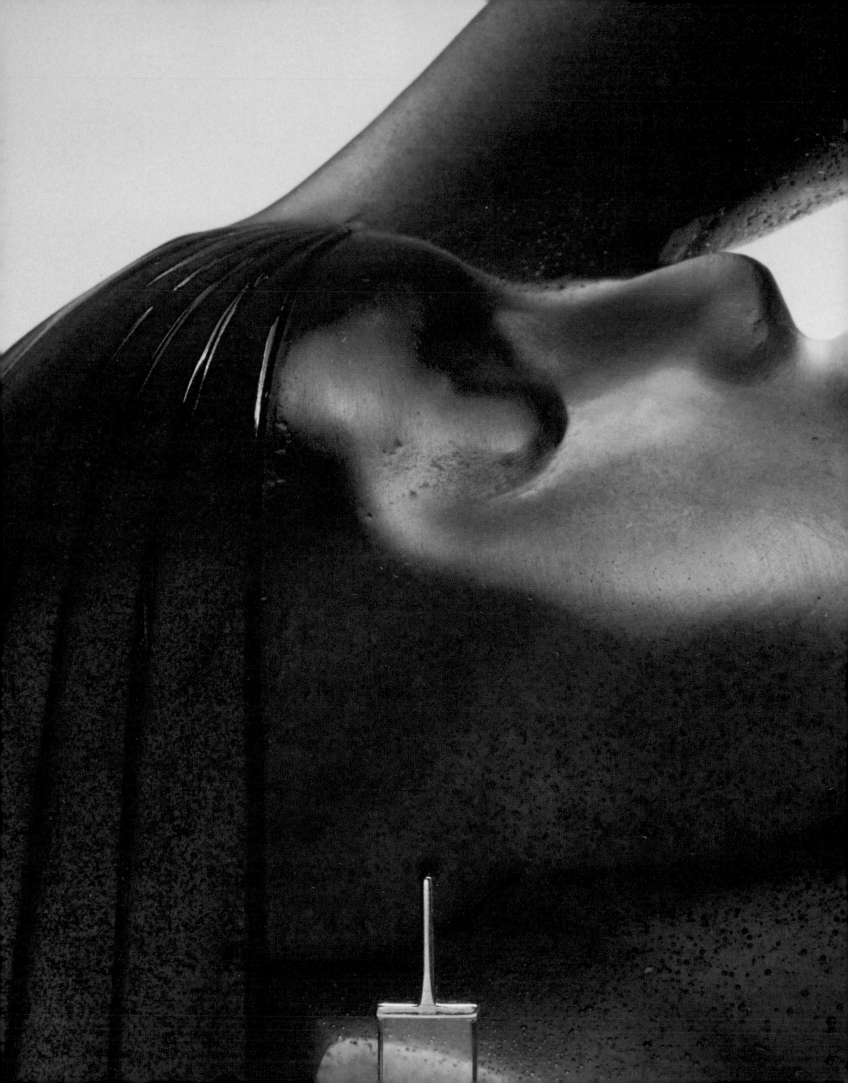

EDITED WORKS

1999 – 2004

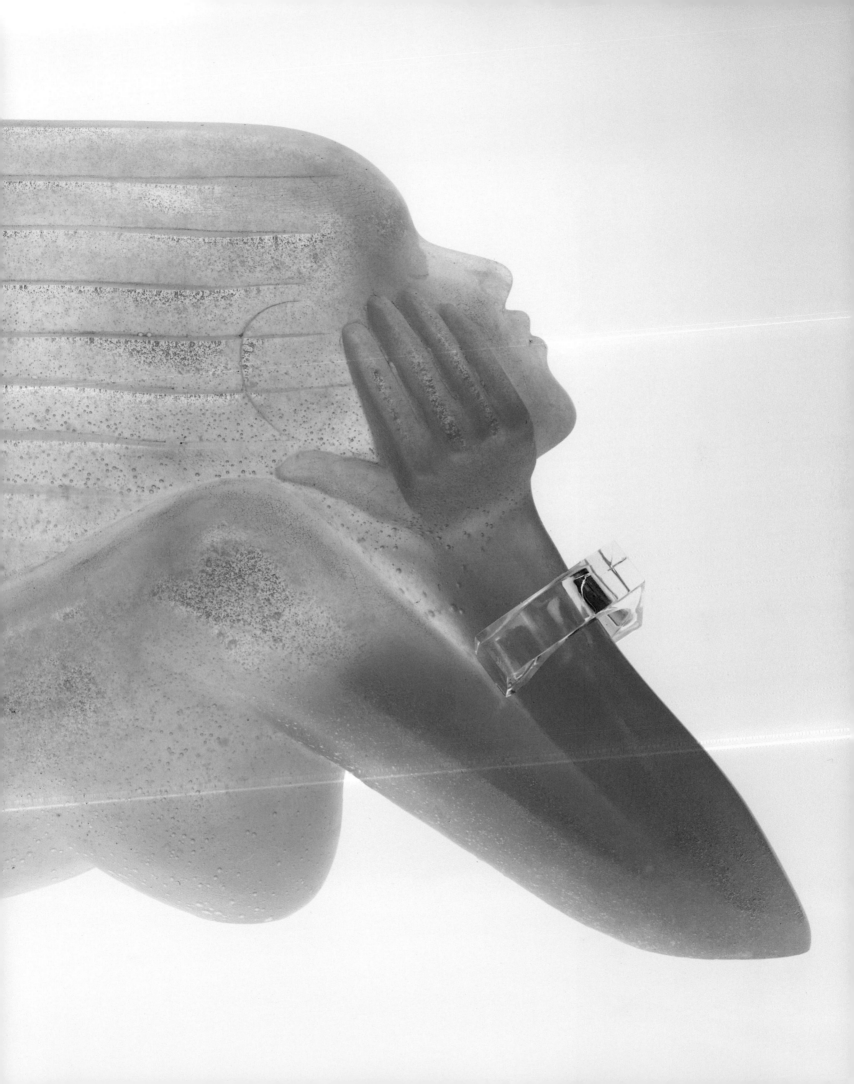

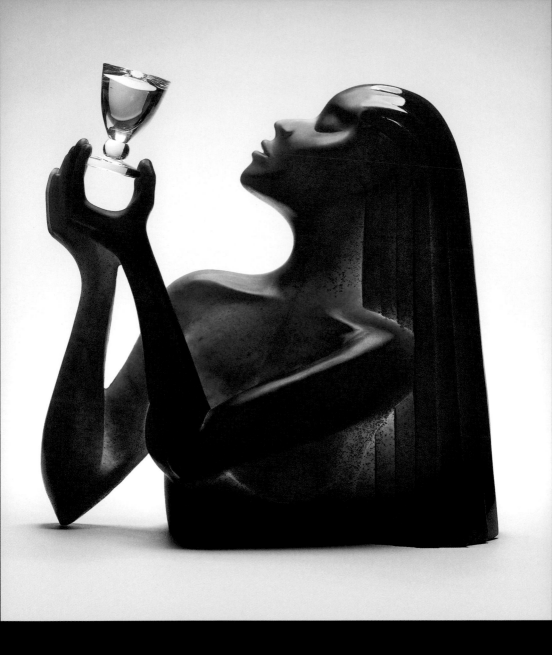

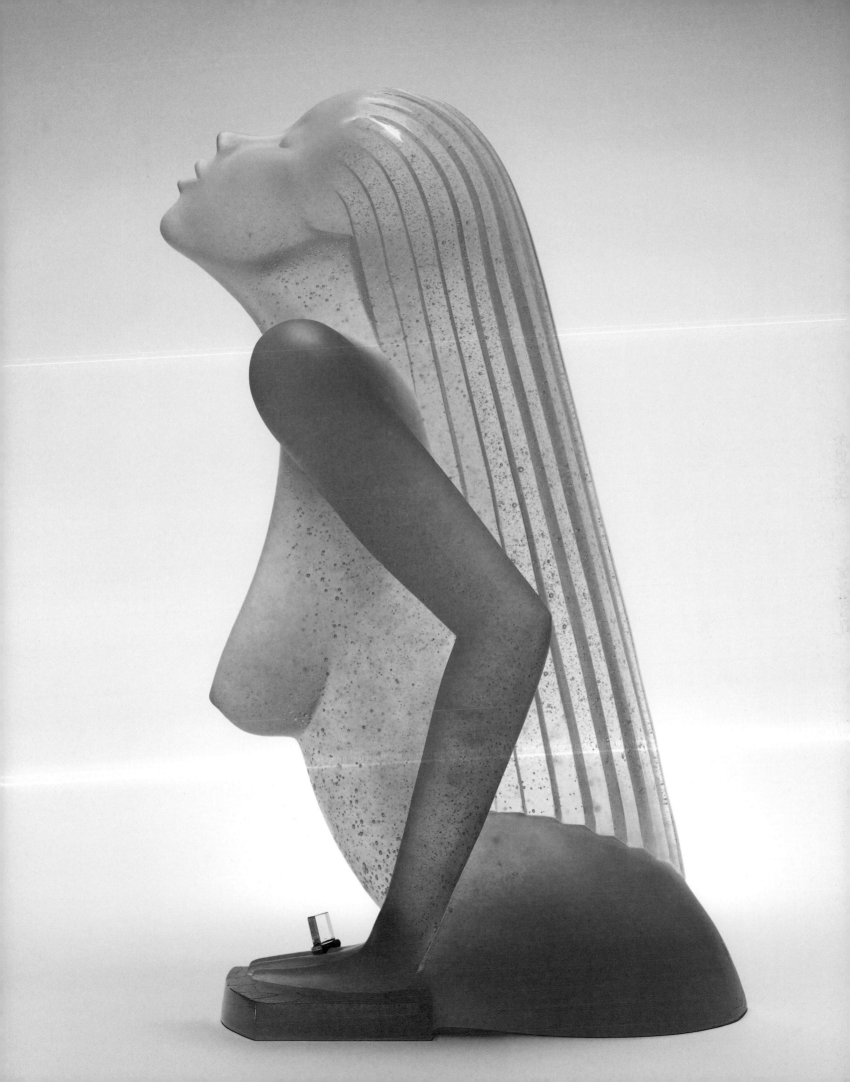

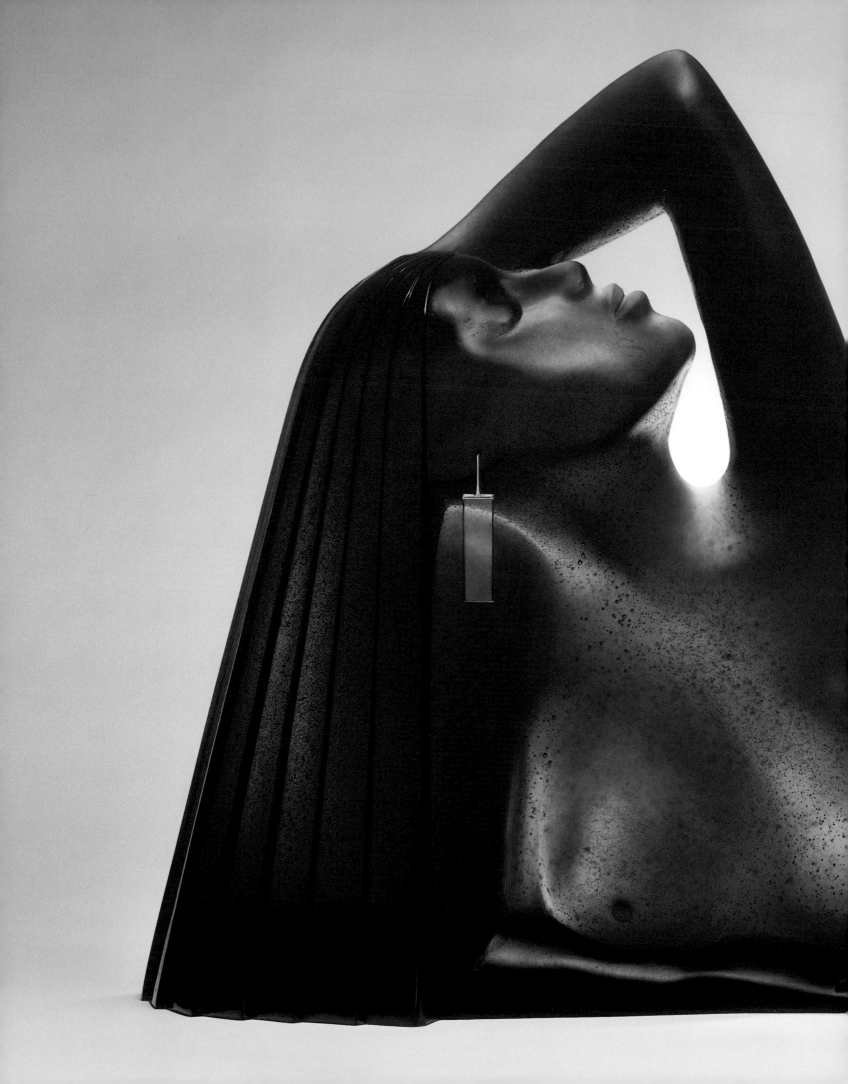

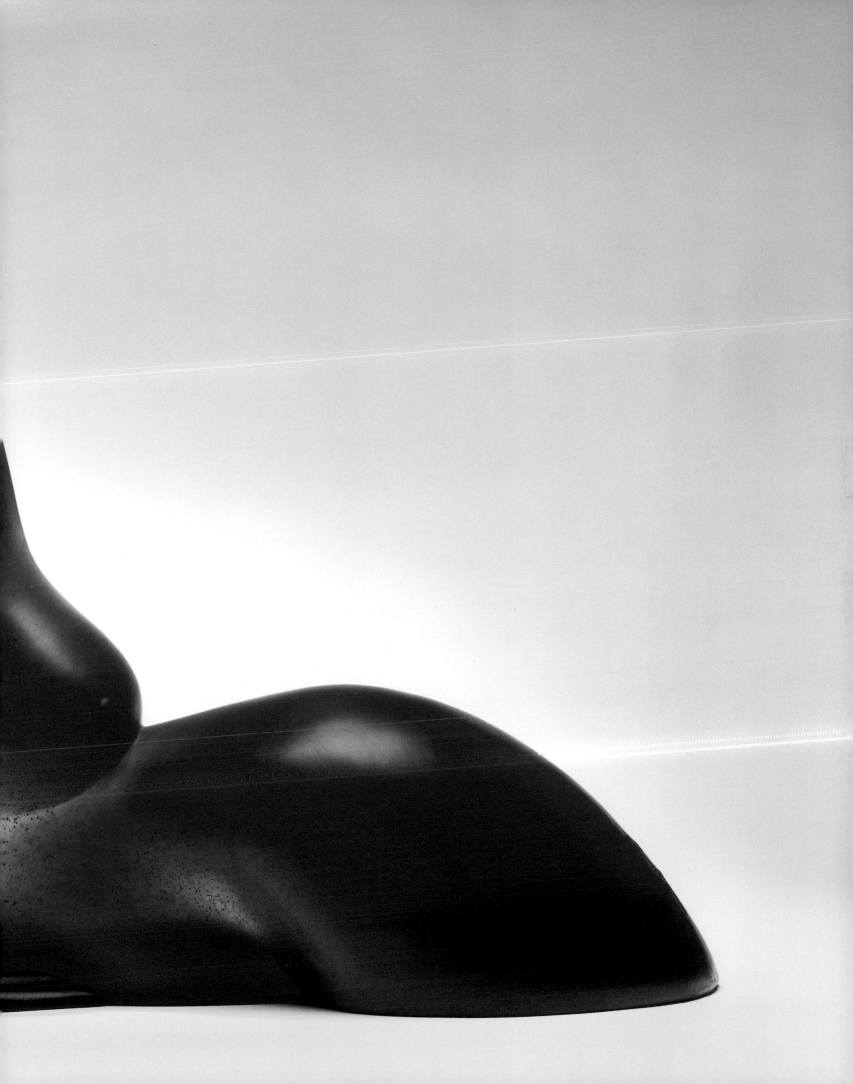

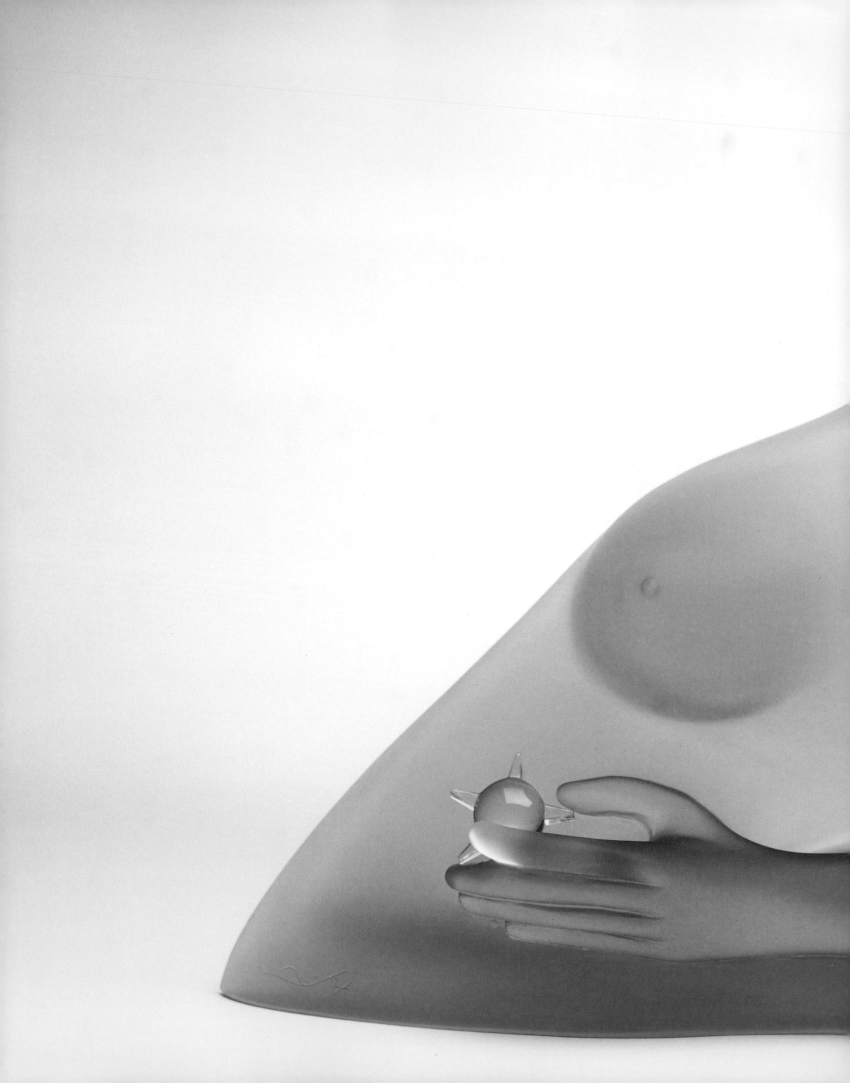

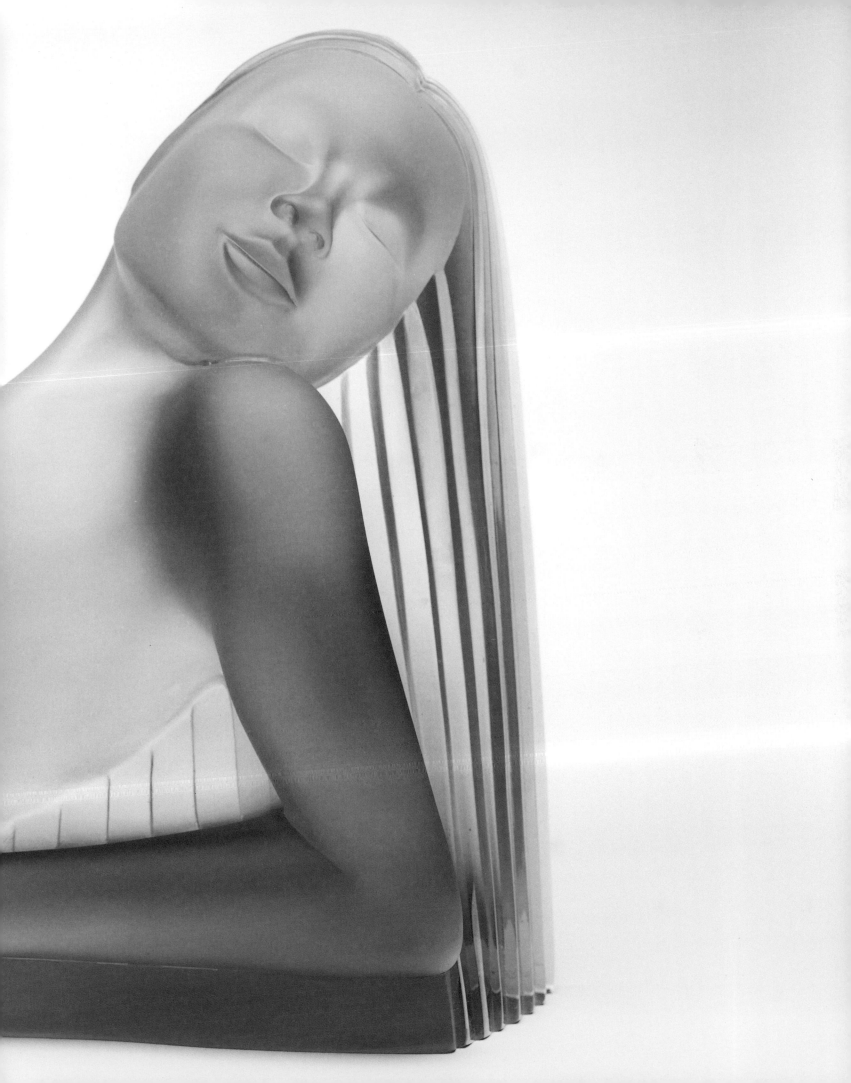

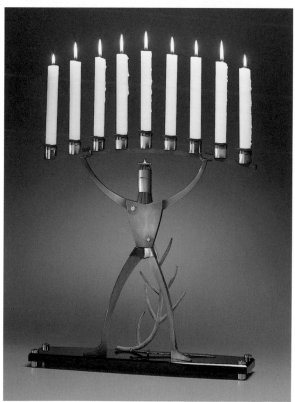

PREVIOUS
Le Soleil
16H X 21W X 4.5D"
2002

ABOVE
*Balancing Female Figure
Candleholder*
7H X 11W X 7D"
1999

BELOW
Maccabee Menorah
24H X 18W X 5D"
2000

346

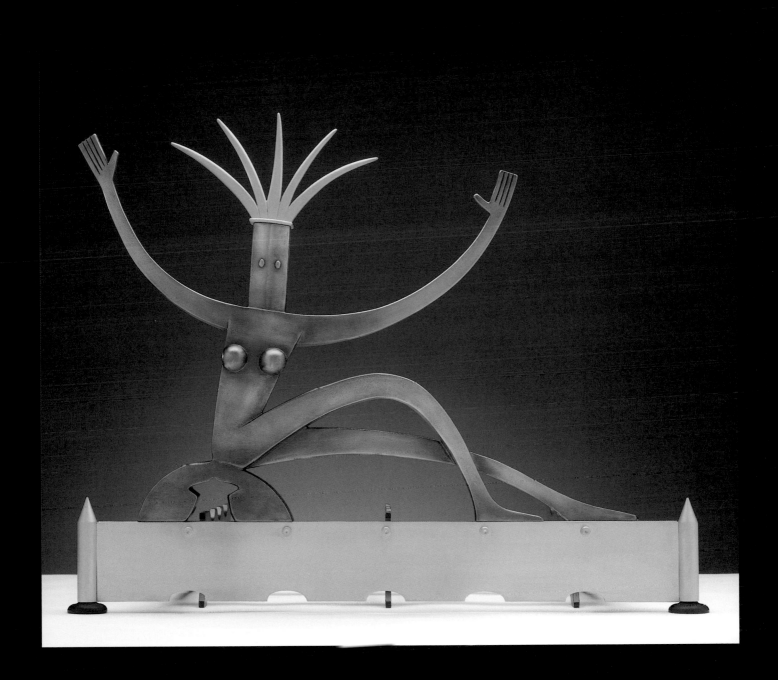

Fireplace Figure
25H X 31W X 20D"
1999

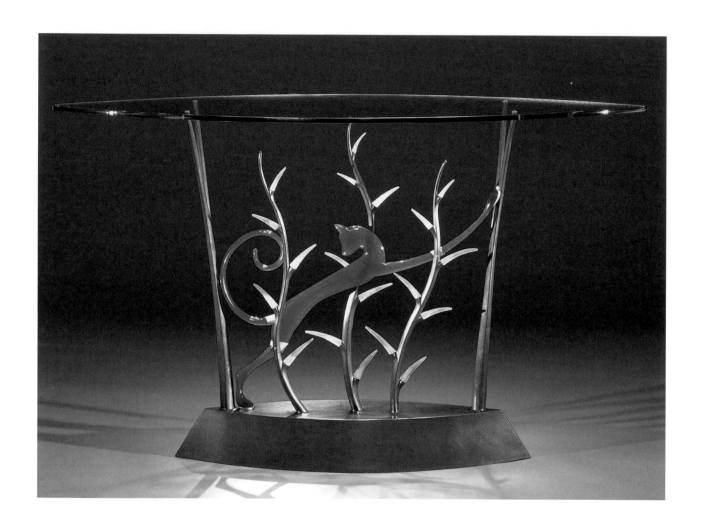

ABOVE
Ratteau's Puma
36H x 64W x 21D"
2000

OPPOSITE
Ratteau's Jaguar (detail)
36H x 64W x 20D"
2001

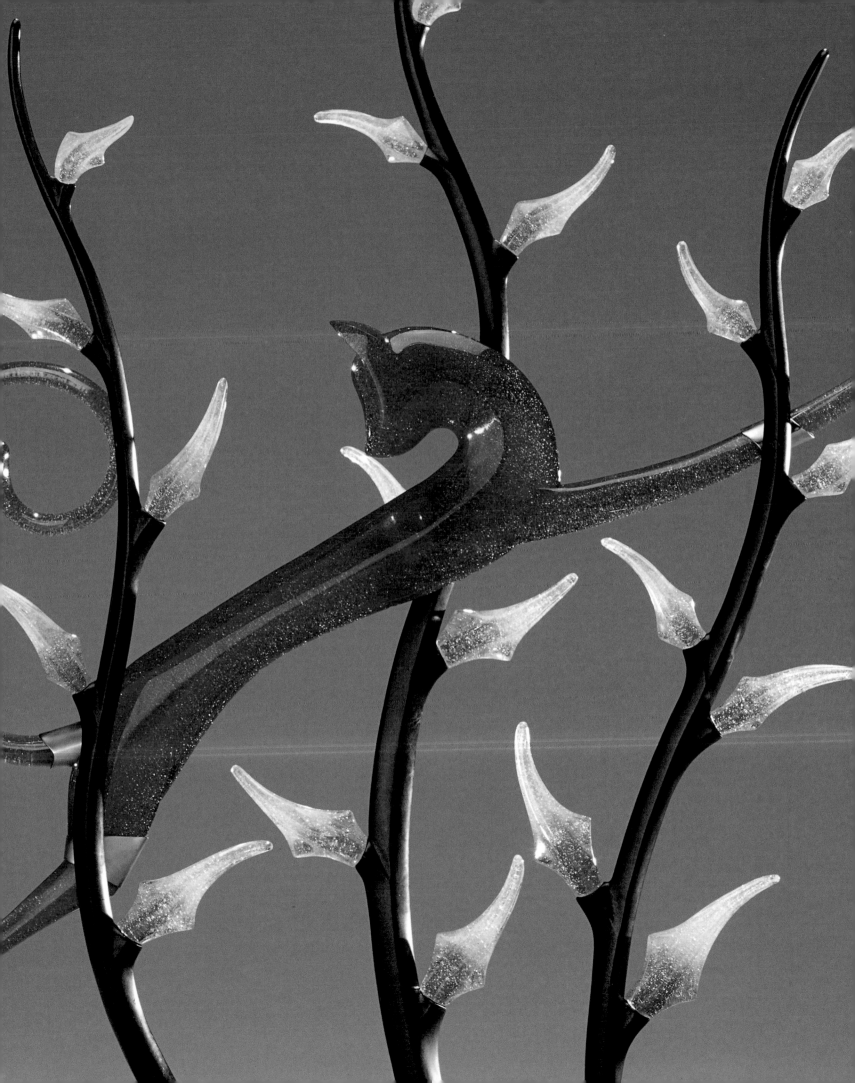

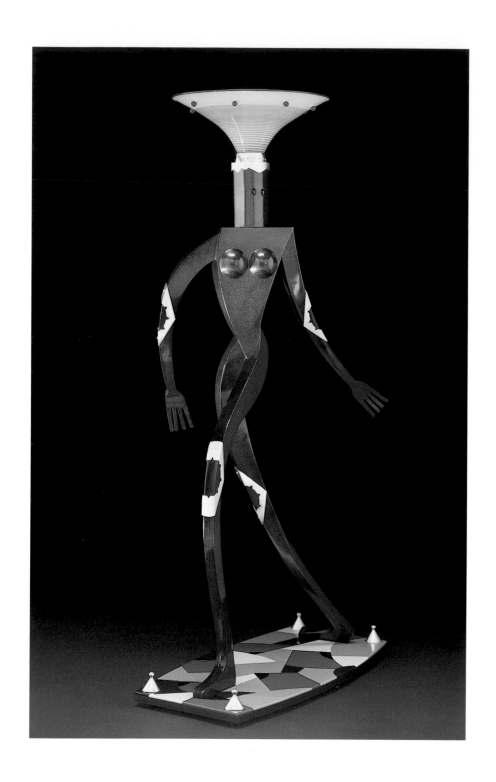

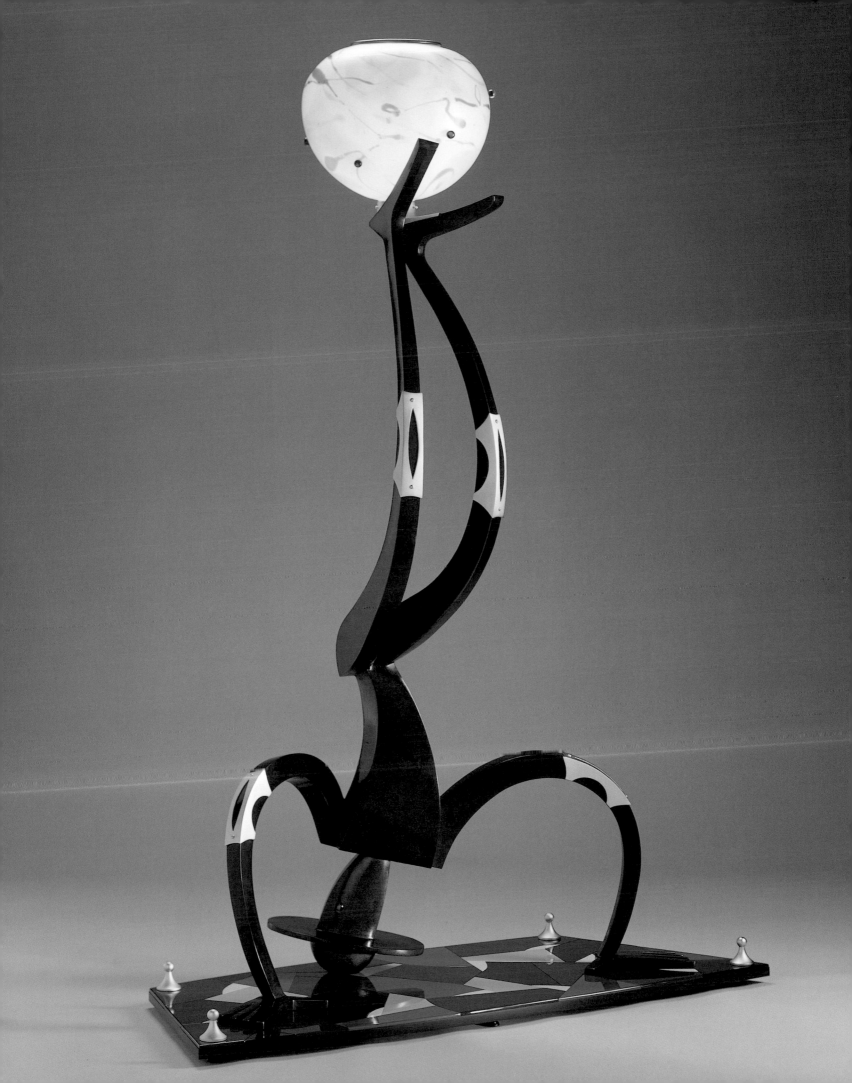

DAN DAILEY

On the occasion of this publication, which amounts to an exhibition without the burden of gathering and shipping the work all to one place, I am compelled to consider my endeavors in retrospect. Almost everything I have made is meant to convey a thought, a feeling or a mood. It could be a representation of something I have observed, where I try to capture the character of the subject portrayed, or it may be a fantasy that began as a drawing as my mind wandered. My sketchbooks are full of imaginings born of meditation on various subjects. I interpret each vision in a deliberately experimental manner in my search for definition and clarification of a thought. What begins as an ethereal wisp in my "mind's eye" becomes somewhat real as an ink drawing, then very real as an object. In my serial work each new version is an opportunity to imagine beyond the initial concept, so it expands the breadth and depth of any thought conveyed by a single representation. These habits of thought and process have guided me to the results pictured in this book.

As much as I have been an active participant in what I call the material arts movement, especially with glass—for the past 40 years—I am not conceptually linked with my contemporaries. We are connected by process and material more than concept. While I am always curious about an artist's thought processes, and can see what they are doing and understand their mechanical and technical methods, why they make the shapes, color arrangements or particular images that they do are at times less obvious to me.

It occurred to me early in my career that only a few subjects have ever been addressed by artists: Nature (every living thing on the planet including rocks, soil and water, plus the sky with all its elements) and the intellectual or physical creations of other humans. There are traditions and precedents to follow, and all of us use these forms of inspiration. Yet, the point of an artist's work is not to recreate that which has already been, but to conjure up something that has never been. Artists may try to invent new concepts, but it all comes back to these basic themes.

None of us invents from thin air, we merely use what exists to imagine and create new combinations. Our manner of selection and blending of elements, and how we incorporate them in our own work, is what differentiates us from our predecessors and contemporaries. The spirit imbued in each creative endeavor gives it a life of its own, striving to engage a viewer with its particular message. It is this interaction, the possibility of affecting someone emotionally and intellectually, that I seek in creating my work. If and when that happens—even though I may never know—I will have reached my goal of communication, and that is the most an artist can achieve.

PREVIOUS
Ballyoyo
14H x 9W"
1998

OPPOSITE
Dan Dailey
KENSINGTON, NH

DAN DAILEY
JONES BEACH, NY
1950

Education

1972
Master of Fine Arts,
Rhode Island School of Design,
Providence, RI

1969
Bachelor of Fine Arts,
Philadelphia College of Art,
Philadelphia, PA

1964
Cheltenham High School,
Cheltenham, PA

1963
Jenkintown High School,
Jenkintown, PA

1962
Germantown Friends School,
Philadelphia, PA

1959
Frankford Friends School,
Philadelphia, PA

1953-56
Moorestown Friends School,
Moorestown, NJ

Affiliations

1985–current
Professor, Glass Program,
Massachusetts College of Art,
Boston, MA

1974–85
Founder and Head of Glass
Program, Massachusetts College
of Art, Boston, MA

2002–current
Advisory Council, UrbanGlass,
Brooklyn, NY

2000–current
Board of Governors, Museum of
Arts & Design, New York, NY

1990–93
Honorary Board, The Renwick
Alliance, Smithsonian Institute,
Washington, DC

1988–current
National Advisory Board,
The University of the Arts,
Philadelphia, PA

1976–current
Independent Artist/Designer,
Cristallerie Daum, Paris and
Nancy, France

1998
Invited Artist, Waterford Crystal,
Kilbarry, Waterford, Ireland

1994
Selection Committee for Creative
Glass Center of America fellowships
–Created CGCA fund-raising poster
for Dodge Foundation and New
Jersey Council for the Arts

1983–92
Board of Trustees, Haystack
Mountain School of Crafts,
Deer Isle, ME

1979–88
Advisor, New York Experimental
Glass Workshop, NY

1984–85
Designer, Fenton Art Glass Co.,
Williamstown, WV

1984–85
Designer, Steuben Glass,
New York, NY

1984
Designer, Herman Miller Co.,
Zeeland, MI

1980–82
President, Glass Art Society

1978–82
Board of Directors, Glass Art Society

1972–73
Fulbright Scholar
Visiting Artist Fellowship
Venini-Fabrica, Murano,
Venice, Italy

Teaching Positions

Lansdowne Friends School,
Philadelphia, PA

Philadelphia Public Schools,
Philadelphia, PA

Rhode Island School of Design,
Providence, RI

University of Massachusetts
Dartmouth, formerly Southeastern
Massachusetts University,
North Dartmouth, MA

Massachusetts Institute of
Technology, Cambridge, MA

Haystack Mountain School of Crafts,
Deer Isle, ME

Pilchuck School, Stanwood, WA

Massachusetts College of Art,
Boston, MA

DAVID B. DAILEY (SECOND FROM RIGHT, BORN 1920)
RCA INDUSTRIAL DESIGN TEAM
CAMDEN, NJ
1950

GROTE
DAILEY PAINT JOB ON 1953 CHEVY
1968

JAMES CARPENTER, DAILEY
RHODE ISLAND SCHOOL OF DESIGN
PROVIDENCE, RI
1970

Exhibitions

1972
Philadelphia Art Alliance, Philadelphia, PA

1973
United States Embassy (U.S.I.S.), Rome, Italy

1975
Massachusetts Institute of Technology, Center for Advanced Visual Studies, Cambridge, MA

1976
Theo Portnoy Gallery, New York, NY

1977
Massachusetts Institute of Technology, Center for Advanced Visual Studies, Cambridge, MA

1979
Theo Portnoy Gallery, New York, NY

1980
Theo Portnoy Gallery, New York, NY

1981
Habatat Galleries, Lathrup Village, MI

Greenwood Gallery, Washington, DC

1982
Theo Portnoy Gallery, New York, NY

American Art Inc., Atlanta, GA

Kurland/Summers Gallery, Los Angeles, CA

1983
Habatat Galleries, Lathrup Village, MI

Betsy Rosenfield Gallery, Chicago, IL

1984
Habatat Galleries, Bay Harbor Island, FL

Walter/White Gallery, Carmel, CA

1985
Heller Gallery, New York, NY

Kurland/Summers Gallery, Los Angeles, CA

1986
Betsy Rosenfield Gallery, Chicago, IL

1987
Habatat Galleries, Bay Harbor Island, FL

Renwick Gallery, National Museum of American Art, Smithsonian Institution, Washington, DC

Rosenwald-Wolf Gallery, Philadelphia College of Art, PA

1988
Betsy Rosenfield Gallery, Chicago, IL

Kurland/Summers Gallery, Los Angeles, CA

1989
Sanske Galerie, Zurich, Switzerland

Yamaha Galleries, Tokyo, Japan (Collaborative work with Lino Tagliapietra)

Habatat Galleries, Boca Raton, FL

1990
Betsy Rosenfield Gallery, Chicago, IL

Habatat Gallery, Farmington, MI

Kurland/Summers Gallery, Los Angeles, CA

Leo Kaplan Modern, New York, NY

Sanske Galerie, Zurich, Switzerland (Collaborative work with Lino Tagliapietra)

Betsy Rosenfield Gallery, Chicago, IL

1991
Riley-Hawk Gallery, Cleveland, OH

Sandra Ainsley Gallery, Toronto, Ontario, Canada

Habatat Galleries, Boca Raton, FL

Leo Kaplan Modern, New York, NY

1992
Helander Gallery, Palm Beach, FL

Sanske Galerie, Zurich, Switzerland

Leo Kaplan Modern, New York, NY

1993
William Traver Gallery, Seattle, WA

Habatat Galleries, Boca Raton, FL

Riley-Hawk Galleries, Cleveland, OH

1994
Habatat Galleries, Boca Raton, FL

Leo Kaplan Modern, New York, NY

Betsy Rosenfield Gallery, Chicago, IL

1995
Habatat Galleries, Boca Raton, FL

Vespermann Gallery, Atlanta, GA

William Traver Gallery, Seattle, WA

Leo Kaplan Modern, New York, NY

Imago Gallery, Palm Desert, CA

1996
Habatat Galleries, Pontiac, MI

Riley-Hawk Galleries, Cleveland and Columbus, OH

Daum, France, New York, NY

1997
Habatat Galleries, Boca Raton, FL

Sandra Ainsley Gallery, Toronto, Ontario, Canada

Leo Kaplan Modern, New York, NY

Sanske Galerie, Zurich, Switzerland

Daum, France, New York, NY and Los Angeles, CA

Fay Gold Gallery, Atlanta, GA

William Traver Gallery, Seattle, WA

1998
Leo Kaplan Modern, New York, NY

Riley-Hawk Galleries, Cleveland and Columbus, OH

Meitsu Gallery, Nagoya, Japan, Courtesy Yamaki Gallery, Osaka, Japan

DAILEY
PHOTOGRAPHING *PALM TREE ASHTRAY*
POSTCARD BY EDWARD ZUCCA, PUTNAM, CT
1971

DAILEY
GLASS BLOWING STUDIO
MASSACHUSETTS COLLEGE OF ART
BOSTON, MA
1975

DAN DAILEY/LINDA MACNEIL WEDDING DAY
TARPAULIN COVE, NAUSHON ISLAND, MA
AUGUST 19, 1978

(exhibitions continued)

1999
The Art Center in Hargate,
(Dailey/MacNeil Archival Selections)
St. Paul's School, Concord, NH

Habatat Galleries, Boca Raton, FL
and Pontiac, MI

Leo Kaplan Modern, New York, NY

2000
Paul Mellon Arts Center Gallery,
(Dailey/MacNeil Archival Selections)
Choate Rosemary Hall, Wallingford,
CT

Imago Galleries, Palm Desert, CA

Leo Kaplan Modern, New York, NY

2001
Leo Kaplan Modern, New York, NY

Habatat Galleries, Boca Raton, FL

South Shore Art Center,
(Dailey/MacNeil Archival Selections)
Cohasset, MA

Riley-Hawk Galleries, Columbus, OH

2002
Habatat Galleries, Royal Oak, MI

Leo Kaplan Modern, New York, NY

2003
Habatat Galleries, Boca Raton, FL

Imago Galleries, Palm Desert, CA

Leo Kaplan Modern, New York, NY

2004
Jenkins Johnson Gallery, San Francisco, CA

Leo Kaplan Modern, New York, NY

2005
Leo Kaplan Modern, New York, NY

Hawk Galleries, Columbus, OH

Habatat Galleries, Boca Raton, FL

2006
Leo Kaplan Modern, New York, NY

Imago Galleries, Palm Desert, CA

Design and Edition Works

1978
Introduction of *pâte de verre* edition
"Les Danseurs," Cristallerie Daum,
Paris and Nancy, France

1984
Introduction of *pâte de verre* edition
"La Dame," Cristallerie Daum, Paris
and Nancy, France

1985
Seven chair designs for Herman
Miller Co., Zeeland, MI

1986
Ten designs for engraved vases on
the theme of sports for Steuben
Glass, NY

1988
Introduction of *pâte de verre* edition
"Le Vent," Cristallerie Daum, Paris
and Nancy, France

1992
Introduction of *pâte de verre* edition
"Le Vin," Cristallerie Daum, Paris
and Nancy, France

1994
Introduction of *pâte de verre* edition
"Le Joyau," Cristallerie Daum, Paris
and Nancy, France

1996
Introduction of *pâte de verre* edition
"L' Eau," Cristallerie Daum, Paris
and Nancy, France

1998-99
Waterford Crystal Artists Project,
one of four invited artists, Waterford, Ireland

2000
Bombay Martini glass design and
commission

2001
Introduction of *pâte de verre* edition
"Table de Hippopotamie" Cristallerie Daum, Paris and Nancy, France

2003
Introduction of *pâte de verre* edition
"Le Soleil," Cristallerie Daum, Paris
and Nancy, France

DALE CHIHULY, DAILEY
CHIHULY'S *MACCHIA SERIES*
1981

PILCHUCK GLASS BLOWING CLASS
DAILEY (LEFT)
AUGUST, 1982

DAILEY, MARK WEINER
WINE + CHEESE
SUPERMARKET, NANCY, FRANCE
1983

Selected Group Exhibitions

More than 300 juried or invitational group shows since 1971.

1972–1973
"American Glass Now," Toledo Museum of Art, Toledo, OH

1973
"First International World Craft Exhibit," Toronto, Ontario, Canada

1976
"Pilchuck Glass Invitational," Seattle Art Museum, WA

1978–1979
"Americans in Glass," Leigh Yawkey Woodson Museum, Wausau, WI

"Glass America 1978," Lever House, New York, NY

"New American Glass, Chihuly, Dailey, Happel, Shaffer," Huntington Galleries, Huntington, WV

1979
"Pilchuck Visiting Artists & Faculty Invitational," Henry Gallery, University of Washington, Seattle, WA

"Sculptures et Volumes De Verre," Musee Chateau D'Annecy, France

"The Unpainted Portrait," John Michael Kohler Arts Center, Sheboygan, WI

1979–1981
"New Glass," Corning Museum of Glass, New York, NY

1980
"Opening Exhibition," California National Invitational, Craft and Folk Art Museum, Los Angeles, CA

"Masterworks," National Invitational, Pennsylvania State University, University Park, PA

"Crafts Biennial," National Invitational, University of Illinois, Normal, IL

"New American Glass–Focus West Virginia," Huntington Galleries, Huntington, WV

"Art for Use," National Invitational Exhibition Pavilion, Winter Olympics, Lake Placid, NY

1981
"Americans in Glass," Leigh Yawkey Woodson Art Museum, Wausaw, WI

"Glass Kunst '81," International Glass Show, Museum of Art, Kassel, Germany

"Contemporary Glass–Australia, Canada, U.S.A. and Japan," National Museums of Modern Art, Kyoto and Tokyo, Japan

"Glass '81 in Japan," Odakyu Department Store Grand Gallery, Japan Glass Art Society, Tokyo, Japan

"Glass Routes," DeCordova Museum, Lincoln, MA

"Glass: Artist & Influence," Jesse Besser Museum, Alpena, MI

"Artifacts at the End of a Decade," Museum of Modern Art, New York, NY

"Emergence, Art in Glass," National Invitational, Bowling Green State University, Bowling Green, OH

1982
"National," Habatat Galleries, Lathrup Village, MI

"Dailey/Weinberg," B.Z. Wagman Gallery, St. Louis, MO

"Craft: An Expanding Definition," J.M. Kohler Arts Center, Sheboygan, WI

"World Glass Now '82," Hokkaido Museum of Modern Art, Sapporo, Japan

"Contemporary American Glass Sculpture," United States Embassy, Prague, Czechoslovakia

"Verriers Contemporains–Art et Industrie," Musee des Arts Decoratifs, Paris, France

"American Glass Art: Evolution and Revolution," Morris Museum of Arts and Sciences, Morriston, NJ

"International Directions in Glass Art," Art Gallery of Western Australia, Perth, Australia; an invitational traveling to seven museums in Australia

1983
"The Art of Private Commissions," Dimmock Gallery, George Washington University, Washington, DC

"The Fine Art of Contemporary American Glass," Columbus College of Art & Design, Columbus, OH

"Sculptural Glass," Tucson Museum of Art, Tucson, AZ

"Glass, Artist/Designer/Industry," Castle Gallery, College of New Rochelle, New Rochelle, NY

"Glass Now '83," Yamaha Galleries, Tokyo, Kyoto, Yokohama, Sapporo and Nagasaki, Japan

"National Glass V," Contemporary Artisans Gallery, San Francisco, CA

1984
"Glass in Miami," Regional Exhibition, Miami, FL

"Glass National," Habatat Galleries, Detroit, MI; Bay Harbor Islands, FL

"Glass National," Elaine Potter Gallery, San Francisco, CA

"Pilchuck Invitational," Traver Sutton Gallery, Seattle, WA

"MCA 3-D Faculty Exhibition," Federal Reserve Bank, Boston, MA

"Innovations–Clay & Glass," Rhode Island College, Providence, RI

"Glass Now '84," Yamaha Galleries, Tokyo, Nagasaki, Kyoto and Yokohama, Japan

"Five International Artists," Shuyu Gallery, Tokyo, Japan

"Aspects of Contemporary Glass," California State University, San Bernardino, CA

"Americans in Glass '84," Leigh Yawkey Woodson Art Museum, Wausau, WI, and several museums in Europe including: Kestner Museum, Hannover, Germany; Athaneum, City Art Galleries, Manchester, England.

SKY DANCE
OTTO PIENE AND ELAINE SUMMER
IOWA CITY, IA
1982

OTTO PIENE TAUGHT WITH DAN DAILEY AT
THE CENTER FOR ADVANCED VISUAL STUDIES, MIT
1980–85

DAILEY AND LINDA MACNEIL
AMESBURY STUDIO
1986

(selected group exhibitions continued)

"Glass '84 in Japan," Japan Glass Artcraft Association, Tokyo, Japan

"New England Glass Art '84," Gallery Naga, Boston, MA

"Contemporary Glass, A Decade Apart," The Boise Gallery of Art, Boise, ID

"Glass America '84," Heller Gallery, New York, NY

"MCA Glass," Snyderman Gallery, Philadelphia, PA

1985
"World Glass Now '85," Hokkaido Museum of Modern Art, Sapporo, Japan

"Glass Now," Kulturhuset Museum, Stockholm, Sweden

"Art Du Verre," Musee des Beaux Arts, Rouen, France

"Narrative Glass," Susan Cummins Gallery, Mill Valley, CA

"Trans-Lucid," Washington Square Gallery, Washington, DC

"Sculpture Invitational," Elaine Potter Gallery, San Francisco, CA

"Pilchuck Artists," Foster White Gallery, Seattle, WA

"14th National," Habatat Galleries, Lathrup Village, MI

"Glass America '85," Yamaha Galleries, Nagasaki, Tokyo, Kyoto, Yokohama, Japan

"Cristallerie Daum–Pâte de Verre," Musee des Arts Decoratifs, Paris, France

1986
"Glass Art–Style and Form," Perception Galleries, Houston, TX

"New American Glass: Focus 2 West Virginia," Huntington Galleries, Huntington, WV

"Craft Today–Poetry of the Physical," American Craft Museum, New York, NY

"Lamps: Works That Illuminate Space," Gallery Naga, Boston, MA

"Contemporary American and European Glass from the Saxe Collection," The Oakland Museum, Oakland, CA

"Glass Now '86," Yamaha Galleries, Tokyo, Japan

"Architecture of the Vessel," Bevier Gallery, Rochester Institute of Technology, Rochester, NY

"Daum Nancy," Musee Bellerive, Zurich, Switzerland

"Glass is the Medium," Newport Art Museum, Newport, RI

"Pilchuck–Governor's Invitational Exhibition," Washington State Capital Museum, Olympia, WA

1987
"25 Years of American Glass," Darmstatt Museum, Darmstatt, Germany

"The Saxe Collection," American Craft Museum, New York, NY

"Busts," 6–Artist Invitational, Betsy Rosenfield Gallery, Chicago, IL

"Glass Now '87," Yamaha Galleries, Tokyo, Japan

"New Work," Wita Gardiner Gallery, San Diego, CA

"New American Glass," Port of History Museum, Philadelphia, PA

"30 Years of New Glass," Corning Museum of Glass, Corning, NY

"50th Anniversary Exhibition," George Saxe Glass Curator, Contemporary Crafts Gallery, Portland, OR

"Drawn to the Surface: Artist in Clay and Glass," Pittsburgh Center for the Arts, Pittsburgh, PA

1988
"Glass Animals: 3,500 Years of Artistry," Steuben Glass, New York, NY

"Glass Now '88," 10th Anniversary Exhibition, Yamaha Galleries, Tokyo, Japan

"25th Anniversary Fellows Exhibition," Center for Advanced Visual Studies, Massachusetts Institute of Technology, Cambridge, MA

"Architectural Art," American Craft Museum, New York, NY

"30 Years of New Glass, 1957-1987," The Toledo Museum of Art, Toledo, OH

1989
"Glass Now '90," Yamaha Corp. of America, touring Japan

"Craft Today USA," European tour '89–92, American Craft Museum, New York, NY

"Group Invitational Glass Exhibition," Joan Robey Gallery, Denver, CO

"Common Roots/Diverse Objectives/Rhode Island School of Design Alumni in Boston," Brockton Art Museum, Brockton, MA

"The Vessel: Studies in Form & Media," Craft and Folk Art Museum, Los Angeles, CA

"Selected Work in Glass," Gallery Naga, Boston, MA

1990
"World Glass Now '91," Hokkaido Museum of Modern Art, Sapporo, Japan

"Contemporary Development in Glass: A Season of Light," Davenport Museum of Art, Davenport, IA

"International Glass 1990," Habatat Galleries, Boca Raton, FL

"Art Focus," New England Biolabs Foundation, Beverly, MA

"The Collaborative Work of Dan Dailey and Lino Tagliapietra," Sanske Galerie, Zurich, Switzerland

Kavesh Gallery, Sun Valley, ID

"The Venetians," Muriel Karasik Gallery, New York, NY

"1990 Economic Summit of Industrialized Nations," Rice University, Houston, TX

Gallery Affiliate: Judy Youens Gallery, Houston, TX

"Lamporama '90," Bank of Boston Gallery and Artist Foundation Gallery, Boston, MA

DAN (WITH HAT), OWEN, ALLIE AND LINDA
OWEN'S BIRTHDAY
1986

DAILEY WITH PARENTS
BARBARA TARLETON TRICEBOCK,
KENNETH FREDERICK TRICEBOCK
EXHIBITION OPENING RENWICK GALLERY
SMITHSONIAN INSTITUTION, WASHINGTON, D.C.
1987

DAILEY
FENTON ART GLASS FACTORY
WILLIAMSTOWN, WV
1989

"18th Annual International Glass Exhibit," Habatat Galleries, Farmington Hills, MI

1991
Blue Heron Gallery, Deer Isle, ME

"Helander Tenth Anniversary Exhibition," Helander Gallery, Palm Beach, FL

"The Americans: A Venetian Tradition," West End Gallery, Corning, NY

"From the Creative Glass Center," Dawson Gallery, Rochester, NY

"19th Annual Glass International," Habatat Galleries, Farmington Hills, MI

"7th Annual Glass Invitational," Judy Youens Gallery, Houston, TX

"Masters of Contemporary Glass," Naples Philharmonic & Museum, Naples, FL

1992
Clark Gallery, Lincoln, MA

"Eighth Annual International Glass Invitational," Judy Youens Gallery, Houston, TX

"Glass '92," Imago Gallery, Palm Springs, CA

"The 20th Annual International Glass Invitational," Habatat Galleries, Farmington Hills, MI

"Architectural Show of Glass," Vespermann Gallery, Atlanta, GA

"Visions," Rufino Tamayo Museum, Mexico City, Mexico

"Clearly Art: The Pilchuck Legacy," Whatcom Museum, Bellingham, WA

Sandwich Glass Museum, Sandwich, MA

"International Directions in Glass," The Art Gallery of Western Australia, Perth, Australia

"Glass Now '92," World Studio Glass Exhibition, Yamaha Corp., Tokyo, Japan

"Glass From Ancient Craft to Contemporary Art: 1962-1992 and Beyond," The Morris Museum, Morristown, NJ

"International Pilchuck Exhibition," William Traver Gallery, Seattle, WA

"Eleventh Annual International Glass Invitational," Habatat Galleries, Boca Raton, FL

"Off the Wall," American Craft Museum, New York, NY

"Le Verre," Exposition International De Verre Contemporain Musee De Rouen, Rouen, France

1993
"Glass Now 15th," Yamaha Corp. Galleries, Tokyo, Japan

"Saxe Collection," Toledo Museum of Art, Toledo, OH

"The Pet Show," Helander Gallery, New York, NY

"Sculptural/Functional Show," Helander Gallery, Palm Beach, FL

"Maximizing the Minimum: Small Glass Sculpture," Museum of American Glass, Millville, NJ

"The 21st Annual International Invitational," Habatat Galleries, Farmington Hills, MI

"International Glass," Judy Youens Gallery, Houston, TX

"CGCA Glass Weekend," Creative Glass Center of America, Millville, NJ

"15th Anniversary Stockbridge Glass Invitational," Holsten Galleries, Stockbridge, MA

"The Rhode Island Connection: Thirteen Contemporary Glass Masters," Newport Art Museum, Newport, RI, Virginia Lynch Gallery, Tiverton, RI

"Glass '93 In Japan," Japan Glass Artcraft Association, Tokyo, Japan

"Chicago International New Art Forms Exposition," Betsy Rosenfield Gallery and Ruth Summers National Bank, Vespermann Gallery, Atlanta, GA

"Close Encounters of the Creative Kind," American Craft Museum, New York, NY

"Year of the Craft," Iowa State University's Brunnier Gallery and Museum, Ames, IA

"Twelfth Annual International Glass Invitational," Habatat Galleries, Boca Raton, FL

"16th Annual International Pilchuck Exhibition," William Traver Gallery, Seattle, WA

1994
"Twelfth Annual International Glass Invitational," Habatat Galleries, Boca Raton, FL

"Group Show," Compositions Gallery, San Francisco, CA

"The 22nd Annual International Glass Invitational," Habatat Galleries, Farmington Hills, MI

"Glass Masters," Helander Gallery, Palm Beach, FL

"Etched in Glass," Habatat Galleries, Boca Raton, FL

"Massachusetts College of Art Exhibition," Clark Gallery, Lincoln, MA

"Contemporary Glass: Process and Technique," Craft Alliance, St. Louis, MO

Leo Kaplan Modern, New York, NY

Riley-Hawk Gallery, Cleveland, OH

"International Survey of Contemporary Art Glass," Pittsburgh Cultural Trust, Concepts Gallery, Pittsburgh, PA; Habatat Galleries, Pontiac, MI

"17th Annual Pilchuck Exhibition," William Traver Gallery, Seattle, WA

DAILEY'S DRAWINGS AND HEAD VASES
BEN MOORE STUDIO
1988

DAN, LINDA, OWEN, ALLIE
KENSINGTON STUDIO, NH
1989

DAILEY
ABSTRACT HEADS BEFORE ACID POLISHING
WEST VIRGINIA FACTORY
1991

(selected group exhibitions continued)

1995
"A Powerful Presence: Pilchuck Glass School's 25 Years," Bumbershoot 1995, Margery Aronson, Seattle, WA

"1995 Stockbridge Glass Invitational," Holsten Gallery, Stockbridge, MA

Marina Barovier Gallery, Venice, Italy

Indianapolis Museum of Art, Indianapolis, IN

"Light Interpretations: A Hanukkah Menorah Invitational," Jewish Museum of San Francisco, San Francisco, CA

"Pilchuck Pioneers," William Traver Gallery, Seattle, WA

"14th Annual International Glass Invitational," Habatat Galleries, Boca Raton, FL

"Figurative Interpretations," Habatat Galleries, Pontiac, MI

"Taipei International Glass Exhibition," China Times, Taipei, Taiwan

"Massachusetts College of Art Faculty Exhibition," Boston, MA

Blue Heron Gallery, Deer Isle, ME

Riley-Hawk Gallery, Cleveland, OH

"Masters of Glass," Port of Seattle, Pilchuck Glass Exhibition, Seattle, WA

"The 23rd Annual International Glass Invitational," Habatat Galleries, Pontiac, MI

"East Coast Glass," University of North Carolina, Charlotte, NC

"Glass as Art: Celebrating the 25th Anniversary of the Glass Art Society," Blue Spiral 1 Gallery, Asheville, NC

"The Venice Art Walk," Venice Family Clinic, Venice, CA

Hisinchu Cultural Center, Hisinchu, Taiwan

"The Beauty of Painted Glass," Habatat Galleries, Aspen, CO

1996
"Studio Glass in the Metropolitan Museum of Art," New York, NY

"Seattle Art Fair," Seattle, WA

Habatat Galleries, Pontiac, MI

Riley-Hawk Gallery, Cleveland, OH

"The 24th Annual International Invitational," Habatat Galleries, Pontiac, MI

Massachusetts College of Art, Main Gallery, Boston, MA

"Glass: New England," Worcester Center for Crafts, Worcester, MA

"Glass," NAGA Gallery, Boston, MA

"Just Add Water: Artists and the Aqueous World," Charles A. Wustum Museum of Fine Arts, Racine, WI

"Venezia Aperto Vetro," Assorato alla Cultura, Venice, Italy

1997
Hsinchu Cultural Center, Hsinchu, Taiwan; Habatat Galleries, Pontiac, MI

"35 Years of American Glass," Philharmonic Center of the Arts, Naples, FL; Habatat Galleries, Boca Raton, FL

"Artistes Verriers Contemporains Europe, Etats-Unis, Japan," Musee des Arts Decoratifs de la Ville de Lausanne, Lausanne, Switzerland

"Inaugural Exhibition," Glass Museum at the Museo del Vidrio, sponsored by Vetro Corp., Monterey, Mexico; Habatat Galleries, Pontiac, MI

"25th Annual International Glass Invitational," Habatat Galleries, Pontiac, MI

"Food, Glorious Food: Artists and Eating," Charles A. Wustum Museum of Fine Arts, Racine, WI

"Masters of Contemporary Glass: Selections from the Glick Collection," Indianapolis Museum of Art, Indianapolis, IN

Chappell Art Gallery, Boston, MA

"Glass Today by American Studio Artists," Boston Museum of Fine Arts, Boston, MA

"15th International Annual Glass Invitational," Habatat Galleries, Boca Raton, FL

"Future Perfect: Mentors & Students of MassArt," Chappell Gallery, Boston, MA

Imago Gallery, Palm Desert, CA

"Translucent and Opaque: Contemporary Glass," Port of Seattle, SeaTac, WA

"Glass Today," Cleveland Museum of Art, Cleveland, OH

1998
"The 16th Annual International Glass Invitational," Habatat Galleries, Boca Raton, FL

"Outbound: Art at the Forefront of International Exchange," Bank of America Gallery, Seattle, WA

"Glass Today by American Studio Artists," Imago Gallery, Palm Desert, CA

"Translucent and Opaque: Contemporary Glass," Port of Seattle 1998 Glass Exhibition, Seattle-Tacoma International Airport, SeaTac, WA

"R.I.S.D. Works: An Invitational of Alumni from the Glass Department at the Rhode Island School of Design 1969-1996," Elliot Brown Gallery, Seattle, WA

1999
"Glass! Glorious Glass!" Renwick Gallery, Smithsonian American Art Museum, Washington, DC

"GlassWeekend '99," Creative Glass Center of America, Millville, NJ

"Steninge World Exhibition of Art Glass 1999," Steninge Slott Cultural Centre, Märsta, Sweden

"The 27th Annual International Glass Invitational," Habatat Galleries, Pontiac, MI

CHRISTINA LOGAN, MARK WEINER,
CHRIS VESPERMANN, KELLMIS FERNANDEZ
ACID POLISHING ABSTRACT HEADS
WEST VIRGINIA FACTORY
1991

DAILEY
ABSTRACT HEADS
AFTER ACID POLISHING
WEST VIRGINIA FACTORY
1991

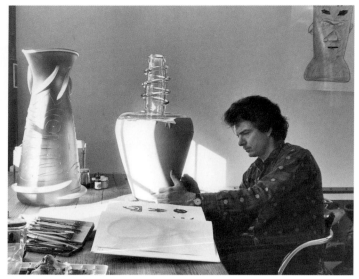

DAILEY
WORKING ON *SCORPION MAN* FACE VASE
KENSINGTON STUDIO
1991

"New Perspectives/Ancient Medium," Grand Central Gallery, Tampa, FL

"Influences in Contemporary Glass," Seattle-Tacoma International Airport, SeaTac, WA

Imago Galleries Grand Opening, Palm Desert, CA

"17th Annual International Glass Invitational," Habatat Galleries, Boca Raton, FL

2000
"Clearly Inspired: Contemporary Glass and Its Origins," Tampa Museum of Art, Tampa, FL

"Made in Washington: Glass at the Millennium," Seattle-Tacoma International Airport, SeaTac, WA

"Diversity in Glass; Master Glass Artists," Sharon Arts Center, Peterborough, NH

"Millennium Glass: An International Survey of Studio Glass," Kentucky Art and Craft Foundation, Louisville, KY

"Glass: Artist, Influence, & Evolution," Habatat Galleries, Pontiac, MI

"Shattering Precepts: The Fine Art of Contemporary Glass," Dennos Museum, Traverse City, MI; Habatat Galleries, Pontiac, MI

"Creatures Great and Small," Chappell Gallery, Boston, MA

"A Singular Vision: Expressive Works in Craft from New Hampshire and Vermont," Hood Museum of Art, Dartmouth College, Hanover, NH

"The 28th Annual International Glass Invitational," Habatat Galleries, Pontiac, MI

"Venetian Influences," American Craft Museum, New York, NY

"Mass Art 3-D Fine Arts 2000 Exhibition," Federal Reserve Bank of Boston, Boston, MA

"Glass & Sculpture Invitational," Jenkins Johnson Gallery, San Francisco, CA

"The 18th Annual International Glass Invitational," Habatat Galleries, Boca Raton, FL

2001
"Lino Tagliapietra e Amici: A Celebration of Italian Glass," Maestro Lino Tagliapietra and his Friends, Fuller Museum of Art, Brockton, MA

"Hot Glass," Mobilia Gallery, Cambridge, MA

"The 29th Annual International Glass Invitational," Habatat Galleries, Pontiac, MI

"Millennium Glass: An International Survey of Studio Glass," Kentucky Art and Craft Foundation, Louisville, KY

"Creativity and Collaboration: Pilchuck Glass School at 30," Seattle-Tacoma International Airport, SeaTac, WA

"International Glass Exhibition" Habatat Galleries, Pontiac, MI; Liuligongfang Studio, Beijing and Shanghai, China

"Objects for Use: Handmade by Design," American Craft Museum, New York, NY

"The 19th Annual International Glass Invitational," Habatat Galleries, Boca Raton, FL

2002
"The 20th Annual International Glass Invitational," Habatat Galleries, Boca Raton, FL

"Going to the Dogs: Man's Best Friend as Seen by Artists," Charles A. Wustum Museum of Fine Arts, Racine, WI

"Contemporary Directions: Glass from the Maxine and William Block Collection," Carnegie Museum of Art, Pittsburgh, PA; Toledo Museum of Art, Toledo, OH

"The 30th Annual International Glass Invitational," Habatat Galleries, Pontiac, MI

"Exploring the Human Spirit in Glass," Habatat Galleries, Boca Raton, FL

"The San Francisco International Art Exposition," Jenkins Johnson Gallery, San Francisco, CA

"The 4th Annual Art Palm Beach Modern and Contemporary Art Fair," Habatat Galleries, Boca Raton, FL

2003
"Intimate Concepts: Important Small Works in Glass," Habatat Galleries, Boca Raton, FL

"Fabricated Music," Jenkins Johnson Gallery, San Francisco, CA

"The 21st Annual International Glass Invitational," Habatat Galleries, Boca Raton, FL

"The 31st Annual International Glass Invitational," Habatat Galleries, Pontiac, MI

"The Glass Continuum," Massachusetts College of Art, Chappell Gallery, Boston, MA

"The Art of Drawing," Concord Art Association, Concord, MA

"Glorious Glass: Color and Form," Seattle-Tacoma International Airport, SeaTac, WA

"Glass Masters: Technology—Old and New," Imago Galleries, Palm Desert, CA

"American Studio Glass: A Survey of the Movement," The William S. Fairfield Public Gallery, Sturgeon Bay, WI

2004
"Multiplicity: Glass in All Its Glory," Seattle-Tacoma International Airport, SeaTac, WA

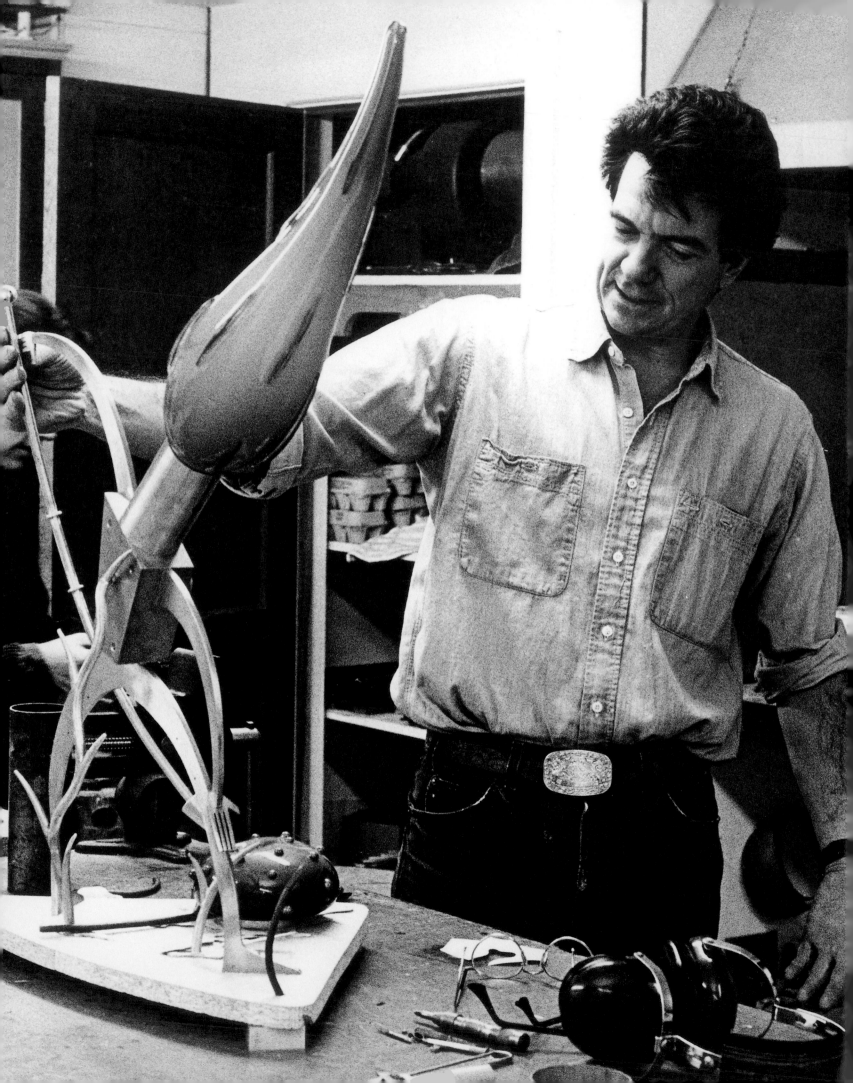

LINDA MACNEIL, DAILEY, MILTON GLASER
CO-TEACHING
HAYSTACK MOUNTAIN SCHOOL OF CRAFTS
DEER ISLE, ME
1992

OPPOSITE:
DAILEY
WORKING ON *HUNTRESS* LAMP SCULPTURE
KENSINGTON STUDIO, NH
1994

LINO TAGLIAPIETRA, DAILEY
NIIJIMA GLASS CENTER
NIIJIMA, JAPAN
1992

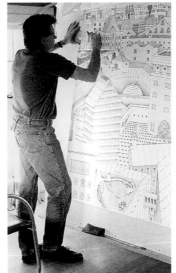

DAILEY
WORKING ON *CITY DREAM* DRAWING
KENSINGTON STUDIO, NH
1994

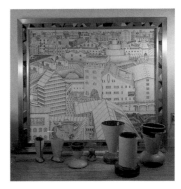

CITY DREAM, VASES IN PROGRESS
KENSINGTON STUDIO, NH
1988-94

(selected group exhibitions continued)

2005

"Magnificent Extravagance: Artists and Opulence," Racine Art Museum, Racine, WI

"Particle Theories," Museum of American Glass, Millville, NJ

"Figures and Form," Leo Kaplan Modern, New York, NY

"Dual Vision: The Chazen Collection," Museum of Art and Design, New York, NY

"Brilliant: Celebrating Pilchuck Glass School's 35 Years," Seattle-Tacoma International Airport, SeaTac, WA

"San Francisco International Art Exposition," Fort Mason Center, San Francisco, CA

2006

"Glass: Material Matters," Los Angeles County Museum of Art, Los Angeles, CA

"2 Media 2 Expressions," Springfield Museum of Art, Springfield, OH

Commissions

1972–ongoing
Numerous residential commissions for lamps, wall reliefs and installations.

1986
The *MASSART AWARD*, an "Emmy for the Arts." Glass and bronze trophy vase presented annually to outstanding contributors to the advancement of the arts.

Dinosaur, Cityscape, Landscape, Hydroplant, Energy Plant, Ocean Drilling Platform, Power Lines, Gas Rig, Primal Energy, Commonwealth Energy Services Corporate Headquarters, Cambridge, MA
Nine cast-glass relief murals: 7H x 8W to 7H x 20W'
Architects: Add Inc.

1987
Orbit, Rainbow Room Installation, Rockefeller Center, New York, NY
Clear cast-glass relief mural with illuminated painting and computerized controlled lighting system: 8H x 16W'. Bronze and glass lamps in various rooms of Rainbow complex.
The Rockefeller Group Inc.
Architects: Hardy Holzman Pfeiffer Associates.

1988
The Parkman Vase, Commemorating Dr. Paul Parkman's discovery in 1969 of the vaccine for rubella. Blown glass and fabricated gold-plated and patinated bronze vase: 17.25H x 10W x 10D"

1988–1994
City Dream, Rockville, MD
Landscape, ink on Canson 240 lb. paper, aluminum and acid polished glass mosaic frame: 6H x 7W'.

1989
Family, Marietta Memorial Hospital, Marietta, OH
Cast-glass relief mural, clear glass castings: 36H x 72W x 2D"
Architect: Frank Wiley.

Trees in Wind, Rain on Water, Rolling Fields, Children's Hospital, Boston, MA
Three cast-glass relief murals; clear glass castings each with a colored border of either blue, maroon or green: 7H x 11W' each.
Architect: Ellenzweig Associates.

1990
Birds in Clouds, Dreyfus Corp., Pan American Building (Met Life Bldg.), New York, NY
Three cast-glass relief murals; violet and amber combination glass: Mural 1: 4H x 7W'; Mural 2: 6H x 13W'; Mural 3: 4H x 7W'
Architects: Swanke Hayden Connel.

Grass in Wind, Northern Essex County Courthouse, Newburyport, MA
Cast-glass relief mural, clear glass castings: 12H x 16W'
Architects: Leers Weinzapfel.

1991
Sculptural installation–Jasper's Restaurant, Boston, MA
Five illuminated Abstract Head vases.

1992
Sconces and ceiling fixture–United Nations Plaza, New York, NY
Four sconces and ceiling fixture with stylized floral forms in blown and cast glass, fabricated, patinated and gold-plated bronze.
Architect: Dan Goldner.

1992–1994
Handrail, mosaic glass mirror and shelf–Zurich, Switzerland
Cast and fabricated bronze three-story handrail with 15 figures; bronze and glass mosaic mirror and shelf with two figurative sconces; 112 nickel-plated bronze cabinet handles and pulls in two kitchens.

1993
Glass mosaic framed mirror and shelf–New York, NY
Bronze and glass mosaic framed mirror and shelf with a pair of twin figurative sconces in a private elevator lobby. Blown and cast glass, fabricated, patinated and gold plated bronze: 48H x 120L"
Architects: Pasanella and Klein (Henry Stolzman).

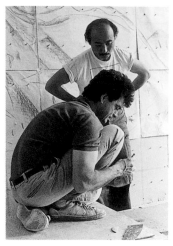

EXUBERANCE
DAILEY, HITOSHI KAKIZAKI
SKETCH STUDIES FOR VAIL TRANSPORTATION CENTER
MURAL
KENSINGTON, NH
1993-94

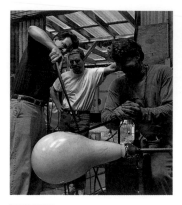

WHITE GORILLA
DAILEY, DANTE MARIONI, RICH ROYAL
BEN MOORE STUDIO, SEATTLE, WA
1994

FRANKENSTEIN
ROGER HOOVER, DAILEY, CECIL VALENTINE
ACID POLISHING FACILITY
FENTON ART GLASS FACTORY
WILLIAMSTOWN, WV
1995

DAILEY, KELLMIS FERNANDEZ
WEST VIRGINIA
1995

(commissions continued)

1993 & 1994
Exuberance, Cast glass relief mural and accents, Vail Transportation Center, Vail, CO
Mural consists of 80 12" square amber castings with an oil painting of the same size, illuminated from behind; seven repeat castings from the original mural set into concrete walls at entrances and stairways throughout the parking structure, creating an interactive piece.

1994
Boca Palms, 26 vases, special edition for the Boca Raton Museum of Arts, FL
Sandblasted, acid polished images of stylized faces and palm trees, variety of colors.

1995
Dining Room–Beverly Hills, CA
Entire terrazzo floor with 100 inlaid glass "leaves," and a wood "rug"; 120" glass and bronze table; 120" bronze tightrope walker mosaic top console; 10 upholstered cherry and bubinga wood chairs with male and female figures, two birds chandelier-bronze and glass; pair of bronze and glass bird sconces; seven neodymium illuminated castings over transom; three doors and terrace grille work.
Architects: Fields & Devereaux, Beverly Hills, CA

Chandelier–San Francisco, CA
Chandelier of fabricated bronze consisting of four birds and four female figures. Chandelier is capable of incandescent light and candlelight.

1996
Chandelier–New York, NY
Fabricated bronze consisting of four female figures. It is capable of both incandescent light and candlelight.

Skyscrapers: The Greatest Bar on Earth, Windows on the World, One World Trade Center Towers, NY
B.E.Windows Corp. Four blown glass and nickel-plated bronze, illuminated sculptures ranging from 96" to 120" high.
Architects: Hardy, Holzman, Pfeiffer, New York, NY

1997
Eye Poems, In honor of the James Renwick Alliance's 15th Anniversary and the Renwick Gallery's 25th Anniversary. Mr. Dailey and Leo Kaplan Modern Gallery produced and donated a limited edition of 100 linen portfolios, each with a suite of four 11 x 15" lithographs as a fund raiser for the Smithsonian.

Jungle Dancer, Palm Beach Gardens, FL
Fabricated bronze and *pâte de verre* glass console table: 46H x 30W x 12D"

Idyll, Columbus, OH
Clear glass castings, scenic marshland with heron, Concorde and brain: 48H x 72W"

1998
Spirit, 92nd Street Y, New York, NY
Cast-glass mural depicting activities at the Y: 84H x 9W"

1999
Statuesque, Hollywood, FL
Female figure floor lamp of fabricated, patinated and gold-plated brass. Blown yellow-amber shade with deep violet spirals and rim with *pâte de verre* elements, polished clear glass base: 42H x 17W x 11D"

Male with Staffs and Female with Prisms Sconces, Boca Raton, FL
Blown opaque white glass, *pâte de verre* castings, lead crystal prisms. Fabricated, nickel-plated, patinated and gold-plated brass and bronze: Each 26H x 20W x 8.5D"

Figures in Clouds, Rancho Mirage, CA
Translucent mural of cast-glass and aluminum entry door: 192H x 60W"

Chandelier–New York, NY
Fabricated bronze, rod and sheet glass, six *pâte de verre* cast-glass figures, 24 electric lamps: 39H x 22W x 47L"

Cupola Lighting–New York, NY
Fabrication and installation of hanging glass lamp and metalwork light system behind seating in cupola room. Lamp: 48H x 19D"

Strong Woman and Strong Man Sconces, Rancho Mirage, CA
Blown opaque white glass. Fabricated, nickel-plated, patinated and gold-plated brass and bronze: Each 25H x 14W x 8D"

2000
Pair of Candelabrums–Cherry Hill, NJ
Fabricated bronze male and female figures, anodized aluminum and multicolored Vitrolite bases.
Female: 14.5H x 5W x 18D"
Male: 13.5H x 10W x 5D"

2001
The UrbanGlass Awards–Brooklyn, NY
Pâte de verre cast bust and ring, nickel-plated cast bronze base, hematite balls, engraved nameplate: 7.5H x 6W x 2D" (Edition of five).

Chandelier and 12 Sconces–Portola Valley, CA
Fabricated, nickel- and gold-plated bronze, blown white shades with cobalt blue spiral wraps.

Mask Sconces–Long Beach, CA
Fabricated, nickel- and gold-plated bronze, blown amber shades with a variety of spiral wraps and balls.

Five Figure Chandelier–Scottsdale, AZ
Blown, slumped, cut and polished glass. Patinated, nickel- and gold-plated bronze, aluminum and steel framework: 54H x 60W x 20D"

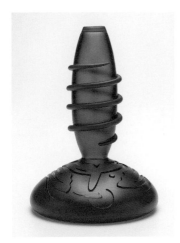

The Good Grandees, The Mayo Clinic, Rochester, MN
Two-part circus vase, lapis blue with amber yellow spirals and gold-ruby rim and balls. Fabricated, patinated, nickel- and gold-plated bronze figures. *Pâte de verre* details: 34H x 19.5W x 14D"

2002
Byzantine Sconces, Restaurant Danielle, New York, NY
Four blown glass, bronze, aluminum and steel wall sconces. Amber, burgundy, amethyst, cobalt blue glass, patinated and gold-plated bronze: 96H x 16W x 14D"

Residential Gates—New York, NY
Painted steel and nickel-plated bronze gates.
Spring, Corridor gate. Moss green fading to golden yellow *pâte de verre* elements: 84H x 54W"
Fall, Vestibule gate. Golden yellow fading to red-amber *pâte de verre* elements: 108H x 72W"

The UrbanGlass Awards—Brooklyn, NY.
Pâte de verre cast bust and ring, gold-plated cast bronze base, gold-plated balls, engraved nameplate: 7.5H x 6W x 2D" (Edition of six).

Two Chandeliers and Six Sconces—St. Georges, Bermuda
Fabricated, gold-plated bronze, blown white shades with cobalt blue spiral wraps. Each chandelier consisting of two bronze balancing female figures.

Shalom, Upper Arlington, OH Fabricated, patinated, nickel- and gold-plated bronze, gold-plated symbol rings and various glass details.
Male: jade globe with amethyst spirals and balls: 23.5H x 15W x 7.5D"
Female: amber globe with amethyst spirals and balls: 23.5H x 16W x 7.5D"

2003
Leaping Figures, Aspen, CO
Hand Railing—Sandblasted, acid polished, laminated plate glass. Powder coated aluminum, steel, oak: 37.5H x various lengths, 5W"

Men with Hats, Aspen, CO
Blown glass, gold- and copper-plated bronze: 16H x 11W x 8D"

Female Figurative Sconces—Aspen, CO
Blown glass, patinated and gold-plated bronze, clear crystal pendants: 50H x 24W x 8D"

2004
The UrbanGlass Awards—Brooklyn, NY
Pâte de verre cast bust and ring, gold-plated cast bronze base, gold-plated balls, engraved nameplate: 7.5H x 6W x 2D" (Edition of five).

Running Nude with Jeweled Rope, Gutow Residence, Nashville, TN
Hand railing—fabricated and nickel- and gold-plated cast bronze with *pâte de verre* details: 36.5H x 19W x 3D"

Tribute, The Providence Performing Arts Center, Providence, RI
Chandelier—three female figures and three male figures holding lanterns. Blown glass; molded and fabricated acrylic sheet, powder coated steel, aluminum and bronze; 260 incandescent lamps w/19 high output L.E.D. clusters: 18H x 15D', 3950 lb.

Dancing in Light, Private commission, Sausalito, CA
Chandelier—four *pâte de verre* figures; slumped, cut and polished glass; fabricated, patinated nickel- and gold-plated bronze, aluminum and steel framework. 53H x 37D"

2005
Quest, Connecticut Agricultural Experiment Station, New Haven, CT
Building Entry—Cast crystal and sandblasted glass panels; electron microscope and 12 images: 16H x 12W' x 4D"

Earth, Sun, Sky, Connecticut Appellate Court, Hartford, CT
Backlit paintings; sandblasted glass; 3 sections: 12H x 10W x4D"

Figures in Space, Private Collection, Atlanta, GA
Three-part chandelier—blown glass, fabricated and patinated nickel-plated bronze figures: 42H x 20W x 12D"; 57H x 21W x 13D"; 69H x 22W x 14D"

2006
Hanging Light and Sconces, Silverstein Properties Executive Suite, New York, NY
Hanging light—bent clear glass cane; white flash glass; laminated flash and plate glass; fabricated nickel-plated polished aluminum, brass and steel: 30H x 30.25D"
Two sconces—blown glass; fabricated and patinated nickel-plated bronze: 12H x 7W x 9D" each.

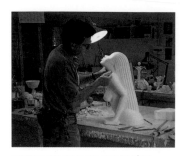

DAILEY WORKING ON PLASTER MOLD FOR *L'EAU*
CRISTALLERIE DAUM
NANCY, FRANCE
1995

DAILEY WITH BMI CREW
L. TO R. PRESTON SINGLETARY, ROBBIE MILLER,
RICH ROYAL, DAILEY, BRIAN PIKE, PAUL CUNINGHAM,
JEFF LEE, BEN MOORE
BEN MOORE'S STUDIO, SEATTLE, WA
1996

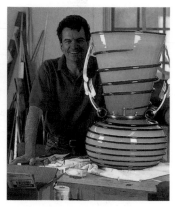

DAILEY WITH *BALANCERS*
CIRCUS VASE SERIES
KENSINGTON STUDIO, NH
1997

Awards

1970–72
Graduate Teaching Fellowship,
Rhode Island School of Design,
Providence, RI

1972–73
Fulbright Hayes Fellowship, Venice,
Italy

1975–1980
Fellowship at the Massachusetts
Institute of Technology Center for
Advanced Visual Studies, Cam-
bridge, MA

1979
National Endowment for the Arts
Fellowship–Glass.

1980
Massachusetts Council on the Arts
Fellowship–Glass.

1989
Masters Fellowship, Creative Glass
Center of America.

1998
Fellow of the American Craft
Council, ACC College of Fellows.

Outstanding Achievement in Glass,
UrbanGlass.

Honorary Lifetime Membership
Award, Glass Arts Society.

2000
Libensky Award, Chateau Ste.
Michelle Vineyards & Winery.

2001
The President's Distinguished Artist
Award, The University of the Arts,
Philadelphia, PA

Masters of the Medium Award,
James Renwick Alliance.

Art of Liberty Award, National
Liberty Museum, Philadelphia, PA

2007
The Silver Star Alumni Award,
College of Art and Design at
The University of the Arts,
Philadelphia, PA

Lectures and Demonstrations

Appalachian Center for the Crafts,
Smithville, TN

Architects Collaborative,
Atlanta, GA

Art and Culture Center of
Hollywood, Hollywood, FL

Arvada Arts Center, Denver, CO

Asilomar Conference Center,
Santa Cruz, CA

Bartlett Museum, Amesbury, MA

Beverly Hills Forum Series,
Beverly Hills, CA

Boca Raton Museum of Art,
Boca Raton, FL

Bunka Center Auditorium,
Seto, Japan

California State University,
Long Beach, CA

Carnegie Mellon University,
Pittsburgh, PA

Carnegie Museum of Art,
Pittsburgh, PA

Cleveland Art Institute,
Cleveland, OH

Cooper Hewitt Museum,
New York, NY

Corning Museum of Glass,
Corning, NY

Cornish College of Art,
Seattle, WA

Creative Glass Center of America,
Millville, NJ

Currier Museum of Art,
Manchester, NH

Experience Music Project,
Seattle, WA

Harvard School, Los Angeles, CA

Haystack Mountain School of Crafts,
Deer Isle, ME

Helander Gallery, Palm Beach, FL

High Museum of Art, Atlanta, GA

Hinckley School, Hinckley, ME

Illinois State University, Urbana, IL

Japan Society, New York, NY

Kent State University, Kent, OH

League of New Hampshire
Craftsmen, Exeter, NH

Leo Kaplan Modern, New York, NY

Los Angeles County Museum of Art,
Los Angeles, CA

Lowe Art Museum Benefit Com-
mittee, Miami, FL

Marshall University, Huntington, WV

Massachusetts College of Art,
Boston, MA

Massachusetts Institute of Technol-
ogy, Cambridge, MA

Miasa Center, Miasa, Japan

Museum of Arts & Design
(formerly American Craft Museum),
New York, NY

Museum of Fine Arts, Boston, MA

National Museum of American
History, Smithsonian Institution,
Washington, DC

New Art Forms Exposition, The
Collectors Alliance, Chicago, IL

CHRISTIAN POINCIGNON, LAURENT POINCIGNON
CRISTALLERIE DAUM
NANCY, FRANCE
1998

PAUL DE SOMMA, DAILEY, SKIPPY, RICH ROYAL,
LOUIS SCALFANI
WATERFORD CRYSTAL, IRELAND
JUNE, 1998

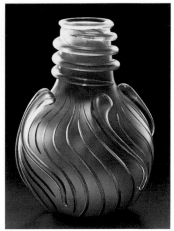

ANGELS IN THE FIRMAMENT
WATERFORD CRYSTAL, IRELAND
18.5H X 14.5W X 14.5D"
1999

New York Experimental Glass Workshop, New York, NY

Niijima Glass Center, Niijima Island, Japan

Ohio State University, Columbus, OH

Norton Museum of Art, West Palm Beach, FL

Pacific Design Center, Los Angeles, CA

Parsons School of Design, New York, NY

Penland School of Crafts, Penland, NC

Pennsylvania State University, State College, PA

Philadelphia College of Art, Philadelphia, PA

Pilchuck Glass School, Stanwood, WA

Portland State University, Portland, OR

Project Image Lecture Series, British Columbia Glass Art Association, British Columbia, Canada

Renwick Gallery, National Museum of American Art, Smithsonian Institution, Washington, DC

Rhode Island School of Design, Providence, RI

Riley-Hawk Gallery, Cleveland, OH

Rochester Institute of Technology, Rochester, NY

Salem State College, Salem, MA

Sierra College, Rocklin, CA

Simon Fraser University, Vancouver, British Columbia, Canada

South Shore Arts Center, Cohasset, MA

The Attleboro Museum, Attleboro, MA

The Fuller Craft Museum, Brockton, MA

The George R. Gardiner Museum of Ceramic Art, Toronto, Ontario, Canada

The National American Glass Club, Portland, ME

The National Glass Seminar, Washington, DC

The New Art Forms Exposition, Navy Pier, Chicago, IL

The Pratt Center of the Arts, Seattle, WA

The St. Louis Museum of Art, St. Louis, MO

The University of the Arts, Philadelphia, PA

Toyama City Institute of Glass Art, Toyama, Japan

Tulane University, G.A.S. Conference, New Orleans, LA

Tyler School of Art, Temple University, Philadelphia, PA

University of Illinois, Normal, IL

University of Wisconsin, Madison, WI

UrbanGlass, New York, NY

Virginia Commonwealth University, Richmond, VA

West Surrey College of Art & Design, Farnham, West Surrey, England

Yamaha Corporation Hall, Ginza, Tokyo, Japan

MAKOTO SUGITA WORKING ON *NUDE RUNNING* TABLE
OCTOBER, 1999

BILL RIGDON AND DAILEY ASSEMBLING
FIGURES IN CLOUDS
RANCHO MIRAGE, CA
1999

FIGURES IN CLOUDS
DAILEY, BILL RIGDON
RANCHO MIRAGE, CA
1999

FIGURES IN CLOUDS
DAILEY
RANCHO MIRAGE, CA
OLSEN SUNDBERG ARCHITECTS, SEATTLE
1999

Public Collections

92nd Street Y, New York, NY

Boca Raton Museum of Art, Boca Raton, FL

Carnegie Museum of Art, Pittsburgh, PA

Chase Manhattan Bank Collection, New York, NY

Corning Museum of Glass, Corning, NY

Creative Glass Center of America, Millville, NJ

Currier Museum of Art, Manchester, NH

Darmstatt Museum, Darmstatt, Germany

Dayton Art Institute, Dayton, OH

Fuller Craft Museum, Brockton, MA

Greatest Bar on Earth, Windows on the World Corp., One World Trade Center Towers, New York, NY

High Museum of Art, Atlanta, GA

Hunter Museum of American Art, Chattanooga, TN

Huntington Museum of Art, Huntington, WV

Illinois State University Galleries, Normal, IL

Indianapolis Museum of Art, Indianapolis, IN

Kestner Museum, Hannover, Germany

Les Archives de la Cristallerie Daum, Nancy and Paris, France

Los Angeles County Museum of Art, Los Angeles, CA

Milwaukee Museum of Art, Milwaukee, WI

Montreal Museum of Fine Art, Montreal, Canada

Morris Museum, Morristown, NJ

Musee de Design et d'Arts Appliques Contemporains, Lausanne, Switzerland

Musee des Arts Decoratifs, Louvre, Paris, France

Museum of American Glass, Millville, NJ

Museum of Arts & Design, New York, NY

Museum of Fine Arts, Boston, MA

National Gallery of Victoria, Melbourne, Australia

National Museum of Modern Art, Kyoto, Japan

Philadelphia Museum of Art, Philadelphia, PA

Racine Art Museum, Racine, WI

Renwick Gallery, Smithsonian American Art Museum, Washington, DC

Rockefeller Center Corporation, New York, NY

Royal Ontario Museum, Toronto, Ontario, Canada

The Detroit Institute of Arts, Detroit, MI

The Mayo Clinic, Rochester, MN

The Metropolitan Museum of Art, New York, NY

The Pilchuck Glass Collection at City Centre and U.S. Bank Centre, Seattle, WA

The Speed Art Museum, Louisville, KY

Toledo Museum of Art, Toledo, OH

Town of Vail, CO

Toyama Institute of Glass, Toyama City, Japan

Visions, New York, NY

Yokohama Museum, Yokohama, Japan

CHATEAU STE. MICHEL WINE BOTTLES
1997 MERITAGE ARTISTS EDITION
RHINO MEN, JAZZ JUNGLE, SOMERSAULT MAN
2000

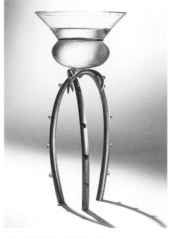

BOMBAY SAPPHIRE MARTINI GLASS
10H X 3.5D"
2000

DAILEY, RICH ROYAL, BEN MOORE
MAKING TOP SECTION OF CIRCUS VASE
QUEENS OF GUILE
SEATTLE, WA
2000
PHOTO: RUSSELL JOHNSON

Articles, Reviews & Publications

1977
Villeneuve, Michel. "Professeur et Artiste, Un Americain Faconne le Cristal Chez Daum." *L'est Républicain*, Jul. 7, p.2.

Piene, Otto. "Glas, Gas, und Elektrizitat." *Du Magazine*, Aug., pp. 62–74.

Harrington, Deborah Weil. "Directions in Contemporary Glass '76."

Third National Glass Invitational, Madison, WI, Feb. 11–29, *Glass Art Magazine*, vol. 4, no.3, pp. 25–26.

1978
Lewis, Albert. "Dan Dailey–Captured Phenomena." *New Work*, Oct./Nov., cover photo, pp. 6–11.

Losken, Manfred. "Feuerzauber–Glas Aus USA." Kunst & Handwerk, *European Handicraft*, L6896E, Nov./Dec., pp. 460–465.

1979
Moser, Charlotte. "Glass Show Goes Beyond Merely Functional Bottles." *Houston Chronicle*, Jun. 13, p. 8.

Kehlmann, Robert. "Four Artists and the Vessel." *Art Week*, vol. 10, no. 33.

1980
Koplos, Janet. "Stained Glass Canvas." *The New Art Examiner*, vol. 7, no. 10, Summer, p. 7.

1981
Spurgin, Judy. "Contemporary Glass Sculpture." *Art Craft Magazine*, Feb./Mar., p. 61.

Spurgin, Judy. "Dan Dailey–An Artist in Total Communication with Contemporary Glass Concepts." *Art Craft Magazine*, Jun./Jul., front cover, p. 26.

1982
Forgey, Benjamin. "Galleries, Private Lives." *The Washington Post*, Dec. 30, p. D7.

Onorato, Ronald J. "Dan Dailey–Directions in Glass." *American Craft*, Feb./Mar., pp. 24–27, 75–76.

"Neues Glas Interview with Dan Dailey." *Neues Glas*, Mar., cover photo, p. 13.

"Gallery: Dan Dailey." *Art Express*, vol. 1, no. 1, May/Jun., pp. 48–49.

Ruby, Kaley. "Exhibitions, Invitational Sampler." *Art Week*, May, p. 1.

Hunter-Stiebel, Penelope. "Contemporary Art Glass: An Old Medium Gets a New Look." *Art News*, Summer, pp. 130–135.

Harrison, Helen A. "Originality at New East End Galleries." *The New York Times*, Aug. 16, p. 16.

1983
Cheek, Lawrence W. "Glass Is Sculpture and Future Furniture in New TMA Show." *Tucson Citizen*, Feb. 11.

LaFave, Kenneth. "TMA Exhibition Cracks Old Cliches About Glass." *The Arizona Daily Star*, Feb. 13.

Horne, David. "Exhibit Illustrates Artistry of Glass." *The Arizona Daily Star*, Feb. 20.

Montini, E. J. "Sculptural Glass." *The Arizona Republic*, Mar. 6, p. D5.

Cohen, Stan and Judy. "Dan Dailey." *Art Papers*, vol. 7, no. 2, Mar./Apr., p. 21.

Degener, Patricia. "Dailey's/Weinberg's Glass," Brown's Oils, Review, *St. Louis Globe Democrat*, Sept. 9.

Rice, Nancy N. "Dan Dailey/Steven Weinberg." *New Art Examiner*, vol. 11, no. 3.

Gardner, Paul V. "Imaginative, Original, Humorous–Glass Creations by Dan Dailey." *Neues Glas*, Dec., pp. 182–189.

1984
Clorman, Irene. "20th Century Look Given to Art of Glass–Dan Dailey Interview." *Rocky Mountain News*, Denver, CO, Jun. 26, p. 81.

Taylor, Robert. "Exhibits: Artists in Glass." *The Boston Globe*, Mar. 30.

1985
Koplos, Janet. "Art With Glass." *Horizon Magazine*, Jan./Feb., masthead, pp. 1 and 15.

Le Canvet, Jean, editor, "Art Du Verre." *Metiers D'Art*, Jun. 1985, pp. 20–22 and 52.

Girard, Sylvie. "Art Du Verre Actualite Internationale." *La Revue De La Ceramique et DuVerre*; cover photo, masthead, pp. 3 and 41.

Van der Meulen, Jack. "Interview with Dan Dailey." *The Pacific Sun*, Mar., pp. 15–21.

"Dan Dailey–Artist's Statement." *New Work*, Winter/Spring, no. 21/22, cover photo, p. 24.

1986
"Dan Dailey." Artist's Statement on Design, *Glass Art Society Journal*, 1986.

Hawkins, Margaret. "(Dailey's) Glass Cartoons at Home Here." *Chicago Sun Times*, Apr. 11.

1987
Goldberg, Ruth E. "Glass Works of Dan Dailey Exhibiting at the Smithsonian." *The Designer*, Aug., p. 52.

Donohoe, Victoria. "Major Exhibit in Glass Art Honors a Native." *The Philadelphia Inquirer*, 'Weekend,' Mar. 6, p. 34.

Lewis, Pamela. "Glass Art: Diversity in Technique, Style, Form." *The Houston Post*, Feb. 28, p. 1C.

Cocordas, Eleni. "Foreword."
Geldzahler, Henry. "Dan Dailey's Work in Glass."
Warmus, William. "The Laughter of Decor."
"Dan Dailey: Simple Complexities in Drawing and Glass, 1972-1987." Exhibition catalog for the Philadelphia Colleges of the Arts, Rosenwald-Wolf Gallery, Philadelphia PA, and the Renwick Gallery, National Museum of American Art, Smithsonian Institution, Washington, DC, 1987.

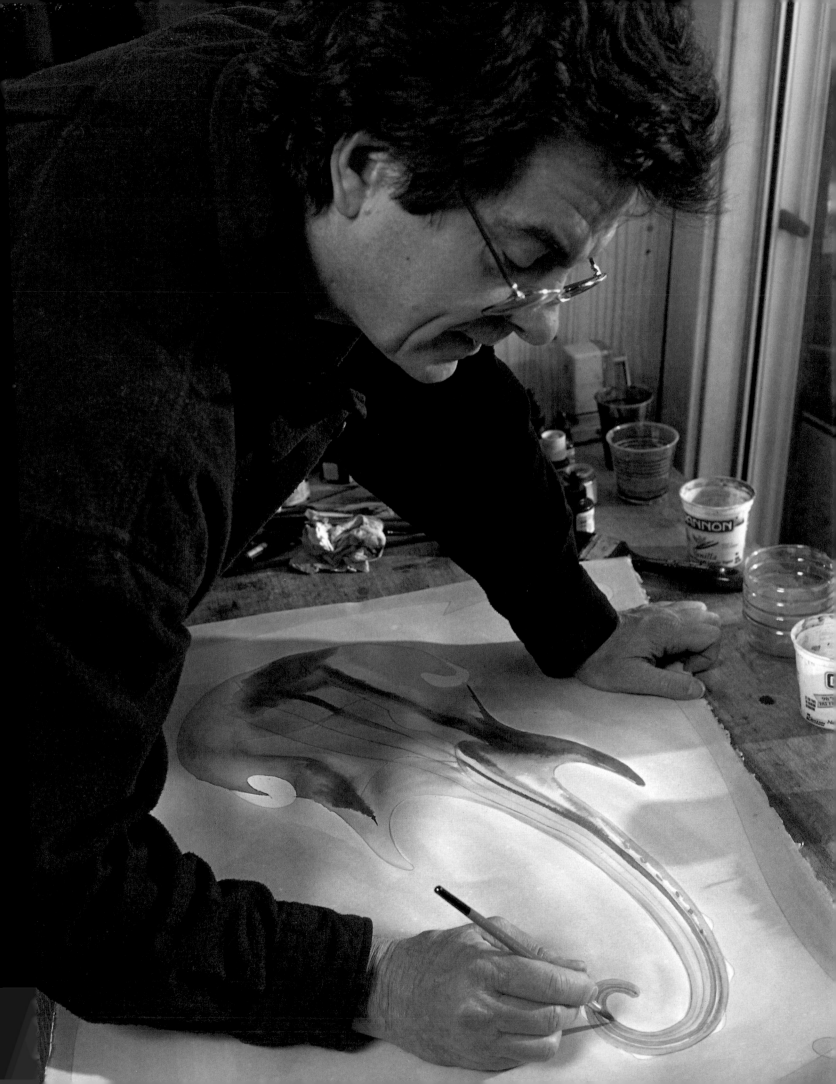

RICH ROYAL, DAILEY, PRESTON SINGLETARY
SEATTLE, WA
2000

OPPOSITE:
DAILEY IN STUDIO
SEATTLE, WA
2000

RESTAURANT DANIELLE
NEW YORK
L. TO R. MAKOTO SUGITA, CHRIS CHANDLER,
DANIEL BALOUD, DAILEY, LEN DOBBS, ALLISON DAILEY
DECEMBER, 2001

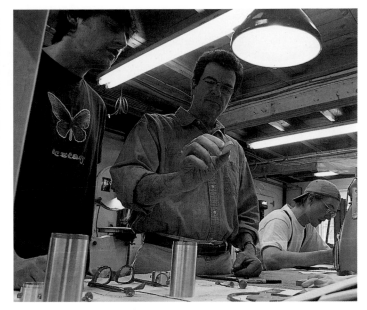

JAKE BLAIS, DAILEY, CHRIS CHANDLER
KENSINGTON STUDIO
2002

(articles, reviews, & publications continued)

1988

Heck, Sandy. "The Only Possible Word is Swank." *Architecture*, Jun., pp. 54–61.

Norden, Linda. "A Rainbow in the Dark." *New Work*, Fall, pp. 20–23.

Knight, Gwen. "Toward a New Perception of Art." *Art Today*, Fall, pp. 24–31.

Lang, George. "Looking for a Rainbow." *Travel and Leisure*, Apr., pp. 114–169.

Cohen, Edie Lee. "Rainbow." *Interior Design*, Jun., pp. 240–250.

Brenner, Douglas. "Change Partners and Dance." *Architectural Record*, Jun., pp. 110–121.

Green, Gael. "Over the Rainbow." *New York*, Feb. 8, pp. 38–46.

Anderson, Barbara. "Local Artists Find Expression Through Medium of Glass." *The Haverhill Gazette*, MA, Nov. 5, p. 15.

Donohoe, Victoria. "Dan Dailey: Simple Complexities in Drawing and Glass, 1972–87." *Museum & Arts Washington*, Jul./Aug., p. 14.

Miller, Donald. "Collective Approach Energizes Galleries." *Pittsburgh Post Gazette*, Sept. 21.

Sweeney, Jim. "Artist's Glass Works Convey Sense of Humor." *The Washington Journal*, Sept. 10.

Hazard, Patrick. "Deco and Such in DC." *The Philadelphia Inquirer*, Jul. 22, p. 53.

Tuchman, Laura J. "Fiber, Glass and Metal Mingle Nicely in Not-So 'New Work'." *The San Diego Register*.

Conroy, Sarah Booth. "The Half-Empty Glass: Dan Dailey's Opaque Humor at the Renwick." *Washington Post*, Jul. 18, pp. G1 and G6.

"Exhibition of Glass and Drawings by Dan Dailey Opens the Renwick June 26." *Renwick Quarterly*, Jun., Jul., Aug.

Sozanski, Edward J. "Glass Comes Into Its Own As An Expressive Medium." *The Philadelphia Inquirer*, Apr.

Burke, Kathleen. "At the Renwick: Dan Dailey." *Smithsonian*, Jun., p. 158.

Kesler, Pamela. "Sculptor Dan Dailey's Glass Act." *Washington Post*, Jul. 3.

Margolies, Jane. "Crafts Cross Over." *Industrial Design Magazine*, May/Jun., pp. 56–59.

1989

Miro, Marsha. "Two Approaches to Glass: One sophisticated, the other sophomoric." *Detroit Free Press*, Jun. 3.

Bernstein, Fred A. "The Greenhouse Effect." *Metropolitan Home*, Feb.

Chambers, Karen. "Dan Dailey—A Designing Character." *Neues Glas*, Jan., pp. 10–19.

Temin, Christine. "The Art of the Lamp." *The Boston Globe*, Feb. 9, p. 66.

Sanske, Mary Anne. "Die Menschliche Weltgemass Dan Dailey." *Anzeiger Von Uster*, Jan. 3.

Hampson, Ferdinand. "Glass: State of the Art." *Progressive Architecture*, Mar., p. 110.

Sanske, Mary Anne. "The Human World According to Dailey." *Deluxe Magazine*, Switzerland, Feb.

Sanske, Mary Anne. "Dan Dailey Messerscharfe Socialstudien." *Der Zuercher Oberlaender*, Dec.

1990

Woodbridge, Sally. "Rising to the Occasion." *Progressive Architecture*, Nov.

Matano, Koji. "Dan Dailey." Interview, *Glass Work*

Hollister, Paul. "The Pull of Venice." *Neues Glas*, Feb.

Conway, Patricia. "Crafting a Style." *House and Garden*, Aug.

Kay, Jane Holtz. "Architects Expand Use of Glass Art." *New York Times*, Jul. 12.

1991

Melby, Rick. "Modern Lighting: A Possible Cross-over Market?" *Glass Art*, Nov./Dec.

Millinger, Lynn. "Dailey's Figures Apply to Glass, Furniture at Leo Kaplan Modern." *Antiques and the Arts Weekly*, Apr.

Puge, Amy. "New York Review." *Collector*, May.

Newhall, Edith. "Art Exhibitions." *Summer Entertainment*, May.

Schmidt, Conrad. "Erotische Kunst." (Erotic Art), *Sammler Anzeiger* (Collectors News), May.

New Glass Review 12, The Corning Museum of Glass.

1992

Ohta, Kazutaka. *The Survey of Glass of the World*, Kyuryudo Art Publishing Co. Ltd., Dec.

Kehlmann, Robert. "20th Century Stained Glass: A New Definition." *Dream Magazine*, Feb.

Betsy Rosenfield Gallery, *Beautiful Home*, Sept.

New Glass Review 13, The Corning Museum of Glass.

Chambers, Karen S. "The Uncontradictable Dan Dailey." *The World & I*, Jan.

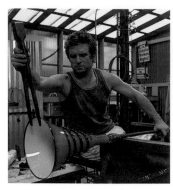

DANTE MARIONI
WORKING ON A FIGURATIVE LAMP SHADE
BEN MOORE STUDIO
SEATTLE, WA
2005

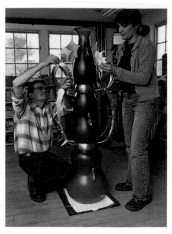

DAILEY AND D'LINDA BARRY
KENSINGTON STUDIO
2005

DAILEY AND WILLIAM DALEY
SCULPTURE OBJECTS AND FUNCTIONAL ART EXPOSITION
NEW YORK, NY
2005

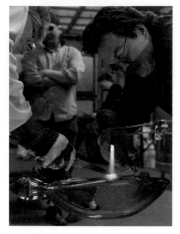

RICH ROYAL, MICHAEL FOX AND DAILEY
WORKING ON *VIRTUE*, INDIVIDUAL SERIES
BEN MOORE STUDIO
SEATTLE, WA
2006

OPPOSITE:
DAILEY AT KENSINGTON STUDIO
2006

(articles, reviews, & publications continued)

"A New Glass Mural for the Transportation Center." *The Vail Trail*, Feb.

Amano, Yuko. "All About Glass." The Shinshusa Co. Ltd., Dec.

1993
"Atlas Didn't Even Sweat." *The New York Times*, Feb. 11, p. C3.

Graham, Jim. "Glass as Art." *Sunday Monitor*, Feb. 7.

Kippen, Karen. "Modern Reflections in Art Glass." *Foster's Daily Democrat*, Showcase Magazine section, Mar.

Kiesewetter, Trish. "The Glass Man Cometh." *Vail Trail*, Daily Options section, Aug.

Taylor, Scott. "Artist Begins Work on VTRC Mural." *Vail Daily*, Aug. 3.

"Dailey Glass Art Benefits Museum." Boca Raton, FL, *Deerfield Beach Observer*, Oct.

Cullinan, Helen. "Glassblower Revels in the Lighthearted." *The Plain Dealer*, Today section, Nov.

1994
Renwick Quarterly, Sept., Oct., Nov., two photos–"Contemporary Crafts and the Saxe Collection" and "Ten Works Acquired for the Renwick Gallery's Permanent Collection."

New Glass Review 15, The Corning Museum of Glass.

1995
New Glass Review 16, the Corning Museum of Glass.

1996
Hall, Jacqueline. "Glass Reflects Dailey's Humor." *The Columbus Dispatch*, Oct. 27.

Chambers, Karen. "The Most Spectacular Restaurant in the World." *SOFA Newsletter*, Oct.

Kummer, Corby. "Windows '96." *New York*, Jul. 15.

Nigrosh, Leon. "Breath of Life." *The Worcester Phoenix*, Jun. 14.

Batterberry, Michael. "Subject to Change." *Food Arts*, May.

1997
Reynolds, Rebecca. "Glass Today by American Studio Artists." Museum of Fine Arts, Boston, MA.

Pagano, Peggy. "A Visual Odyssey." *AmericanStyle*, May.

Chambers, Karen. "Artful Dining A Peak Experience." *AmericanStyle*, Winter.

1998
"Dan Dailey: Vases from the Archives 1974-1988." Riley-Hawk Galleries and Dan Dailey, a catalog showcasing works from the artist's personal archives.

Leigh, Bobbie. "Prepare to Be Dazzled: Studio Glass Hits its Stride." *The Ritz-Carlton Magazine*, Fall/Winter.

1999
Whitney, D. Quincy. "Shapes of Fantasy Emerge from Glass." *The Boston Sunday Globe*, Jan. 17, pNH14.

"Dan Dailey and Linda MacNeil: Art in Glass and Metal." Printed on the occasion of the exhibition at The Art Center at Hargate, St. Paul's School. A catalog showcasing the artists' works and processes.

2000
Yelle, Richard. "Glass Art, From Urban Glass." Schiffer Publishing, Ltd., pp. 47–50.

2001
Klein, Dan. "Artists in Glass: Late Twentieth Century Masters in Glass." Mitchell Beazley, pp. 52–57.

Gorfinkle, Constance. "Double Vision." *The Patriot Ledger*, May 12–13, Weekend Entertainment, pp. 47–48.

Jacobson, Seth. "Glass with Class." *Hingham Journal*, May 10, p. 23.

"The Heart and Art of Glass." Beverly Hills Forum Series, Apr. 23.

2002
Friedman, Jane. "Kindred Spirits." *American Style*, Summer, 2002, pp. 68–77.

Oldknow, Tina. "Letter from Waterford." Internet ArtResources, http://www.artresources.com/features/article.

2003
Schofield, De. "Dan Dailey: Raconteur of Glass." *Florida Design*, vol. 13, no. 1, pp. 334, 336, 338, 340.

Yelle, Richard Wilfred. "International Glass Art." Schiffer Publishing, Ltd., pp. 14–16, 87–89, 366, 387.

Warmus, William. "Fire and Form: The Art of Contemporary Glass." Norton Museum of Art, pp. 4, 71, 78–79.

2004
Van Siclen, Bill. "PPAC to unveil new chandelier today." *The Providence Journal*, Sept. 16, pp. G1–G3.

2005
Helander, Bruce. "Dailey's Narrative Hieroglyphics." *Art of the Times*, April, pp. 18–19.

Daniels, Mary. "Fantasies in Glass." *Chicago Tribune*, Oct. 23, Home & Garden, p. 23.

2006
Kiener, Robert. "Splendor in the Glass." *New England Home* September/October: pp. 74–86.

Index of Works

Except where indicated works are in the collection of the artist.

p.113 *Vanity*: Vitrolite; chrome-plated brass; aluminum.

p.114 *The Artist's Book*: Ink on paper; from artist's sketchbook.

p.115 *Kismet*: Vitrolite; blown red glass w/green rim; sandblasted surface drawing; acid polished; vitreous enamel.

p.116 *Beauty Barge*: Vitrolite; chrome-plated brass; aluminum; collection of Ruth & Rainer Neumann, Binningen, Switzerland.

p.117 *Latter Day Viking*: Vitrolite; chrome-plated brass; aluminum; private collection.

p.117 *Fern-O*: Vitrolite; chrome-plated brass; aluminum; collection of Susan & Mark Mulzet, Paradise Valley, AZ

p.118-19 *Voyeur*: Vitrolite; nickel & gold plated bronze; aluminum; private collection, New York, NY

p.121-122 *Disc Revelers*: Hand blown crystal into mold; sandblasted & acid polished; made at Cristallerie Daum, Nancy, France; collection of Saralou & Philip Shore, Boca Raton, FL

p.123 *Dancers*: Hand blown crystal into mold; sandblasted & acid polished; made at Cristallerie Daum, Nancy, France.

p.124 *Nimble*: Hand blown crystal into mold; sandblasted & acid polished; made at Cristallerie Daum, Nancy, France.

p.125 *Waterfall*: Hand blown crystal into mold; sandblasted & acid polished; made at Cristallerie Daum, Nancy, France; private collection.

p.125 *Startled, Downpour, Acrobats*: Hand blown crystal into mold; sandblasted & acid polished; made at Cristallerie Daum, Nancy, France.

p.126 *Jesters in Falling Water*: Hand blown crystal into mold; sandblasted & acid polished; made at Cristallerie Daum, Nancy, France; private collection, Los Angeles, CA

p.127 *Electric Storm*: Hand blown crystal into mold; sandblasted & acid polished; made at Cristallerie Daum, Nancy, France; private collection.

p.128 *New York–3*: Blown violet fade glass w/blue rim; sandblasted surface drawing; acid polished; collection of Dreyfus Corp., New York, NY

p.129 *New York–4*: Blown blue fade glass w/orange rim; sandblasted surface drawing; acid polished; collection of Dreyfus Corp., New York, NY

p.130 *New York–5*: Blown amber fade glass w/blue rim & clear additions; sandblasted surface drawing; acid polished; collection of Antonio Amado, Miami, FL

p.130 *New York–6*: Blown green to blue glass w/yellow rim & clear additions; sandblasted surface drawing; acid polished; private collection, Sao Paulo, Brazil.

p.130 *New York–7*: Blown gray-green to blue glass w/orange rim & clear additions; sandblasted surface drawing; acid polished.

p.130 *New York–8*: Blown gray-green to amethyst glass w/yellow rim & clear additions; sandblasted surface drawing; acid polished.

p.131 *Deco Building Detail Series*: Blown glass w/rims of various colors & additions; sandblasted surface drawing; acid polished.

p.133-134 *The Chef*: Blown clear glass w/black rim & wrap; purple & clear additions; sandblasted & acid polished; patinated bronze; copper; collection of Toledo Museum of Art, Toledo, OH

p.135 *The Prince*: Blown clear glass w/purple rim & wrap; black & clear additions; sandblasted & acid polished; patinated bronze; iron; collection of Detroit Institute of Art, Detroit, MI

p.136 *The Counselor*: Blown clear glass w/wraps & additions; sandblasted & acid polished; Vitrolite; patinated bronze.

p.136 *The Soldier*: Blown clear glass w/black rim & additions; sandblasted & acid polished; patinated copper; collection of Arlene & Harold Schnitzer, Portland, OR

p.136 *The Gourmand*: Blown clear glass w/black rim & additions; sandblasted & acid polished; Vitrolite; patinated bronze; private collection.

p.136 *The Empress*: Blown clear & white glass w/black rim & additions; sandblasted & acid polished; collection of Lynn & Jeffrey Leff, New York, NY

p.137 *The Doctor*: Blown clear glass w/black rim; black & clear additions; sandblasted & acid polished; Vitrolite; patinated bronze; collection of the Musee des Arts Decoratifs, Louvre, Paris, France.

p.138 *The Duchess*: Blown clear glass w/black rim & white prunts; black, clear & green additions; sandblasted & acid polished; patinated bronze.

p.139 *The Genius*: Blown clear glass w/black rim & wrap; black & clear additions; sandblasted & acid polished; patinated bronze; collection of Gloria & Sonny Kamm, Los Angeles, CA (destroyed in earthquake 1994).

p.139 *The Matron*: Blown clear glass w/white rim & green wrap; black, clear, white & green additions; sandblasted & acid polished; patinated bronze; collection of Mr. & Mrs. Ben W. Heineman, Sr., Chicago, IL

p.139 *The Buffoon*: Blown clear glass w/blue & black wraps; clear, blue, yellow & black additions; sandblasted & acid polished.

p.139 *The Sage*: Blown clear glass w/black rim & wrap; yellow & green tints; black & clear additions; sandblasted & acid polished.

p.140 *Mars*: Blown purple to blue glass w/red rim; clear, blue & black additions; sandblasted & acid polished; collection of Joan Borinstein, Los Angeles, CA

p.141 *Venus*: Blown purple to orange glass w/red rim; clear & green additions; sandblasted & acid polished; collection of Ruth & Rainer Neumann, Binningen, Switzerland.

p.141 *Siren*: Blown clear to amber glass w/yellow rim; clear & green additions; amber & green surface thread treatment; sandblasted & acid polished; collection of Cincinnati Art Museum, Cincinnati, OH

p.141 *Athena*: Blown clear to green glass w/blue rim; clear, blue & green additions; sandblasted & acid polished; collection of Eugene & Marilyn Glick, Indianapolis, IN

p.141 *Poseidon*: Blown clear to blue glass w/red rim; clear, blue, green & black additions; sandblasted & acid polished; private collection.

p.142 *Nymph*: Blown blue-green to orange glass w/red rim; clear, amber & multicolored patch additions; sandblasted & acid polished; private collection, Zurich, Switzerland.

p.142 *Medusa*: Blown color-spotted green glass w/yellow rim; clear, red & black additions; sandblasted & acid polished.

p.142 *Hercules*: Blown light-blue glass w/red rim; clear, red, blue & black additions; sandblasted & acid polished; private collection.

p.142 *Pan*: Blown green to amber glass w/red rim; clear & multicolored additions; sandblasted & acid polished; private collection, Zurich, Switzerland.

p.143 *Apollo*: Blown clear to amber glass w/black rim & stripe; clear, black & multicolored additions; sandblasted & acid polished; copper wire; collection of Haskell & Joanne Klaristenfeld, Forest Hills, NY

p.145-146 *Notte Freddo*: Blown clear glass w/yellow rim; sandblasted & acid polished; multicolored vitreous enamel; clear & yellow additions; private collection.

p.147 *Viali*: Blown black glass w/white rim; sandblasted & acid polished; multicolored vitreous enamel; clear additions.

p.148 *Villa Misteriosa*: Blown white glass w/black rim; sandblasted & acid polished; multicolored vitreous enamel; clear & black additions; private collection.

p.148 *Pomeriggio*: Blown white glass w/black rim; sandblasted & acid polished; multicolored vitreous enamel; black additions; private collection.

p.148 *Scalli*: Blown glass; black body w/white rim; sandblasted & acid polished; multicolored vitreous enamel; clear additions; private collection.

p.148 *Incrocio*: Blown clear glass w/black rim; sandblasted & acid polished; multicolored vitreous enamel; clear & black additions; private collection.

p.149 *Sera*: Blown black glass w/white rim; sandblasted & acid polished; multicolored vitreous enamel; white additions; collection of the Musee de Design et d'Arts Appliques Contemporains, Lausann, Switzerland.

p.150 *Faces*: Ink on paper; from the artist's sketchbook.

p.151 *Scorpion Man*: Blown clear glass w/clear wrap; sandblasted surface drawing; acid polished; vitreous enamel.

p.152 *Somersault Man*: Blown yellow glass w/marbleized rim & blue wrap; sandblasted surface drawing; acid polished; vitreous enamel; collection of John & Sherry Gordon, OH

p.153 *Time Man*: Blown blue glass w/yellow rim & clear additions; sandblasted surface drawing; acid polished; vitreous enamel; private collection.

p.154 *Star Man*: Blown blue glass w/red rim & balls; sandblasted surface drawing; acid polished; vitreous enamel; collection of Gallerie Yvonne Benda, Zurich, Switzerland.

p.155 *Corn Man*: Blown green to blue glass w/yellow rim & wraps; sandblasted surface drawing; acid polished; vitreous enamel; collection of Franklin & Frances Horwich, Chicago, IL

p.155 *Firecracker Man*: Blown red glass w/marbleized rim & balls; sandblasted surface drawing; acid polished; vitreous enamel; private collection.

p.155 *Carrot Man*: Blown blue glass w/orange rim & clear wing additions; sandblasted surface drawing; acid polished; vitreous enamel; collection of Joan Borinstein, Los Angeles, CA

p.155 *Two-Heart Woman*: Blown lavender glass w/orange rim & clear flange additions; sandblasted surface drawing; acid polished; vitreous enamel; collection of Anna & Joe Mendel, Montreal, Canada.

p.156 *Ginko Man*: Blown cobalt blue glass w/orange rim & wrap; sandblasted surface drawing; acid polished; vitreous enamel; private collection.

p.156 *Pine Tree Man*: Blown olive glass w/lapis rim & prunts; sandblasted surface drawing; acid polished; vitreous enamel.

p.156 *Dragonfly Man*: Blown orange to red glass w/blue rim & wrap; sandblasted surface drawing; acid polished; vitreous enamel; private collection.

p.156 *Planet Man*: Blown deep red to amber glass w/blue rim & wrap; sandblasted surface drawing; acid polished; vitreous enamel; collection of Alan Benaroya, San Diego, CA

p.157 *Regal Woman*: Blown lavender glass w/red rim & balls; sandblasted surface drawing; acid polished; vitreous enamel; private collection, Brookline, MA

p.158 *Three Fig Man*: Blown amethyst glass w/blue rim, wrap & prunts; sandblasted surface drawing; acid polished; vitreous enamel; private collection.

p.158 *Prickly Man*: Blown light olive glass w/orange rim; orange & marbleized surface drawing; acid polished; vitreous enamel.

p.158 *Bullfrog Man*: Blown cobalt blue glass w/red rim & wrap; sandblasted surface drawing; acid polished; vitreous enamel; private collection.

p.158 *Rug Man*: Blown cobalt blue glass w/blue & black marbleized rim & balls, sandblasted surface drawing; acid polished; vitreous enamel.

p.159 *Poison Ivy Man*: Blown cobalt blue glass w/orange rim & blue-black prunts; sandblasted surface drawing; acid polished; vitreous enamel.

p.161-162 *Secret*: Blown pale blue to olive glass w/red rim & wrap; black prunts & additions; sandblasted & acid polished.

p.163 *Sweet*: Blown light blue glass w/black & white marbleized rim; orange and clear additions; sandblasted & acid polished.

p.164 *Absent*: Blown light olive to amber glass w/red, black & white marbleized rim; clear, red & blue additions; sandblasted & acid polished; private collection, Norfolk, VA

p.165 *Statue*: Blown amethyst to blue glass w/black & white marbleized rim; orange wraps, red balls & clear additions; sandblasted & acid polished; collection of Dreyfus Corp., New York, NY

p.166 *Foreign*: Blown red glass w/black & white marbleized rim, base & prunts; clear & black additions; sandblasted & acid polished.

p.166 *Bravado*: Blown pale olive glass w/blue & white marbleized rim; clear, red, yellow & multicolored additions; sandblasted & acid polished; private collection.

p.166 *Wise*: Blown amber & green glass w/red rim & wraps; clear, red, blue additions; yellow & red marbleized prunts; sandblasted & acid polished; private collection.

p.166 *Jest*: Blown yellow & red glass w/red rim; clear, red & blue additions; green marbleized prunts; sandblasted & acid polished.

p.167 *Haute*: Blown white glass w/red & blue marbleized rim; clear, red & blue additions; black marbleized balls; sandblasted & acid polished; private collection.

p.168 *Chill*: Blown pale yellow glass w/black rim; clear & black additions; sandblasted & acid polished.

p.169 *Vogue*: Blown lavender-gray glass w/blue rim; clear, blue & yellow-red marbleized additions; sandblasted & acid polished.

p.170 *Balance*: Blown amethyst & white glass w/red rim; red & deep blue additions; yellow & black marbleized wrap w/red cylinder cap; sandblasted & acid polished.

p.171 *Chase*: Blown red & purple glass w/yellow rim; clear & green additions; marbleized turquoise balls; sandblasted & acid polished; collection of Anita Tress Waxman, Lakeville, CT

p.171 *Confusion*: Blown clear glass w/turquoise rim & wraps; clear & red additions; sandblasted & acid polished.

p.171 *Daze*: Blown lavender glass w/blue rim; clear & red additions; yellow & black marbleized balls; sandblasted & acid polished.

p.171 *Serenity*: Blown amethyst to blue glass w/red rim; clear, red & yellow additions; clear & red marbleized prunts; sandblasted & acid polished.

p.172 *Watch*: Blown amethyst to blue glass w/orange & amethyst marbleized rim; amethyst wrap; clear, red & marbleized additions; sandblasted & acid polished; collection of Joseph F. Miller, Indianapolis, IN

p.172 *Fate*: Blown amethyst to yellow glass w/blue & red marbleized rim; black & red marbleized wrap; clear, green & red additions; sandblasted & acid polished; collection of Joseph F. Miller, Indianapolis, IN

p.172 *Smirk*: Blown amethyst & cobalt blue glass w/orange; clear, green & black additions; blue & white marbleized balls; sandblasted & acid polished; collection of Joseph F. Miller, Indianapolis, IN

p.172 *Exotic*: Blown gold & green glass w/clear & amethyst marbleized rim; clear & black additions; red surface thread treatment; sandblasted & acid polished; collection of Joseph F. Miller, Indianapolis, IN

p.173 *Sour*: Blown gold glass w/green rim; clear & black additions; red marbleized prunts; sandblasted & acid polished.

p.175-176 *White Gorilla*: Blown white glass w/red rim; black & white additions; white surface thread treatment; sandblasted & acid polished.

p.177 *Gorilla*: Blown black glass w/red rim; black & white additions; black surface thread treatment; sandblasted & acid polished, collection of Susan & Ron Crowell, Ashland, OR

p.178 *Zebra*: Blown black glass w/blue rim; red, black & white additions; sandblasted & acid polished; private collection, Seattle, WA

p.179 *Giraffe*: Blown pale pink glass w/green rim; red, black, white & multicolored marbleized additions; orange & brown marbleized surface patches; sandblasted & acid polished.

p.180 *Walrus*: Blown olive green glass w/red lip; gray, brown, white & beige speckled marbleized additions; black & green surface thread treatment; sandblasted & acid polished; The Beverly and Sam Ross collection at Christian Brothers University, Memphis, TN

p.181 *Toad*: Blown green glass w/green & brown marbleized lip; yellow, green & yellow-brown multicolored marbleized additions; sandblasted & acid polished; collection of Chris Rifkin, Hingham, MA

p.182 *Alligator*: Blown green glass w/iron oxide crackle; orange rim; red, green, white, amethyst & green-black marbleized additions; sandblasted & acid polished; collection of Mr. & Mrs. Ben W. Heinemann, Sr., Chicago, IL

p.183 *Lizard*: Blown black glass w/red shards & green rim; clear & black additions; sandblasted & acid polished; collection of David Pollart, Seattle, WA

p.183 *Toucan*: Blown black, blue, white & red glass; orange & black additions; sandblasted & acid polished; collection of Toyama Glass Center, Toyama, Japan.

p.183 *Sawfish*: Blown gray glass w/yellow rim; black & gray-white marbleized additions; sandblasted & acid polished.

p.183 *Shark*: Blown gray glass w/yellow rim; green, white & red additions; sandblasted & acid polished.

p.184 *Warthog*: Blown tobacco glass w/black, yellow & red surface thread treatment; yellow rim; white w/black & white marbleized additions; sandblasted & acid polished; private collection, Washington, DC

p.184 *Elephant*: Blown gray w/white & black speckles; red rim; white w/brown & gray-green marbleized additions; sandblasted & acid polished; collection of Nicki & J. Ira Harris, Palm Beach, FL

p.184 *Panther*: Blown black glass w/orange rim; white, green, black & red additions; black surface thread treatment; sandblasted & acid polished.

p.184 *Rhinoceros*: Blown white glass w/multicolored speckles; yellow rim; white w/black & white marbleized additions; sandblasted & acid polished; collection of Barbara & Richard Basch, Sarasota, FL

p.185 *Dog*: Blown light brown w/red rim; white, black, red, green & multicolored marbleized additions; sandblasted & acid polished.

p.186 *Baboon*: Blown dark brown w/purple rim; black, white w/black & white marbleized additions; red surface thread treatment; sandblasted & acid polished; collection of Dorothy & George Saxe, San Francisco, CA

p.187 *Black Mandrill*: Blown black w/ black & white surface thread treatment; red rim; red, white & blue additions; sandblasted & acid polished; private collection, Brookline, MA

p.188-189 *Balustrade Man*: (detail); Blown blue globe w/black rim & wrap; Vitrolite; patinated & gold-plated bronze; collection of Simona & Jerry Chazen, New York, NY

p.190 *Man Lamp and Woman Lamp* (above): Blown white globes; patinated & gold-plated brass; private collection.

p.190 *Man Lamp and Woman Lamp* (below): Blown white globes; patinated & gold-plated brass; collection of Rainbow Room, Rockefeller Center, New York, NY

p.191 *Balustrade Man*: Blown blue globe w/black rim & wrap; Vitrolite; patinated & gold-plated bronze; collection of Simona & Jerry Chazen, New York, NY

p.192 *Beacon*: Blown yellow globe w/green additions; Vitrolite w/vitreous enamel; patinated & gold-plated bronze; collection of Daniel & Victoria Weiskopf, New York, NY

p.192 *Searcher*: Blown yellow globe w/red lip & green additions; Vitrolite w/vitreous enamel; patinated & gold-plated bronze; collection of Daniel & Victoria Weiskopf, New York, NY

p.193 *Dangerous Vine Wrestler*: Blown yellow globe w/green & red marbleized rim & wrap; black & green additions; Vitrolite w/vitreous enamel; patinated & gold-plated bronze; collecton of Dr. & Mrs. Cyrus Katzen, Chevy Chase, MD

p.194 *Nude with Green Rug*: Blown gold globe w/magenta wrap; lapis additions; topaz base; fabricated, patinated & gold-plated bronze; collection of Anna & Joe Mendel, Montreal, Canada.

p.195 *Nude Skulking in Weeds*: Blown white globe w/red rim & additions; plate glass; patinated & gold-plated bronze; collection of Sheldon & Myrna Palley, Miami, FL

p.196 *Nude in Junk*: Blown white globe w/purple wrap & additions; plate glass; fabricated & gold-plated bronze; collection of Dr. & Mrs. Morton Mandell, private collection, Boca Raton, FL

p.197 *Nudes with Scarf and Prisms*: Blown yellow globes w/red wrap & lapis balls; Vitrolite; crystal; fabricated, patinated & gold-plated bronze; private collection, Bern, Switzerland.

p.197 *Seated Nudes with Prisms*: Blown amber globes w/burgundy wrap & lapis dots; crystal; fabricated, patinated & gold-plated bronze; collection of Frank & Pamela Cox, Santa Barbara, CA

p.198 *Nude with Scarf*: Blown gold globe w/blue rim, green balls & red surface thread treatment; Vitrolite; fabricated, patinated & gold-plated bronze; collection of Richard & Linda Schlanger, OH

p.300-301 *Fantasy Mural*: Cast, sandblasted & acid polished glass; aluminum; paint on canvas; collection of Los Angeles Museum of Art, Los Angeles, CA

p.302-303 *Rain on Water, Trees in Wind, Rolling Fields*: Boston Children's Hospital, cast glass panels, with blue, maroon & green borders; sandblasted & acid polished.

p.304 *School of Fish*: Sandcast, sandblasted & acid polished neodymium glass, stainless steel.

p.305 *Figures in Clouds*: Cast, laminated, sandblasted & acid polished glass; milled aluminum; steel; collection of William & Cydney Osterman, Rancho Mirage, CA

p.306 *Mirror and Shelf with Nude Lamp*: Blown amber glass; Vitrolite; gold-plated; fabricated, patinated bronze; collection of Boris Wechtenbruch, Essen, Germany.

p.306 *Mirror and Shelf with Two Nude Lamps*: Vitrolite; blown glass; gold-plated & patinated bronze; courtesy of Gallerie Yvonne Benda, Zurich, Switzerland.

p.306 *Sloth*: Vitrolite; plate glass; nickel- & gold plated brass, anodized aluminum; courtesy of Gallerie Yvonne Benda, Zurich, Switzerland.

p.307 *Figures with Crystal Orbs*: Cast glass; crystal; cast bronze; courtesy of Gallerie Yvonne Benda, Zurich, Switzerland.

p.308 *Nude Male with Cactus*: Blown gold-yellow globe w/blue rim & wrap; acid polished plate glass; fabricated, patinated & gold-plated bronze; collection of Donna & Cargill MacMillan Jr., Indian Wells, CA

p.309 *Nude Female with Palm Tree*: Blown gold-yellow globe w/blue rim & maroon wrap; acid polished plate glass; fabricated, patinated & gold-plated bronze; collection of Donna & Cargill MacMillan Jr., Indian Wells, CA

p.310-311 *Four Women Four Birds*: Blown gold shades w/blue dots & red wraps; slumped white glass; fabricated, patinated & gold-plated bronze; private collection.

p.312 *Four Balancing Women*: Blown gold shades w/red rims & wraps; slumped white glass; aluminum, fabricated, patinated & gold-plated bronze; private collection, New York, NY

p.313 *Turning Nudes*: Blown gold shades w/amethyst rims, wrap & red balls; fabricated, patinated & gold-plated bronze; collection of Ruth & Leo Kaplan, New York, NY

p.314 *Arm Chairs*: Hand carved cherry & bubinga wood; gold leaf; Vitrolite; private collection, Beverly Hills, CA

p.315 *Chandelier*: Slumped white glass; fabricated, patinated & gold-plated bronze; private collection, Beverly Hills, CA

p.315 *Bird Wall Sconces*: Blown white glass globes; plate glass; fabricated, patinated & gold-plated bronze; private collection, Beverly Hills, CA

p.315 *Dining Table*: Plate glass; Vitrolite; bubinga wood; bronze; private collection, Beverly Hills, CA

p.316-317 *Skyscraper Studies*: World Trade Center for Windows on the World Corp's. *Greatest Bar on Earth* restaurant; watercolor on paper.

p.320-321 *Olive and Red, Topaz, Celadon, & Blue Skyscrapers*: Handblown glass w/additions; fabricated bronze; World Trade Center for Windows on the World Corp's. *Greatest Bar on Earth* restaurant; New York, NY

p.322-323 *Jungle Dancer*: Plate glass; Prometheus blue Daum *pâte de verre* figure w/amber leaves; cast bronze branches & base; fabricated gold-plated bronze details; collection of Mr. & Mrs. Robert Rieder, Palm Beach Gardens, FL

p.324 *Seated Nudes*: Blown gold globes w/blue dots & mauve wrap; Vitrolite; fabricated, patinated & gold-plated bronze; collection of Pamela & William Johnson, Monterey, MA

p.324 *Shalom*: Left: Blown jade globe w/amethyst rim, balls & wrap; Right: Blown amber globe w/amethyst rim, balls & wrap; Both: Vitrolite; fabricated, patinated & gold-plated bronze; collection of Dr. Jan Schrier Streicher & Dr. Michael Streicher, Upper Arlington, OH

p.325 *Statuesque*: Blown yellow-amber shade w/violet rim & wrap; light green to amber *pâte de verre* leaves, aqua & amber glass elements & polished clear base; fabricated, patinated & gold-plated brass; collection of Joan & Milton Baxt, Hollywood, FL

p.326 *Chandelier*: Blue & green *pâte de verre* figures w/*pâte de verre* details; slumped white glass; fabricated & gold-plated bronze; collection of Nannette Laitman, New York, NY

p.327 *Chandelier*: Blue, green & yellow *pâte de verre* figures; pulled glass rod; plate glass; fabricated bronze & aluminum; collection of Simona & Jerome Chazen, New York, NY

p.328 *Woman with Violin Prisms*: Blown opaque white glass; yellow & green *pâte de verre* w/pale green prisms; fabricated, nickel-plated, patinated, gold-plated brass & bronze; private collection.

p.328 *Man with Jeweled Rope*: Blown opaque white glass; blue &green *pâte de verre*; fabricated, nickel-plated, patinated, gold-plated brass & bronze; private collection.

p.329 *Sconces*: Blown yellow-gold globes w/red wraps & details; fabricated, nickel-plated, patinated, gold-plated brass & bronze; courtesy Restaurant Danielle, New York, NY

p.330-331 *Mask Sconces*: Blown yellow-gold globes w/red & green wraps; deep red & transparent red stripes; red, blue, green & multicolored *pâte de verre* details; fabricated, patinated, & gold-plated bronze; collection of Susan & Ron Crowell, Ashland, OR

p.332-333 *Tribute*: Blown glass; acrylic, aluminum; bronze; stainless steel; Providence Performing Arts Center, Providence, RI

p.334-335 *Fall, Spring*: Cast Bronze; *pâte de verre*; steel; private collection.

p.336-337 *Le Joyau* (detail): Cristallerie Daum, *pâte de verre*; made at Cristallerie Daum, Nancy, France; edition of 150.

p.338-339 *Le Vent*: Cristallerie Daum, *pâte de verre*; made at Cristallerie Daum, Nancy, France; edition of 150.

p.340 *Le Vin*: Cristallerie Daum, *pâte de verre*; made at Cristallerie Daum, Nancy, France; edition of 150.

p.341 *L' Eau*: Cristallerie Daum, *pâte de verre*; made at Cristallerie Daum, Nancy, France; edition of 150.

p.342-343 *Le Joyau*: Cristallerie Daum, *pâte de verre*; made at Cristallerie Daum, Nancy, France; edition of 150.

p.344-345 *Le Soleil*: Cristallerie Daum, *pâte de verre*; made at Cristallerie Daum, Nancy, France; edition of 195.

p.346 *Balancing Female Figure Candle-holder*: Cast bronze; edition of 100.

p.346 *Maccabee Menorah*: Gold-plated bronze; Vitrolite; edition of 2.

p.347 *Fireplace Figure*: Cast bronze; fabricated, patinated, nickel- & gold-plated elements; stainless steel; edition of 12.

p.348 *Ratteau's Puma*: Plate glass; *pâte de verre*; cast & fabricated bronze; gold plating; private collection.

p.349 *Ratteau's Jaguar*: Plate glass; *pâte de verre*; cast & fabricated bronze; gold plating; private collection.

p.350 *Female Floor Lamp*: Blown glass shade; Vitrolite; cast bronze, anodized aluminum.

p.351 *Upside Down Man*: Blown glass shade; Vitrolite; cast bronze, anodized aluminum; collection of Boris Wechtenbruch, Essen, Germany.

p.352 *Ballyoyo*: Ink on paper; from artist's sketchbook.

Production Assistance Acknowledgments

The creation of my objects, from the smallest vase to the largest architectural installations, has been made possible by a dedicated team of assistants working in my own studio since 1974. Many of these individuals were educated as artists with emphasis on skills specific to glass or metal. Their abilities and attention to detail extended my own potential to realize ideas for work that is labor-intensive. Their hours, in combination with my own, have enabled me to bring many hundreds of ideas to reality, and a portion of that work is pictured in this book. I wish to convey my sincere appreciation to all who have labored so well on my behalf.

Makoto Sugita
Chris Chandler
D'Linda Barry
Jake Blais
Hitoshi Kakizaki
Chris Vespermann
Steve Carrigan
Jinan Kim
Kristina Logan
Ken Ikushima
Robert Peacock
Lys Ackerman
Alan Bull
Regina Logan
Julia Haack
Han Sung Beak
Nicole Matwijeczk
Sean Aldrich
Donna Trusillo
Morae Becker
Dan Ryan
Aaron DiGaudio
Brian Ferrell
Richard Duggan
Ken Gray
Steve DeVries
Sean Salstrom
Sarah Vespermann
Sidney Hutter
Carmen Sasso
Robert Ricciardelli
Tracy Mastro
John Liston
Brian Ripel
Steve Haszonics
Tarja Eklund
Aaron Bohus
Allison Dailey
Owen Dailey

Further, I must extend special gratitude to my friends who have done excellent glass blowing for me in their own studios. They have taken the time from their own work to make many blown glass elements for my vases, lamps and sculpture. This collaboration has been immensely important to the making of my art, and I am very lucky to have the opportunity to work with such skilled individuals striving to do their best. It is the tradition of glass blowing to work as a team, and our teamwork has produced objects that could not be made by any individual. The level of quality has always been top notch because of their demands upon themselves to create as exactly as possible what I have drawn.

Benjamin Moore
Richard Royal
Dante Marioni
Robbie Miller
Paul Cunningham
Michael Fox
Kellmis Fernandez
Michael Schunke
Preston Singletary
Brian Pike
Nadege Desgenetez
Paul DeSomma
Tony Bianco
Rachael Moore
Scott Darlington
Greg Dietrich
Deborah Moore
Joe Rossanno
Louis Scalfani

Finally, I need to recognize the following individuals who have helped me in their professional capacities as machinists, electro-platers, and in other glass and metal fabrication processes. Several companies have also helped by allowing me to work on their premises, using their large-scale facilities. I have received exceptionally high quality work performed by many thoughtful and skilled experts. These working relationships have enabled me to realize concepts far beyond the capacity of my personal studio.

Bill Johnson
Rod L'Italien
Christian Poincignon
Derek Bala
Jesse Cortez
Peter Cox
Richard Delaney
Larry Fischer
John Flury
Bob Hayes
George Hayhoe
Roger Hoover
Dennis Lumbatis
Kenny McElvoy
Henry Mugrage
Jorge Najo
Terrence O'Neil
Ed Pike
Laurent Poincignon
Mike Regalia
Bill Rigdon
Jesse Sargent
John Stenson
Delmer Stowasser
Cecil Valentine
Bullseye Glass
Cristallerie Daum
EuropTec USA
Fenton Art Glass
Monterey Sculpture Center
Paul King Foundry
Waterford Crystal

Series Listing

Titles	Dates	No. of Pieces
Engraved	1972–75	24
"M"	1975–76	3
Nail Vases	1976	12
"Skagit"	1977	11
Wire Glass	1978	9
City Vases	1979	14
Oceanic Vases	1979	12
Scenic Vases	1979–80	22
Distorted Vessels	1979–82	19
Vitrolite Wall Reliefs	1979–90	30
Head Vases	1980	21
Tripod Vessels	1980–81	23
People & Animal Vases	1981–82	11
Fish Vases	1981	24
Bird Vases	1982	28
Travel Vases	1982	9
Constructed Heads & Busts	1982–87	20
Automobile Vases	1983	20
People Holding Animals	1983	3
Constructed Animals	1983–95	16
Science Fiction Vases	1984–85	24
Portrait Vases	1986	18
Character Heads	1988–89	20
Nature Vases	1988	10
Face Vases	1988–97	196
Dailey/Tagliapietra Vases	1989–90	54
Mythology Head Vases	1989–90	22
Male/Female Figurative Vases	1989–94	38
Characters from Literature	1990	2
Mask Vases	1990	5
Abstract Head Vases	1990–94	80
Figurative Lamps	1990–ongoing	111
Dailey/Tagliapietra Mini Vases	1992–93	53
Animal Vessels	1992–98	50
Boca Palm Vases	1993	26
Skyscraper New York Vases	1993–94	10
Art Deco Building Vases	1995	5
Circus Vases	1995–ongoing	134
Individuals	2004–ongoing	15

Photography

Noel Allum: pp.30,257,259 top right,328,329,348.
Jan Bindas: pp.188,190 bottom.
Tom Bonner: pp.314,315.
John Cahalin: p.227.
John Carlano: pp.25,99,355.
Chateau Ste. Michelle: p.371 left.
Kathleen Corcoran: pp.300,301.
Susie Cushner: pp.14,26,62–64,68, 69,71–80,82,93–95,98,100–03,106, 108 bottom,109–13,115–17,134–39, 190 top.
Allison Dailey: p.365 center left.
Dan Dailey: pp.18,19,22,23,33,38, 39,42,48–51,53,56,60,65,362 left, 363 left,367 left,367 center,369 left, 370 left.
Kate Elliot: p.359 left.
Kellmis Fernandez: pp.359 center, 362 right,363 center,364,365 center right,365 right.
Michael E. Garland: pp.330,331.
Anthony Gomez: pp.209,305.
Julie Haack: p.363 right.
Hanson/Mayer: pp.141–43,168.
Russell Johnson: pp.318–20, 366 center left,367 right,368 center & right,370,371 right,372,373 left, 374 center left.
Stuart Kestenbaum: p.365 left.
Nancy MacNeil: p.361 left.
Magnet Communications: p.371 center.
Guy Mangin: p.121.

Charles Mayer: pp.120,122,123, 144–49,302,303,373 right,374 center left.
Terry Murphy: pp.208,369 right.
Richard Nowitz: p.15.
John Paskevich: p.333.
Richard Passmore: p.17.
Christian Poincignon: p.359 right.
Laurent Poincignon: p.368 left.
Joe Rapone: p.361 center.
Joe Rossano: p.369 center.
Doug Schaible: pp.199,218–20, 232–34,240,266 lower left & lower right,267.
Dwight Schenk: p.362 center.
Roger Schreiber: p.360 left.
Bruce Schwartz: pp.326,327,334,335.
Shane Photography: p.332.
Bill Truslow: pp.12,20,21,28,31, 34–36,41,43–47,52,54,55, 57–59,66,84–92,96,97,104,105, 108 top,124–31,140,151,153–60, 163–67,169–87,192,193,196–99, 200–03,205–07,210–15,216,217, 221–31,235–39,242–56,258,259 top left,bottom left & bottom right,260–65, 266 top left & top right,268–96, 306–13,321–25,336–51,375.
Brad Tuckman: p.304.
David VanAllen: p.360 left.
Chris Vesperman: pp.37,299, 361 right.
Ed Zucca: p.358 left.
Kim Zumwalt: p.359 left.

RAPONE, JOE.
EDITOR AND
BOOK DESIGNER

GLASER, MILTON.
FOREWORD

WARMUS, WILLIAM.
MAKE IT REAL

OLDKNOW, TINA.
STYLE AND THE DELUXE

ISBN 13: 978-0-8109-9319-8
ISBN 10: 0-8109-9319-8

COPYRIGHT©2007 MILTON GLASER,
WILLIAM WARMUS, TINA OLDKNOW

Printed and bound in China
10 9 8 7 6 5 4 3 2 1

HNA ▮▮▮▮▮
harry n. abrams, inc.
a subsidiary of La Martinière Groupe

115 West 18th Street
New York, NY 10011
www.hnabooks.com